A Garland Series

OUTSTANDING DISSERTATIONS IN THE

FINE ARTS

Niccolò and Piero Lamberti

George R. Goldner

Garland Publishing, Inc., New York and London

1978

All volumes in this series are printed
on acid-free, 250-year-life paper.

Library of Congress Cataloging in Publication Data

Goldner, George R 1943-
 Niccolò and Piero Lamberti.

 (Outstanding dissertations in the fine arts)
 Originally presented as the author's thesis, Princeton,
1972.
 Bibliography: p.
 1. Lamberti, Niccolò. 2. Lamberti, Piero, 1393-
1435. I. Title.
NB623.L25G64 1978 730'.92'2 [B] 77-94697
ISBN 0-8240-3229-2

Printed in the United States of America

NICCOLÒ AND PIERO LAMBERTI

George R. Goldner

A DISSERTATION

PRESENTED TO THE

FACULTY OF PRINCETON UNIVERSITY

IN CANDIDACY FOR THE DEGREE

OF DOCTOR OF PHILOSOPHY

RECOMMENDED FOR ACCEPTANCE BY THE

DEPARTMENT OF

ART AND ARCHAEOLOGY

February, 1972

<u>Preface</u>

In the seven years since I wrote my dissertation a number of related publications have appeared. V. Herzner has re-opened the question of the Porta della Mandorla ("Bemerkungen zu Nanni di Banco und Donatello," <u>Wiener Jahrbuch fur Kunstgeschichte</u>, 26, 1973, pp. 74-95). Although the solution he advances for the arch reveals is consistent with the circumstantial evidence concerning Nanni di Banco, it does not supervene the stylistic arguments made by Wundram, with whom I continue to concur.

Professor Middeldorf has published the theory he generously shared with me about the Strozzi Tomb ("Additions to Lorenzo Ghiberti's Work," <u>Burlington Magazine</u>, CXIII, 1971, p. 76.).

As for the Venetian work of the Lamberti, the most important publication has been the excellent book by W. Wolters, <u>La Scultura Veneziana Gotica 1300-1460</u>, Venice, 1976, 2 vols. He offers a thorough analysis of the documents which supersedes all previous readings of them. In terms of attributions, he and I are quite far apart. He expresses doubt about Niccolò Lamberti's participation on the San Marco program, even removing from his <u>oeuvre</u> the central statue of Saint Mark, and denies any role there to Piero Lamberti. On the other hand, he suggests a prominent position for Giovanni Martino da Fiesole. Though the documents alone do not sustain the attributions to Niccolò, they are suggestive in his regard and silent about Giovanni. Wolters wrongly describes the two sculptors as "minor Florentines" in the same breath, thereby giving the false impression that they

i

were comparable in ability and status. Niccolò was an important figure in Florence, whereas Giovanni is known to us solely on the basis of his collaboration with Piero Lamberti on the Mocenigo Tomb. The stylistic arguments supporting my attributions are given in the dissertation. As for the tabernacle statues on the lateral sides of the basilica, I do not see a compelling relationship between the Saint Anthony Abbot from this series and the image of the same saint on the tomb of Prediparte Pico della Mirandola. Nevertheless, these tabernacle figures may be by Paolo di Jacobello Dalle Masegne since the documents suggest his participation on the program. On the other hand, I now agree with Wolters that all of the Virtues are Italian. I also accept the similarity he suggests between the Fortitude, the Angels on the central pinnacle, and at least the Angel at the right of the Mocenigo Tomb, though I am not sure that the sculptor who carved them was Giovanni Martino. Equally, I am now convinced that the Annunciation is by the same sculptor as the four Evangelists on the West and that all six were at least designed by Niccolò. For my most recent views on this aspect of the subject see my article, "Niccolò Lamberti and the Gothic Sculpture of San Marco in Venice," Gazette des Beaux-Arts, LXXXIX, 1977, pp. 41-50.

My views on Piero Lamberti have not changed significantly, though I am less certain than before about his authorship of the second and third doccioni on the North side of the basilica. With regard to the Mocenigo Tomb,

ii

Wolters has wrongly proposed Giovanni Martino as designer. The distinctive architectural motifs on the tomb occur earlier in the work of Niccolò and would have been most readily used by his son. Equally, it was Piero and not Giovanni who received an important commission of similar type (the Fulgosio Monument) six years later.

Aside from Wolters' book, there has not been much written on the Venetian work of the Lamberti in recent years. A. Rosenauer, *Studien zum frühen Donatello*, Vienna, 1975, pp. 68-9, has independently discussed the relationship between the Coscia and Mocenigo tombs.

I have made very few alterations from the original version of my dissertation, mainly correcting typographical and other minor errors.

As in the original Preface, I would like to thank my advisor at Princeton University, Professor Felton Gibbons, for his advice on specific points and for offering me the optimum blend of encouragement and criticism throughout. Others who were helpful in one way or another were: Professors David Coffin, Robert A. Koch, Ulrich Middeldorf, Cesare Gnudi, Creighton Gilbert; the staff of the Fondazione Cini; Sita Chitiea. On a personal level, my wife and son were patient and cheerful during our year in Venice. Most importantly, my greatest appreciation is due my mother and late father for making my work in Venice possible.

Table of Contents

List of Plates

48 - Anonymous Lombard Assistants of Niccolò Lamberti: prophet busts and foliage, western face of San Marco, Venice. Gable figure by Giovanni Martino da Fiesole.

49 - Anonymous Lombard Assistants of Niccolò Lamberti: prophet busts and foliage, western face of San Marco, Venice. Gable figure carved by a Lombard assistant of the Lamberti.

50 - Anonymous Lombard Assistants of Niccolò Lamberti: prophet busts and foliage, western face of San Marco, Venice. Gable figure carved by a Lombard assistant of the Lamberti.

51 - Anonymous Lombard Workshop: prophet busts and foliage, southern face of San Marco, Venice. Gable figure by an assistant of the Lamberti.

52 - Anonymous Lombard Workshop: prophet busts and foliage, southern face of San Marco, Venice. Gable figure by an assistant of the Lamberti.

53 - Anonymous Lombard Assistants of Niccolò Lamberti: prophet busts and foliage, southern face of San Marco, Venice. Gable figure by an assistant of Lamberti.

54 - Anonymous Lombard Assistants of Niccolò Lamberti: prophet busts and foliage, southern face of San Marco, Venice. Gable figure by an assistant of Lamberti.

55 - Anonymous German Sculptor: Justice, San Marco, Venice.

56 - Anonymous North Italian Sculptor: Fortitude, San Marco, Venice.

57 - Anonymous Assistant of Niccolò Lamberti: Charity, San Marco, Venice.

58 - Anonymous German Sculptor: Faith, San Marco, Venice.

59 - Anonymous North Italian Sculptor: Temperance, San Marco, Venice.

60 - Anonymous North Italian Sculptor: Hope, San Marco, Venice.

61 - Niccolò Lamberti and Assistants: Saint Mark and Angels, San Marco, Venice.

62 - Niccolò Lamberti: Saint Mark, San Marco, Venice.

63 - Niccolò Lamberti: Saint Mark (detail), San Marco, Venice.

64 - Assistant of Niccolò Lamberti: Angel, San Marco, Venice.

65 - Assistant of Niccolò Lamberti: Angel, San Marco, Venice.

66 - Assistant of Niccolò Lamberti: Angel (detail), San Marco, Venice.

67 - Assistant of Niccolò Lamberti: Angel, San Marco, Venice.

68 - North Italian Sculptor: Saint Benedict, San Marco, Venice.

69 - North Italian Sculptor: Saint Anthony Abbot, San Marco, Venice.

70 - North Italian Scultor: Saint Ambrose, San Marco, Venice.

71 - North Italian Sculptor: Saint Augustine, San Marco, Venice.

72 - North Italian Sculptor: Saint Gregory the Great, San Marco, Venice.

73 - North Italian Sculptor: Saint Jerome, San Marco, Venice.

74 - Anonymous Lombard Sculptor: Saint Michael, San Marco, Venice.

75 - Niccolò Lamberti and Assistant(?): Gabriel, San Marco, Venice.

76 - Niccolò Lamberti and Assistant: Saint Matthew, San Marco, Venice.

77 - Niccolò Lamberti and Assistant: Saint Matthew (detail), San Marco, Venice.

78 - Niccolò Lamberti and Assistant: Saint Mark, San Marco, Venice.

79 - Niccolò Lamberti and Assistant: Saint Mark (detail), San Marco, Venice.

80 - Niccolò Lamberti and Assistant: Saint John, San Marco, Venice.

81 - Niccolò Lamberti and Assistant: Saint John (detail), San Marco, Venice.

82 - Niccolò Lamberti and Assistant: Saint Luke, San Marco, Venice.

83 - Niccolò Lamberti and Assistant: Saint Luke (detail), San Marco, Venice.

104 - Giovanni Martino da Fiesole: seated figure, San Marco, Venice.

105 - Piero Lamberti: Moses, San Marco, Venice.

106 - Giovanni Martino da Fiesole: seated figure, San Marco, Venice.

107 - Giovanni Martino da Fiesole (?): seated figure, San Marco, Venice.

108 - Giovanni Martino da Fiesole: seated figure, San Marco, Venice.

109 - Giovanni Martino da Fiesole (?): seated figure, San Marco, Venice.

110 - Niccolò Lamberti: Abraham, San Marco, Venice.

111 - Niccolò Lamberti: Isaac, San Marco, Venice.

112 - Piero Lamberti: Jacob, San Marco, Venice.

113 - Piero Lamberti: Noah, San Marco, Venice.

114 - Giovanni Martino da Fiesole: Evangelist, San Marco, Venice.

115 - Piero Lamberti: Evangelist, San Marco, Venice.

116 - Giovanni Martino da Fiesole: Saint Matthew, San Marco, Venice.

117 - Giovanni Martino da Fiesole: Evangelist, San Marco, Venice.

118 - Bernardo Ciuffagni: Isaiah, Cathedral, Florence.

119 - Piero Lamberti and Giovanni Martino da Fiesole: Mocenigo Tomb, Santi Giovanni e Paolo, Venice.

120 - Piero Lamberti: Angel, Mocenigo Tomb, Santi Giovanni e Paolo, Venice.

121 - Piero Lamberti: Angel, Mocenigo Tomb, Santi Giovanni e Paolo, Venice.

122 - Piero Lamberti: Fortitude, Mocenigo Tomb, Santi Giovanni e Paolo, Venice.

123 - Piero Lamberti: Prudence, Mocenigo Tomb, Santi Giovanni e Paolo, Venice.

Introduction

The purpose of the present study is to isolate
the authentic oeuvre of the Lamberti, to analyze it, and
thereby to construct a coherent picture of their careers.
There are several methodological problems which arise in
attempting such a study; foremost among them is the question
of whether to deal with all of the works which have at one
time or another been attributed to them. I have rejected
this approach for several reasons. Many of the older
attributions to Niccolò of works in Florence have long
been discarded and there is no reason to revive them;
examples which fit this category are the Annunciation group
in the Museo dell'Opera del Duomo and part of the campanile
Prophet series in Florence. Similarly, a large and hetero-
geneous group of sculptures has been ascribed to Piero
Lamberti, mostly in Venice, many of which have no relation-
ship whatsoever to his authentic work. A fresh study of
the sculpture of the Porta della Carta, the lunette of the
Scuola Grande di San Marco, and the Beato Pacifico Monument,
though desirable in general, would have no bearing on the
present context. They have therefore been excluded from
the discussion entirely, and all works not mentioned here
are, in my opinion, unquestionably not by the Lamberti. In
virtually all of these cases preferable ascriptions have
appeared in the scholarly literature. I have instead

focused on those works which are frequently, though in certain instances erroneously, attributed to them. In one case, the sculptural decoration of San Marco in Venice, I have discussed the entire project programmatically since I felt that this was the best way to arrive at a proper understanding of the role which the Lamberti played there.

The documentation relating to the Lamberti is contained in a very limited number of sources. They are cited in the notes and the documents are reviewed in the text. Plates reproducing a given work are noted in the left hand margin, whereas picture sources are offered in the notes for those not illustrated here.

Part 1: Niccolò Lamberti in Florence
A Chronological Survey of the Life of Niccolò Lamberti

Niccolò di Piero Lamberti was born about 1370, probably in Florence.[1] He may have been born several years earlier as there are references to apprentices with similar names in the cathedral workshop as early as 1378; unfortunately, it is impossible to determine whether any of them is Lamberti.[2] By contrast, we do know that Niccolò was married in Florence in 1392 - the marriage contract still exists[3] - and that a year earlier he joined Giovanni d'Ambrogio, Jacopo di Piero Guidi, and Piero di Giovanni Tedesco in the beginnings of the decoration of the Porta della Mandorla.[4] It therefore seems unlikely that he could have been born much after 1370.[5] The Florence in which Niccolò grew up gave no indication in its artistic production of the revolutionary developments which would come a generation later. Among the sculptors, only Giovanni d'Ambrogio revealed a confirmed interest in the classical past and its impact on his work was not very broad. It was instead the late Gothic which dominated the Florence of Lamberti's youth and which irrevocably established the direction of Lamberti's art.

Niccolò worked on the Porta della Mandorla from 1393 until the first months of 1395.[6] In 1395/6 he carved a large Madonna and Child group - which may well be the Madonna della Rosa at Or San Michele - for which he received

final payment in July of 1396;[7] during the same year he was
paid for an unidentified figure of an angel.[8] In 1395
Niccolò and Piero di Giovanni Tedesco were commissioned to
carve statues of the four Latin Church Doctors for the
facade of the cathedral.[9] Lamberti worked on his pair, the
figures of Saint Augustine and Saint Gregory, very slowly,
completing them only in 1401.[10] In 1401 he carved an
apparently minor representation of a lion head which no
longer exists.[11] In the same year he and the mysterious
Urbano of Pavia and Venice were commissioned to carve four
marble figures;[12] this project, like another of the same
year in which Niccolò, Urbano, and Giovanni d'Ambrogio were
to participate,[13] did not materialize. However, the most
important event of this time for Niccolò was doubtless the
competition for the second set of doors of the Florentine
Baptistery. He was one of seven contestants, a great honor
in itself, but he lost to Ghiberti; unfortunately, Niccolò's
competition panel does not survive.[14]

The year 1402 saw Niccolò at work on the Porta
dei Canonici. He carved the major part of the Madonna and
Child during that year and in October was commissioned to
sculpt an angel for the same doorway.[15] In 1403/4 the Guild
of the Magistrates and Notaries commissioned Lamberti to
design their niche at Or San Michele and to carve a statue
of Saint Luke for it.[16] The year 1403 also saw Lamberti
receiving a further honor: the Doge of Venice, Michele Steno,

asked the Florentine _Signoria_ to allow Niccolò to come to
Venice and work on the Ducal Palace. They refused - a fact
which would further indicate the high esteem in which
Lamberti was then held - and his departure to Venice was
thereby delayed for twelve years.[17] Niccolò's training and
professional activities were broad in scope and in 1404 he
served in an advisory capacity concerning an architectural
problem at the cathedral.[18] In 1405 he carved the no longer
extant tomb slab of Leone Acciauolo for the cloister of
Santa Maria Novella;[19] in the same year he and Lorenzo di
Giovanni d'Ambrogio went to Carrara to procure four marble
blocks and were paid later in the year for preparing them.[20]
It is usually thought that these blocks were later used for
the four statues of the Evangelists which were carved by
Niccolò, Donatello, Nanni di Banco, and Bernardo Ciuffagni.[21]
During the latter half of 1406 Niccolò received the vast
majority of the payments for his work on the niche and statue
for the Guild of the Magistrates and Notaries;[22] it therefore
seems very likely that he spent the better part of that
year working on this project.

During the years 1406/7-9 Niccolò returned to
work at the Porta della Mandorla, collaborating with Nanni
di Banco and perhaps Donatello on the sculptural decoration
of the arch reveals; Lamberti received final payment of
February 4, 1409.[23] In the interim, on December 19th of the
previous year, Niccolò received the prize commission to

-5-

carve the marble statue of Saint Mark for the facade of the
cathedral.[24] His work on this important statue was slow;
it seems likely that he did not even begin until at least
the middle of 1409.[25] By August of 1412 he had accomplished
only forty florins worth of work and the following three
years were filled with interruptions as well. On February
15, 1409 he was entrusted by the Linen Drapers' Guild with
the task of procuring marble for a statue of Saint Mark
which was to be placed in their niche at Or San Michele.[26]
His association with the project ended on February 16, 1411
with the delivery of the block; however, he did serve as one
of Donatello's guarantors in connection with this commission,
thereby underwriting Donatello's obligation.[27]

In 1409-10 he held an administrative post at Or
San Michele,[28] but was no longer in Florence on December 18,
1410.[29] It seems almost certain that Lamberti went to Prato
where he is mentioned in January of 1411.[30] He appears to
have divided his time between Florence and Prato during the
period of 1410-3. Niccolò carved the Datini tomb slab in
Prato between January of 1411 and August of the following
year[31] and was again in Prato, working on the cathedral
facade, in 1413.[32] In the meanwhile, on August 12, 1412,
he was ordered by the operai of the Florentine cathedral to
return the forty florins which he had received up to that
point in connection with the seated Saint Mark.[33] He returned
hastily from Prato - where he was given final payment for the

Datini tomb on August 16[34] - and the punitive order was
rescinded by the operai on August 17.[35] However, Niccolò's
enthusiasm for the Saint Mark commission seems once again
to have waned and the major portion of the work was carried
out between the first few months of 1414 and March of 1415
when he received final payment for it.[36] Finally, Niccolò
was paid for carving a water spout in the shape of the head
of a hunting dog in February of 1415;[37] it has never been
identified and probably no longer exists.

Lamberti must have left Florence shortly after
receiving final payment for the Saint Mark, because he is
mentioned in a document of October 23, 1416 in Venice, deeply
involved in the sculptural decoration of San Marco.[38] In
1419 and 1420 he journeyed to Lucca to acquire marble for
the Venetians.[39] He was in Florence in 1419 where he
purchased marble for an unspecified tomb[40] and again in
1420 when he returned tools which he had left in the cathedral
workshop.[41] There is no evidence to indicate that he
remained in Florence for any considerable length of time;
indeed the circumstantial data points in the opposite
direction.[42]

The documentary material on the remainder of
Niccolò's life is extremely sparse. A certain "ser Nicolaus
lapizida de florentia" is mentioned in Venice in 1424, but
it is not sure that this person is one-and-the-same as
Lamberti.[43] In 1428 he was asked by the officials of

San Petronio in Bologna to serve as an arbiter in a dispute
between them and a certain Domenico di Sandro Da Fiesole
over the worth of a capital which the latter had carved
for the church.[44] In 1429 he did some unspecified work for
the Palazzo degli Anziani in Bologna, which had been damaged
by a fire in 1425.[45] He appears to have spent much of this
period of his life in Bologna; he is mentioned there in
1434 and in 1439 when he was living in the house formerly
occupied by Jacopo della Quercia;[46] he was entrusted with
the belongings which Jacopo left behind at his death and
so it would appear that they had a friendly relationship.[47]
In 1439 he purchased stone for some unrecorded purpose in
Bologna; this is the last mention of him there.[48]

Niccolò returned to Florence at some point during
the next twelve years for in 1451 the following notice
appears in the Registro dei morti of the Guild of the
Physicians and Apothecaries: "A di 15 giugno Nicholo
chiamato il pela populo di S. Lorenzo riposto in Santo
Barnaba."[49]

Aside from the factual data concerning Niccolò's
whereabouts and professional activities, scarcely anything
is known about him. Therefore, while it is possible to
reconstruct and study his work and development as an artist,
one cannot gain any insight into his personality.

The Porta della Mandorla

The decoration of the Porta della Mandorla was
one of the most important sculptural projects of the period
spanning the last decade of the 14th century and the first
two decades of the 15th century. Virtually all of the
leading Florentine sculptors of the period participated in
this elaborate program which was interrupted at several
stages. The first campaign on the project took place
between 1391 and 1397, during which time the jambs, lintel,
and reveals of the doorway were decorated and the two figures
of prophets above the lintels were carved.[50] The two
prophets were carved by Lorenzo di Giovanni d'Ambrogio in
1396/7[51] while the remaining parts of the work were divided
between Giovanni d'Ambrogio, Piero di Giovanni Tedesco,
Jacopo di Piero Guidi, and Niccolò Lamberti. The second
campaign consisted of the decoration of the arch reveals by
Niccolò Lamberti, Nanni di Bancò,[52] and perhaps Donatello,[53]
who definitely carved a figure of a prophet for the Porta
della Mandorla during this period;[54] this period of work
spanned the years 1404 to 1409.

There has been an enormous amount of scholarly
argument which has raged around the works produced during
these two campaigns.[55] The difficulties have been lessened
by the existence of nearly complete documentation for the
Porta della Mandorla and by the judicious attributions made
by Kauffmann and Wundram.[56] The former correctly gave the

jamb and lintel decoration to Giovanni d'Ambrogio and Piero
Tedesco, dividing the various parts in a manner which has
seldom been questioned since. He went on to attribute the

Pl.1&2
&6(fig- second and third (from the top) angels and figurines on the
urine)
left side to Piero Tedesco. On the opposite side he
attributed the first and second figurines as well as the

Pl.3&4 second and third angels in hexagons to Jacopo Guidi. Here
too his ideas have met with justifiable approval generally.
Finally, he gave the remaining parts of the decoration of

Pl.5-7
&1(fig- the left reveal to Giovanni d'Ambrogio and those on the
urine)
Pl.8-10 right to Niccolò Lamberti. This latter group of attributions
has been challenged by two leading authorities in the
field of Italian sculpture, Charles Seymour and Giulia
Brunetti. In both cases they reject the possibility that
Giovanni d'Ambrogio could have been the creator of the most
progressive works in sculpture of the decade. Brunetti
tried to resolve this problem by giving the works on the
left side to Jacopo della Quercia who would then have been
working as an assistant to Giovanni d'Ambrogio.[57] By
contrast, Seymour divided these between Niccolò Lamberti,
to whom he attributed the lower sections, and Lorenzo di
Giovanni d'Ambrogio, to whom he gives the upper section.[58]
These two solutions suffer from several points of logical
difficulty. The most important objection to both of them
is simply that neither Jacopo della Quercia nor Lorenzo di
Giovanni are mentioned in the documents, while Giovanni
d'Ambrogio is mentioned without any hint that he might be

acting on behalf of another sculptor. Of almost equal
importance is the fact that it is extremely difficult to
see a close connection between the authentic works of
Quercia and Lamberti on one hand and the sections of the
reveal sculpture attributed to them by Brunetti and Seymour
respectively. In other words, there is no reason whatsoever
to doubt that the documents should be read at face value.
This is confirmed by Wundram's exemplary analysis of the
problem in which he reasons that since Lamberti was the only
sculptor who carved parts of both the door reveals and of
the arch reveals and that certain similarities would certainly
occur between the two parts he carved despite the intervening
years.[59] Using a series of careful comparisons he concludes
that Kauffmann was correct in his attributions of the reveal
sculpture dating from 1391-7, but that he was incorrect
in giving the decoration of the left side of the arch to
Pl.11-14 Lamberti and the right side to Nanni di Banco.[60] In addition
to showing that the right reveal sculpture of the arch and
the disputed parts on right side of the doorway correspond
in style and are therefore by Lamberti, he also is able to
make clear connections between those sections which he
attributes to Giovanni d'Ambrogio and Nanni di Banco and
other works in their careers. In the case of Giovanni
d'Ambrogio he is able to relate his work on the Porta della
Mandorla to the Saint Barnabas and to the Annunciation, both
in the Museo dell'Opera del Duomo, and also to the seated
figure of Justice on the Loggia dei Lanzi.[61] Although it

is true that the Barnabas and the Annunciation are both
disputed works as well, it is clear that they and the
Porta della Mandorla reliefs have much in common and are
therefore mutually supporting attributions. The fact that
Giovanni was older than the other two artists proposed
does not mean that he was less progressive, so that Seymour's
statement that there was, "...an ever-widening rift between
Lamberti, still on the track of a 'new' style, and the older
artist (Giovanni d'Ambrogio), in 1408 still trying to stem
the current..." seems totally without visual, documentary,
or logical support.[62] Wundram also relates the sections
of the arch reveals which he, as well as the majority of
scholars, give to Nanni de Banco to Nanni's other works.
Here too he connects them mainly with a disputed work, the
statue which formerly stood in a niche on the campanile
and which was generally attributed to Giuliano di Giovanni
da Poggibonsi.[63] Wundram attributes this statue to Nanni
di Banco, claiming it as his Isaiah for the cathedral
buttress.[64] Here again the attributions are mutually
buttressing, and they seem fully convincing to me. Finally,
it should be added that the same holds true of the parts of
the reveal sculpture which Wundram attributes to Lamberti.
In my opinion - and as I hope will be apparent from the
discussion of the remainder of Niccolò's work which follows -
the attribution of any of the other parts of either the
door or arch reveals to Lamberti would be inexplicable on
any grounds other than those of an eccentric deviation from

-12-

his stylistic development and artistic outlook throughout his long career.

Pl.8-10 The style which appears in Niccolò's three half-length angels in hexagons and in the two figurines in foliage on the right side of the doorway show him to be a sculptor of considerable refinement already at an early age and one who is strongly attuned to earlier _trecento_ styles in sculpture. In the three angels there is a marked linearity in the treatment of drapery which harks back to the francophile linear delicacy of Nino Pisano. Along with this tendency comes a feeling of insubstantiality in the rendering of the torsos of the angels. The heads are treated in a corresponding manner, with thinly drawn eyes and eyelids and minutely differentiated strands of hair which form delicate curls. In these respects as well one may think of the works of Nino Pisano, such as the beautiful Madonna and Child now in the Museo dell'Opera del Duomo of Orvieto.[65] The sides of the face are treated in smooth and unmodulated planes which betray not a hint of naturalism. The figurine which is sometimes called "Abundantia" is one of the very few renderings of a nude - or near-nude - by Lamberti. It too is a very graceful and linear form, but one lacking in volumetric force and plasticity. In addition, the transitions between the various limbs and the torso are not smoothly handled and the pose does not appear to be fully resolved throughout the figure. There is also a

tendency for this figure to become part of the rich
ornamentation which surrounds it, in a way which sharply
contrasts with the much bolder and more fully classical
Pl.7 "Hercules-Fortitude" on the other side of the doorway which
was carved by Giovanni d'Ambrogio.

Niccolò completed his work on the lower reveal
sculpture in 1395, but returned to this project in 1406/7
to carve the decoration of the right side arch reveals.[66]
Although there had been a lapse of over ten years between
the two campaigns Niccolò's style remains remarkably
consistent and unchanged in its fundamental characteristics.
The three angels are still composed by means of a linear
Gothic style which tends towards flatness and decorativeness.
Yet, within the group of three angels there is also a
noticeable, although quite limited, degree of change in
his style. The earliest of the three is doubtless the
Pl.11 figure who holds his scroll with both hands. The facial
features and planes are tightly and sharply drawn and the
torso seems not to be much more than a surface upon which
Pl.12 the sculptor has incised a linear pattern. The second
angel to be carved was the one which is badly damaged; it
lacks almost all of the right side of the body. Here the
physiognomic details remain quite similar, but there is a
greater sense of volume and roundness to the head. Lastly,
the angel who holds his scroll in his left hand must
certainly have been the final one of the trio to be executed.

The drapery is fuller and the patterning formed by it is
composed with deeper grooves and broader rhythms. The
treatment of the head has changed considerably as well; it
turns expressively upward and to the left and begins,
especially in the left cheek and the neck, to take on
something of the quality of fleshiness. In general the
figure is much more volumetric and naturalistic than any of
its predecessors. There is, I think, a very clear reason
for this change; this was the influence of Nanni de Banco's
figures on the opposite side of the arch. His figures are
more volumetric - and therefore project more forcefully
from the back planes of the relief space - than any others
at the Porta della Mandorla and are much more activated and
naturalistic in both form and spirit. Nanni's drapery
style is still made up of a linear Gothic idiom, but it is
bolder and more animated than that of his predecessors and
co-worker on this program. Lamberti was influenced not only
by the general characteristics of Nanni's three angels, but
also by the technique of cutting deeper and broader grooves
in the drapery. It is therefore sure that Lamberti carved
his third angel after one or more of Nanni's angels was
already completed.

The change in style between the "Abundantia" in
the right doorway reveal and the three figurines in the
right arch reveal is equally substantial. However, here
it is difficult to reconstruct the order in which they were

carved because one of the major agents of the change was
Giovanni d'Ambrogio's "Hercules-Fortitude" figurine, carved
during the first campaign of the project. This is clearly
the example which can account for the more classical and

Pl.13 more ponderated quality of Niccolò's Hercules as compared
to the "Abundantia". Lamberti's Hercules is the only example
in Lamberti's career of any interest in the Antique; although
it is not entirely unsuccessful, it indicates that he was
not nearly as fully comprehending a reviver of classical

Pl.14 art as was Giovanni. The two youthful figurines which
complete Lamberti's contribution to the Porta della Mandorla
are cruder in execution than the Hercules; in one case this
may be accounted for in part by weathering. On the other
hand they are much more animated than any of Lamberti's
works up until this time. Once again the change in Lamberti's
style is due to outside influence from his younger col-
laborator on the arch reveals. The figurine who bends

Pl.14 forward by Niccolò derives his pose from the lowermost
figurine by Nanni, whereas Lamberti's second youthful figure
more generally relates to the last of Nanni's in that they
both are shown turning their heads sharply to the left. It
is possible, although hardly provable, that the two youthful
figurines are later in date than the Hercules since they
reveal the influence of Nanni's work of the arch reveal
whereas it does not. This theory gains support from the
cruder and more unfinished quality of the bending figure.
This roughness and lack of definition cannot be fully

explained by weathering and it may well be that Niccolò
carved it rather hastily because of pressure placed upon
him to finish his work on the project. This seems to be
one of the two correct inferences which can be drawn from
the well-known document of 1408 in which Lamberti was
censured by the cathedral authorities. The significant
portion of the document reads as follows: "Niccolaus non
prosequitur constructionem dicte porte et eius ornamentam
prout principiavit et secundum forman exemplum dicti
Johannis capudmagistri...".[67]. The only proper reading of
this document is that given by Wundram who interprets it
as meaning only that Niccolò was to finish up his work
according to the design of Giovanni d'Ambrogio from which
he had apparently departed in some respect.[68] Since Lamberti
did finish his part of the project quite speedily thereafter,
it is possible that the relatively unfinished character of
this small figurine may have been the result of the pressure
from the authorities and that it may have been his last
work on the Porta della Mandorla.

It is very difficult, if not impossible, to
determine what may have been Niccolò's deviation from the
design of Giovanni d'Ambrogio. There is nothing to support
Seymour's suggestion that the document is indicative of a
broader conflict between the younger Lamberti and the older
Giovanni d'Ambrogio;[69] if anything Giovanni was consistently
the more progressive sculptor. I would suggest a more

mundane possibility which relates to technical rather than temperamental differences. The fragmentary angel carved by Niccolò for the arch reveal is the only one of the many angels in hexagons at the Porta della Mandorla that is situated markedly off-center in relation to its hexagonal frame. It is also not the last of Lamberti's three angels for the arch, but the middle one of the three in terms of chronology. It therefore seems plausible that this could have been the cause of the reprimand and the fine. It should be added that this suggestion would not lend support to the hypothesis of a broad conflict of purposes between Lamberti and Giovanni d'Ambrogio. As capomaestro, it was Giovanni's responsibility to maintain a sense of unity throughout the project; he would, therefore have been more concerned with the manner in which a given part of it related to the program as a whole than with the question of whether it was conservative or progressive.

The Madonna della Rosa

In June of 1395 Niccolò was paid ten florins for
a Madonna which he was carving for the cathedral.[70] On July
11th of the following year he received final payment for
what is then referred to as, "figure beate Virginis et
nostri domini Jesu Christi".[71] There is no sculpture
group in the cathedral or its museum which can be related
to these documents. However, several scholars have main-
Pl.15 tained that this group is the Madonna della Rosa in the
niche of the Physicians and Apothecaries at Or San Michele.[72]
Others have denied the relationship and have variously
suggested the names of Giovanni d'Ambrogio, Piero Tedesco,
and Lorenzo di Giovanni as author of the work.[73]

The documentary and circumstantial evidence is
inconclusive, although it perhaps favors Lamberti somewhat.
There are several examples of the cathedral authorities
acquiring or disposing of fully completed major statues
during this period, so the connection between the cathedral
documents and the Madonna della Rosa cannot be excluded on
these grounds.[74] It should be added that there is no
documentation which in any way relates this group to any
other sculptor. The date 1399 is inscribed on the base of
the niche; this would seem to indicate the date for the
completion of the whole ensemble and would thereby invalidate
any connection between a Madonna which Piero Tedesco was
carving for the cathedral in 1399/1400 and the Madonna della

Rosa.[75] Indeed, the date of 1399 circumstantially supports
the attribution to Lamberti, since it places the architectural
activity at the completion of the Madonna and Child group of
1396. However, this would be a very tenuous basis for making
any attribution and therefore, barring the discovery of as yet
unknown documents, the decision must be made mainly on the
basis of stylistic criteria.

Of the four sculptors whose names have been
proposed two, Giovanni d'Ambrogio and his son Lorenzo, may
be excluded with assurance; there is simply nothing about
the style of the Madonna della Rosa which is more than
very generally analogous to the sure works of either
sculptor. The choice is therefore reduced to either Niccolò
Lamberti or Piero Tedesco and it is anything but an easy
one. The two sculptors were working in close proximity
to one another for most of the decade of the 1390's, first
on the Porta della Mandorla and then on the four statues
of the Latin Church Doctors. It is therefore not terribly
surprising that there are certain aspects of the work which
relate to each of the two artists. The Christchild's head

Pl. 2 and hair are comparable to the music-making putto between
the two angels which Piero Tedesco carved on the left side
of the Porta della Mandorla. Equally, the heavier eyelids
and the softer texture of His face are more easily relatable
to Piero's known oeuvre than to Lamberti's. Finally, the
rather block-like character of the group can be seen in

Piero's other works such as the figure of a Church Doctor
who holds a book in his hand in the Museo dell'Opera del
Duomo in Florence.[76] However, these are the only points of
similarity between the Madonna della Rosa and Piero's sure
works. The handling of the Madonna's head is completely
dissimilar to that employed for either the music-making

Pl.1&2 angels in the Museo dell'Opera del Duomo,[77] the two angels
on the Porta della Mandorla, or the two Church Doctors.[78]
This is true both of the treatment of details and for the
overall shape and conception of the head. The drapery
style here is also at variance with that employed by Piero
throughout his brief career in Florence. It is crisper,
more varied, and more sharply directional than that of any
of his known statues. In all of his free-standing statues
there is an amorphous, doughy quality which is, at least in
part, the result of the lack of incisive and varied movement
in the drapery forms.

The degree to which the group can be related to
Lamberti's secure works is much greater. Close analogies
may be seen to exist between the shape of the Madonna's
head and the treatment of the face here and in works such

Pl.10 as the lowermost angel on the lower right reveal of the
Porta della Mandorla, the Church Doctor without a beard,[79]

Pl.17 and the Madonna of the Porta dei Canonici. The thinly
drawn and delicately formed lips, the prominent jaw, and
the broad and smoothly undifferentiated planes of the face

-21-

are all characteristic of Lamberti's style during this period. The drapery style is also fully intelligible within the context of Lamberti's stylistic development. It is lively and varied, but tends to conceal and almost submerge the human form behind it. More specifically, the sharply incised grooves on the right arm of the Madonna, the thin tubular folds which hang from the knees, and the lowermost level of the drapery are all comparable to other examples

Pl.8 of Niccolò's work; I refer to the uppermost angel on the
Pl.21 lower reveal of the Porta della Mandorla, to the Saint Mark
Pl.18 carved for the cathedral facade, and to the Saint Luke respectively. Finally, the finely rendered hands of the Madonna are characteristic of Niccolò's refined style; they are very similar in their smooth surfaces and thin fingers

Pl.8- to those of the earlier angels of the Porta della Mandorla
10,18 and of the later Saint Luke.

In addition to specific questions of style there is one further aspect of the sculpture group which would tend to favor the attribution to Lamberti over Piero Tedesco; this is the matter of its general stylistic sources. The physiognomic type of the Madonna seems to refer to earlier trecento types which may be seen in the work of Nino Pisano on one hand - for example the Madonna del latte in Santa Maria della Spina in Pisa - and to that of Tino da Camaino on the other - as in the Madonna and Child in the Museo Nazionale in Florence.[80] Equally, the gesture of the

Christchild is reminiscent of the Madonna and Child by Nino
Pisano, also in Santa Maria della Spina,[81] in which the
Madonna is shown standing. Even if these relationships are
acceptable only on a generalized basis, they would tend to
favor an attribution to Niccolò as against Piero. The
reason for this is that Piero's style seems to have been
formed before he came to Florence and changed only to a
minimal extent during his stay there; this can be seen by
comparing the pair of music-making angels in the Museo dell'
Opera del Duomo of the second half of the 1380s with the
two Church Doctors of approximately a decade later. Further-
more, his style bears little relationship to earlier Tuscan
styles, aside from the generic Gothic character which they
share. Lamberti, by contrast, was deeply influenced by the
art of both Andrea and Nino Pisano; a particularly strong

Pl.18 example of the influence of Nino may be seen in the drapery
of the Saint Luke. It is therefore much more likely that
Lamberti would have turned to earlier trecento sources for
inspiration than that Piero Tedesco would, which is one
further point in favor of attributing the group to Niccolò.

 In addition to the reasons put forth above, there
is one further factor concerning the Madonna della Rosa

Pl.16 which binds it very closely to Lamberti; this is the
architecture of the niche which houses it. It consists of
a simple base which carries two ornate spiral columns and
an elaborate canopy above the whole ensemble. This last

element is in turn made up of a projecting three-sided
structure, with each side having a pointed arch with a
gable above, and a ribbed domical section at the very top.
In all respects this architectural design is without
precedent at Or San Michele. The ornate spiral columns
replaced the flat pilasters which may be seen in earlier
niches such as those containing the Saint Stephen and the
Saint Peter.[82] The use of a projecting overhang separates
this niche not only from its predecessors, but also from
the later niches. Finally, the use of a domical structure
is also unique among the various niches at Or San Michele.
It does, however, unite this project with Niccolò's much
later tomb slab for Francesco di Marco Datini, as well as
to works on which he and his son Piero collaborated in
Venice. The use of this motif was highly unusual at this
time - Lamberti may well have derived it from the tabernacle
by Orcagna inside Or San Michele[83] - and it therefore
seems certain that he was responsible for the design of the
niche of the Physicians and Apothecaries. The possibility
that Piero Tedesco could have designed it is very remote,
especially since it was Lamberti and not Piero who was
well-known as an architectural designer.

Pl.20

This would add the final piece of evidence which
must, I think, lead to the attribution of the whole project
to Niccolò. It is very likely that the Madonna and Child
mentioned in the cathedral documents is the Madonna della Rosa

although this cannot be definitely proven. If it is the case then it would appear that the niche was worked on in 1398 and 1399, when Lamberti curiously received no payments for the Church Doctors he was carving for the cathedral, and that the statue was placed in the completed niche in 1399, the year inscribed on the base.

The Statues of Saint Augustine and Saint Gregory

On October 15, 1395 Niccolò and Piero Tedesco
were commissioned to carve four statues of saints;[84] although
the identities of the figures is not mentioned, it is
certain from later documents that the statues referred to
are the four Church Doctors and that Lamberti's share of
the project consisted of the Saint Augustine and the Saint
Gregory.[85] On October 21, 1395 Agnolo Gaddi was paid for
making drawings for the four statues.[86] Piero Tedesco made
rather rapid progress on his two figures, completing the
Saint Ambrose by April 1, 1398 and the Saint Jerome by
August 5th of the following year.[87] He received a total of
140 florins for each of his figures.[88] By contrast,
Lamberti made very slow progress on his two figures and
did not receive final payment until July 19, 1401.[89] The
original destination of the four statues is revealed in a
document of March 11, 1400 which states that the statues
were to be placed, "super portas que sunt ante plateam S.
Iohannis".[90] It has been proposed by some scholars that
the four figures were placed on the third level of the
facade, in the tabernacles on either side of the gables
above the side portals of the facade.[91] And while it is
true that the figure of a Saint Jerome appears in the second
tabernacle from the right in the 1587 drawing of the facade,
it is also apparent that there are differences between the
four statues by Piero and Niccolò and the four figures in

the drawing, including the Saint Jerome.[92] In addition,
no documentation exists for the actual placing of the
figures on the facade, although later sources speak of
them as belonging to this location.[93]

The four statues are in a very poor state of
preservation.[94] In the 17th century they were situated on
the Viale del Poggio Imperiale where they remained until
1936, when they were brought to the Museo dell'Opera del
Duomo. By this time they had suffered both from weathering
and from a mutilation of certain sections. The two statues
which are correctly considered by most scholars as Lamberti's
pair, have had the tops of their heads sawed off and
replaced by laurel wreaths.[95] The face of the beardless
statue was reworked - not very much, I believe - and its
head was reattached at some unspecified point. The beard-
less statue is lacking both of its hands and is badly worn
down, particularly along the arms, shoulders, and in the
face. The bearded Church Doctor is in better condition,
although it lacks the right hand and two fingers of the
left. There is also noticeable breakage in the upper corner
of the book held in the left hand and in the lower drapery.
This statue is less badly weathered, though; unfortunately,
the face seems to have suffered the most. Despite this
unhappy history and state of preservation, one can still
discern a great deal about the original character of these
two figures.

In terms of overall composition the two statues are block-like and have only the most hesitant sense of movement. There is a slight sway at the hips and the legs are only differentiated in a very tentative way. The drapery is composed of thin softly moving folds which form very similar patterns in the two statues. By comparison with Piero's two Church Doctors, Lamberti's are handled with a sharpness of line and of direction in the drapery. The drapery does not seem to suit the heavy and graceless forms of the figures themselves. It would therefore seem that these two statues form a point of transition between the massive, block-like Madonna della Rosa and the graceful, delicate forms of the Madonna and Child of the Porta dei Canonici and the Saint Luke. The facial types and the general proportions of the figures hark back to the earlier group, whereas the more refined drapery style and the slight movement point forward to his next stage of development.

Pl.15

Pl.17

Pl.18

The Porta dei Canonici

In 1402 Niccolò and Lorenzo di Giovanni d'Ambrogio received payments from the cathedral authorities for work on a Madonna and Child group;[96] there is nothing in the various documents though to indicate whether the payments are for the same group. However, we do know that Lorenzo received payment from the cathedral after Niccolò had ceased to and that it is therefore entirely possible that he completed the group which Niccolò had started earlier in the year. Also in 1402, Niccolò was commissioned to carve an angel for the Porta dei Canonici which was to be like the one already in place;[97] he received a further payment for the completed angel in 1403.[98] It is virtually certain that the Madonna and Child of 1402 is the one in the lunette of the Porta dei Canonici who stands between Lamberti's angel and the earlier one, which was perhaps carved by Lorenzo di Giovanni.[99]

The Madonna is very evidently a work of collaboration between the two sculptors. The smooth planar face of the Madonna, with narrow eyes and mouth, recalls Niccolò's earlier work on the Porta della Mandorla and on the Madonna della Rosa. Her pose may be easily seen at a logical stage in the development from the Church Doctors to the Saint Luke. The differentiation of the legs and the swaying of the hips are much more pronounced than in the earlier statues, but not nearly as well managed as in the

Saint Luke. The drapery covering the legs is extremely
close to that of the Saint Luke; in both one finds thin
tubular folds and the placing of one layer of cloth neatly
above the other with a thin horizontal ridge formed by
the end of the outer layer. The strips of drapery which
hang at the sides can also be seen, with minor variations,
on both the Saint Luke and the Church Doctors. It is in
the central section of the drapery that the figure differs
markedly from the known work of Niccolò, as Wundram has
pointed out, and it is here that the hand of Lorenzo di
Giovanni appears.[100] Lorenzo di Giovanni's drapery style
can be distinguished by one characteristic which is rather
unusual, the use of a series of thin folds and grooves
which reverse direction in a rapid and somewhat disconcerting
manner. The hands of the Madonna and the drapery of the
Christchild are also surely the work of Lorenzo di Giovanni.
However, I would be inclined to attribute the head of the
Christchild to Niccolò since the hair and eyes are charac-
teristic of his manner.

In terms of emotive values, the Madonna and Child
of the Porta dei Canonici evokes a mood of gentle intimacy,
particularly noticeable in the loving gesture of the Christ-
child and in glances which they exchange. This expressive
mood is reinforced by the softly swaying pose of the
Madonna and by the graceful linearity of the drapery; in
both the effect is somewhat vitiated by Lorenzo's rather

clumsy work, but Niccolò's conception is nevertheless
clear. The emotive and stylistic idiom employed here is
seldom to be found among Niccolò's Florentine contemporaries.
However, it is analogous to the work of Nino Pisano and
his followers, as in works such as the Madonna and Child
in Santa Maria della Spina, Pisa, and the Madonna and Child
in Trapani.[101]

Pl.17 There has been considerable disagreement as to
the correct identification of Niccolò's angel in the
lunette.[102] It seems clear to me that the angel at the
left is the correct choice. The handling of the eyes, hair,
and drapery all find analogies in Niccolò's work, whereas
the drapery style of the angel at the right is surely that
of Lorenzo di Giovanni. There is one further point which
helps to confirm this attribution. The cloud formation
upon which the left-hand angel kneels is very similar to
the one in the gable of the niche of the Guild of the
Pl.19 Magistrates and Notaries which Niccolò was entirely responsible
for. By contrast, the clouds under the other angel, which
are composed in very regularized, diamond shapes, are quite
different from the ones used at the Or San Michele niche.
Although not a primary point in itself, this minor note
helps to substantiate the attribution to Niccolò.

The Niche and Statue for the Guild of the Magistrates and Notaries

Pl. 18 &
19

The Guild of the Magistrates and Notaries commissioned Lamberti to carve a statue of Saint Luke and to design a niche for it at Or San Michele between November of 1403 and the early months of the following year.[103] He does not appear to have accomplished very much on the project until 1406, as the vast majority of the payments of which record survives were made in that year.[104] However, the documentation for the project is incomplete and therefore the point cannot be maintained with absolute assurance. It is certain though that he was responsible for both statue and niche, and that the project was completed in 1406.

The Architecture

Pl. 19

The design of the niche was highly progressive for its date and established a type which, with variations, was employed at Or San Michele for about a decade.[105] In comparison with the trecento niches at Or San Michele - aside from Lamberti's niche for the Madonna della Rosa - it is far more elaborate and sophisticated. The heraldic arms of the guild are now at the base and flank a heretofore non-existent field of foliated ornamentation which has at its center the symbol of the saint. The pilasters, their bases, and their upward extensions all are indented; this lends some spatial movement to a previously dull ornament and allows for the inlaying of decorative strips of a

different color. The design is further enlivened by the
spiral columns attached to the inside of the pilasters
and by the division of the arch into eleven sections by cusps.
Finally, the gable field contains figurative sculpture, in
the form of a half-length figure of Christ, whereas previous
niches had included either ornamentation or symbolic
representations there; the spatial aspect of this relief
is enhanced by the receding levels of the molding. From
this brief description of the niche it should be apparent
that Niccolò's reputation as an architectural designer was
well-merited. This fact, in turn, would further substantiate
the attribution of the niche of the Physicians and Apothecaries
to him.

The Statue of Saint Luke

Pl.18 The Saint Luke is the last work of Lamberti's
early career. Although it was carved several years after
the turn of the century, it retains an entirely trecento
quality. The stance of the figure is like that of the
Madonna of the Porta dei Canonici; it is determined by a
Gothis S-curve that again recalls the work of Nino Pisano.
Pl.17 Here, as in the Porta dei Canonici Madonna, Niccolò has
Pl.15 departed from the ponderous mode of the Madonna della Rosa
and the two Church Doctors - which was perhaps the result
of his close contact with Piero Tedesco - and moved in the
direction of a more fluent, graceful, and intrinsically
linear style. In other words, line is no longer merely

etched on a pre-existent volumetric mass, but becomes the
primary determinant of the form of the entire statue. This
linear emphasis is supported by a highly ornamentalized
and abstracting treatment of the head and the face. This
is particularly clear in the hair and beard, which are
composed mainly of abstracted corkscrew curls, and in the
eyebrows which are formed by a regularized ornamental
pattern. The modeling of the face is more advanced than
in any of his previous statues and the eyes are opened
much wider; unfortunately, they are almost expressionless.
Finally, the proportions of the face are thinner, thereby
conforming with the graceful character of the torso.

It is difficult to arrive at a proper qualitative
judgment of this statue. It is obviously lacking in respect
to the qualities of naturalism and classicism; this is not
entirely due to its date, as can be seen by comparing it
to the earlier work of Giovanni d'Ambrogio, Ghiberti, and
Brunelleschi. However, it is equally clear that Lamberti
had, at this point, not the slightest interest in either
classicism or naturalism and that he succeeds quite well
within the context of his own artistic aims. He achieves
a fully unified and consistent work of art through the
crisp, animated movement of line, so that while it is
obviously not a work of landmark importance, it does
deserve some measure of critical favor.

The Gable Relief

Pl.19 The half-length figure in the gable of <u>Christ</u>
<u>Blessing</u> is similar in style to the niche statue; the
forms of the body are again obscured behind a linear
drapery pattern. The facial expression is harsh and force-
ful, far more so than the <u>Saint Luke</u>. In a sense the
relief is most important on account of its mere presence;
it established a usage which reappears in the gables on
all three of Nanni di Banco's niches at Or San Michele and
also on those containing Donatello's statues of <u>Saint Mark</u>
and <u>Saint George</u>.[106] Yet, the relief does have considerable
merit in an of itself. It is set within a convincing
three-dimensional field - that is abetted by the sophisticated
molding which recedes in carefully demarcated steps - and
is successfully foreshortened at the right forearm.

Conclusion

 The picture of Niccolò which emerges from this
project is that of a highly accomplished and sophisticated
architectural designer, not at all lacking in a feeling
for spatial manipulation within an architectural context.
At the same time though, his figural sculpture on a large
scale reveals no comparable interests, but instead displays
an overriding concern for abstracted linear rhythms.

The Datini Tomb Slab

Francesco di Marco Datini died on August 16, 1410.

Pl.20 He is buried under a tomb slab at the foot of the High Altar of the church of San Francesco in Prato. The following Latin inscription may be read along the inner border of the tomb slab: "Here lies the body of the prudent and honorable man, Francesco di Marco Datini of Prato, citizen and prosperous merchant of Florence, who died on August 16th, 1410. May his soul rest in peace."[107] The tomb slab was carved by Niccolò Lamberti; he is mentioned only once in connection with this work, in the final payment document of August 16, 1412.[108] He was in Prato as early as January of 1411, but there is no evidence to indicate that he was already working on the Datini tomb.[109] It is therefore impossible to be more precise than to date the work somewhere between the time of Datini's death and the date of final payment.[110]

The tomb slab has been worn down over the centuries to the point where one can only make out the general outlines of certain areas, such as the face. It is therefore difficult to assess the stylistic character of the execution, beyond noting the elegant linear quality of the drapery. One can, however, readily discern the startling conception of the work as a whole. The figure of the deceased is shown reclining in a three-dimensional, illusionistic niche which appears to continue well behind

the figure. In other words the viewer is confronted with
a paradoxical situation in that Datini "...sleeps the
eternal sleep while ostensibly standing upright in a
niche..."[111] This statement was written by Professor
Panofsky in connection with Donatello's tomb slab of
Giovanni Crivelli; furthermore, he credits Donatello with
the introduction of this paradox and states that with the
Crivelli and Pecci tomb slabs, "...he administered to
Lorenzo Ghiberti what has been called 'a sharp rebuke'
(both in the name of classical antiquity and modern
naturalism)."[112]

Panofsky was certainly correct in pointing out
the existence and nature of the paradox, but was mistaken
in claiming its invention for Donatello. Clearly, it was
in the Datini tomb slab that this conception first appears,
some fifteen years before the Pecci tomb and about twenty
before the one for Giovanni Crivelli.[113] In addition, it
should be noted that Lamberti's work is far more extreme
in its paradoxical aspect than either of Donatello's two
tomb slabs. In fact, the Pecci slab has scarcely anything
paradoxical in it at all. It shows the deceased resting
in a three-dimensional, illusionistic bier which seems
perfectly appropriate for its purpose. The shell motif
creates a degree of ambiguity, but does not significantly
distract the viewer from realizing that he is looking at
an effigy of the deceased in a bier. In other words,

while it is conceivable to criticize the work for its
visual complexity, it is not correct to include it in a
group of works having the above-mentioned paradoxical
conception. By contrast, the Crivelli tomb slab does very
definitely contain this paradoxical element of the sleeping
effigy apparently standing within an illusionistic niche.
However, Donatello appears to have been quite conscious of
the problem and therefore toned down the degree of illusionism,
while, at the same time, heightening the surface design.
This latter characteristic is particularly noticeable in
the garment of the effigy. This toning down of the paradox
is especially evident when one compares the Crivelli and
Datini slabs. In Lamberti's work the niche appears to
be part of a more extensive architectural structure with
a cupola behind it, whereas the Crivelli slab has no
comparable architectural configuration or extension into
much deeper space. Here then, while Donatello clearly
employs this paradoxical conception, he, at the same time,
goes far in stripping it of its extreme character.

In looking at Ghiberti's beautiful tomb slab for
Leonardi Dati,[114] it is evident that he rejected any
illusionistic handling, and were this Ghiberti's only work
in this genre, one would certainly agree with the distinction
made between him and Donatello in their respective approaches
to this problem. However, we know that during the same
period as the Dati tomb, Ghiberti furnished designs for

two other tomb slabs, those of Bartolomeo Valori and Lodovico
degli Obizzi, both in Santa Croce.[115] The Valori tomb
slab is of the same type as the one for Leonardo Dati, but
the one for Lodovico degli Obizzi is fully illusionistic
and, in certain respects, indicates a knowledge of Lamberti's
work in Prato. As in the Datini tomb slab, the figure is
shown reclining within a niche which has a small base,
spiral columns at the sides, and a very similar decorated
gable. Of much greater importance for establishing a
connection between them is the presence here again of a
cupola with the coat-of-arms of the deceased on either side
of it. Ghiberti places an even greater emphasis on
illusionism than Niccolò, as can be seen in the sharply
foreshortened sides of the superstructure above the head
of the effigy. From the above I think it is clear both
that Ghiberti was not adverse to employing an illusionistic
scheme within the context of a tomb slab and that he drew
his inspiration from Lamberti's precedent. Despite this
latter fact, there are certain differences between the
Datini and Obizzi tomb slabs. The major ones are that
Ghiberti employs a three-sided overhang, that he dispenses
with the smooth inner columns, and that the ribs of the
domical sturcture are much more decorative than Lamberti's.
All of these features do, however, appear elsewhere in
Lamberti's work, in the niche containing the Madonna della
1.16 Rosa at Or San Michele. Indeed, Ghiberti's tomb slab for
Lodovico degli Obizzi is little more than the combination

of elements and ideas from the two designs by Niccolò.

The sources of Lamberti's design for the Datini tomb are more diffuse. It has no precedent within its own genre, but does share certain characteristics with his earlier niche designs for Or San Michele. It has the

Pl.19 following in common with the Saint Luke niche: the division of the upper arch into a series of smaller ones, the use of spiral columns, and the placing of one set of architectural elements within another on the sides in order to achieve a sense of recession. With the niche for the Madonna della

Pl.15 Rosa it shares the use of spiral columns, a roughly similar handling of the base, and, most important of all, the cupola at the top of the entire structure. This in turn brings up the question of the source for the use of the domical motif, not only in the Datini tomb, but also in the earlier niche. There was no precedent available to him of a figure placed in a niche surmounted by a dome. However, there was one monument which was readily available to him which, though lacking in figural sculpture beneath the dome, seems to have considerably influenced his conception. This is the tabernacle of Andrea Orcagna inside Or San Michele. The dome above the tabernacle, with its ornamentalized ribs, was very probably the model for the dome of the Madonna della Rosa niche and therefore the indirect source for the dome in the Datini tomb. Orcagna's tabernacle also shares many common points with Lamberti's various

designs, aside from the matter of the dome. The following
of its elements reappear in Lamberti's three works: the
spiral columns (in all three), the arch broken into many
smaller sections (in the Saint Luke niche and the Datini
tomb), the decorative inlays (in the Saint Luke niche), the
round arch (in the Datini tomb), and the recessional use
of paired elements (in the Saint Luke niche and the Datini
tomb). Its free and brilliant decorativeness appealed
greatly to Lamberti at the turn of the century, but by the
time of the Datini tomb his taste became a bit more severe,
as can be seen in the less ornate nature of its dome; it
is also possible that this distinction may have resulted
from the relative importance of the figures represented
within these two structures.

The Saint Mark

On December 19, 1408 Donatello, Nanni di Banco, and Niccolò were commissioned to carve figures of three seated Evangelists for the niches flanking the upper part of the main portal of the west facade of the cathedral.[116] Although they were at first to compete for the right to carve the fourth statue, of Saint Matthew, this commission was given to Bernardo Ciuffagni on May 29, 1410.[117] The four statues were in all probability carved from the four blocks purchased and prepared by Lamberti and Lorenzo di Giovanni d'Ambrogio in 1405.[118] The complete payment documents for the Saint Mark reveal that his work on the statue falls into three distinct periods. The first of these begins towards the latter part of 1409 - he received his first payment on November 13th - and continues until the payment of April 8, 1410; at this point he had received a total of 40 florins.[119] There then follows a hiatus of more than two years during which time he carved the Datini tomb and perhaps worked on another major project in Florence. On August 12, 1412 the cathedral authorities, angrily noting that he had not been working on the Saint Mark, ordered him to return the 40 florins.[120] This order was rescinded on August 17th,[121] one day after Niccolò had received final payment for the Datini tomb; he had evidently returned to Florence with great haste and convinced the authorities that he would work in earnest on

the statue of the Evangelist. He apparently did work
vigorously on the Saint Mark for the next four weeks,
because he received an additional 20 florins on September
15th.[122] However, his interest in the project seems to
have waned once again and the next payment, made on January
5, 1413, was for only 10 florins.[123] After this date work
on the statue was again interrupted - he received only 4
additional florins during all of 1413[124] - and Niccolò
spent part of the year working on some unidentified part
of the facade of the Cathedral of Prato.[125] The third and
final period of work is signaled by a payment of 20 florins
to Niccolò on May 21, 1414[126] and continues until March 18th
of the next year when the finished statue was evaluated
at 130 florins;[127] Niccolò received the final 15 florins
on March 21st.[128] This detailed examination of the pattern
of payments reveals that he worked on the Saint Mark slowly
and sporadically - as he had with some of his earlier
commissions - and that he therefore had ample time to
work on several other projects during this period of seven
years.

.21 The statue has evoked some praise, but is more
usually criticized negatively. Typical of its critics is
Wundram who calls attention to "...the mannerism of heaping
fold motifs which suffocate the whole appearance with
numerous details and independent single forms."[129] He also
criticizes Lamberti for not attempting to foreshorten the

legs and states that the head is treated in an even more
ornamentalized manner than the Saint Luke. By contrast,
Seymour praises the statue for, "...the noble head and
shoulders" and feels that, "...the formal research into the
abstract system of interlocking and echoing spirals is
remarkably intense, in its intensity beyond any other
sculpture of the period save perhaps by Nanni di Banco."[130]
There is considerable merit to the observations of both
of these scholars. Niccolò did not attempt any spatial
subtleties along the lines of either Nanni or Donatello
and did instead emphasize the expressive possibilities of
an abstract drapery pattern. It is true that certain parts
of the head - the beard and hair particularly - are highly
ornamentalized, but the overall effect is much more

Pl.18 naturalistic and expressive than the Saint Luke. In general
I feel that Seymour's positive approach is much preferable
to Wundram's negative attitude in that it takes into
account the evident goals of the artist and judges the
work on how well it measures up to these aims, rather than
setting for the sculptor purposes which he never had and
criticizing the result for not conforming to these ideals
or for not choosing them in the first place. Within the
context of the path which Lamberti has taken it is a
tour-de-force of abstract movement and decorative design
and a work of enormous skillfulness in terms of technical
facility. The ornamental character of the statue would
doubtless be further enhanced if the original bronze

patina of the beard still were present in a noticeable way.

As a whole the statue is part of the International Gothic current which was sweeping through Italy at this time. More specifically though, it is intimately related to the work of Lorenzo Ghiberti on the second set of doors for the Florentine Baptistery. The overall pose, the position of the arms, the relative positions of the legs, and the upper drapery - with a softly silhouetted S-curve flap at the figure's left and a prominent decorative knot tied over an inner garment which crackles with narrow vertical folds - are all closely related to the figure of Christ in the relief of Christ Among the Doctors by Ghiberti.[131] The lower part of the drapery is even more closely related to Ghiberti's work, in this case to the eight panels of the Evangelists and Church Doctors.[132] The loops which fall between the knees of Lamberti's Saint Mark with variations in the panels of Saints Gregory, Augustine, and Mark, while the long diagonal which falls from the left knee appears in the panels of Saints Ambrose and John. Additionally, the heaping folds which hang from the knees are derived from comparable passages in the panels of Saints Mark, Matthew, and John. Finally, the drapery which hangs over the base of Niccolò's Saint Mark is an extension of a usage found, to a greater or lesser extent, in all eight of Ghiberti's reliefs of seated figures. More generally, Lamberti's statue is relatable to the manneristic

drapery style of the great Saint John the Baptist which
Ghiberti created for the niche of the Guild of the Wool
Merchants at Or San Michele during this period. Niccolò's
strong interest in Ghiberti's work was occasioned not
only by the predictable attraction which Lorenzo's style
would have held for him, but also as a result of the
internal necessities of Lamberti's artistic development.
With the completion of the Saint Luke he seems to have
exhausted whatever creative inspiration he had acquired
from looking at the work of trecento artists like Nino
Pl.11- Pisano. This is evident in the relief figures which he
12
carved for the arch reveal of the Porta della Mandorla,
which shows the drying up of the creative possibilities
from these earlier sources and the resultant search for a
new one. This new source was now Ghiberti whose style
was at this point the predominant outside influence on
Lamberti in his last works before departing for Venice in
1415/6.

 The payment records are in full conformity with
the proposed areas of dependency discussed above. The Christ
Among the Doctors is dated by Krautheimer early in his
1407-13 group,[133] while the panels showing the Evangelists
and Church Doctors are placed by him towards the end of
this period.[134] Lastly, he dates the Saint John the Baptist,
that is the design for it, in late 1412 or the beginning
of 1413.[135] When we turn back to the payments for Niccolò's

Saint Mark we see that by August of 1412 he had received
only 40 florins. And since the fine which was imposed and
then rescinded in that month called for the return of all
40 florins it is likely that he could not have progressed
very far by that time. He did work on it for the remainder
of 1412 and until January of 1413 when he left the project
again. He did not pick it up in earnest again until 1414
and 1415 when he completed it. It is to these two periods -
August of 1412 to January of 1413 and early 1414 to March
1415 - that the statue really belongs. There would there-
fore have been adequate opportunity to have studied and
learned from the works by Ghiberti which are mentioned above.
Finally, I would suggest that the drapery was largely the
product of the period of August 1412 - January 1413 since
it is less close to Niccolò's Venetian work than the head.

 After their completion the four great Evangelist
statues were placed in the niches on either side of the
main portal of the facade.[136] Although there has been
considerable disagreement as to the specific locations of
the individual statues, it seems perfectly clear to me
that Lamberti's was situated in the southernmost of the
four niches; in the famous drawing of 1587 the statue in
this niche is the only one shown with a raised right arm,
just as Niccolò's Saint Mark is the only one of the actual
statues to which is similarly posed.[137] I agree with
Janson that the other statue on the south side of the facade

is Donatello's Saint John in the drawing.[138] As to the
other pair, the one nearest the main portal appears to be
Nanni's Saint Luke.

The four great statues which form this group are
exemplars of the various approaches a sculptor can take in
dealing with the problem of the seated monumental figure.[139]
Donatello, ever the bold and innovative artist, achieved,
with daring adjustments of proportion and with a remarkably
expressive treatment of the head, a result which is both
progressive and starkly emotive. The torso is elongated -
the head and beard together render a similar effect, although
they are not contrary to naturalistic proportion - in order
to compensate for the intended placement of the figure
well above ground level. Equally, the turning of the legs
to the right and the drapery folds which slant to the right
are conceived with the foreknowledge that the statue would
be placed to the right (south) of the main entrance portal
of the cathedral. The head of Donatello's Saint John is
powerfully expressive and reveals a decisive change from
the Bargello David towards a more monumental idiom. This
expressiveness is achieved by the grand proportions of the
head and by the manner in which the eyes, eyebrows, and
nose project from and contrast with the relatively unmodeled
planes of the forehead and cheeks. The Saint John is a
highly ambitious and forward-looking work, but one which is
not without imperfections and also evidences of a partially

Gothic sensibility. The hair is set on the head like a wig and the beard is treated in a flat and decorative manner. The upper torso seems thin and its relatively undifferentiated surface stands in sharp, and not entirely pleasing, contradistinction to the International Gothic folds which cover the legs. These areas of indecision and inconsistency - which would to some extent be obscured if the statue remained in its intended location - do not significantly detract from our appreciation of it as a work of great expressive intensity and technical progressiveness. They simply indicate that the distance between the style of the Bargello _David_, on one hand, and that of the _Saint Mark_ and _Saint George_, on the other, is enormous and that the passage from one to the other in so short a time could not possibly have been managed without some degree of difficulty. It is testimony to the sublime genius of Donatello that the work which marks this difficult point of transition is so profound an emotive and aesthetic achievement.

Nanni di Banco's _Saint Luke_ is the temperamental antipode of Donatello's _Saint John_. It is a much less ambitious work, but is more consistently resolved and is clearly indicative of a more mature, albeit perhaps more limited, aesthetic and expressive outlook. The proportions are entirely naturalistic and what compensation there is for the intended placement of the figure consists of the

forward tilt of the head and the lowering and broadening
in the position of the arms. Although unlike Donatello,
he attempts no contrapposto pose, Nanni's figure is more
classical in that its form is fuller and more ponderated
and is more evenly balanced and organically conceived. The
head of the Saint Luke is one of the true masterpieces of
the early Renaissance. In its overall form, its sense of
structure, and its grand expression, it may be related to
the Antique, which it to some extent depends on. Equally,
it has a directness and depth of naturalistic expression
which transcend general stylistic sources and reflect the
emotive profundity of its author. The treatment of drapery
forms in the lower half of the figure is the only aspect
of the work which relates to the International Style; they
tend towards decorativeness in their repeating looped
motifs. Yet, even in this area, where Nanni makes his sole
concession to the International Style, the sense of
volumetric structure is scarcely impaired at all as the
projecting knees are used as guideposts in making the inner
framework of the figure readily intelligible to the viewer.
In this respect, as in general, the Saint Luke is a work
of consummate balance and--harmony.

The Saint Matthew of Ciuffagni, if taken out of
its historical context, would appear as virtually the
qualitative equal of the Evangelists carved by Nanni and
Donatello. It is, however, almost entirely derived from

Donatello's Saint John and Lamberti's Saint Mark in terms
of its significant features. The elongated torso and the
position of the right hand are taken over from the Saint
John, while the placement of the left hand and the use of
the rosette motif on the base were borrowed from Lamberti's
work. The overall conception of both the head and the
drapery relate to Niccolò's statue, but are much less
decorative and, in the latter case, less elaborate than in
the Saint Mark. The Saint Matthew marks a point in Ciuffagni's
development when he was moving away from his Ghibertian
heritage towards the Donatellian idiom which he pursued
throughout the remainder of his career. It is carved very
skillfully and is an adept synthesis of its various sources.
However, its largely derivative nature prevent it from
being considered as a work of conceptual greatness as well
as technical facility.

Lamberti's Saint Mark is not competitive with the
other three Evangelist statues in regard to those qualities
which modern scholars would consider progressive. No
adjustments are made to compensate for the intended place-
ment of the figure and its composition is simple and direct;
furthermore it betrays not the slightest interest in
classicism. Yet, what appears as a conservative or retro-
gressive work to 20th century eyes need not have seemed so
to a Florentine living in 1415.[140] The International Gothic
Style - of which it and Ghiberti's Saint John the Baptist

are the prime examples in Florentine sculpture - was, as
Krautheimer states, "...the height of fashion..." at the
time that these four Evangelist statues were created and
there is no reason to think that Lamberti's statue was
considered as backward by his contemporaries. Indeed, the
three other Evangelist figures all contain elements which
reflect the International Style. As a representative of
this great stylistic current Lamberti's Saint Mark is a
fully consistent and effective work of art, one which reveals
the maturity and confidence of its sculptor. The conception
of the head entails a finely established balance between
the potent expressiveness that emanates from the weighty
proportions of the whole and from the deeply set eyes and
the decorativeness that tends to render the hair and beard
as simple ornament. This harmony of disparate tendencies
is rejected in the rest of the figure where a freely
abstract conception of drapery forms overcomes and dominates
the simply conceived structural framework upon which it
moves. This vibrant rhythmic handling of the drapery
parallels a similar manneristic interpretation of the
International Style in Ghiberti's Saint John. And like the
Saint John, Lamberti's Saint Mark is not very well liked
by many critics who, in my opinion, confuse historical
importance with quality. I do not suggest that Niccolò's
Saint Mark is the qualitative equal to the Evangelists of
Nanni and Donatello, but only that it is a work of sufficient
originality, consistency, expressiveness, and technical
skill, to merit a favorable and even an admiring critique.

The Saint James at Or San Michele

Of the many independent projects undertaken by
the various guilds at Or San Michele the one commissioned
by the Furriers' Guild has been among the most problematical
for scholars. Not a single document concerning it survives
and the work has received diverse attributions and dates.

Pl. 22 The statue has been attributed to the "school of Ghiberti,"
Ciuffagni, Niccolò Lamberti, Piero Lamberti, or to a
combination of the latter pair.[141] The ascriptions to
Ciuffagni and to the school of Ghiberti can be summarily
rejected, despite certain Ghibertian characteristics which
the Saint James and its socle relief undeniably possess.
In my opinion the statue bears hardly any resemblance to
the few certain works of Piero Lamberti, but does, as
Wundram has shown, have striking areas of similarity with

1.18, the Saint Luke and the Saint Mark. There is an undeniable
21
quality of disjointedness in the statue, particularly
between the upper torso and head and the lower half of the
figure. However, this does not seem to me to indicate
the presence of different hands, but rather of interruptions
in the execution of the project. This is confirmed, at
least in the first respect, by the uniform technique
employed throughout the figure. It is equally certain that
the niche was conceived by Niccolò Lamberti and not his son,
since it has much in common with Niccolò's architectural
designs and shares nothing with the two known projects by

Piero, which are in part architectural. The gable and socle
reliefs are much more complex in this respect and will be
discussed in detail below. As to the date of the project,
suggestions have ranged between 1405 and 1425. It is, I
think, within the context of this matter of chronology
that solutions to most of the other problems related to the
project can be resolved.

The Statue of Saint James

The Saint James has been assigned the following
dates: 1405-10 by Krautheimer, 1415 by Seymour (as Piero's
work with a question mark), 1420 by Paatz, and early 1420s
by Wundram.[142] Of the above only Wundram discusses the
question at length. He believes that the Saint James
depends on Ghiberti's Saint Matthew[143] for the Guild of
the Bankers and Money Changers and must therefore have been
done no earlier than the beginning of the third decade of
the century. He points to the slanting drapery folds, the
large fold at the hip, the way that the drapery is used to
model the free leg, the triangular drapery near the bottom
of the figure, and the tentative contrapposto stance as
elements which Lamberti derived from the Saint Matthew.
In general, he notes a greater freedom in this statue as
compared with Niccolò's earlier statues, a condition which
he again feels reflects the Saint Matthew. I am afraid
that I find all of these relationships illusory and without
substance. In not one of the specific areas that Wundram

-54-

mentions is there more than the most generalized relationship between the two statues. The pose of Saint Matthew is, as Krautheimer has shown, based upon that of classical orator statues;[144] it displays a full comprehension and implementation of the use of a contrapposto stance. By contrast, the Saint James shows only the very tentative beginnings of the possibilities of such a pose and could quite obviously hardly be further from the Antique. The difference between the two may also be extended to the hands, the arms, the entire conception of the upper drapery, and most of all, the heads.

Despite this, there is an undeniably Ghibertian character to the Saint James, which at one time led Venturi to attribute the statue to Lorenzo's school. Of the figures of the second doors for the Baptistery it compares most closely to the Christ of the Transfiguration.[145] The slight turning of the body, the tall proportions, and the treatment of the lower drapery are all points of considerable similarity between the two figures. In addition to the Christ of the Transfiguration, the Saint James also has much in common with Ghiberti's Saint John the Baptist at Or San Michele. The points which they share are: the V-shape formed by the drapery at the shins, with one side of the V continuing diagonally to the ground; the position of the left arm; and the frontal poses which mark similar stages in the development towards a contrapposto stance.

These relationships between the Saint James and the work of Ghiberti would seem to point towards a date of about 1413 for Lamberti's statue. The Transfiguration is placed by Krautheimer at the middle of his group of 1407-13.[146] The Saint John the Baptist was not completed until later - casting was begun on December 1st, 1414 - but Krautheimer has concluded that the design for it existed as early as the end of 1412 or the beginning of 1413.[147] Returning now to Lamberti, we know that he worked hardly at all on the Saint Mark during 1413 and the early part of 1414. It is true that he was in Prato during 1413, but there is nothing to indicate that his work on the facade of the cathedral there was very extensive and there is also a document of June 1413 which locates him in Florence. Even if one attributes part of the facade of the Cathedral of Prato to Niccolò, it would be difficult to maintain that his continuous presence was called for. Surely his function would have been to provide a design and to check on the progress of the work - which he could easily have done by coming to Prato from time to time - but he certainly did not remain in Prato working on architectural ornaments while the Saint Mark for the Florentine cathedral lay unfinished. Indeed, one could rightfully speculate that only a commission of nearly comparable importance - such as the Saint James and its niche - could have drawn so much of his time away from a commission like the one to carve the Saint Mark.

It would seem from the above that the statue
could be comfortably dated in 1413 - early 1414. This,
however, is not the case. As I indicated previously, the
statue has a strangely disjointed quality which can be seen
in the clumsy transition from the upper to the lower half
of the figure and in the mild disparity in style between the
two sections. The treatment of the head and drapery of the

Pl.18
&19
upper torso recalls both the Saint Luke and the half-length
relief figure of Christ in the gable of the Saint Luke
niche. In these areas the Saint James seems closer to the
Pl.21
style of the earlier project than to the Saint Mark. The
lower half of the Saint James is handled with a much
broader style and relates very closely to Ghiberti's work.
The softer and more flowing drapery in the lower half of
the Saint James is far removed from the incised linear
style of the Saint Luke and is comparable to that of the
Saint Mark. I would suggest therefore that the statue was
worked on in two distinct stages, with the upper half of
the figure being largely the product of the first stage
and the lower half resulting from the second period of
work. This second period probably took place in 1413 -
early 1414. The earlier stage is more difficult to pinpoint
as a review of Niccolò's activities from 1410-1412 reveals.
In April of 1410 he received a payment for the Saint Mark;
his activities for the rest of the year are undocumented,
except for the fact that he had returned to Florence by
December 18th. In January of 1411 he was in Prato, but had

returned to Florence by April when he served as a guarantor for Donatello. He appears next in August of 1412 when he receives final payment for the Datini tomb slab and begins work on the Saint Mark once again. Therefore, the Datini tomb is the only documented work of the period of April 1410 - August 1412 which was divided between Prato and Florence. It is during this period - or perhaps at various points throughout it - that Lamberti carved the upper half of the Saint James. Then, after a short campaign of work on the Saint Mark - from August 1412 to January 1413 - he resumed work on the Saint James, completing it by the beginning of 1414. Between these two periods Ghiberti had designed the Saint John the Baptist which had a decisive effect on the change in Niccolò's style from the first to the second stage of work on the Saint James.

The Architecture of the Niche

Pl.22 The niche containing the Saint James is dated by Wundram towards 1420,[148] that is after all other niches at Or San Michele excepting those for Ghiberti's Saint Matthew and Donatello's Saint Louis of Toulouse. He bases this late dating on the belief that it is the most advanced of all the niches - save the two mentioned above - and on the theory that, due to the competitive nature of the work at Or San Michele, the more progressive work will always be the later in date.[149] He allows for only one exception, the niche for Nanni's Saint Eléqius, and suggests that it

did not follow this overall pattern of development entirely because of unusual circumstance pertaining to its location.[150] It is my contention that both in terms of the specific case of the _Saint James_ niche and of the theory of the overall development of the Or San Michele niches Wundrams' ideas must be revised considerably. In the process of attempting such revision I believe that a more correct dating for the Saint James niche can be found.

To begin with one aspect of Wundram's overall approach, there are instances of usages which may have been generally viewed as progressive, but which were not adopted frequently, probably on account of finanical considerations. An example of this may well be the making of bronze rather than marble statues, first introduced with Ghiberti's _Saint John the Baptist_ and used thereafter only for the statues of _Saint Matthew_, _Saint Stephen_, and _Saint Louis of Toulouse_.[151] A problem of a somewhat different nature concerns the matter of the Saint Eligius niche which Wundram concedes is less advanced in certain respects than the earlier Quattro Coronati niche. He claims that the reason for this was the desire of the Farriers' Guild to maintain a sense of stylistic unity with the earlier _trecento_ niche of the west front of Or San Michele, the one which presently contains Ghiberti's _Saint Stephen_.[152] This is, however, a very unlikely explanation for the overall character of the Saint Eligius niche; there is not a single

further example among the many niches at Or San Michele
of this factor playing any role whatsoever. Indeed, we
know, for example, that the Saint Matthew niche, which
was begun within five years of the Elegius niche, could
hardly be further in style from its two companions on the
same west front of Or San Michele. Still further diffi-
culties arise in Wundram's discussion of the Quattro
Coronati niche. In his brilliant analysis of the statuary
Wundram shows that the two figures at the right in the
Quattro Coronati group are the earliest and that they have
a great deal in common with the statues of Saint Phillip
and Saint Luke by Nanni, the later of which was completed
in 1413.[153] He is, however, constrained to date the niche
architecture considerably later, since he accepts the
completion dates of the niches for Donatello's Saint Mark
and Ghiberti's Saint John - that is 1415/6 - as the
terminus post quem for the Quattro Coronati niche. He is
obviously correct in pointing out the much more progressive
nature of the Quattro Coronati niche, but overlooks one
very simple point - that the respective dates of design
and completion for all of the documented niches are
separated by a period of several years. Once work was
well under way on a given niche it might have been imprac-
tical or difficult for aesthetic reasons to readjust the
scheme in order to include some more progressive concept
which had just been elaborated elsewhere. To choose a
specific example, let us consider the case of the niche

for Ghiberti's Saint John the Baptist. Documents show
that work on the niche was already under way in 1414 and
that it was continued into 1415-6.[154] Furthermore, let us
postulate that the design which Nanni made for the niche of
the Quattro Coronati dated from 1414, that is after the
work on the niche for the Baptist had begun. Is it not
likely that the Wool Merchants' Guild would not have
interrupted the work on their niche in order to have it
readjusted in accordance with the new concepts expressed
in Nanni's Quattro Coronati design? And if they indeed
would have done so, then why did they and others not make
these changes after seeing Nanni's ideas concretized? In
other words, to choose one significant example, why did
they not commission a new base with a narrative relief
after seeing the idea used by Nanni? This cannot be viewed
as an obscure possibility since we learn from Wundram
himself that the reliefs in the gable and on the socle of
the niche of the Armourers' Guild were probably added by
Donatello well after the construction of the niche itself.[155]

I would therefore propose to modify Wundram's
approach in several respects. First of all, it should be
recognized that while the competitive spirit of the
Florentine Guilds undoubtedly led each of them to desire
the most beautiful and perhaps also the most progressive
niche, that this was not an absolute principle of the
development of the niches and that it was tempered by

various circumstances. Equally, we must assume that some
of the guilds were more conservative in taste than others.
Next, it is quite clear that there was a fairly long
separation between the respective dates of design and
construction for a given niche, so that, for example, the
John the Baptist niche which was completed in 1415/6
represents a point in development of perhaps 1412. Lastly,
it must be accepted that every change cannot be viewed as
a progressive step, so that differences between one and
another niche may be the result of considerations having
nothing to do with which of them is more advanced. This
last point is particularly relevant to Lamberti's Saint
James niche. Wundram states that among the more advanced
aspects of its architecture is the turning of the pilasters
into a diagonal position; this serves to create a more
interesting spatial setting for the statue and for a more
comfortable placing of the coats-of-arms at the corners of
the base.[156] He employs this as a basis for dating the
niche after those for the Quattro Coronati and the Saint
Elegius, that is, at the end of the group of niches which
have narrative reliefs on their socles. However, Wundram
should have noted that Nanni could hardly have employed
diagonally situated pilasters without disrupting the entire
spatial organization of the Quattro Coronati and without
removing the cloth which hangs from these pilasters.[157]
Furthermore, when a comparison of the two niches is pursued,
it is evident that Nanni's is the more advanced in every

area in which they differ. One of the most significant

differences between the two is that Nanni makes the ground

upon which the figures stand an organic part of the niche

and uses its shape in organizing the spatial configuration

of his figures, whereas the Saint James stands on an

independent pedestal which relates to the diagonally sit-

uated pilasters, but which is otherwise independent of the

niche architecture. A further distinction between the

two niches - one which Wundram entirely ignores - is the

relatively greater size of the narrative relief in the

Pl. 23 socle of Nanni's niche. In this respect the Saint James

niche clearly reveals itself as earlier than the Quattro

Coronati niche. It represents, in relation to this issue, a mid-

point between the niches for the Saint Luke, the Saint Philip, the

Saint Mark, and the Saint John the Baptist, on one hand, and

Nanni's for the Quattro Coronati. In the earlier group the

socle field is decorated with foliated ornament; in the Mark

and Luke niches one also finds the symbols of the respective

Evangelists, whereas in the Philip niche a tiny putto can

be seen in the center of the foliage. Lamberti's base,

by contrast, has a narrative relief, but it takes up less

than half of the socle field, the remainder of which is

decorated again with foliage. When we finally turn to

Nanni's Quattro Coronati niche - and also to the niches for

Nanni's Saint Eligius and Donatello's Saint George - we see

that the relief now spans almost the entire range of the

base and is no longer accompanied by any form of ornamentation.

This kind of difference would certainly have been much more likely to arouse the competitive spirit of the Guilds than one which consists of a minor architectural variation.

Finally, there is one element of the Saint James niche which reveals the hazards of confusing change with progress. Unlike the Quattro Coronati niche and all others done between the Saint Luke and Saint Matthew niches - I here exclude the Saint George niche which may or may not date from this period - the one for Saint James has a tripartite instead of a multipartite gable arch. In discussing the Saint Luke niche Wundram mentions the multipartite gable arch as one of the progressive aspects of the design which separate it from the trecento type used for the niches containing the Saint Stephen, the Saint Peter, and the Saint John the Evangelist.[158] Is it not anomalous that Lamberti would return many years later to the trecento type which he had personally superseded? The answer must be that choices like that between a tripartite and multipartite arch have nothing whatsoever to do with the relative progressiveness of a design and must be sharply distinguished from the type of change which occurs with the Saint Matthew niche, which is both developmental and generic.

To summarize: if one follows Wundram's method strictly, then he must arrive to a contradictory result because the tripartite arch and the relatively small

narrative relief are retrogressive, while the position of the pilasters and the resultant ease with which the coats-of-arms are placed on the corners of the base are progressive. By contrast, a more selective approach which also takes into account the time lapse between design and completion, yields a more satisfactory solution. Since it includes a narrative relief - and also perhaps because of the diagonal pilasters - it can be dated after the group consisting of the niches for the Saint Phillip, the Saint Mark, and the Saint John the Baptist. The Saint Phillip and its niche are correctly dated by Wundram in 1410-2,[159] whereas the design for the Saint Mark niche was submitted in 1411.[160] Work on the niche for Ghiberti's Saint John the Baptist was under way in 1414, but as with the statue itself, it would not seem unreasonable to suggest that the design for the niche might have been made in 1412 or 1413. This then would serve as the latest terminus post quem for Lamberti's design for the Saint James niche. There is no sure terminus ante quem for its design, since the niche which follows it in date, that for Nanni's Quattro Coronati, is not specifically dated either. It does seem very likely though, that the Quattro Coronati niche dates from between 1414 and 1416; this then may serve as a broad terminus ante quem for the Saint James niche design. In any case, it would preclude the possibility of the niche having been the product of the end of the decade or the beginning of the 1420s. It would also

conform very well with whatever else we know about Lamberti's career at this time. From January of 1413 until the early months of 1414 he was free of any documented work and it is to this period that I would attribute the design and execution of the Saint James niche.

The Socle Relief

Pl.24 The relief situated in the socle beneath the statue of Saint James shows the scene of his martyrdom, or more precisely, the moment following the event. It is framed by a quatrefoil which differs from those which surround Ghiberti's narratives in that it is rectangular. The relief has suffered considerably on account of weathering and several figures are in a very poor state of preservation. The martyred saint shows damage in the left hand and the head, while the exuberant figure at the right lacks its left hand, its right forearm, and its face. Despite this unhappy situation it is still possible to study the relief fruitfully.

The relief has been attributed to Niccolo Lamberti, to his son Piero, to Ciuffagni, and to Ghiberti's work-shop.[161] It has also been suggested that Ghiberti supplied the drawing from which the relief was carved.[162] Although it does have certain strongly Ghibertian qualities, the relief cannot sensibly be attributed to Ghiberti's work-shop and it is highly unlikely that he was responsible for its design in any case. It lacks the elevated sense of

spatial unity and the figural cohesiveness which one
would expect from a Ghibertian design. There is no basis
at all for attributing the work to Ciuffagni, so that
the real choice rests between Niccolò Lamberti and his son.
The overall circumstances of the project would seem to
favor an attribution of the design to Niccolò, since he
was responsible for both the statue of the saint and the
niche architecture. The execution, however, is very
likely not due to him. This can be seen in figures such
as the one at the extreme left of the composition. The
head seems to lack a sense of formal definition and the
drapery style is without technical parallel among Niccolò's
work of this time. It is composed by a series of sharp,
deeply cut grooves on the front of the torso which are at
variance with the smoother, more gracefully flowing style
exemplified in the Saint Mark and the Saint James. The
technique employed here does, however, have much in common
with that used for the statuettes of Virtues on the front
of the tomb of Tommaso Mocenigo which were carved mainly
Pl.126 by Piero Lamberti in 1423. The head of the Temperance on
the Doge's tomb is very analogous in proportions and
handling to that of the figure at the extreme left of the
Saint James relief. it therefore seems apparent that
Piero was also responsible for the carving of the Saint
James relief.

The composition of the relief is universally

regarded as Ghibertian and Wundram has claimed that it

depends almost entirely on the panels of Ghiberti's first

baptistry doors.[163] This, however, is not the case. It is

instead modeled very closely after a predella painting

of the same subject by Lorenzo Monaco, now in the Louvre.[164]

In overall terms the two compositions agree to a strikingly

great extent. The general distribution of the figures

is very similar, with two figures at the left, the saint

in the center foreground, and a larger group behind him

at the right. The poses of the three soldiers at the

right of Lamberti's relief are taken from comparable ones

in Lorenzo's painting; however, the warrior at the extreme

right of the panel is left out of the relief. Despite the

great similarity between them, there are also important

differences. The changes are the result of the fact that

Lorenzo was working with a square picture space, while

Lamberti's relief is rectangular. Therefore, the figures

in Lorenzo's work are more closely bunched together and tend

to form more diagonal rhythms than those of Lamberti. A

case in point is the positioning of the two onlookers at

the right of both compositons. In Lorenzo's panel they are

overlapping and form a roughly 45 degree angle to the

picture plane, thereby creating a sharp sense of movement

from the left edge of the painting to the center foreground

where the saint lies. This sharp diagonal rhythm is

complemented by the similarly angular placement of the

saint which, in turn, carries the eye into the figural

group at the right. In the relief the two figures at the
left are placed almost side-by-side, with the one at the
extreme border of the composition, somewhat in front of his
companion. From these two figures the eye is brought to the
diagonally situated rock formation which serves several
compositional functions. It sets the two figures at the
left apart from the rest of the scene and also tends to
bring one's attention to the saint. Finally, its presence
indicates, albeit hesitantly, that space continues behind
the figural group. The sense of recession is not very
effective though, because the figures are all in the fore-
ground and the saint is almost parallel to the relief
plane. This is at least in part due to the rectangular
shape of the relief plane. Lamberti's figures are distrib-
uted over a wider spatial area than Lorenzo's, so that he
needed a strong compositional link between the two sides
of the scene. The group at the right of the relief is
different from Lorenzo's in that the figures are now all to
the right of center and appear to continue the movement
from left to right in the composition, instead of being in
back of the saint as in the panel. Lamberti has also
corrected the clumsy figure of the soldier at the center
of Lorenzo's composition. In the panel he holds his spear
in his left hand while pointing with his right towards the
foreground. Unfortunately, both his hand gesture and his
sharp glance seem to be directed beyond the figure of the
saint and into the left side of the panel. Lamberti moves

him to the right and plants him solidly at the proper
angle to the saint. He now holds his spear in the right
hand; it forms a sharp V-shape which focuses directly on
the saint. In this respect, and in most others, Lamberti's
composition is a vast improvement over Gaddi's. The figures
have a much greater spatial volume in which to move and
the overall layout is more evenly modulated.

The smoother sense of transition throughout the
composition is undoubtedly related to the reliefs of the
second baptistery doors. This relationship is noted by
Wundram who feels that the Saint James relief reflects a
knowledge of all of Ghiberti's panels, including the last
ones.[165] This is not the case, however, since Lamberti's
composition has nothing in common with the last group of
Ghiberti's panels, except for a few elements which appeared
earlier among the baptistery reliefs and were retained in
the later ones. To be more precise, the Saint James relief
in no way reveals an appreciation of any element which
entered Ghiberti's relief style beyond the panel of the
Raising of Lazarus. The figures which are placed on either
end of the composition to close it off appear already in
the Lazarus relief. Equally, the use of spatial recession
in the Saint James relief does not imply a knowledge of
any of the panels beyond the Raising of Lazarus, which it
resembles more closely in this respect than any of the
others. Finally, the manner in which Lamberti uses the

prostrate figure of the saint is analogous to the purpose
which it served in Ghiberti's Lazarus panel by the figure
of Lazarus' sister;[166] in both cases the figures are placed
almost parallel to the relief plane and are employed to
unify the two sides of the composition. However, the
figure of Saint James in the relief was not modeled after
Ghiberti's panel, but instead is far closer to the figure
at the lower right of the relief of Christ Receiving the
Messengers of Saint John on the silver Altar of Saint John
the Baptist, now in the Museo dell'Opera del Duomo of
Florence.[167] The lower half of Lamberti's figure is almost
entirely a copy of the one in the altar relief. The upper
half of the martyred saint is different from both Ghiberti's
figure and the one on the altar; it is borrowed from Lorenzo's
panel. Lamberti's hybrid figure is an imporvement over
its models and over Ghiberti's sister of Lazarus.[168]
It has retained much of the finely spun rhythmic sensibility
of the altar figure, while, at the same time having ac-
quired a sense of dramatic force, which in turn outstrips
Lorenzo's representation. The forcefulness of the rendering
derives from the tension which exists between the lower half
of the figure, placed parallel to the relief plane, and the
upper half, which turns at an angle to that plane. It is to
Lamberti's credit that he has assimilated his sources so
well here that his figure has none of the flaws which often
occur in a composite form.

Of the remaining figures, the one at the extreme right is the most clearly derivative. In its general function it relates to the corresponding figure in Lorenzo's panel. It is, however, much livelier and bolder than Lorenzo's and, as Wundram noted, depends upon the figure at the extreme right of Ghiberti's Nativity.[169] The figure shown at the extreme left is also Ghibertian. Wundram relates it to the representations of Christ in the Arrest of Christ and the Christ in the Storm.[170] In my opinion it is no closer to these than it is to figures from earlier panels, such as the Christ of the Temptation and the Magus at the extreme left of the Adoration of the Magi.[171] Finally, the soldier at the left of the saint is said by Wundram to have been derived from a Ghibertian type which appears at the extreme left of the Christ before Pilate and at the extreme right of both the Arrest of Christ and the Way to Calvary.[172] This last relationship is vital for the correct dating of the relief. Niccolò Lamberti left Florence for Venice in 1415 or 1416, whereas all three of the reliefs by Ghiberti are dated in 1416 or thereafter;[173] furthermore, all of the other sources for individual figures in the Saint James relief date from well before 1415/6. There are several possible ways in which this apparent impasse can be resolved. It is possible that the Christ before Pilate, whose martial figure is closest of the three to Lamberti's, dates from 1415 instead of 1416/7 as Krautheimer suggests.[174] A further explanation would be that figure in the Saint James

relief was derived from a drawing in one of Ghiberti's model books.[175] The third possibility is that Lamberti's soldier is not modeled after a Ghibertian representation, but that they are both variants based upon a pre-existent type. A notable example which both sculptors doubtless saw on many occasions was the representation of Saint Michael at the extreme left of the Strozzi altarpiece by Andrea Orcagna in Santa Maria Novella in Florence.[176] It would be not much more than guesswork to choose one of these solutions; indeed, it is even possible that more than one of them applies. However, they are all preferable to dating the relief around 1420, since there is not a single further aspect of it, however small, which would support this late dating. The latest of the panels by Ghiberti which the relief reflects is the Raising of Lazarus which is dated by Krautheimer at the beginning of his 1414-6 group.[177] This would provide a very accurate terminus post quem for the Saint James relief, precisely because Niccolò had so keen an interest and appreciation for Ghiberti's work. In other words, had Niccolò designed the relief after Ghiberti had completed the last panels, then one would expect to find some reflection of them in his conception. However, his composition has nothing in common with the panels after the Raising of Lazarus and the only detail which relates the relief to the late members of Krautheimer's 1416-9 group is the soldier.

73-

Since both Niccolò and Piero Lamberti are mentioned in Venice in 1416, the relief must date from between about 1414 and 1416.[178] It is possible that the decision on Niccolò's part to hand the actual carving of the relief over to his son may reflect the intensive work on the Saint Mark that is indicated by the resumption of payments by the cathedral authorities on May 21st, 1414.

The Gable Relief

Pl.22 The relief in the gable shows the kneeling saint being borne by two seraphim. It is unique among the gable reliefs at Or San Michele in that the niche saint reappears in it, is shown full-length and in profile, and that he is accompanied by other figures. He and the two seraphim are composed in a triangular grouping which conforms to the shape of the gable. The representation of the saint looks stiff and unnatural, while the gable field as a whole seems cramped. It is easy enough to see why later niches at Or ·San Michele do not follow this unusual example.

The relief seems to have been carved by Niccolò. The thin, smooth drapery forms are very close to those which cover the lower abdomen and the left thigh of the niche statue. On the other hand, they contrast quite strongly with the motifs and technique of the drapery of the figures in the martyrdom relief which was carved by Piero Lamberti. On account of the analogies noted above with the niche statue, a date of about 1413 seems likely.

Conclusion

An analysis of the niche, statue, and reliefs commissioned by the Furriers' Guild yields a date of between 1410 and 1415 for the entire project. The earliest campaign of work ended somewhat before August of 1412 and consisted solely of the carving of the head and upper torso of the saint. After a period of several months, during which Lamberti worked on the Saint Mark, he returned in 1413 to design the niche, carve the gable relief, and complete the statue of the saint. In the early months of 1414 he returned once again to the Saint Mark, giving to his son Piero a drawing from which the latter carved the socle relief. The entire project was certainly finished by 1415, since there is no mention of either Lamberti in Florence after the spring of that year and they both are referred to in Venice in documents of October 1416. By that date Niccolò seems to have been working at San Marco for some time, so there is every likelihood that they left Florence during the previous year.[179]

Finally, I would add that there is not a single piece of evidence which would indicate that Niccolò ever returned to Florence for a lengthy visit.[180] He was there in April of 1419, purchasing marble for an unnamed tomb. Three months later he was in Lucca buying marble for the Venetians, a function which he repeated in February of 1420;[181] Fiocco has with good reason related these Lucchese documents

with the restoration work which followed the fire of June 1419 in Venice.[182] Finally, in April 1420 Lamberti was again in Florence where he returned his tools which he had left in the cathedral workshop.[183] Surely if anything is to be inferred from these documents it is that while he was in the area buying marble for the Venetians, he stopped in Florence to close out whatever unfinished matters he had left behind when he left in 1415.

The Two Figures from the Doorway of the Campanile

On February 5, 1431 the operai authorized the
removal of three figures from the store-rooms of the
cathedral workshop and their emplacement above the doorway
to the campanile which was to be refurbished for that
purpose.[184] They presumably were not intended originally
for that location and are the products of two different
periods. The figure which stood above the gable of the
doorway was carved around the middle of the trecento,[185]
P1.25-6 while the other two, that were situated on the pinnacles
on either side of the gable, are of the first quarter of
the 15th century. There has been considerable discussion
as to whether the group was intended to represent the
Transfiguration or instead simply shows three prophets.[186]
I think that the best solution is that offered by Becherucci
who proposes that the trecento figure was originally intended
as a prophet, but later used as a Christ of the Transfig-
uration.[187] In 1965 all three were removed from the door-
way and placed in the Museo dell'Opera del Duomo.[188] They
have both suffered considerably from weathering and are in
1.26 a rather poor state of preservation. The bareheaded figure
who formerly stood to the right of the doorway lacks most
of his right hand, part of his nose and left foot, and
1.25 almost all of his scroll. His companion is missing most of
his nose and part of the drapery covering the left hand and
right shoulder. The top of his scroll has also been lost.

The two figures have received a variety of
attributions in recent times. Schmarsow gave them to
Niccolò, but his attribution is weakly founded, since he
bases it upon a supposed relationship between these two
Pl.33 figures and the Annunciation which flanks the gable of the
Saint Matthew niche at Or San Michele.[189] The latter is
surely not by Lamberti and it has little in common with the
campanile figures in any case. Brunetti instead proposed
Pl.27 that the pair are by the same hand as the prophet statue
that formerly stood in the second niche from the left on
the east side of the Campanile.[190] To the same artist she
also attributed the sculpture of the left arch reveal and
keystone of the Porta della Mandorla.[191] She identifies
this sculptor as Nanni di Bartolo. Her attributions are
without visual or documentary support. The one sure work
Pl.28 in Florence that is entirely by his own hand, the Abdias,
differs in all significant respects from this group of
works; it is Donatellian and without a trace of the
Gothicisms which pervade these other sculptures. In addition,
the other statues which can be tentatively or partially
attributed to him on the basis of documentary evidence -
Pl.29, these are: the Saint John the Baptist, the Joshua[192] and the
30 Abraham and Isaac[193] - are still further away from Brunetti's
proposed group of youthful works. This is particularly
important since they are all earlier than the Abdias. Finally
there is not the slightest mention of Rosso in the cathedral
documents before the end of the second decade of the

century, nor is he known to have been working elsewhere
at an earlier date. It therefore seems very likely that
he began his career as a close follower of Donatello; this
is supported by the fact that his work becomes less, rather
than more Donatellian as he develops. Lanyi also connected
the two doorway figures with the statue of a prophet from
the second niche of the east face of the campanile. Basing
his theory on documents which show that a Giuliano di
Giovanni was commissioned by the cathedral to carve a
statue in 1410-2 and that an artist of the same name was
responsible for a figure in 1422-3 which was intended for
the cathedral facade, he hypothesized that the two Giulianos
were the same person and that this sculptor carved the two
doorway figures as well as the niche statue, relating the
former to the documents of 1410-2 and the latter to those
of 1422-3.[194] The documentary basis for this theory has
been challenged effectively by Krautheimer who shows that
the two sets of records very probably refer to two different
individuals.[195] On the other hand Wundram has gone on to
attribute the large prophet statue from the campanile to
Nanni di Banco, claiming it as Nanni's Isaiah of 1408.[196]
I believe that he is correct, since his theory is the only
one which can account for the physical evidence - the
pentagonal base and the residue of iron supports on the
back of the figure - and for the close stylistic connection
between it and the three angels in the left arch reveal
of the Porta della Mandorla. It is therefore clear that

Lanyi's hypothesis must also be discarded and that a more
satisfactory attribution for the two campanile statuettes
must be found.

The search for the identity of the true author
of these two figures may begin with an evaluation of their
sources. Brunetti has suggested that Ghiberti's Trans-
figuration might serve as a terminus post quem for the
pair.[197] There is one significant similarity between
Ghiberti's panel and the statuettes; the drapery of the
lower half of the Moses in Ghiberti's panel was undoubtedly
used as the model for the corresponding section of the
turbaned campanile figure. In other respects there are no
important relationships between panel and statuettes. There
is, however, a strong interest shown by the sculptor of the
two statuettes in the two buttress statues carved by
Donatello and Nanni di Banco in 1408-9. The sharp upward
thrust of the left hip of the turbaned figure was derived
from the statue which Wundram identifies as Donatello's
David;[198] however, this sculptor did not pursue the
implications of this contrapuntal motif throughout the rest
of the figure, as Donatello did in the David. The bare-
headed figure from the doorway of the campanile is also
derived from two sources; they are the Isaiah of Nanni di
Banco and the Christ in Ghiberti's Temptation. It is
comparable to Ghiberti's figure in the silhouette of its
torso and in the positioning of the legs, while with the

Isaiah it shares a similar placing of the hands and an
ambivalent sense of movement throughout the figure. The
buttress statues were carved in 1408 and 1408-9 respectively,[199]
whereas Ghiberti's Temptation and Transfiguration are
among the earlier members of Krautheimer's 1407-13 group
of panels.[200] We therefore know only that the two statuettes
were carved sometime after 1409. However, an analysis
of the sources of these figures reveals much about the
temperament of the sculptor who carved them. In every
case he has tended to neutralize the progressive aspects
of his models, particularly when they relate to the
decisive movement of form or the plastic character of the
latter. This is easily seen in the drapery, which is
decorative and fluid, but which reveals nothing of the
plastic strength or volume of the forms behind it. It is
solely in the treatment of the heads that one feels a
conscious effort to transcend the purely decorative aspects
of form. The hair and beards are ornamentalized, but there
is in the faces of the figures a sense of deep and sustained
expressiveness; at the same time there is a much greater
plastic force in the heads.

The stylistic character of these statuettes
seem to all point in the direction of Niccolò Lamberti's
work shortly before his departure for Venice. The orna-
mentalized hair and beards are analogous to the corresponding
1.21 areas of the Saint Mark in Florence and also of the

Pl.62 <u>Saint Mark</u> which Niccolò carved for the pinnacle of the
central arch of the facade of San Marco in Venice.[201] The
eyes are treated in almost precisely the same manner as
those of the seated <u>Saint Mark</u>, while the drapery of the
bare-headed figure finds its closest analogue in the central
section of the garment which covers the <u>Saint Mark</u> in
Venice. Finally, the positioning of the arms of this same
campanile figure point forward to the Venetian <u>Saint Mark</u>.

In general the two statuettes mark a point in
Lamberti's development during which he insists - despite
more progressive influences - on a decorative handling of
form, while at the same time elaborating a more active and
expressive idiom, particularly in the heads of his figures.
It is during the same period that he very likely carved
the head and upper torso of the seated <u>Saint Mark</u> and that
he furnished the design from which Piero Lamberti executed
the relief in the socle of the Saint James niche. As
there are also close analogies between these campanile
figures and the <u>Saint Mark</u> in Venice, I feel that they can
be securely dated just before his departure from Florence,
that is, in about 1414/5.

Lamberti's Status in Florence

It has been asserted by Wundram that Lamberti was poorly thought of by his contemporaries in Florence and that he was invited to Venice because the Venetians knew that they could not induce a first-rate master to come.[202] He attempts to support this evaluation by pointing out that Lamberti was paid less for his Saint Augustine than Piero Tedesco was for the Saint Ambrose, that he was similarly paid less than the other three sculptors who carved the seated Evangelist statues, that he was reprimanded for his work at the Porta della Mandorla in 1408, and that he lost the commission for the Saint Mark to Donatello. There is no evidence that Niccolò ever received the commission for the Saint Mark, so it is suppositious to assume that he lost it. All that is known in this connection is that he went to Carrara to purchase marble for the statue, which was a function that he performed on several occasions throughout his career.[203] It should also be noted that he served as a guarantor for Donatello in this same commission, a fact which would hardly bespeak the bitterness that would naturally arise in a situation where one artist had lost a previously acquired commission to another.[204] By the same token the document of 5 May 1408 in which he is censured in regard to his work at the Porta della Mandorla, has nothing whatsoever in it which would relate to the quality of his

work.[205] It is one thing to note that the capomaestro found him uncooperative and quite another to derive from this fact any support for the idea that he was poorly thought of as an artist. It is true that he received lower payments than his collaborators on the two projects mentioned above, but this seems a very tenuous basis upon which to evaluate his status. Surely it is much more significant to note that from the beginning of the last decade of the 14th century until his departure for Venice in 1415 Niccolò was a participant in virtually all of the major sculptural projects undertaken in Florence. Indeed, throughout this lengthy period of some twenty-five years, there is not a single year during which he was not engaged to some important commission. Surely he could not have maintained so fortunate a situation had he not been admired by the leading patrons of Florence.

Change and Development in Niccolò Lamberti's Florentine Work

Lamberti is generally thought of as a conservative Gothic artist and it is perhaps for this reason that the developmental nature of his work has seldom been assessed. From the first Niccolo reveals a very strong decorative sensibility which, from the beginning of his career through the Saint Luke, manifests itself largely through a revival of the francophile linearism of Nino Pisano and his followers. The primary example of this style in Niccolò's oeuvre is the Saint Luke. Its pose is entirely frontal and betrays no hint of potential movement, except at the hips where the figure is given a gentle Gothic sway. The drapery style is sharp and linear, creating throughout an incised, decorative pattern; there is no indication of structural form beneath these folds which very closely parallel those of countless figures by Nino and his school. In this statue and almost all his other works of this first stage of his career the linear surface effects are dominant and almost completely obscure any note of ponderated structure or naturalistic expression. His ornamentalizing tendency is most clearly present in the head of the Saint Luke where the hair, beard, eyebrows. and eyes are abstract decorative forms which lack any naturalism of form or content.

During the first fifteen years of his career Niccolò seldom departed from the idiom which produced the

Saint Luke. Towards the end of the 1390s he experimented with heavier and coarser proportions in the Madonna della Rosa and in the statues of Saint Augustine and Saint Gregory. The impetus for this probably came from the work of Piero Tedesco, with whom Lamberti collaborated several times during the period. The change was only temporary and even during its short duration did not alter Niccolò's primary emphasis on decorative, abstract rhythms; the treatment of drapery forms in these works remains pattern-istic and linear, while the facial planes are smooth and not naturalistically conceived.

It was only towards the end of the first decade of the quattrocento that Lamberti began to move away from his youthful style. Perhaps he realized that it held no new formal or expressive possibilities for him and he began to display a first, tentative interest in the work of the more progressive sculptors around him. In the figurines of the arch reveals of the Porta della Mandorla - particularly the Hercules - he indicates his first and last interest in classicism. Its unique presence in his work on this project indicates unequivocally that his classicism was the result of the subject - matter and of the close proximity of Giovanni d'Ambrogio's earlier "Hercules-Fortitude". Although Niccolò's figure was carved more than a decade after Giovanni's, it betrays a markedly lesser comprehension of the Antique; it is a less

heroic and lively an image and has all the earmarks of a
second-hand derivation rather than the direct study of
classical art. In the figures of angels in the hexagons
of the arch reveals Niccolò gradually turns to a livelier
and more expressive idiom. There is no classicizing
element in these figures, but they are nevertheless
progressively fuller, more active, and more expressive.
This growing naturalism may well have resulted from the
appreciation of the work which his young collaborator,
Nanni di Banco, was creating on the opposite side of the
arch and becomes a fundamental, albeit limited, aspect of
Niccolò's style in the second decade of the century.

Niccolò's innate tendency towards decorativeness
and the slowly emerging naturalism of his last figures
on the Porta della Mandorla became synthesized under the
imeptus of Ghiberti and the International Gothic Style
which had just swept into Florence.[206] The clearest point
of transition in Lamberti's work from a _trecento_ Gothic
character to the International Style is the _Saint James_ at
Or San Michele. The head is handled in a decorative
manner and the facial details are still conceived and
executed largely as ornamental motifs; it is this part
of the figure which is closest to the _Saint Luke_ and
Lamberti's early style. The remainder of the statue is
reflective of Ghiberti's recent work, particularly the
Saint John the Baptist. The drapery forms are broader,

smoother and livelier than in the Saint Luke and in the
lower half of the figure take on the extreme gracefulness
which typifies the International Style. At the same time,
this drapery reveals the structure of the body, although
in this respect it leaves much to be desired.

The Saint James is a transitional work and
appears to have been executed with long interruptions; it
therefore does not yet reveal a full commitment to the
International Style. This, however, is no longer the case
in regard to the last works which Niccolò carved before
his departure for Venice, the seated Saint Mark and the two
figures which stood above the entrance to the campanile.
The Saint Mark is one of the prime exemplars of the
International Style in Florence and reveals a close and
careful study of Ghiberti's work on the panels of his first
baptistry doors. The drapery style, with its elaborate
and continuous linear rhythms, parallels in intention
the manneristic treatment of drapery in Ghiberti's Saint
John the Baptist. The head, though ornate in certain
details, is powerfully and expressively naturalistic in
feeling. The two small campanile statuettes are less
Ghibertian than the Saint Mark and, at the same time,
reveal a direct interest in the work of Donatello and
Nanni di Banco. Their poses are lively and largely
convincing in their movement and the drapery acts, for
the first time in Niccolò's oeuvre, as an at least partially

functional element. These figures relate very strongly
to the David of Donatello and the Isaiah of Nanni di Banco
(as identified by Wundram), but, at the same time, betray
the fundamentally different personality of their author.
A comparison of the turbaned campanile figure with
Donatello's David demonstrates that whereas Donatello -
whose drapery style is here still strongly Gothic - emphasizes
the roundness of his form by bringing some of the upper
folds around the side of the figure and by sharply setting
the left knee forward, Lamberti tends to interpret the
drapery folds more nearly as forms which rest upon a
primarily flat surface and clearly reduces the contrast
between free and weight-bearing legs. Equally, Niccolò's
campanile statuettes lack the heavily ponderated character
of Nanni's Isaiah. They are fully within the International
Gothic Style and have a tone of lightness in their move-
ments, while also maintaining the naturalistic expressive-
ness of the Saint Mark in the conception of their heads.

It is by no means surprising that when Niccolò
abandoned his early style that he should have turned to
Ghiberti for inspiration and become a major proponent of
the International Style. At the time, that is about 1412,
Nanni di Banco's classicism had yet to reach its maturity
and the overwhelming genius of Donatello had still to
emerge as such. Ghiberti was in 1412 the leading artist
in Florence and it is only natural that Lamberti would

have turned first to him for a new direction. Moreover,
Niccolò's strong decorative sensibility had always been
at the very core of his art and so the International
Style would certainly have been more attractive to him
than any other evolved during this period. At the same
time it should be recognized that his turn towards the
International Style represented nothing unusual or reactionary
on his part, but placed him in the mainstream of Italian
art in the period 1410-5. There was not a single Florentine
sculptor whose work during this time does not reflect this
trend. This holds true even for Donatello and Nanni di
Banco. The graceful silhouette of Donatello's Bargello
David and the decorative style of the lower drapery of his
Saint John are International Gothic in character, while
the adherence to surface pattern in the folds of Nanni's
Saint Elègius are of similar origin. By this I do not
suggest that Lamberti would have become a revolutionary
artist had he remained in Florence. The first great
statements of the early Renaissance style were in the
process of being pronounced during his last few years
there - in the form of Nanni's Saint Philip, Quattro
Coronati, and Saint Luke, and in Donatello's Saint Mark -
and Niccolò's work betrays little interest in these
developments.

Lamberti's strongest affinity during this period
was with Ghiberti and with other artists of the International

Style, such as Stefano da Verona, rather than with the most
progressive Florentine artists.[207] It was therefore highly
appropriate that Lamberti should have spent the latter part
of his active life in Northern Italy rather than in the
Florence of Donatello, Nanni, Masaccio, and Brunelleschi.
His reasons for leaving Florence were very likely not as
abstract as that and there is surely no cause to believe
that his departure resulted from the competitive situation
in Florence. If anything, he was more active in the last
few years before going to Venice than at any previous time
in his career. Instead it seems more reasonable to assume
that he was unwilling to reject the unique opportunity of
becoming the dominant figure in the decoration of one of the
greatest churches in Italy.

Part 2: Piero Lamberti in Florence

A Chronological Survey of the Life of Piero Lamberti

The documentary evidence concerning the life of Piero Lamberti is very sparse. He appears to have been born in or about 1393 since he is referred to as a "giovane" in a document of 1410.[1] The same document states that he was sent on August 5th of 1410 by his father to perform some menial task at Or San Michele.[2] On May 2nd, 1415 he matriculated in the Stonecarvers' Guild, but apparently left Florence shortly thereafter.[3] On October 29th 1416 a "Magister petrus de florentia lapicida" served as a witness in Venice to the testament of a stonecarver named Cristoforo di Campione;[4] it seems very likely that this is the same person as Piero Lamberti. In 1418 he was back in Florence where he was working on the tomb of Onofrio Strozzi in Santa Trinita; he received partial payment for this work on August 4, 1418.[5] There is no further mention of Piero until 1423 when he and a certain Giovanni Martino da Fiesole signed their names as the creators of the tomb of Tommaso Mocenigo in Santi Giovanni e Paolo in Venice. This is followed by still another long hiatus in the documentary material which ends with the commissioning of the monument for Raffaelle Fulgosio in early 1429.[6] By October of 1430 he was in Verona from where he wrote to his collaborator on the Fulgosio monument, Giovanni Bartolomeo da Firenze, asking him to collect the

remainder of what was owed to him by Fulgosio's widow.[7]
Four more years pass before we hear of Piero again; in
1434 he received the commission to carve two chimney-pieces
for the Ca d'Oro.[8] His work on this project was interrupted
by his death which occurred before December 7, 1435, when
he is mentioned as dead in a document referring to the
confiscation of stone in payment for the debts which he
owed before his death.[9]

Of the various documents concerning Piero's
career, only two present any problem of identification or
interpretation. The first of these dates from 1410 and
reads as follows: "Martedi a di V di gosto a ora di nona
ci mando el pela due giovani a nettare l'oratorio cioe el
tabernacolo Piero di Niccholo detto pela a Vettorio di
Giovanni Piero di Niccholo lavoro nove opere Vettorio di
Giovanni lavoro otto opere somma 17 opere".[10] The document
goes on to state that Vettorio di Giovanni received 20
soldi for each of the "opere" whereas Piero was paid at
the rate of 17 soldi for each. From this document it is
impossible to arrive at any conclusion other than that
these two "giovani" were sent by Niccolò to perform some
sort of menial work, which seems to have involved cleaning
or polishing various objects at Or San Michele. There
is absolutely nothing in the document which would allow
it to be understood as providing support for some form
of sculptural activity on Piero's part at that time.

Furthermore, if one were to choose to do so - and to connect
the document with a work like the <u>Annunciation</u> on the
Matthew niche or the <u>Saint James</u> - he would be constrained
to define the role of the Vettorio di Giovanni who also
appears in it. Indeed, the latter was paid more and at
a higher rate than Piero and so he would have been
responsible for a still greater part in this hypothetical
work than Piero. Therefore I think that the document is
best understood at face value; its value to us rests
solely on the indication of Piero's age which we derive
from it.

The second document concerning Piero which is
problematical is that of October 29, 1416 which apparently
mentions him as a witness to the testament of a certain
Cristoforo di Campione; since it is the only possible
reference to him in Venice before 1423 it is of considerable
significance. In it there is mention only of a "magister
petrus de florentia" and it is uncertain whether this is
Piero Lamberti or not. Yet, we know that Niccolò Lamberti
was in Venice at the very same time and that another
Campionese stonecarver was working for him at San Marco.
In addition, there is no notice of any other Florentine
sculptor in Venice at this time with the name Piero. For
these reasons it seems reasonable to accept the identifi-
cation of "Magister petrus de florentia" with Piero Lamberti.

The Tomb of Onofrio Strozzi

Onofrio Strozzi died on April 3, 1418 and is
buried in a tomb in the sacristy of Santa Trinità in
Pl.31-2 Florence. The tomb consists of a double-sided sarcophagus
with a pair of classical putti on each side bearing the
coat-of-arms of the Strozzi family. The sarcophagus
rests on four balls and is situated within a lunette that
is decorated with low relief freizes of putti entwined in
garlands on both sides of the arch. At the base of the
arch there are classicizing capitals; finally, on the
principal face of the tomb non-functional brackets are
found at the bottom of the ensemble.

There is only one known document which is related
to the tomb. It reads as follows: "A 4 d'agosto [1418] o
dato a chonto fiorini sei a mo Piero di Niccolo che fa il
cassone di marmo per defunto Messer Onofrio."[11] Since
there can be no reasonable doubt that the "Piero di Niccolo"
of the document is Piero Lamberti, it would seem that the
attribution to him of the tomb would be a relatively
simple matter. This, however, is not the case; the
design of the tomb is very progressive, particularly for
a date of 1418, and Piero's indisputably mediocre achieve-
ments elsewhere have led many scholars to doubt that he
could have designed so advanced a work. Fabricizy, Poggi,
and other have insisted upon the validity and significance
of the document and have therefore maintained that Piero

was the author of the tomb.[12] Bode, Reymond, and several

other scholars have rejected this thesis, noting that the

acceptance of Piero's authorship would imply that he had

a.strong influence on Donatello.[13] Reymond also raised

the objection that six florins was too small an amount

for so grand an undertaking and proposed that the document

may refer to a work which Piero began, but was not able

to complete for some reason.[14] Poggi refuted Reymond's

argument, pointing out that the six florins were only on

account ("a chonto") and that the document clearly refers

to a "cassone di marmo".[15] It is highly unlikely that

Strozzi's heirs would have commissioned a temporary tomb

to be made of marble. The situation was complicated

further by the detailed study made by Lisner;[16] she

attributed the conception and design of the entire monument

to Donatello, while dividing its execution between

Donatello, Piero, and Donatello's workshop. More specifically,

Pl.31-2 she gave the execution of the sarcophagus and of the

Pl.32 secondary face of the arch to Piero, while attributing

Pl.31 the execution of the main side of the arch to Donatello

and assistants. Finally, she restricted Donatello's

direct participation in the actual carving to the putto

at the extreme lower right of the main face of the arch.

There are debilitating problems inherent in each

of the three interpretations. Reymond's simply does not

conform to the documentary evidence and must be discarded

for this reason. Poggi's approach is based upon the document, but it does not take several significant factors into account. The low relief putti on the arch are diverse in style and cannot be ascribed to the same hand. They are in turn also quite different from the two pairs of putti on the sarcophagus itself. The low relief figures are equally at variance with the secure work of Piero Lamberti, who is not known to have never employed the Donatellian rilievo schiacciato used here. Indeed if one insists that the low relief putti-on the arches of the Strozzi tomb were carved by Piero in 1418, then he must realize the implication to be drawn from this conclusion - that Piero was a pioneer, together with Donatello, in the development of this technique. This is clearly not likely to have been the case. Finally, the architecture of the tomb is entirely different from that of the later

Pl.119
Pl.134
documented tombs of Tommaso Mocenigo and Raffaelle Fulgosio. Lisner's solution is much more complex and difficult to refute.

It is perhaps best to begin with the document itself. It contains a reference only to the sarcophagus; therefore we are constrained only to attribute it to Piero Lamberti and to date it in 1418. When viewed from this standpoint the correct solution becomes clearer. The sarcophagus sits uneasily within the framing lunette; indeed their relationship is one of tension and discordance

rather than of a compatability of proportions, directions
of movement, and motifs. Finally, the style of the four
putti on the sarcophagus is vastly different from that of
low relief figures on the arch. It is therefore my belief
that the sarcophagus was commissioned from Piero Lamberti
in 1418 and carved by him entirely, whereas the framing
lunette and its decoration were a much later creation.

The handling of the putti on the arches supports
this contention and, at the same time, makes it very
unlikely that Donatello himself had any part in the project.
When one looks for parallels between them and works in
Donatello's secure oeuvre it is inevitable that he must
turn to projects of a later date, such as the Prato
pulpit and the Cantoria; this holds true for both sides
of the arch. An instructive comparison can be made between
the figure at the extreme lower left of the main face of
Pl.31 the arch and the primary figure on the right side of the
seventh relief panel of the Prato pulpit.[17] In both
examples the head is turned to the right and downwards,
while one arm is extended upwards in an unusual fashion
so that the back of the hand faces the viewer. The type
is so distinctive and the similarity so marked that one
must conclude either that the two figures were the product
of one mind or that one depends upon the other. The former
possiblility would coincide with Lisner's view of the
entire matter; it is, however, unlikely to be the correct

choice. In both figures the extended arm and hand are placed in a position which is both uncomfortable and difficult to maintain. This pose is fully explicable and appropriate for a figure dancing ecstatically while holding on to his cohorts. The implication in this situation is of movement captured and frozen momentarily, and within this context the difficult pose is readily understood and admired. By contrast, when the same gesture is employed for a motionless standing figure it appears forced and clumsy. This is a primary example of a motif which is created by a master for a specific context which it suits perfectly, becoming an awkward and misunderstood device at the hands of a lesser follower. It is theoretically possible to suggest that the relative weakness of the putto on the arch resulted from the fact that Donatello was much less experienced in 1418. On the other hand one could hold that the difference between the two figures was due to the quality of the execution in each case. The first point is invalid because by 1418 Donatello had already carried out a number of splendid works of the greatest subtlety. The second point is countered with equal ease, as it is precisely in the conception and design of the figures that the issue arises. The remaining putti on this same side of the arch - where direct analogy exists - are relatable to figures in Donatello's oeuvre from the Saint Louis niche through the Cantoria. The same
1.32 is true for the putti on the secondary face of the arch,

which Lisner ascribes to Piero Lamberti. A case in point is the second figure from the right whose pose depends upon that of the putto at the extreme left of the second panel of the Prato pulpit and whose facial type appears in the Cantoria, in the turning angel who is partially obscured by the fourth column from the left.[18] It therefore seems clear that the arches are the product of a second stage of work which took place perhaps in or about 1440. It also seems quite certain that Donatello took no part in the project, since the figural decoration is in every respect inferior to his autograph works. It may, however, represent the efforts of workshop assistants who had a first-hand knowledge of the Prato pulpit, the Cantoria, and the other great undertakings of the period which Donatello was responsible for.

The sarcophagus, by contrast, is by Piero Lamberti. Its execution presents no problem since it is fully analogous to his later work. The four putti are dry and rigid in pose and detail. The heads and feet are turned in an artificial manner in order to create simple horizontal and vertical relationships. In all four the lower part of the body is almost frontally situated while the upper torso is turned at a very sharp angle to the relief plane. The transition between these two regions of the body is poorly resolved in every case, so that the viewer may feel that he is looking at a composite of two

different figures, rather than one which turns in space. This inability to create a smooth sense of transition is best seen in the awkward and unconvincing points at which the heads and limbs meet the torsos. Finally, the surfaces are poorly articulated and uniformly modeled, so that there is almost no textural variation in any of the figures. Unfortunately, these characteristics remain true of Piero's work throughout his career, as can be seen in the scroll-bearing figures on the front of the tomb of Raffaelle Fulgosio which Piero carved in 1429/30.

Pl.136

The choice of this classical motif and the design of the sarcophagus itself are more difficult to see as Piero's. There is nothing in his later work which would suggest a direct interest in the Antique, nor is there any analogue to the refined and spatially sophisticated design of the sarcophagus. This can be readily seen in comparing the latter to the section of the Fulgosio tomb with the scroll-bearing figures. The sarcohpagus design does, however, seem to be closely related to the Cassa dei SS. Proto, Giacinto e Nemesio which was made by Ghiberti in about 1427.[19] On the front and back faces of each a large rectangular field is located behind and within an outer border. All four of these rectangular fields contain winged pairs of figures who hold devices through which the viewer can learn the identity of the remains therein contained. They also share stepped moldings both above

-101-

and below the relief fields, with ornamentation appearing
only in the lowest level of the upper molding. The super-
structure of each is composed similarly in each, with a
flat surface at the top - again with a series of moldings -
from which curved surfaces descend downward and outward.
These curved surfaces contain a large field which is set
behind an outer border in both the sarcophagus and the
reliquary. There are also several differences between
them; these include the more horizontal proportions of the
tomb, the presence of angels on the reliquary and putti on
the tomb, and the decorative foliage which appears only on
the upper part of the reliquary. In addition, the ornament
on the reliquary is more emphatic and the moldings smoother
in the transitions from one level to the next. I believe
that the similarities far outweigh the differences and that
the relationship between the two is not at all coincidental.
Yet, there is a fundamental problem which exists in trying
to establish the connection; Piero's sarcophagus dates
from 1418 whereas Ghiberti's reliquary was not made until
almost a decade later. It is almost as unlikely that
Ghiberti would have modeled his design after Piero's as it
is that Donatello would have borrowed figural motifs from
him, and so the answer must lie elsewhere. In January of
1420 Ghiberti was appointed as a supervisor of work on the
choir stalls and furnishings of the sacristy and Strozzi
tomb chapel at Santa Trinita.[20] In addition, Marchini has
attributed the portal of the Strozzi Chapel to Ghiberti.[21]

His attribution is followed with reserve by Krautheimer, who sums up his view of the evidence by writing, "All this seems to indicate that Ghiberti's design, though somewhat misinterpreted (and poorly executed), had formed the basis of the portal at Santa Trinita."[22] It is my contention that a similar description could be accurately applied to the sarcophagus of the Strozzi tomb. We know from Ghiberti's own testimony that he was very generous in providing other artists with designs and I have attempted to show that there was considerable professional communication between Ghiberti and Niccolò Lamberti. It is not difficult to imagine the younger Lamberti turning to Lorenzo for advice on his first major commission. This is made all the more likely by the fact that Ghiberti served in a supervisory capacity in connection with the chapel containing the tomb and may well have designed its doorway. It would then have been Ghiberti and not Piero who was responsible for the idea of re-introducing the Antique motif of the pair of winged putti which was shortly thereafter employed by Donatello.[23]

The Annunciation on the Niche of the Bankers' Guild at Or San Michele

Aside from the Strozzi tomb and the Saint James and its socle relief the only work in Florence that has ever been attributed to Piero Lamberti is the small pair of figures which stand on either side of the gable of the niche containing Ghiberti's Saint Matthew. Vasari attributed them to Niccolò Lamberti, but among modern critics only Schmarsow agreed with him.[24] The style of the pair is so sharply at variance with that of the many secure works of Niccolò that a new attribution was obviously called for. The most attractive alternative for some scholars was Piero Lamberti;[25] it could then be assumed that since Vasari probably had no knowledge of Piero, he simply added this work to his catalogue of Niccolò's oeuvre. This theory seems to have merit from a methodological standpoint and has the appeal of apparently tying the figures to a relatively early source. It is, however, very weakly founded. Vasari's "Life" of Niccolò contains only two provably accurate factual statements, that he carved the Saint Mark and that he competed for the commission for the baptistery doors. It is a composite of Lamberti's career and that of another artist, Niccolò di Luca Spinelli, and even where one can be sure that Vasari writes about Lamberti his statements are filled with errors.[26] A case in point is the fact that Vasari indicates that it was on account of the success of these two figures that Lamberti was

given the invitation to compete for the baptistery doors.[27]
Therefore there is no basis for drawing support for an
attribution to Piero Lamberti from Vasari; instead any
decision in regard to their authorship must rest on
stylistic and circumstantial evidence.

The statue of Saint Matthew was commissioned in
1419, but work on the project lasted through 1422.[28]
Pl.33 Although the Annunciation is not mentioned in the documents,
it seems very likely to me that it formed part of the
original design. As decorative devices they replace the
pinnacles which had surmounted the side pilasters of the
previous quattrocento niches at Or San Michele. If they
were not part of the original plan, some other elements -
either architectural or figurative - must have been. Since
there is no evidence of a later campaign of work on the
project and in view of the fact that the style of the
two figures does not conflict with a date of about 1420,
it seems much more likely than not that they were carved
at the same time that the rest of the project was being
created.[29]

This seems to be indicated by the style of the
figures which , as Seymour has noted, echo the design of
the Saint Matthew.[30] Ghiberti's statue was composed in a
4:5 ratio between the head and torso on one hand and the
legs on the other, thereby creating what Seymour refers
to as "leggy proportions".[31] These new and more graceful

proportions are repeated in the statue of Gabriel, although
the sculptor appears to have had some difficulty in
carrying them through smoothly in the center of the figure.
The Gabriel also follows its model closely in the legs.
In both the right knee projects sharply and is set apart
by a thin diagonal fold which extends from the right foot
to the waist. Similarly, the left leg of each figure is
hidden behind bunched perpendicular folds which are formed
by both the inner and outer garment. The rest of the
Gabriel is, however, unrelated to Ghiberti's work here or
elsewhere. The drapery style becomes more Donatellian in
the upper half of the figure, and the head in broad, clearly
defined planes, revealing the very classical temperament of
the sculptor who carved it. The figure of Mary Annunciate
is much more difficult to assess. According to Milanesi
its head was missing at his time and many scholars have
doubted the authenticity of the one it presently bears;[32]
their doubts are well substantiated and it is difficult to
see the hand of any quattrocento sculptor here. The rest
of the figure is authentic and repeats the positioning of
the hands of the Saint Matthew. In general, the sculptor
who carved these statuettes seems to have been someone
closely associated with Ghiberti and directly influenced
by his work. At the same time, he appears to have had a
strong and independent artistic personality which is
revealed in the classicizing head of the Gabriel and in
the free and generally Donatellian drapery style of the

upper half of the Gabriel and of the Virgin.

 The names of three sculptors have been proposed
by modern scholars as the possible authors of these figures;
they are Piero Lamberti, Nanni di Bartolo, and Michelozzo.[33]
The suggestion of Piero Lamberti's authorship can be most
easily dealt with by comparing the Gabriel to one of Piero's
certain works, such as the Faith of the Mocenigo Tomb.
Whereas the sculptor of the Gabriel exhibits a delight and
considerable accomplishment in rendering clearly differen-
tiated and activated drapery forms, Piero employs coarse
and summary motifs which conjoin to create an impression of
limpness. The differences between the two are at least as
evident in the conception and execution of the heads. In
both figures the facial planes are broad and simplified;
however, whereas the Gabriel has a sense of sharpness and
clarity in its expression, the Faith is heavy and primitive.
It therefore seems virtually impossible that the same sculp-
tor could have carved both figures, so that the possibility
of Piero's authorship can safely be dismissed.

 The case against an attribution to Rosso is almost
as strong, although his work is qualitatively equal to the
Gabriel. There is, first of all, considerable circumstan-
tial evidence for rejecting this possibility. It is clear
that the Annunciation was carved concurrently with the cre-
ation of the rest of the project or afterwards, but certainly

l. 124

-107-

not before. Ghiberti received the commission from the
Bankers' Guild on August 26, 1419, a date which may be used
as a terminus post quem for the Annunciation.[34] Six weeks
earlier Rosso had received his first commission from the
cathedral authorities and began work on it shortly there-
after.[35] The statue - which is probably the Saint John the
Baptist - was completed by January of 1420.[36] He received
final payment in March and a month later took over a statue
which had been started and abandoned by Ciuffagni; he com-
pleted this statue - probably the Joshua - by April 26, 1421
when he was given his final payment.[37] A month earlier he
accepted the commission to carve the Abraham and Isaac on
behalf of both himself and Donatello.[38] This work was fin-
ished by November of 1421.[39] Soon thereafter Rosso began
work on an independent commission, the Abdias, for which
he was paid in March, June, September, and finally November
of 1422.[40] Five weeks later he received still another com-
mission from the cathedral authorities, this time for a
figure for the campanile.[41] He began work on the statue,
receiving a payment in March of 1423[42] - but work on it was
soon permanently interrupted by his departure from Florence
well before February of 1424.[43] In view of this very full
schedule of work, it seems not too likely that he could have
found time to carve these two figures at Or San Michele.
Furthermore, it seems certain that his artistic origins are
to be found in the orbit of Donatello and there is not the

slightest bit of evidence to support any form of association with Ghiberti. This is borne out by the absence of any Ghibertian element in his work. Indeed, Rosso was one of the very few sculptors in Florence during this period who shows not a trace of Ghibertian influence in his style.

Pl. 28 A comparison between the Gabriel and the Abdias confirms the fact that Rosso was not the sculptor of the former. The face of the Abdias is softer in texture, less crisply defined, and less classical than that of the Gabriel. The drapery of the Abdias is heavier than that of the Gabriel and lacks its decisive sense of direction and movement. There is therefore neither circumstantial nor stylistic support for the attribution of the Gabriel to Rosso.

The ascription of these figures to Michelozzo is much more acceptable. There is some circumstantial support for this attribution; Michelozzo had assisted Ghiberti in the project for the Bankers' Guild, as well as in the latter stages of the work on the second baptistry doors.[44] His precise role in the Or San Michele project has not been completely established, although it appears very likely that he assisted Ghiberti in the casting of the statue.[45] It is entirely plausible that he could have gone on to carve these two statuettes during the same period. Indeed, he is the only marble carver of note who appears in the documentation of the project. Lastly, we know that Michelozzo

was responsible for a considerable share of the marble
sculpture on the Coscia Tomb and the Brancacci Monument,
both of which were collaborative works which he and Dona-
tello produced together.[46] It therefore seems likely that
he had proven himself as a sculptor of some accomplishment
before their partnership began in the middle of the third
decade.

It is somewhat more difficult to substantiate this
attribution from a stylistic standpoint. This is especially
so on account of the uncertainty which exists concerning
the extent to which the sculpture of the Coscia Monument
was carved by Michelozzo. It is perhaps easiest to see the
head of the statuette of Gabriel as his work. The insistent
classicism of Michelozzo's sculpture on the Aragazzi and
Brancacci Monuments is prefigured in the Gabriel. The
closest analogy exists between the Gabriel and the figure
standing in the center of the relief which shows Bartolommeo
Aragazzi Bidding Farewell to his Family from the Montepul-
ciano Monument.[47] The clear and sharply defined planes of
the face are common to both figures, although the one in
the relief is handled with still greater crispness and a
much more advanced comprehension of the antique. Similarly,
the treatment of the hair of both figures is quite analogous.
It is more difficult to see a direct relationship between
the Annunciation and Michelozzo's secure work with respect
to the handling of drapery forms. Yet, there are several

common points which exist in the drapery of the _Virgin_ and
the _Saint Bartholomew_[48] from the Aragazzi Tomb; this is
particularly true of the forms along the right side of both
figures. The similarity is not a close one, but the circum-
stantial evidence, as well as the treatment of the head, are
telling points and seem to strongly favor the ascription to
Michelozzo.

Part 3: The Sculpture of the Upper Arches of San Marco

In 1385 construction was begun for the purpose of completing the decoration of the upper part of the cathedral of San Marco. The document which reveals this fact reads as follows: "fo schomenzado i capiteli che xe sora la iexia de San Marcho la o che sona le ore per mezo la jexia de San Basso in 1385, a uno altro capitelo suxo l'altro canton."[1] It refers only to architectural work and establishes no more than a terminus post quem for the work on the north side of the cathedral; the "altro capitelo suxo l'altro canton" most probably refers to the south side, although it may instead deal with the extension on the north side which faces westward and which is only one bay in length.[2] No further mention is made of the progress of the work for many years. On March 19, 1414 a letter from the Doge Tommaso Mocenigo to Paolo Guinigi of Lucca refers to the acquisition of marble, ". . . ad ornamenta ecclesiae Sancti Marci,"[3] but there is no way of knowing more specifically to what purpose the marble was to be put. A document of the following year is revealing. It reads: "En 1415 fo fati i capitelli in la Gliesia de San Marco in ver San Basso e fo fato le figure che e dentro et suxo i fluori e scomenzati a meter le foie de piera atorno i archi."[4] The document indicates that the work on the upper architectural decoration of the north side of the cathedral which had been started in 1385 was now completed. It is more difficult to be sure which figures are meant by, "le figure che e dentro et suxo i fluori." It

seems certain that the half-length prophet busts are referred
to, but the reference could be extended to also include the
statues at the pinnacles of the arches and in the tabernacles
as well. This is the way in which Planiscig interpreted
the phrase;[5] he therefore believed that 1415 serves as a
firm terminus ante quem for all of the sculptural decoration
of the north side. By contrast, Fiocco finds support for a
diametrically opposite interpretation in the document.[6] He
sees it as marking the starting point for the decoration of
the cathedral and therefore as a terminus post quem for the
statues on the pinnacles and in the tabernacles. In my
opinion the document is ambiguous in this respect and reveals
nothing more about the sculptural program than that the
prophet busts and foliated decoration were being placed on
the north side of San Marco in 1415.

There is one further document which related to
the decoration of the upper arches of San Marco. It dates
from October 23, 1416 and reads as follows: "Mi Maistro
piero da chanpion die aver da Zanin campion duc.ti XVIIIJ.
Item die aver da Maistro Nicolo Pela de foie 8 a raxon de
duc.ti XV, compide, monta in tuto duc.ti 120."[7] There can
be no doubt that the "Maistro Nicolo Pela" is Lamberti, as
he was frequently referred to with the nickname "il Pela"
appended to his name in the Florentine documents. The "foie
8" seem surely to be identified with the foliated ornamenta-
tion which appears on the arches of the cathedral. I would

suggest that it may also refer to some of the prophet busts
which spring from the stone leafage as well, since at 15
ducats per ornamental section these would have been exorbi-
tantly expensive decorative elements. There are, however, two
major facts which can be unequivocally understood from this
document. The first is that Niccolò Lamberti was by this
time in Venice, deeply involved in the sculptural decoration
of San Marco and seemingly in a position of authority. The
second is that whatever one believes about the progress of
work on the north side, there was still considerable activity
on the cathedral decoration going on in 1416.

There is no documentary evidence which links Piero
Lamberti to the work at San Marco. He appears to have jour-
neyed with his father to Venice in 1415/6. A document of
October 29, 1416 mentions him as a witness to the testament
of a sculptor by the name of Cristoforo da Campione.[8] How-
ever, he returned to Florence at some point before August 4,
1418 when he received six florins on account for work on the
Strozzi tomb.[9] Therefore, the documentary evidence for Piero'
participation on the work at San Marco is tenuous at best,
and places rather strict limitations on the amount of time
which he could have spent on this project before the fire
in Venice in June of 1419.

The Program

The program of sculptural decoration of the upper

arches of San Marco is among the most extensive of the

period. Above the four lateral arches of the west facade

Pl. 34- and the seven arches of the north and south sides there

54

rise ogival gables upon which alternate prophet busts emerg-

ing from foliage and independent leafage ornament; on either

side of the pinnacle of each gable there are two prophet

busts and two stone leaves. These eleven pinnacles carry

platforms on which rest the pedestals of free-standing

Pl. 55 statues. The figures on the south are of Justice and Forti-

Pl. 56, tude, whereas those of Charity, Prudence, Faith, Temperance,

57-60

and Hope (on the extension which faces westward) appear on

the north side; the statue of Prudence is a 17th century

replacement for a figure destroyed in an earthquake in 1511.[10]

On the pinnacles of the lateral arches of the west facade

stand statues of four martial saints; they are all 17th

century replacements.[11] Over the central arch of the facade

Pl. 61- six large figures of angels - who alternate with foliated

67

ornamentation - take part in a procession which culminates

with the majestic statue of Saint Mark who stands in glory.

On either side of each arch one finds large Gothic

tabernacles which contain a total of eleven free-standing

l. 68 statues. The figure of Saint Benedict is situated in the

tabernacle between the two arches of the south side and is

l. 69 accompanied to the east by a statue of Saint Anthony Abbot.

On the north side, beginning with the second tabernacle from

. 70-4 the west, we find the figures of Saint Ambrose, Saint Augustine,

Saint Gregory the Great, Saint Jerome, and Saint Michael
(who like the Hope stands on the westward-facing extension).
The tabernacles of the main facade contain, beginning from
Pl. 75- the north end, the statues of Gabriel, Saint Matthew, Saint
85
Mark, Saint John, Saint Luke, and the Virgin Annunciate.

Figurative sculpture also appears in the gables
Pl. 43- of the lateral bays of the west facade and of the south
56
side of the cathedral. In each a half-length figure of a
saint or prophet projects sharply in very high relief.
Finally, directly beneath the tabernacles containing the
Pl. 86, four Evangelists and the four Latin Church Doctors one
87-90
finds figures of water-spout carriers situated within ir-
regularly shaped compartments with tripartite Gothic over-
hangs.

Despite the impressive quantity of sculptures
which compose this program, it has received very little
scholarly attention. Fiocco attributed all of the original
pinnacle statues to Niccolò Lamberti, also claiming for him
all of the tabernacle figures on the lateral sides of the
cathedral except the Saint Michael.[12] To the younger
Lamberti he gave the six tabernacle statues of the main
facade and to Piero with the help of the Campionesi he at-
tributed the forty-four prophet busts and the six gable
reliefs.[13] Finally, he attributed the Saint Michael and
the four water-spout carriers of the west facade to Lombard

-116-

sculptors.[14] Planiscig reacted vigorously against Fiocco's
proposals, rejecting almost all of them.[15] The only statue
which he accepted as Niccolò's was the Saint Mark on the
central pinnacle;[16] the others, he felt, were not especially
close to Lamberti's work and were products of the Interna-
tional Gothic style in general.[17] Although he does not
discuss them, he seems, by implication, to reject all of
Fiocco's attributions to Piero Lamberti that are mentioned
above.[18]

The Prophet Busts

Pl. 34-54

The forty-four prophet busts which decorate the
arches of San Marco are heterogeneous in style and perhaps
also diverse in date. There are, broadly speaking, three
groups which can be isolated. The first of these consists
of the prophets found on the arches bearing the statues of

Pl. 34-38

Charity, Prudence, and Faith, that is, the first three arches
of the north side of the cathedral. They all have robustly
naturalistic heads which rest on torsos that are covered
with patternistic drapery. The drapery forms are composed
largely in a series of parallel loops which create abstract,
rhythmic patterns of movement. The physiognomic types and
drapery motifs of all twelve figures are so close to one
another that they could easily have been carved by the same
sculptor; at the very least, they are all the products of a
homogeneous workshop. To choose one example, the heads of

. 35, , 38

the lower right prophet on the Charity arch, the two on the

left side of the Prudence arch, and the lower left prophet
of the Faith arch are almost identical in form and handling.
The synthesis of a rugged naturalism, seen in the heads,
and an abstract linearism, which appears in the drapery,
seems to be reflective of the roughly contemporaneous work
at the Cathedral of Milan.[19] In Milan a wide variety of
late Gothic styles, representing many parts of western
Europe, were being practiced. Among the most notable statues
of the Cathedral of Milan is the Isaiah, which was carved
by some unknown sculptor under the influence of Sluter.[20]
At its core lies a similar stylistic synthesis, which con-
sists of an awesome and almost coarse naturalism in the head
and a delicate patternistic treatment of drapery. Comparable
Pl. 35 drapery motifs appear in the Isaiah and the prophets on the
lower right of the Charity arch and the upper right of the
Pl. 36 Prudence arch. Further analogies exist between these twelve
prophets and other statues in Milan; works such as "Gigante
67," which is attributed to Alberto da Campione, and the
"Prophet 2838"[21] seem to have been particularly influential
on the master who carved the prophet busts at San Marco. The
work of this master must also be clearly distinguished from
the primary style which dominated Venetian sculpture at the
turn of the century, that of the Dalle Masegne.[22] Although
there are certain superficial characteristics which they
share, the work of this master is crude, repetitive, and
without movement, whereas that of the Dalle Masegne is

refined, varied, and highly activated. It would therefore
seem that the sculptor of these twelve figures originated
not in Venice, but in Lombardy, and came to Venice after
the work on the Cathedral of Milan had progressed quite
far. The analogies suggested above would indicate a date
of about 1410 as the terminus post quem for his work in
Venice.

The second group of prophet busts which can be
distinguished as a separate entity are the remaining eight
Pl. 39-
42 figures on the north side, those above the Temperance and
Hope arches. The poses and gestures of these figures are
much more animated than those of the other group on the
north. There is also a much greater variety of form and
expression here; these characteristics reveal this sculptor
as one of much greater imaginative capability than his co-
worker on the north side. The common authorship of these
eight figures is attested to by a variety of details which
they share such as the large, heavy-lidded eyes, the sharp
thin noses, and the decorative curls which frame the faces.
The drapery style of this master - or workshop - tends to
be freer and less patternistic, even to the point of reflect-
ing the movement of the body in some cases. The drapery
folds of this master are thinner than those of the sculptor
of the other prophets of this side and tend to form ridges
which cut sharply across the front of the figure. The

component parts of the style of this master are generally
like those of the sculptor of the remaining twelve prophet
busts of the north side. It too depends upon a synthesis
of a naturalistic approach to physical reality and of a
decorative sensibility; the two elements are not truly syn-
thesized, but are at once complementary and competitive.
The primary differences between the two masters lie in the
greater expressiveness of the second and in his more pic-
torial sensibility. One is reminded in looking at his work -
for example, the lower right bust of the Hope arch - of the
figure of Christ in Giovannino de' Grassi's Christ and the
Woman of Samaria over the lavabo of the south sacristy of
the Cathedral of Milan.[23] Although his artistic personality
was quite different from that of the other master of the
north side, his artistic origins also are to found in Lom-
bardy. Both his exaggerated expressiveness and his pictorial
approach to sculpture are characteristics which he would
have acquired by studying the sculptors and working methods
of the various workshops in Milan.

 The styles of the two masters of the north side
of San Marco reveals not the slightest kinship with or knowl-
edge of Florentine sculpture. This, however, is not the
case with respect to the master who designed the sixteen
busts of the lateral arches of the main facade. The two
busts on the left side of the first arch from the north show
strong Ghibertian influence. The drapery of the lower one

Pl. 43-
50
Pl. 43

derives from that of the standing Magus who bears a gift
in his left hand in Ghiberti's panel of the Adoration of
the Magi.[24] His companion is taken over directly from
Ghiberti's Saint John the Baptist at Or San Michele. The
proportions and morphological details of the face, hair and
beard are virtually identical with the statue by Ghiberti.
The drapery too repeats the form of the Baptist statue, with
a series of highly charged loop folds meeting at the front
of the torso. The influence of Ghiberti is noticeable in
several figures of the remaining arches of the facade. The
drapery forms of the figure of Christ in Ghiberti's Resur-
rection[25] are reflected to some degree in the lower left

l. 45,
48

prophet bust of the second arch and in the upper right figure
of the third arch; the position of Christ's arms in the
panel seems to have been taken over and reused in the latter
of these two busts. They also indicate a knowledge of Dona-
tello's Saint John, as can be seen in the elongated propor-
tions, the treatment of the beard (and the hair of the second),
and in the composition and expression of the faces. The
work of still another leading Florentine sculptor was em-
ployed by the designer of the prophet busts of the main
facade; this is Filippo Brunelleschi, whose Church Father
for the Altar of San Jacopo in Pistoia, which is shown stand-
ing and turning sharply upward and to his left, was the

. 50

source used for the prophet bust on the upper right of the
arch nearest to the south.[26] The extreme angle at which

the head is turned is repeated, creating, as in the original, a sense of great tension. The pose is highly unusual and the details of the face and beard are very similar, so there can be scant doubt that the figure at San Marco was modeled directly on Brunelleschi's statuette. The list of Florentine sources of which this master availed himself

Pl. 91 can be extended to also include Ciuffagni's Saint Matthew; the distinctive form of the knot which binds the two sides of the drapery of the prophet bust on the upper left of the

Pl. 43 first arch was copied from Ciuffagni's statue. Similarly, the heads of the lower left prophet of the same arch and

Pl. 47 the upper left figure of the third arch were derived from that of the Saint Matthew; in addition, the drapery forms of the latter of these two prophets were copied from those of the statue which Wundram identifies as Nanni di Banco's

Pl. 27 Isaiah.[27] The heads of these two prophet busts also reveal

Pl. 21 a knowledge of Niccolò Lamberti's Saint Mark in Florence, particularly of the ornamentalized handling of the hair and beard. Lastly, the form of both the drapery and the

Pl. 45 head of the upper left prophet bust of the second arch are

Pl. 18 closely patterned after Lamberti's Saint Luke. From this brief survey of the sources of some of the figures on the lateral arches of the facade it is clear that whoever de-signed them had an almost encyclopedic knowledge of Floren-tine sculpture from the beginning of the century until 1415. By contrast, the carving does not represent the work of any

Florentine sculptor. Instead, it seems almost certain
that these sixteen prophet busts were carved by the same
workshop which was responsible for the eight figures above
the Temperance and Hope arches. This fact is borne out in

Pl. 43 a comparison of the upper left prophet of the first arch
of the west facade, which is based entirely on Florentine

Pl. 41 models, and the lower left figure of the Hope arch. The
treatment of the eyes, forehead, and cheeks is almost iden-
tical in the two, so it seems certain that the same hand
was responsible for both; where they differ is in the Flor-
entine sources which appear and dominate the prophet of
the west facade that had been entirely absent from the
figure of the north side.

The creative procedure involved in the design
and execution of these sixteen figures of the main facade
seems quite clear. They were carved by a Lombard sculptor
after designs made by a Florentine artist who was familiar
with the development of Florentine sculpture for the first
fifteen years of the century. The latter figure was surely
Niccolò Lamberti. He was very familiar with all of the
sources for the prophet busts and had displayed a particular
interest in Ghiberti's work shortly before coming to Venice.
He had left Florence in 1415/6 - almost certainly the earlier
year - which is the precise date when the last of the Flor-
entine models for these prophet busts was completed. Finally,
he is mentioned in the document of October 23, 1416 as owing

120 ducats to a certain Pietro da Campione for "foie 8 a
raxon de duc.ti XV." This document refers in all likelihood
to the decoration of the arches of the facade, and may very
well deal with the carving of the prophet busts as opposed
to the sections of purely foliated decoration. The reason
for this is that 15 ducats would have been a great deal to
have paid an insignificant sculptor for non-figurative orna-
ment. There are very few documented works in sculpture in
Venice from this period with which one can compare relative
payments. However, we do know that Bartolommeo Buon received
a total of 50 ducats for his large relief of the Coronation
of the Virgin for the Scuola della Carità between 1442 and
1444.[28] Not only was Buon the leading sculptor in Venice
at the time that he carved it,[29] but it is a work of con-
siderable intricacy, importance, and beauty; none of these
statements can be applied to Pietro da Campione or his work.
It therefore seems impossible that the document of 1416
could refer to simple ornament and must surely deal with
the prophet busts themselves. This hypothesis can be re-
conciled with the visual data and the document itself. The
prophet busts spring from foliated ornament and seem to have
even been carved from the same stone block as the foliage.
It would therefore appear very plausible that the figure
and ornament could have been shortened for the sake of
brevity and be referred to simply as "foie."

A reconstruction of the chronology of the work on

-124-

the prophet busts of the north and west faces of the cathedral cannot be made with complete certainty, but it is very likely that the figures on the north preceded those of the main facade. The document of 1415 tells us that in that year, "fo fato le figure che e dentro et suxo i fluori" on the north side. There is every likelihood that they were carved before Lamberti's participation in the project began, since they have not a single Florentine characteristic. There were two workshops active on the decoration of the arches of the north side. The first of these, which was responsible for the figures of the Charity, Prudence, and Faith arches does not appear elsewhere at San Marco or in Venice. The second one, which executed the busts on the Temperance and Hope arches, remained in the midst of the sculptural activity after Niccolò Lamberti's arrival in Venice. At this point he seems to have been appointed capomaestro of the sculptural program and provided this second Lombard workshop with designs from which they executed the prophet busts of the main facade.

The point of transition between the period of independent work by the Lombards and that in which Niccolò dominates the work at San Marco can be seen in the differences between the prophet busts of the two arches of the south side of the cathedral. The eight prophet busts of these two arches are again the product of the same workshop that had carved the figures on the main facade and on the

1. 51-54

Pl. 51-52 Temperance and Hope arches on the north. In the figures of the Fortitude arch the forms and poses are most like

Pl. 52 those of two arches of the north; to choose two examples,

Pl. 42 the figure at the lower right of this arch is very close

Pl. 51 to the one on the upper right of the Hope arch, while the

Pl. 40 upper left prophet of the arch is closely akin to the upper

Pl. 53-54 right figure of the Temperance arch. By contrast, the four prophet busts of the Justice arch are more closely related to the figures of the main facade; to choose two examples

Pl. 53 again, the upper left prophet of this arch is comparable

Pl. 45, 54 to that of the second arch of the main facade, while the

Pl. 47 lower right figure repeats the physiognomic type of the upper left prophet of the third western arch. The figure on the lower right of the Justice arch is the most completely Florentine of the quartet; the pose reflects a knowledge of Nanni di Banco's Saint Phillip,[30] while the head is

Pl. 91 much like that of Ciuffagni's Saint Matthew. The various analogies which exist between the figures of the Fortitude and Justice arches on one hand and those of the north and west sides of the cathedral on the other reveal that the prophet busts of the Fortitude arch were carved before Lamberti took charge of the work at San Marco, while the prophets of the Justice arch post-date the beginning of his participation. And, like those of the west facade, the figures of the Justice arch seem to have been executed after his designs.

The Gable Reliefs

In the gables of the four lateral arches of the
west facade and of the two on the south side of San Marco
there are half-length figures of prophets and saints in
high relief, contained within decorative borders which
are, in turn, surrounded by rays of stone. The very fact
that these figures are found on the south and west faces
of the cathedral and not on the north side would lend some
further support for the hypothesis that the north side was
the earliest to be completed.

The most conservative of the six figures is that
of a saint in the gable of the Justice arch. It was carved
by the same hand that made the upper left prophet bust of
the same arch. The pose is frontal and contains no impli-
cation of movement. There is a generalized reminiscence
of Lamberti's Saint Mark in the treatment of the head, and
it would appear that he was responsible for its design.
Its rather stiff character may be accounted for by the pos-
sibility that it was the first of the six gable figures.
The second gable figure of the south side, the one situated
below the statue of Fortitude, is much livelier in both
form and spirit. It begins to turn and move in space, al-
though it does not approach a fully comprehended implemen-
tation of contrapposto. Although it does not appear to be
specifically modeled after another work, it does bear a
general resemblance to Ghiberti's Saint Matthew panel. It

Pl. 53-
54

l. 21

l. 51

too seems to have been designed by Lamberti and executed
by a Lombard assistant.

The four gable figures of the main facade are
fundamentally different from the pair on the south side.
There is in these four reliefs a clear attempt to emulate
many of the characteristics of the more progressive Floren-
tine sculptors of the time, especially Nanni di Banco.

Pl.44 This can be seen most readily in the first gable relief
from the north. Its head was modeled after Nanni's Saint
Philip at Or San Michele. The large and heavy forms of
the Saint Philip are taken over, but retain none of the
structure or formal definition of the original. The Roman-
izing hair style of the Saint Philip has become a series
of decorative curls, while his toga has been transformed
into a Gothic design. Nevertheless, there is an evident
desire to capture the heroic spirit and the grand sense
of form which Nanni achieved in his statue. In addition,
the sculptor of the gable figure attempts to use some of
Nanni's spatial refinements. He locates his figure off-
center, just as Nanni had placed the Saint Philip sharply
to the left of its niche. More importantly, he has copied
the right arm of Nanni's Saint Luke, perhaps in an attempt
to compensate, as Nanni had done, for the placing of his
figure well above ground level.[31] This passage is entirely
unsuccessful since the arm appears artificially grafted on

to the rest of the body and because it is the only part of the relief which has been adjusted for the purpose of compensating for its location. The relief may be generally categorized as ambitious in conception, but clumsy and uncomprehending in execution. The sculptor who carved it was neither Niccolò Lamberti nor one of his Lombard assistants. Instead, it seems surely to have been Piero Lamberti, who is mentioned in Venice in October of 1416. The form and details of the head are reproduced in all essentials

Pl. 124 in the statuette of Faith in the central niche below the effigy of Tommaso Mocenigo on his tomb in Santi Giovanni e Paolo, carved in 1423. The large bulging eyes, the curls of hair, the large broad nose, and the unmodeled planes of the face are all present in both works. The Faith statuette does have a sharper and tighter sense of form and a more advanced drapery style. The more Gothic character of the drapery of the gable figure probably resulted from the influence of Niccolò Lamberti, who was directing the project at San Marco. By 1423 Piero was an independent artist who had developed his own style. It is difficult to be sure whether the gable figure dates from before or after the Strozzi Tomb. I would favor the earlier dating on account of the drapery style and also because of the immature quality that the figure as a whole possesses.

Pl. 45-46 The second gable figure from the north was also carved by Piero. The forms of the face and hair are analogous

to those of the first gable figure on the west facade, but they are sharper and more confidently handled. Unlike its predecessor, this relief is not directly modeled on the specific work of Nanni or any other artist. However, it is possible that it may reflect a study of the drapery of the second figure from the left in the Quattro Coronati.[32] In general, this relief is superior in execution and more advanced in its drapery style than the one on the first arch on the west. It is not improbable that a period of one or two years separates the two and that this relief was carved after Piero's return from Florence.

Pl. 46-47′ The third gable figure from the north was not carved by Piero, but seems instead to be the work of his collaborator on the Mocenigo tomb, Giovanni Martino da Fiesole. The form, as well as the grouchy expression of the face, are repeated in the statuette of a saint which stands Pl. 129 in a niche between the figures of Gabriel and Saint Paul in the upper level of the Mocenigo tomb. The facial planes are more naturalistically modeled than in Piero's gable reliefs, and their classicism - albeit indirect - is no longer present. Unfortunately, nothing is known about Giovanni, except that he collaborated with Piero Lamberti on the Mocenigo tomb in 1423. His work there does not suggest that he was trained by any of the leading Florentine sculptors, nor does it indicate an understanding of progressive developments in Florence. The gable relief at San Marco

tells us little more about his origins as an artist; it differs from the later work on the Doge's tomb only in the coarser and more undisciplined handling of drapery.

Pl. 50 The last of the six gable reliefs, that is situated at the south end of the west facade, is in certain ways the most enigmatic. It was executed by one of Niccolò's Lombard assistants and the handling of details is as fully Gothic as the prophet busts of the arches. Yet, in terms of the conception of its pose the figure is perhaps the most progressive of the six gable figures. It turns sharply to the right and downward and is markedly off-center in relation to the gable field. The left shoulder and arm are extensively foreshortened in order to compensate for the spatial distortion which results from the radical pose of the figure. There are two sources for this figure in Florentine sculpture. The first is the Saint Matthew panel by Ghiberti, from which the form of the right arm was derived.[33] The second and by far the more important is the relief of the Assumption of the Virgin in the gable of the Porta della Mandorla.[34] From the figure of the Virgin in Nanni's great relief, the sculptor at San Marco derived the overall conception of a figure turning sharply in space with arms extended. As in the figure of the Virgin, the head is tilted and the arm and shoulder sharply foreshortened. It is admittedly difficult to accept the relationship between Nanni's masterpiece and the relief in Venice. The qualitative

disparity between them is immeasurable and they also differ
in other respects. Yet, the fundamental conception of
the San Marco relief is so strikingly radical - particularly
when considered alongside the conservative style of its
execution - that it could not have been designed without
exterior stimulus.

The figure of the Virgin in Nanni's relief was
very probably completed by October 12, 1418; a document of
that date reveals that Nanni had already finished six of
the relief figures.[35] It is very likely that it was carved
after Niccolò left Florence in 1415/6, presumably together
with Piero. The younger Lamberti was back in Florence in
1418 to work on the Strozzi tomb and Niccolò made visits
there in 1419 and 1420. There was therefore ample oppor-
tunity for both of them to see Nanni's figure and bring a
drawing of it back to Venice. It is very difficult to de-
cide which of them was responsible for the design of the
relief in Venice. Its ambitious character would seem to
favor Piero, but the drapery style, as well as Niccolò's
pre-eminent role at San Marco, make an attribution to him
more likely.

The Virtue Statues

Standing on the pinnacles of the arches of the
north and south sides of the cathedral are seven statues
of Virtues. Of these, only the Prudence on the second arch

of the north flank does not originate from the early quat-
trocento; it is a 17th century replacement for an earlier
statue which was destroyed in an earthquake in 1511.[36] The
remaining six figures have been attributed by Fiocco to
Niccolò Lamberti. Planiscig rejected Fiocco's proposal,
but offered no alternative.[37]

 The six quattrocento statues of Virtues do not
form a single homogeneous unit and cannot have been the
product of one workshop or sculptor. There are two Virtues,
though, that were certainly carved by the same hand; these
are the Justice, on the first arch of the south side, and
the Faith, on the third arch of the north side. In both,
the drapery is built up of a multitude of zigzagging folds
which alternate with deeply cut, rounded grooves. The pro-
portions of both figures are thin and elegant, conforming
to Northern taste. The long, wavy curls of hair frame the
face and create a flowing abstract rhythm. The proportions
of the faces are also thin, and both contain large, bulging
eyes, narrow pursed lips, and smooth, unmodeled cheeks and
forehead. Finally, each of them smiles gently and generally
expresses nothing which would relate to the Virtue being
personified by the respective figures. I can find nothing
in this pair of statues which in any way would point to
Niccolò Lamberti's authorship. Indeed, I would doubt that
they are Italian in origin. Their characteristics, both
general and specific, suggest very strongly that they are

Pl. 55
Pl. 58

Germanic in origin.

 From this pair of Virtues which are surely not Italian, we may next consider two others which display decisive Northern influence, but which are nevertheless the work of Italian sculptors, in all likelihood. The first

Pl. 60 of these is the Hope, which stands on the arch above the one-bay extension on the north which faces west. It bears some resemblance to the Faith and the Justice, particularly in the rendering of the face and hair. However, the forms of the face are fuller and fleshier than those of the other two Virtues, and the remainder of the figure is entirely different from them. There is a much greater sense of volumetric form behind the drapery, and it, in turn, is not completely abstracted in its movements. The style of the drapery is, of course, fully Gothic, but it could just as easily represent Italian models as foreign ones. Close parallels may be seen to exist between the drapery forms here and in the work of both Andrea and Nino Pisano, as well as of the many sculptors who were influenced by them, such as the Dalle Masegne.[38] This sculptor's style is also

Pl. 41- very close to that of the artist responsible for the prophet
42 busts of the same arch. The large oval eyes with heavy, even lids, the shape of the face, and the way in which it

Pl. 41 is enframed by the hair are all comparable to the upper left prophet bust. The drapery style is quite different, though, and it may well be that the sculptor of the Hope was a member

of the same workshop, but was not one of the participants
in the carving of the prophet busts. In any case, his
work reflects strong Northern influence in the rendering
of the head, a truly International Gothic drapery style,
and a natively Italian feeling for the sculptural quality
of form which combine to make his statue one of the more
successful of the Virtue series.

l. 59 The statue of Temperance over the fourth arch
of the north side may also be related to Italian and North-
ern works. It has many points in common with the German
gilt-copper Madonna and Child in the Cathedral of Milan.[39]
The mask-like appearance of the face, with highly abstracted
individual features, and the thin folds of drapery which
flow upward and to the right from the right leg and hip
are characteristics which the two works share. There are,
however, parallels which may be drawn between the Temperance
and Italian sculpture, as well as with this German example.
The drapery forms are again comparable to those of Andrea
and Nino Pisano and their followers, while the facial type
had already passed as far south as Florence well before the
date of the Temperance; it can be seen in several of the
. 92 playful figures in the left door jamb of the Porta della
Mandorla. It is difficult to be sure, but on balance the
sculptor of this figure seems to have been a North Italian
who came under foreign influence, perhaps at the Cathedral
of Milan.

The four <u>Virtues</u> thus far considered are almost
entirely unrelated to Niccolò Lamberti or to Florentine
sculpture in general. This is no longer true of the last
Pl. 56-
57
Pl. 56 pair, the statues of Fortitude and Charity. The <u>Fortitude</u>
is a far more progressive work than its four predecessors.
The figure turns in space and the actions of the hands are
reflected in the rendering of the shoulders and the rest
of the upper torso. The face is both more classical and
more naturalistic than those of the four previous Virtues.
There are, to be sure, also Northern characteristics in
the statue, such as the ornamentalized handling of the mane
and feathers of the lion and the buttoned sleeve along the
right arm. Nevertheless, I feel that it is likely that the
statue is the product of Lamberti's design and was executed
by one of his assistants. This view is supported by the
fact that the facial type is closely analogous to that of
Pl. 66 the second angel to the left of <u>Saint Mark</u> on the central
arch of the main facade of San Marco, which was surely de-
signed by Niccolò. The sculptor who executed the <u>Fortitude</u>
was more independent of Lamberti than the assistant who
carved the angel statue of the central arch, so it is pos-
sible that the degree of Lamberti's participation may not
have extended beyond furnishing a design for the overall
pose of the statue and for the head.

Pl. 57 The last of the Virtue series, the <u>Charity</u>, is
more directly associable with Lamberti and with Tuscan

sculpture of the period. The physiognomic type is very
close to that of the upper right prophet bust of the second
arch of the main facade. The handling of details such as
the hair, mouth, and chin in the two works is almost iden-
tical. The drapery forms are comparable to those found in
several autograph works by Niccolò. The lower drapery is
closely analogous to that of the Madonna of the Porta dei
Canonici and also to the forms of the Saint Luke and the
Saint Mark on the main facade. The bunched tubular folds
at the left hip and similar motifs along the hem of the
intermediate garment stem from the same temperament as
those of the seated Saint Mark. On the other hand, the
overall drapery pattern lacks the animated, rhythmic quality
that is found in the works carved by Lamberti, and the sum-
mary treatment of the drapery of the upper torso is com-
pletely uncharacteristic of him. It therefore seems certain
that the design was again due to Niccolò, but that the
statue was executed by an assistant, who was perhaps identi-
cal with the sculptor that carved the prophet bust of the
second arch of the main facade.

Pl. 18,
62

The figure of the child supported by the left arm
of Charity is much more surprising in its form than the
larger statue of the Virtue. It is shown in sharp contrap-
posto, with the head facing to the right and left arm drawn
back across the body. The pose is highly progressive, par-
ticularly in light of the styles of the Charity and the

other Virtues. It appears to have been modeled after the
child held by Acca Larentia on the Fonte Gaia in Siena.[40]
The two figures are not identical, but the primary motif
of both is fundamentally the same. The Acca Larentia seems
to have been carved as late as 1418/9, but designs for it
were made much earlier.[41] The drawing now in the Metro-
politan Museum of Art of the left section of the Fonte
Gaia, which represents the project's design as of January
1409, shows the child held by Acca Larentia in a less
sharply contrapuntal pose than in the actual statue, but
with the legs in a position that is closer to the figure
held by the San Marco Charity.[42] A number of variant de-
signs of the Acca Larentia may have been drawn by Jacopo
between 1409 and 1418/9 and it is possible that Lamberti
could have seen one of them either in the original or in
the form of a copy. It is also entirely possible that
either Niccolò or Piero could have been in Siena just at
the time that the statue was being carved; Piero was in
Florence in 1418, while Niccolò was in both Florence and
Lucca in 1419 and again in 1420.

The dating of the Virtue series is almost impos-
sible to pinpoint. The Charity and Fortitude post-date
Lamberti's arrival in 1415/6, and it may well be that the
other four were completed before that date. However, it
is not by any means certain that he had complete control
over the work of all aspects of the sculptural program at

San Marco, and so a later date is hypothetically possible.
Despite this possibility, I would favor the earlier dating,
for reasons of style as well as general circumstance.

The Tabernacle Statues of the North and South Sides

Unlike the six original statues of Virtues on the
pinnacles, the group of seven saints in the tabernacles of
the north and south sides of the basilica form a virtually
homogeneous group. The sole exception is the Saint Michael,
which differs from the others in every respect and was
surely carved by a Lombard sculptor; this was established
by Fiocco, whose position has not been challenged.[43] He
went on to ascribe the other six tabernacle saints of the
lateral sides to Niccolò Lamberti.[44] Once again Planiscig
rejected his attribution, but did not suggest an alternative.
He simply maintained that they were reflective of the Inter-
national Gothic tide which swept through western Europe at
this time, and that they are only related to Lamberti in
terms of generic similarity to his work.[45]

These six statues were all the work of one work-
shop, and perhaps largely of one hand. For example, the
drapery of the lower half of the Saint Jerome is repeated
with minimal variation in the Saint Benedict and again in
the Saint Gregory the Great. In all three a series of
heavy rounded folds descend in parallel formation and dis-
appear near the knees. Below them all three have a group

Pl. 68-74

Pl. 74

. 73

. 68, 72

of vertical tubular folds which do not seem to flow natur-

Pl. 70 ally out of the forms above them. The drapery of the <u>Saint</u>

Pl. 68 <u>Ambrose</u> is very close to that of the <u>Saint Benedict</u>; in

fact, it is virtually identical to it up to knee-level.

Pl. 71 The garment worn by the <u>Saint Augustine</u> differs from these

four in that it does not have the parallel horizontal looped

folds, but both the upper and lower sections of its drapery

Pl. 72 have a great deal in common with those of the <u>Saint Gregory</u>

<u>the Great</u>. The thin ridge-folds used in the upper torso

of each of these figures are almost identical. Finally,

Pl. 69 the vertical tubular folds of the <u>Saint Anthony Abbot</u> are

found in almost all of the other figures, and are particu-

Pl. 71 larly close to the drapery forms of the lower half of the

<u>Saint Augustine</u>. The treatment of the heads reveals further

evidence of common authorship. They all have prominent,

broadly set noses, large almond-shaped eyes, and heavy

foreheads. There are occasional attempts at naturalistic

Pl. 70 detail - as in the drawn cheeks of the <u>Saint Ambrose</u> or

Pl. 73 the furrowed brow of the <u>Saint Jerome</u> - but these are ex-

ceptional and perfunctory. The similarities in execution

are so numerous and so pronounced that there can be little

doubt that all six figures are entirely, or very nearly,

the work of one sculptor. Whatever his identity, he was

clearly a retrogressive artist with a very limited aesthetic

vocabulary. The poses of his figures vary from the inert,

Pl. 69 block-like stance of the <u>Saint Anthony Abbot</u> to the swaying

Pl. 72 movement of the <u>Saint Gregory the Great</u>, but in both cases the result is stiff and primitive.

There is nothing about any of these statues which would in any way betray a knowledge of early <u>quattrocento</u> Florentine sculpture. Fiocco has stated that the <u>Saint</u> Pl. 68 <u>Benedict</u> is a close repetition of the <u>Saint Luke</u> by Lamberti, but I am afraid that I can see no more than the most generic relationship between the two statues. The drapery style of the <u>Saint Benedict</u>, like that of the other members of this group, is crude and unimaginative, both in design and execution. It is repetitious and simplistic, whereas the drapery in Niccolò's secure work of the 15th century is varied, elaborate, and skillfully executed. Furthermore, there is no parallel in his work after the two statues of Church Doctors of 1396-1401 for the block-like compositions of figures like the <u>Saint Anthony</u> Pl. 69, 71 <u>Abbot</u> or the <u>Saint Augustine</u>, and even in these works of his youth the movement of form is livelier than in the majority of these figures at San Marco. Therefore, they cannot be attributed to Lamberti, unless it is to be presumed that his work changed direction and simultaneously declined upon his arrival in Venice. There is nothing to indicate that either of these developments occurred, as Pl. 62 even a cursory look at his <u>Saint Mark</u> above the central pinnacle instantly reveals. There is scarcely any greater likelihood that the six figures were designed by him and

executed by assistants, since characteristics such as
proportions, poses, and primary drapery motifs would surely
have been established in these designs.

It is admittedly easier to reject the attribution
to Lamberti than it is to find an alternative hypothesis.
The style of these figures may be related to several pos-
sible sources, but these are tentative. They may reflect
a knowledge of late trecento Florentine sculpture, since
their heavy forms and bulky proportions appear in the work
of several of the leading Florentine sculptors of the
1390s. At the same time, there is a pronounced similarity

Pl. 68,
70 between two of these statues, the Saint Benedict and the
Saint Ambrose, and the mitred saint on the front of the
Arca Carelli in the Cathedral of Milan.[46] There are, how-
ever, no statues in Florence which closely recall these six
figures, and the statuette on the Arca Carelli, while very
similar in pose and drapery pattern, is in every respect
much more sophisticated and refined in execution. Indeed,
the coarse drapery forms of the tabernacle figures recall
those of "Gigante 59" at the Cathedral of Milan in their
primitive character and rough execution.[47] The image of
the sculptor who carved them which emerges is perhaps of
someone who had worked in Florence and in Milan as well,
and who had absorbed a series of influences from both. He
also does not seem to have formed his style long after the
turn of the century, since it specifically reflects pre-

fifteenth century Florentine traits. A possible candidate might be the mysterious Urbano da Pavia who worked in Florence in 1400/1 and who shared several abortive commissions there with Niccolò Lamberti and other sculptors.[48] Although he is most often referred to in documents as being from Pavia, there are also documents which indicate a Venetian origin.[49] After leaving Florence, presumably in 1401, he went to Milan where he worked on a figure of a prophet in 1403. He then disappears from view until the early 1420s when he was back in Milan. Finally, he is mentioned in 1427 at the Certosa of Pavia, which is the last reference to him[50] during his lifetime. All of the exterior facts of his life would at least allow for the possibility that he was the sculptor of the six statues in the tabernacles at San Marco. However, there is one major problem in relation to this tentative hypothesis which precludes any further analysis of it; this is the unfortunate fact that not a single work by Urbano has been identified, if indeed one still exists.[51] Therefore, all that can be reasonably said about it is that the outline of his career would seem to be suggestive of the type of sculptor who was responsible for these statues.

Under the circumstances a firm date for the six figures can hardly be ascertained. However, their primitive style and the fact that they do not reflect Lamberti's influence would suggest a date of not much after 1410. The

Arca Carelli, which appears to have been completed in 1408, provides a <u>terminus post quem</u> that is tentative, but which supports the stylistic data.[52]

The Statue of Saint Mark and the Decoration of the Central Arch

Pl. 62

The statue of Saint Mark on the pinnacle of the central arch of the main facade of San Marco was attributed by Fiocco to Niccolò Lamberti.[53] Although there is no documentary evidence to support this ascription, it has never been challenged and is very well founded.[54] The pose and

Pl. 18

movement of the <u>Saint Mark</u> recall the <u>Saint Luke</u>, but also demonstrate the more advanced character of the later statue. It moves much more freely than the <u>Saint Luke</u> and there is a new visual contrast which appears in the positioning of the hands. In both of these respects the <u>Saint Mark</u> has much in common with one of the figures which formerly stood

Pl. 25-26

above the entrance to the campanile of the Florentine Cathedral. The drapery style also relates to that of the <u>Saint Luke</u> in its general configuration and in certain details such as the small fold just below the neck and the handling of the section covering the shins and feet. It is, however, not as sharply incised as the drapery of the <u>Saint Luke</u> and is closest in this respect to the campanile figures. It shares with one of the latter pair not only a common technique, but also many nearly identical motifs, especially in the drapery covering the middle of the figure.

The treatment of the head of the Saint Mark is
less precisely relatable to the rest of Niccolò's oeuvre.
Nevertheless, there are several physiognomic details which
are close to previous works. The curls of the beard are
treated almost exactly like those of the seated Saint Mark,

P1.21 while the longer proportions of the face, the drawn cheeks,
and the sunken eyes are analogous to the Saint James. The
execution of the face is cruder than in his previous works,
but it is easy enough to appreciate the reason for this;
the Saint Mark is situated far above street level, so that
it would have been unnecessary for him to expend much energy
carving details which he assumed would never be seen.

The head of the Saint Mark is the single greatest
1.63 achievement of Niccolò's career. It has a forceful and
direct expressiveness that is much greater than in any of
his previous statues. Although it is true that in his last
works before leaving Florence, the Saint Mark and the two
campanile figures, the emotive content of his idiom was
greatly extended, the Saint Mark in Venice indicates a
change in this respect which would have been almost entirely
unimaginable in the light of his work in Florence. The
stimulus for this change came, nevertheless, from Florence,
more specifically, from the work of Nanni di Banco and Dona-
tello in the period immediately preceding Lamberti's departure

for Venice. Statues such as the Santo Coronato at the extreme right of Nanni's Quattro Coronati and the Saint Mark and Saint John of Donatello contained a new emotive potency which must surely have impressed Lamberti greatly. In particular, the Saint John by Donatello seems to have had the most direct influence on Lamberti, since several of its characteristics were used by Niccolò in the Saint Mark in Venice. Of these the most important is the elongation of the proportions of the head in order to compensate for its placement high above street level. This device was not commonly employed in the early quattrocento, so there can be little doubt that the Saint John was Lamberti's source in this respect. In fact, the tall proportions of the Saint Mark in general may also have resulted from Lamberti's desire to emulate Donatello in this way, as well as from his desire to create a figure with a refined and elegant silhouette. The details of the Saint Mark are not as closely related to the Saint John, but do, in a few respects, reveal its influence. This is especially true of the treatment of the area around the eyes, the eyes themselves, and the hair. The handling and expression of the eyes and eyebrows are very similar to the Saint John, although the Saint Mark is less carefully modeled on account of its placement. The hair of the Saint Mark seems to form a cap above the head and does not appear to be organically united with the forehead; precisely the same fault occurs in the Saint John, although the individual motifs are entirel

different.

The elements which these two statues share should
not and cannot obscure the gulf which separates Niccolò
from the progressive masters of the early Renaissance.
The decorative conception of the drapery, the entirely
Gothic stance of the figure, and the ornamental treatment
of the hair and beard, are all hallmarks of Lamberti's
essentially conservative idiom. At the same time, the
fact that he employed several aspects of Donatello's revo-
lutionary image without renouncing his fundamentally Gothic
and decorative sensibility reveals him as a figure of con-
siderable independence and ingenuity.

Pl. 61,
64-67

On either side of the <u>Saint Mark</u> three statues of
angels, alternating with foliated decoration, rise in a
gradual, processional movement up the sides of the arch.
They are designed in matched pairs, with those on the upper

Pl. 64

level carrying censers, the middle pair bearing holy-water

Pl. 65

sprinklers and vessels, and the last two figures crossing

Pl. 67

their arms in a demonstration of their devotion. The en-
semble as a whole is a <u>tour-de-force</u> of decorative design
and of carefully modulated movement, achieved through the
alternation of angel statues springing from foliage and of
pure foliage. There is no known precedent for the composi-
tion of these figures and it must be considered one of Lam-
berti's most successful accomplishments.

The individual statues of angels are on a much
lesser plane than the Saint Mark and none of them could
possibly have been carved by Lamberti. Instead, it seems
certain that he designed the composition as a whole, made
designs for the angels and carved only the Saint Mark. The
attribution of the designs of these figures to Niccolò is
supported by the analogies which exist between the head of
Pl. 65, the second one on the left of the arch and the angel which
66
Pl. 17 he carved for the Porta dei Canonici many years earlier.
In both, the heads are full and heavy and are supported
by thick necks; similarly, the hair of these two figures
is composed of large, rounded, semi-independent motifs.
And as with the Saint Mark, the heads of several of these
angels are enlarged in order to compensate for their high
placement.

The identity of the sculptors who carved these
six figures is unknown. It appears as if they were executed
by three different hands, with each of them carving the pair
of figures on the same level of the arch. The sculptor
Pl. 56 responsible for the angel in the middle of the left side of
the arch may also have carved the Fortitude on the south
side of the cathedral, since the facial characteristics of
the two statues are very similar. On the other hand, the
much weaker quality of the angel would argue against this
possibility, and it may be that the similarity between them
is simply the result of the common source of their designs.

The Evangelist Statues in the Tabernacles of the West Facade

Pl. 76-
83

The statues of the four Evangelists on the main
facade of San Marco were attributed to Piero Lamberti by
Fiocco more than forty years ago. Since that time they
have rarely been mentioned in the scholarly literature and
no new ascriptions have been offered.[55]

Pl. 76

Pl. 22

Of the four statues only the Saint Matthew was
directly modeled on a known work. Its pose, the position
of the right arm and hand, and the lower drapery all reveal
the influence of Niccolò Lamberti's Saint James. In particu-
lar, the drapery at the lower right of the Saint Matthew
repeats with little variation the motifs of the Saint James.
The heads of these two figures are more generally related;
both are thinly proportioned, with deeply set eyes, narrow
cheeks, and ornamentalized curls framing the face. There
are also many differences between the two statues. The pose
of the Saint Matthew is freer and livelier and the drapery
is broader, heavier, and more rounded. Similarly, the hand-
ling of the details of the face, hair, and beard, while gen-
erally analogous, is not close enough to support a common
attribution of the execution of these two statues. At the
same time, it seems certain that Niccolò was responsible
for the design of this statue, since it also shares several
significant characteristics with the Saint Mark over the
central arch. The marked swaying of the body, the handling
of the eyes and parts of the lower drapery, and the directness

1. 62

of the facial expression, keynoted in the open mouth of the saint, are common to both statues. The execution of the statue cannot be related to any of the secure works of Piero Lamberti and there is no documentary or circumstantial basis for postulating his intervention here. Instead, it appears as if the carving was accomplished by one of the numerous Lombard assistants who helped Niccolò throughout the course of this elaborate sculptural program. This hypothesis gains strong support from the style of the symbol of

Pl. 77 the Evangelist which is conceived as an "animated lectern."[56] The execution of the head of this small figure is very similar

Pl. 74 to that of the statue of Saint Michael on the north side of the cathedral, which is unquestionably the work of a Lombard sculptor.

The tabernacle statue of Saint Mark has much in

Pl. 78-79 common with the Saint Matthew. The poses are generally similar and the carving of certain details, such as the hair, beard, and several drapery motifs, are closely analogous. On the other hand, the gesture of the Saint Mark is more direct and the conception of the face is more naturalistic and more expressive than the Saint Matthew. It also has much in common with the head of the Saint Mark by Lamberti over the central arch. The deeply set eyes, the open mouth, and the prominent forehead are all comparable to the

Pl. 63 other rendering of Saint Mark on the facade. It may also be noted that the handling of the hair and beard of these

two tabernacle statues is quite close to that of the two
campanile figures by Lamberti. However, there is little
reason to believe that he carved any part of this Saint Mark.
The drapery is carved in a much cruder manner than in any
of Niccolò's autograph works. The naturalistic treatment
of the face may not only reflect Lamberti's Saint Mark, but
also figures like the Cain on the Cathedral of Milan.[57]
Therefore, the Saint Mark of the tabernacle series once
again appears to result from the combination of Lamberti's
design and Lombard execution. The sculptor who carved this
statue may have been the same as the one responsible for
the Saint Matthew; if they are not one and the same, then
they surely were part of the same workshop.

Pl. 82-
83
The Saint Luke has many points of similarity with
the Saint Matthew and the Saint Mark, particularly in the
heavy, voluminous drapery style which all three possess.
There are, however, two primary differences between the
Saint Luke and its two predecessors. Whereas they are
aligned frontally with respect to the tabernacle, the Saint
Luke turns to his right and downwards. He is situated off-
center within the tabernacle and thereby creates a diagonal
and downward movement. The head of the Saint Luke is also
rendered somewhat differently from those of the two previously
discussed tabernacle figures. It is more smoothly modeled
and much less forceful and expressive. The hair is composed
of a series of thin and semi-independent curls which are

neatly arranged in a cap-like formation. Despite these differences, there is enough in common between the Saint Luke and the two other tabernacle figures to indicate that it resulted from a similar creative procedure. However, the sculptor who carved it seems to have been less directly influenced by Lamberti's Saint Mark in the execution of details and in the facial expression. It may be that it was designed and carved shortly after the Saint Matthew and Saint Mark, since it is more inventive in its pose and its relationship to the tabernacle which houses it.

The last remaining Evangelist statue of the main

Pl. 80-81 facade is that of Saint John. He is shown turning sharply to his left and swaying towards the opposite direction with his torso, thereby for the first time in this series of statues indicating an interest in contrapposto. There is a much greater sense of movement here than in the previous Evangelist statues and, at the same time, a much more monu- mental conception of form and expression. This is particu- larly true of the head, which is far grander and more emotive than those of the other three statues. It is also much closer to the secure work of Niccolò than any of the others. The overall shape of the head and the high, prominent fore-

Pl. 21 head both recall the seated Saint Mark, as do the structure of the nose and even the precise manner of carving the eye- brows. The form of the eyes, with detailed and sharply cut

Pl. 25-26 pupils, is reminiscent of both the Saint Mark in Florence

and the two campanile figures. With this latter pair of
statuettes the Saint John shares a common handling of the
curls of the hair and beard, and with the one that formerly
stood to the right of the campanile doorway, a similar over-
all distribution of drapery. All of these relationships
would lead to an attribution to Niccolò and there can be
scant doubt that he conceived this statue. However, the
drapery is executed on a qualitative level that is far below
that of Niccolò's secure works and corresponds closely to
the carving of the other three Evangelist statues. There-
fore, it seems likely that the head was designed and carved
by Lamberti, while the remainder of the figure was executed
by one of the assistants who had sculpted the other three
statues of Evangelists.

It is impossible to be sure of the chronological
sequence of these four statues and their relationship in
this respect to the Saint Mark over the central arch. Within
the group of four Evangelist statues in tabernacles, it seems
likely that the Saint Luke and the Saint John were the later
pair to be designed and executed, since they are more ad-
vanced than the other pair. It is possible that the earlier
pair were sculpted contemporaneously with the Saint Mark of
the central arch, and that after Lamberti completed that
statue he was able to take a more direct hand in the work
on the Saint John, which is the only one that was in part
carved by him. This hypothetical reconstruction of the

chronological order of these statues is very tenuous and
is only one of several legitimate possibilities which would
conform to the visual evidence, particularly in regard to
the relative chronology of the Saint Mark and the four
tabernacle figures. Of far greater importance, though, is
the fact that they belong to the oeuvre of Niccolò Lamberti
and his workshop, not to his son, to whose secure work they
bear not the slightest resemblance.

The Annunciation

Pl. 75,
84-85 The statues of Gabriel and the Virgin on the ex-
treme ends of the main facade have been attributed by Fiocco
to Piero Lamberti and more recently by Gnudi to Jacopo della
Quercia.[58] The attribution to Piero Lamberti is unsupport-
able on any grounds, while the suggestion of Quercia's au-
thorship, though thought-provoking, is equally unacceptable.
They share with Jacopo's authentic work only a common in-
fluence from northern Gothic art.

The conception of these two figures has little
to do with Florentine sculpture. They are neither natural-
istic nor sculptural, but instead, are strongly character-
istic of the pictorial conception of sculpture which played
so important a role in the decoration of the Cathedral of
Milan. In fact, perhaps the closest parallel to the physiog-
nomic type of the Gabriel can be seen in "Gigante 51," which
has been attributed to Matteo Raverti and in the Saint Babila,

which was definitely carved by the same sculptor.[59] Raverti was in Venice by 1421 and would therefore presumably have been available for work on the sculptural program at San Marco.[60] On the other hand, the drapery style of these two figures argues against this attribution, since it conforms very closely to that of the four statues of Evangelists in the tabernacles. There are therefore several variant possibilities, all of which involve some form of compromise between Lamberti and a Lombard sculptor with some degree of independent status. The conception of the figures and of the group as a whole would argue against the possibility of Lamberti having designed them. It seems much more likely that the sculptor who created them was given a free hand, except for the requirement of bringing his two figures into general conformity with the remaining tabernacle statues of the main facade.

Conclusion

An analysis of the sculptural program of the upper arches of San Marco reveals that it consists of a heterogeneous group of works which cannot be simply divided between the Lombards, Niccolò Lamberti, and Piero Lamberti. This is most easily illustrated in the series of prophet busts. Those on the north side were carved by two very different Lombard workshops before the arrival of the Lamberti. After Niccolò took charge of this aspect of the project, one of these workshops remained and executed the prophet

busts of the main facade from his designs. From the fact that the same workshop carved prophet busts on both the north and west sides, it is ascertainable that there was a period of activity on this part of the program which antedated Lamberti's arrival in Venice; this conforms to the document of 1415 cited above.[61] There seems also to have been a pre-Lambertian period of work on the Virtue series, since four of the six remaining quattrocento statues of which it is composed are unrelated to his work. The seven tabernacle statues of the lateral sides of the cathedral may also have been carved before Lamberti's participation in this program began, since they too do not reflect his influence, but this is not absolutely certain, since it cannot be demonstrated that Lamberti was in complete control of every aspect of the sculptural decoration from the time of his arrival in 1415/6. Nevertheless, the visual evidence seems to strongly support the suggestion, first made by Fiocco,[62] that Lamberti was capomaestro of the project, since there are many works at San Marco which reflect his influence and very likely his designs as well. The extent of his direct participation varied from one work to another and could have depended on any number of situations.

There is no firm terminus ante quem for the parts of the program which were executed after Lamberti became capomaestro. It appears likely, though, that much of it was completed by April of 1419, when Niccolò is mentioned in Florence purchasing marble for an unspecified tomb.

Part 4: The Decoration of the Arch of the Main Facade

Windows

The arch around the main window of San Marco is
one of the most richly decorated parts of the exterior of
the cathedral. On its outer face there are nine reliefs
within hexagonal frames which illustrate scenes from Genesis;
they alternate with eight seated figurines that are contained
within foliated ornamentation. The intrados of the arch
have eight statuettes of Old Testament figures and the
Evangelists, shown standing beneath domical baldachins.

The first scholar to draw attention to this
part of the sculptural embellishment of San Marco was Pao-
letti, whose few lines are still the most illuminating on
the subject.[1] He pointed out the overall similarity between
the decorative scheme of the outer face of the arch and that
of the Porta della Mandorla, and revealed that two of the
Genesis reliefs are related to panels by Andrea Pisano and
Ghiberti. He also noted that several of the seated figurines
were similar to Lamberti's Saint Mark in Florence and that
analogies exist between the statuettes of the intrados and
the figures of the Mocenigo tomb. Finally, he indicated
that the baldachins which are found above the statuettes
of the intrados are like those behind the row of arches at
the back of the Mocenigo tomb. He concluded tentatively
that the relationships between the arch decoration and the
work of Niccolò on one hand, and between the former and the

Pl. 93-
101

Pl. 103-
109

Pl. 110-
117

. 119

-157-

Mocenigo tomb and Justice capital on the other, make it
very likely that Piero Lamberti and Giovanni Martino da
Fiesole played a major role in the sculpture of the arch.[2]
Fiocco attributed the entire sculptural program of the
arch to Piero Lamberti, while Seymour claims them for both
Lambertis.[3] Only Planiscig specifically rejects the possi-
bility that Piero worked on these sculptures, but offers no
alternative.[4] Although he notes similarities between the
decoration of the outer face of the arch and Niccolò's work
at the Porta della Mandorla, he does not attribute the former
to Niccolò. Instead, he emphasizes the International Gothic
aspect of the design. Wundram also expresses some doubt
about the ascription to either Lamberti of these sculptures,
and suggests that in certain respects they are closer to
Ciuffagni.[5] It is, I think, best to explore the sources
and the chronological boundaries of these works before at-
tempting to arrive at a plausible series of attributions.

The Sources of the Genesis Cycle

Pl. 93 The first relief, beginning at the lower left,
shows the Creation of Adam. The figure of Adam was related
by Professor Krautheimer to the versions of the same subject
which Ghiberti and Uccello made for the Gates of Paradise
and the Chiostro Verde, respectively.[6] It is also compar-
able to the figures of Adam in the scenes of his creation
carved by Jacopo della Quercia for the Fonte Gaia and the
portal of San Petronio.[7] It is impossible to single out one

of these as the source for the relief at San Marco. Ghi-
berti visited Venice in 1424/5 and returned there in 1430,
while Uccello came there in 1425 and remained for about
five years.[8] Lastly, Jacopo della Quercia was in Venice
at some point during almost every year between 1426 and
1433.[9] Furthermore, the San Marco relief shares certain
characteristics with each of these four versions of the
same subject. Whereas Ghiberti and Uccello[10] show the
figure of God the Father physically lifting Adam from the
ground, Quercia and this sculptor show them separated. In
the San Marco relief and in Ghiberti's panel, the figure
of God is shown standing upright and relatively motionless,
while in the other versions He moves vigorously in the direc-
tion of Adam. With Uccello's fresco alone the San Marco
relief has in common the placing of Adam on a flat surface
instead of on an incline. Lastly, and perhaps most impor-
tantly, the style of the figure of God seems much closer to
Ghiberti's than to that of either Uccello or Quercia, while
the smooth and graceful manner in which the composition re-
lates to the frame reflects an appreciation of several of
the earlier quatrefoil panels of Ghiberti's first baptistry
doors.

This analysis does not yield a firm <u>terminus post</u>
<u>quem</u> for the relief. However, if we accept that Ghiberti's
version had an influence on the sculptor of the San Marco
relief - and this appears to be very likely - then a <u>terminus</u>

post quem of not earlier than 1424/5 emerges. The fact
that Ghiberti's panel was not cast until many years later
does not make much difference, since it has been established
by Krautheimer that various passages from the Gates of Para-
dise were available to artists well before the actual com-
pleted execution of the doors.[11]

Pl. 94 The second relief shows the scene of the Temptation.
Its composition is not at all unusual, as the two main pro-
tagonists are shown symmetrically situated on either side
of the tree. The head of Adam .. missing and the surfaces
are again badly weathered, but it is still possible to point
decisively to the sources which inspired the two figures.
As was already noted by Planiscig, both figures relate
very closely to several of the small figurines in the foli-
ated decoration of the Porta della Mandorla.[12] In particular,
the "Abundantia" on the right side door served as the source
for the poses of both Adam and Eve. They also very nearly
reproduce the treatment which the sculptor of the "Abundantia"
gave to details such as the abdomen and the hips. In addi-
tion to the "Abundantia," which was almost surely carved
by Niccolò Lamberti, there are two further models for the
figures of Adam and Eve. The first of these is the Acca
Larentia on the Fonte Gaia. The upper torso of the figure
of Eve is little more than a debased variant of the corres-
ponding part of Jacopo's statue, while its physiognomy is
a coarse repetition of a type employed by Quercia for the

-160-

Justice, the Rea Silva, and the Acca Larentia.[13] There is
one other work by Jacopo which inspired the sculptor of the
Temptation relief; this is the panel showing the same sub-
ject at San Petronio in Bologna.[14] From the figure of Adam
in Quercia's relief he derived the sharp movement of Eve's
legs away from the center of the composition; he did not,
however, go as far as Jacopo in rendering this decisive
action, so that the pose of his Eve is a compromise between
the Adam and the "Abundantia." The relationship between
the San Petronio relief and the one at San Marco is further
evidenced in the fact that the feet of Eve in the latter
are identical to those of Adam in the former. In addition,
the very distinctive motif of the left hand, bent sharply
at the wrist and resting on the hip, is common to both
figures, as is the treatment of the left arm. Finally, the
shape of the ground upon which the figures stand is organized
similarly in each case, with two large areas divided by a
sharp indentation near the center of the composition. In
neither relief cycle is this distribution and division of
the ground repeated so that the connection can hardly be
coincidental.

The dependence of the San Marco Temptation relief
on Jacopo's version of the same subject at San Petronio is
extremely helpful in establishing a proper dating for the
Genesis cycle. Beck has shown that the Old Testament reliefs
at San Petronio were carved between the very end of 1429 and

1434,[15] so that 1430 is the earliest terminus post quem for the San Marco cycle.

Pl. 95 The third relief in the series shows the scene of the Slaying of Abel. It is forcefully and dramatically conceived and in this respect makes one think of several of the San Petronio reliefs, particularly the one of the same subject and the Sacrifice of Isaac.[16] The figure of Cain, as Paoletti acutely noted,[17] is a copy of the executioner in Andrea Pisano's relief of the Beheading of Saint John the Baptist on the first bronze doors of the Florentine Baptistry.[18] The figure of Abel does not seem to have been directly modeled on another work, but may reflect the figure at the lower left of Ghiberti's Transfiguration panel, who is also shown turning back and almost out of the composition.[19] The relationship is, however, a vague one.

Pl. 96 The relief of the Slaying of Abel is followed by the scene of the Building of the Ark, which is the first of four narratives dedicated to the life of Noah. The disproportionate extent to which his activities are depicted in this cycle may conceivably be related to his role as a symbol of salvation and be connected with some contemporary event, such as the unsuccessful attempt on the life of Francesco Foscari which took place on March 11, 1430.[20] On the other hand, it may be no more than a reflection of the maritime interests of the Venetians. The composition of the Building of the Ark is far weaker than those of its three

predecessors. There is no sense of spatial interlude or
void, and equally, no distinctive feeling of movement or
overall compositional rhythm. There may be some reflection
here of Nanni di Banco's two socle reliefs at Or San Michele
in the manner in which the ark is set at an angle to the
rear plane of the relief in order to create some sense of
spatial recession and in a few drapery motifs, but the re-
lationship is a very generalized one.[21]

1. 97 The second of the Noah scenes and the fifth in
the entire cycle shows the Exit from the Ark. There is no
model for the composition as a whole, although it does ap-
pear to be related to the mosaic of the same subject in
the atrium of San Marco.[22] The figure at the right is
virtually identical to the disciple who bends to look through
the bars in the panel of the Visit of the Disciples to the
Baptist in Prison by Andrea Pisano on the first set of bap-
tistry doors.[23] As so often occurs when a lesser artist
reuses the motif of a greater one, the sculptor of this re-
lief seems unable to relate it convincingly to its new con-
text. The figure appears to be looking into the ark or
simply touching it, and it is by no means an easy task to
discover that he is supposed to be exiting from it. The
gestures and expressions of the remaining three figures are
equally difficult to relate to the narrative; the one at
the extreme left serves a similar compositional purpose to
the corresponding figure in Andrea's relief, but they are

unrelated stylistically.

Pl. 98 The relief of the <u>Exit from the Ark</u> is followed
by the <u>Drunkenness of Noah</u>. Its composition relates to the
"effetto" of the same subject in the lower left of the Noah
panel of the Gates of Paradise, and is generally speaking
a compressed and reversed version of it.[24] The poses of
Noah are very similar, as are their compositional functions.
However, whereas Ghiberti's Noah is almost nude and shows
an evident interest in both classical form and anatomical
detail, the Noah in the San Marco relief is fully clothed
above his waist and betrays no interest whatsoever in the
Antique. There are further differences between the two re-
liefs, but I would still maintain that the San Marco version
was inspired by Ghiberti because of the fundamental similarity
between the two compositions. There are several other indi-
cations that the sculptor of this relief was very well ac-
quainted with Ghiberti's work. The drapery style and the
handling of the left arm and hand have much in common with
the figure of the Virgin in Ghiberti's panel of the Nativity,
while the son of Noah who stands in the center of the group
was derived from the figure at the extreme right of Ghiberti's
<u>Christ before Pilate</u>.[25] It seems very likely that the com-
position as a whole was derived not from the actual panel
on the Gates of Paradise, but instead from a sketch in one
of Ghiberti's model books.[26] By the time that he visited
Venice in 1430, he would very probably have begun making

designs for the panels,[27] and it is perhaps from one of those designs that the relief at San Marco derives.

Pl. 99 The last of the Noah scenes and the seventh in the cycle as a whole shows the Curse of Noah. The composition does not appear to have been modeled on some work elsewhere, but the figure of Noah depends for its drapery style on the series of Evangelists and Church Doctors on the second baptistry doors.[28] His head seems to be generally based
1. 21 upon the type of Lamberti's seated Saint Mark in Florence, but it is difficult to judge the extent of the similarity because of the condition of the Noah.

1. 100 The eighth scene in the series depicts the Covenant between God and Abraham. In its overall character it is Ghibertian, but it is not very closely modeled after any of Lorenzo's works. The headless figure of God reflects a long series of comparable representations in Ghiberti's work, from the competition panel through the Gates of Paradise. The figure of Abraham is closest in its pose to the representation of Christ in the Agony in the Garden and the compositional relationship between the two figures seems to have also been derived from this source.[29] There are differences between them, most importantly in the positioning of the arms. However, this may be explained by the different narratives which are depicted and by the fact that this is an adaptation, not a copy, of Ghiberti's work. One

relatively minor detail which further unites the two is
the presence of the tree in comparable positions behind the
figures of Christ and Abraham, respectively; in each case
it is shown on a small raised surface.

Pl. 101 The ninth and last would seem to be the one with
the most obvious source. It shows the Sacrifice of Isaac
and, as was noted by Paoletti, was derived from Ghiberti's
competition panel.[30] Indeed, the similarity between the
two representations is so pronounced that further analysis
would seem superfluous. However, there are vital differences
between the two reliefs in the conception and handling of
the figure of Abraham. First of all, whereas Ghiberti had
created a sharp sense of contrast between the frontal pose
of the body and the profile view of the head, the sculptor
of the San Marco relief shows the figure in near profile.
At the same time, he does away with the Gothic sway of Ghi-
berti's Abraham and instead, represents him in an almost
perfectly upright position. Finally, and most importantly,
the crucial right arm of Abraham was shown in an entirely
different position in the San Marco relief. In Ghiberti's
figure it protrudes straight outward from the body and then
turns at the elbow and cuts sharply across the chest. By
contrast, the arm of the Abraham in Venice was held upward,
above the head. These distinctions are helpful in determin-
ing the complete range of sources employed for the San Marco
relief and also in arriving to a correct dating for it. In

certain respects it is closer to Ghiberti's second repre-
sentation of the theme, on the Abraham panel of the Gates
of Paradise.[31] There, the figure of Abraham is also shown
with his right arm raised above his head. Furthermore, there
is some resemblance between the settings, with Abraham stand-
ing on a depression in the ground and a group of thin trees
behind him. On the other hand, there are again a number
of differences which appear, the most important of which
are the more frontal pose of Ghiberti's Abraham and the
diagonal placement of Isaac's legs, so that he is turned com-
pletely away from his father. This once again does not in-
dicate that the relief at San Marco was carved after the
completion of the Gates of Paradise. The relationship is
a broad one and perhaps reflects an intermediate point in
the development of Ghiberti's conception of the theme.

 The sources employed for the nine Genesis reliefs
reveal that whoever conceived them was very well versed in
Ghiberti's vocabulary and seems to have had access to his
model books. He also was able to draw from the work of
Jacopo della Quercia on the Fonte Gaia and the San Petronio
doorway. From the models which he employed, particularly
the Temptation by Quercia, we can establish firmly that he
could not have begun to design these reliefs before 1430.[32]
We may therefore safely exclude Bernardo Ciuffagni from con-
sideration; his supposed stay in Venice - if indeed such a
visit occurred at all - would have ended by 1422.[33] A

solution to the problem of attribution will be attempted
after an analysis of the eight seated figures between the
Genesis reliefs.

The Sources of the Eight Seated Figures

The identity of all but one of the eight subjects
represented in the statuettes of seated figures is unknown.
The fourth figure from the left is Moses, who is shown hold-
ing the tablets of the law; six of them hold books, while
the seventh seems to have held one before it was damaged.

Pl. 102 The first in this series, beginning at the lower
Pl. 91 left of the arch, was copied from Ciuffagni's Saint Matthew.
It is a reproduction of its model in every respect except
for the handling of the drapery, which falls between the
legs. The large V-shaped motif is a debased variant of
the two folds in the corresponding part of Lamberti's Saint
Pl. 21 Mark in Florence. Here the sculptor of this figurine re-
veals himself as a mediocrity, even as a copyist!

Pl. 103 The second seated figure derives from two sources.
The positioning of the legs and the handling of the lower
drapery are modeled after the panel showing Saint John the
Evangelist on the second baptistry doors. The head appears
instead to be a crude variant of the head of Lamberti's
Saint Mark in Florence. Finally, the position and handling
of the right arm are closely analogous to the upper right
Pl. 50 prophet bust on the fourth arch of the main facade of San

Marco.

1. 104 The third member of this series is again deriva-
tive. The lower drapery is crudely modeled after Ciuffagni's
1. 91 Saint Matthew, while the upper section dimly recalls Nanni
di Banco's Saint Luke.[34]

1. 105 The next figurine is by far the most ambitious
and interesting of this otherwise uninspired group. It
represents Moses holding the tablets of the law. His head
was taken from that of Donatello's Saint John the Evangelist;
like the head of Saint John, that of Moses is enlarged, both
to increase its monumental character and to compensate for
the placement of the figure well above street level. In
order to serve this latter purpose, the torso of each figure
is also elongated. The attempted illusionistic effect in
the Moses is not convincing, largely on account of the clumsy
handling of the lower section of the figure, which derives
from the Doctor at the front of Ghiberti's Christ Among the
Doctors.[35] The drapery style depends entirely on Ciuffagni's
118 statue of Isaiah for the facade of the Florentine Cathedral.
The folds which cover the left leg of the Moses are almost
identical to those which hang from the shins of the Isaiah;
the remainder of the drapery does not follow Ciuffagni's
statue as literally, but has a great deal in common with it.
The treatment of the head also appears to relate the Moses
to the Isaiah, but this similarity is mainly due to the

common Donatellian source which they share.

Pl. 106 The fifth seated statuette, which is also the
first on the right side of the arch, is once again com-
pletely derivative. The pose and handling of the torso are
virtually identical to those of the representation of Christ
in Ghiberti's panel of Christ Among the Doctors on the second
baptistry doors. The left hand is treated differently and
Pl. 21, is taken from Lamberti's Saint Mark or Ciuffagni's Saint
91
Matthew. Lastly, the head is a crude copy of that of Ciuf-
fagni's Saint Matthew.

Pl. 107 The sixth figure also contains a very strong Ghi-
bertian element. The lower drapery is similar to that of
several of the representations of the Evangelists and Church
Doctors on the baptistry doors; it is particularly close
to the Saint Augustine in this respect.[36] It is difficult
to speculate on the possible source for the head of this
figure because of its poor condition. Nevertheless, it
appears to relate closely to a type which is found frequently
in Ghiberti's work on the second baptistry doors; it is
perhaps nearest to the turbaned Magus in the scene of the
Adoration of the Magi.[37]

Pl. 108 Of these eight figures, the seventh is by far the
most animated and expressive. Its exaggerated gesture and
facial expression almost give it the appearance of a gargoyle
The drapery style of the figure is again Ghibertian and

recalls the forms of the lower half of the panels of Saint Jerome and Saint Mark in this respect. The folds which hang from the right knee also relate to the robust figure in the front of the panel of Christ Among the Doctors. Furthermore, the physiognomic type of this figure is quite similar to that of the statuette at San Marco.

1. 109 The final member of this group is, like all of its predecessors, heavily dependent upon Florentine models. The lower drapery forms were derived from Ghiberti's panel of Saint Mark and, to a lesser extent, from Ciuffagni's Saint Matthew, while the position of the left hand was taken from Donatello's Saint John the Evangelist. The face is almost entirely obliterated, so that it is impossible to evaluate it.

The picture of the sculptor of this series which emerges is of someone who had an encyclopedic knowledge of Florentine sculpture and who freely reused the works of all of the leading Florentine sculptors of the first quarter of the century. He also appears to have had very little creative imagination, so that his borrowings are frequently no more than copies. The latest terminus post quem for the group of seated figures is 1427, the date when Ciuffagni completed his Isaiah.[38] However, there can be no doubt that this series was created concurrently with the Genesis cycle and must therefore have been carved after 1430.

Problems of Attribution

The Genesis reliefs may be divided into two distinct groups. The first of these consists of the <u>Creation of Adam</u>, the <u>Temptation</u>, the <u>Slaying of Abel</u>, <u>God's Covenant with Abraham</u>, and the <u>Sacrifice of Isaac</u>. The sculptor of these scenes employs open compositions with a strong sense of dramatic focus. His figures are monumental and highly activated. The second sculptor was responsible for the four Noah scenes. His compositions are cluttered and his figures coarse and crudely executed. He tends to repeat certain types with regularity, so that, for example, the two frontal figures in the relief of the <u>Exit from the Ark</u> are very similar to the son of Noah at the center of the group in the scene of the <u>Drunkenness of Noah</u> and also to the figure of Ham in the <u>Curse of Noah</u>. This facial type reappears in the first, second, and fifth of the seated statuettes, while the third and seventh figures in the same series are variants of the representation of Noah in the <u>Curse of Noah</u>. It is very difficult to be sure about the sixth and eighth figures because of the poor state of preservation of their heads, but their drapery styles seem fully consistent with those of the other statuettes, except for the <u>Moses</u>. It is clearly by a different sculptor, one who was more daring and more accomplished than his collaborator; he seems very likely to have been the same sculptor who carved the figure of Abraham in the scene of <u>God's Covenant with Abraham</u>, since

Pl. 93-95
100, 101

Pl. 96-99

Pl. 97

Pl. 98

Pl. 99

Pl. 102-103, 106
Pl. 104, 108
Pl. 97

Pl. 107, 109

Pl. 100

the treatment of the heads of the two figures is analogous.

The two sculptors who carved these works were, in my opinion, Piero Lamberti and Giovanni Martino da Fiesole; this was already broadly indicated by Paoletti.[39] Piero executed the Creation of Adam and allied scenes, as well as the figure of Moses in the foliage. The drapery style of the representation of God in the Creation of Adam is comparable to that of the statuette of Fortitude on the Mocenigo Tomb in Santi Giovanni e Paolo and also to that of the warrior who stands at the extreme left of the same monument. The conception and the handling of the head of Eve in the Temptation are closely analogous to several of the figures of the Fulgosio Monument in the Santo, particularly the Faith and the Prudence. In addition, the head of Cain in the Slaying of Abel is more generally related to that of the warrior at the left of the Doge's tomb, while the Moses repeats a facial type used by Piero throughout both monuments; it is perhaps closest to the Fortitude of the Fulgosio Tomb.

There are also a number of specific similarities which reveal the participation of Giovanni Martino da Fiesole in the remaining sections of the program. The drapery style used for the representation of Ham in the Curse of Noah and and for his two brothers in the drunkenness scene is very close to that of the niche figures of the Mocenigo Tomb.

. 122
. 127

. 94
. 139,
142

. 95
. 127
. 105
122

99,
98

129,
130

-173-

In addition, the manner of carving certain details remains
the same in both groups of work. For example, the handling
of the hair of Saint Peter and of Saint Paul on the tomb
is employed again for the representation of Noah in the

Pl. 99 Curse of Noah and also for the third and fifth seated statu-
ettes. Facial types are also repeated, so that the kneeling
son in the Curse of Noah is a slightly fuller-faced version
of the figure of the Virgin in the niche at the right of
the Mocenigo Tomb. Equally, the same crudely expressive
faces appear in both groups; indeed, in looking at them
one cannot help but notice the unusually limited range of
Giovanni's ability to render emotive values.

The major remaining question regarding this part
of the sculptural program at San Marco is whether Niccolò
Lamberti had any hand in it, and if so, in what capacity.
It is clear that he did not carve any of the figures him-
self, but could conceivably have designed the overall scheme
and even the various parts of it. There is a great deal
of evidence to support this hypothesis. First of all, the
overall format of the decoration of the outer face of the
arch depends on the Porta della Mandorla. In addition,
Niccolò had served as the leader of the project to decorate
the upper exterior of San Marco and could logically have
continued in that capacity. The sculptures themselves also
would point in this direction, since they indicate a depth
and breadth of knowledge of Florentine sculpture that would

be difficult to believe was possessed by Piero or Giovanni
Martino. Finally, the use of a motif from the Temptation
relief by Quercia would also favor Niccolò, since he was
in Bologna in 1428 and 1429 and appears to have known Quer-
cia fairly well.[40] On the other hand, the qualitative dis-
parity between the narratives carved by Piero and those
by Giovanni Martino would seem to argue against Niccolò's
direct participation in the designing of the cycle, since
the distinction applies as strongly for the compositions
as for the carving of the individual figures within them.
Perhaps the correct answer lies somewhere between the two
extremes. He could have informally assisted Piero and Gio-
vanni Martino, but not actually designed each part of the
scheme. Or alternatively, he could have kept model books -
just as Ghiberti apparently did - and the various motifs
could have been taken from them by the two collaborators
on the project. A firm solution to this aspect of the work
is impossible; it does, however, strongly appear that
whatever his precise role, it was quite limited.

The Statuettes of the Intrados of the Arch

110-
117
 The eight statuettes of the intrados of the arch
are situated beneath tripartite domical baldachins and stand
on pedestals which rise from foliated ornament. Pedestal
and overhang are united by a series of four obliquely-set
engaged colonnettes. It was noted by Paoletti that in both
the use of the domical in superstructures and in the purpuse

and configuration of the foliage, these ensembles are com-

Pl. 119 parable to the upper row of niches on the Mocenigo Tomb.[41]

Further analogies may be drawn between the design of these

Pl. 16,
22 structures and the niches for the Madonna della Rosa and

the Saint James and the Datini Tomb.[42] The form of the

baldachin design at San Marco is closest to that of the

niche for the Madonna della Rosa, in that they alone are

trifaceted, with tripartite arches on each side. The use

of the engaged colonnettes to give the appearance of a

Pl. 20 functionally unified structure derives from the Datini

Tomb, while the oblique placement of these elements and

of the pinnacles between the gables of the baldachins de-

pends upon a usage first employed by Niccolò for the Saint

James niche. There are also several less significant points

of similarity between these designs and the work of the

Lamberti. The moldings of the bases of the engaged colon-

nettes repeat the form of the lower part of the bases of

the outer pilasters of the Saint James niche, while the

acanthus decoration of their capitals is virtually identi-

cal to that used in the corresponding parts of the Datini

Tomb. Finally, the rosette motif which is found on the

Pl. 21 base on the seated Saint Mark and on the pilasters separat-

ing the Virtue statues of the Mocenigo Tomb reappears in

the gables of all the eight figures at San Marco. There-

fore, although the authorship of the eight figures cannot

be decided on this basis, it is clear that the design of

the structures which house them were conceived by one or
both of the Lambertis.

Pl. 110 The first statuette in the series, beginning at
the lower left, depicts Abraham with a vibrant and awesome
expressiveness. It reflects several of the major statues
of the period in Florence, but is nevertheless an impres-
sive work on its own merits. The conception and handling
of the head derive from Donatello's Saint Mark, which was
also the source of inspiration for the forceful expression
of the face. The tall proportions and the sweeping sense
of movement betray a knowledge of Ghiberti's Saint Matthew,
even though the two works have nothing more specific in
common. The drapery style is not as closely related to
that of other works, although certain parts of the lower
1.118 sections are broadly connected with the forms of Ciuffagni's
Isaiah and Donatello's David (as identified by Wundram). The
Abraham reveals a fully developed ability on the part of
its sculptor to synthesize effectively motifs and ideas
drawn from diverse sources and, at the same time, to mold
them into a unified work composed in a distinct idiom. It
is an idiom which is made up in part of striking elements
of modernity, but which retains a prounounced degree of
Gothicism, particularly in the insistence on a decorative
drapery style.

 Fiocco attributed the Abraham to Piero Lamberti,

but it has very little in common with any of his authentic sculptures.[43] On those occasions when Piero employed the work of other sculptors as a basis for one of his own sculptures, he invariably became subservient to the model; a prime example of this phenomenon is his figure of a war-

Pl. 127 rior at the left of the Mocenigo Tomb, which depends on Donatello's Saint George.[44] Furthermore, his drapery forms are invariably unimaginative, and are lacking in the decorative and textural sensibility which is so strongly present in the Abraham. Comparisons of the upper drapery forms

Pl. 125 with those of the Charity of the Mocenigo Tomb and of the
Pl. 138 lower section with that of the Hope of the Fulgosio Monument unequivocally proclaim that the same sculptor who carved the two Virtue statues could not have possibly sculpted the Abraham. Lastly, there is not a single example in Piero's oeuvre of a sculpture with the expressive intensity of the Abraham.

There are, however, parallels for the various characteristics of the Abraham in the work of Niccolò. The elaborate and sophisticated decorative drapery style, as well as the combination of it and of a naturalistically rendered, expressive physiognomy, are the fundamental elements of not only this statuette, but of all of his work from the seated Saint Mark and the two campanile figures on. Equally, the comprehensive nature of the sources of this statuette, and the manner in which they are made to

serve the purposes stated above also support the attribution to Lamberti. Finally, there are several details which echo various aspects of his earlier work. The high and prominent forehead and the thinly formed nose appear in all of his later work. Also, the luxuriant motif of the knot of Abraham's waistband is carved in precisely the

l. 21 same manner as that of the seated <u>Saint Mark</u>. There are, to be sure, differences between it and Niccolò's earlier work, but they can be accounted for in part by the influ- ence of the work of other sculptors that were carved in the interim - the prime example being Ghiberti's <u>Saint Matthew</u> - and by the changes that his own style would rea- sonably have undergone during the intervening years. As I will attempt to demonstrate below, the series of eight statuettes was carved no earlier than the end of the 1420s and so a period of approximately a decade would have passed between the standing <u>Saint Mark</u> and the <u>Abraham</u>.

. 111 The second statuette, showing Isaac, is obviously by the same hand. The head again reflects a major work by Donatello - in this case the <u>Saint John the Evangelist</u>. The beard, the modeling of the face, and the hair - to the extent that it appears in the <u>Isaac</u> - are all very closely related to Donatello's statue. Moreover, Niccolò has once again adopted the forcefully expressive tone of Donatello's work. The stance of the <u>Isaac</u> is less decisive than that of <u>Abraham</u>; it seems almost as if Niccolò could not resolve

the choice between the sweeping grandeur of Ghiberti's
Saint Matthew and the more ponderated and contrapuntal
composition of Donatello's Saint Mark. The drapery forms
are highly original, although those in the lower half of
the figure contain some reminiscence of the buttress fig-
ures by Donatello and Nanni di Banco, as well as of one of

Pl. 25 the figures which Niccolò himself carved for the campanile
doorway. There is also some similarity between the tech-
nique employed for carving the drapery covering the upper

Pl. 21 chest of the seated Saint Mark and the Isaac. For the
most striking motifs - the manneristic folds near the
waist and on the right arm - there are no true precedents.
Despite this fact, they are surely more fully consistent
with the artistic sensibility that was behind the seated
Saint Mark than that of any other sculptor of the period.
Here again one will search in vain for a comparable approach
in Piero's work. And it is still more difficult to see the
statuette as Ciuffagni's.[45] Aside from the fact that it
is carved in an entirely different manner from all of his
secure works, it is impossible to see it bounded chronologi-

Pl. 91,
118
cally by the Saint Matthew on one side and by the Isaiah on
the other; nor does it bear the slightest resemblance to
the "Poggio Bracciolini" which seems to have been worked
on by Ciuffagni both before and after his absence from
Florence from 1417 to 1421. It is, however, not very dif-
ficult to view the Isaac as the last known work by Niccolò,

as it represents an extension of the interests, tendencies, and idiosyncrasies which appeared throughout his earlier works.

Pl. 112 The third statuette, which depicts Jacob, was carved by a different hand. The figure is posed in a much less graceful manner than either of the previous pair, and scarcely gives any indication of movement. The head is formed by broader and less differentiated planes and is coarse in expression. The treatment of the drapery confirms this relative weakness. It is composed of a series of un-related patterns which serve neither an ornamental nor a functional purpose. The head is perhaps closest to that l. 105 of the figurine of Moses on the outer face of the arch, while the upper drapery may be compared with the forms of l. 141-143 the three Virtue statuettes on the second face of the Ful-gosio Monument. One of the most revealing details from the point of view of attribution is the right hand, which is treated in precisely the same manner as that of the Charity and other figures of the Fulgosio Monument. The lower drapery forms are the only part of this work which resemble the figures of Abraham and Isaac; the Jacob is, however, handled in a more random fashion and is much less effective in differentiating between the free and weight-bearing legs. This very same failing occurs throughout the statuettes of the Mocenigo and Fulgosio tombs. There can therefore be little doubt that the sculptor of this figure was Piero

Lamberti.

Pl. 113 The fourth figure, which may well represent Noah
holding a model of the ark, is also the work of Piero Lam-
berti. The conception and execution of the face are very
similar to those of the Jacob, although the form of the
beard has been changed. It is composed of thinner, more
generally Donatellian forms which are regularized into
two virtually identical halves. The drapery has been modi-
fied somewhat, but is even closer to Piero's work else-
where. In particular, there is a pronounced similarity
between the upper drapery here and on the figure of an
Pl. 120 angel at the head of the effigy on the Mocenigo Tomb.
The lower drapery is still clumsier and less functional than
that of the Jacob, and it again does not successfully dif-
ferentiate between the standing and free legs. Lastly,
the pose and treatment of the right forearm and hand final-
ize the attribution to Piero; they are almost precisely
Pl. 128 the same as in the martial figure at the right of the Mo-
cenigo Tomb.

 The four statuettes on the right side of the in-
trados of the arch depict the four Evangelists; however, only
the seventh, Saint Matthew, can be identified by an inscrip-
tion on his pedestal. Of these four statuettes only one
can be attributed to either of the Lamberti. It is the
Pl. 115 sixth in the series and was carved by Piero. The pose,

the treatment of the head, and the drapery forms are all
taken from Ciuffagni's Isaiah; the only significant change
occurs in the different positioning of the right hand.
However, the figure is a poor transcription of Ciuffagni's
model and has the same stiffness and ambivalent movement
which typify Piero's work throughout his career. In terms
of execution, the carving of the upper drapery forms is
very similar to that of the Jacob, while the coarsely exe-
cuted hands and the unmodeled facial planes are common to
all three of his works in this series and to most of his
figures elsewhere.

Pl. 117
Pl. 129

The eighth statuette of this group is almost a
replica of the figure of Saint Paul on the Mocenigo Tomb
and is therefore clearly the work of Giovanni Martino da
Fiesole. There are differences between them - the Evange-
list figure is softer and more Gothic and its right hand
is no longer modeled after Donatello's Saint John - but
the similarity in the treatment of the heads and most of
the drapery is so pronounced that there can be no serious
doubt as to their common authorship. The fifth statuette
of the San Marco series is comparable to the eighth in all
significant respects and must surely also be the work of
Giovanni Martino. The facial type employed for both of
these figures is closely akin to that of the lower right
prophet bust of the Justice arch. The similarity does
not extend to execution, but instead points to a common

Pl. 118

Pl. 114

origin in the Lamberti workshop.

Pl. 116 The same is true of the seventh statuette of the intrados, the Saint Matthew, which is modeled very closely
Pl. 53 after the upper left prophet bust of the Justice arch; in this case, both physiognomic type and drapery forms are repeated. The carving of the drapery forms, as well as of details such as the beard and mouth, is virtually the same as in the eighth statuette. Therefore, it is certain that the Saint Matthew was also the work of Giovanni Martino.

The Gable Relief above the Isaac

The gables above the eight statuettes of the intrados are decorated in all but one case with rosettes.
Pl. 111 The sole exception is the main gable above the Isaac, which contains a low relief showing the figure of Christ the Man of Sorrows in a simple and sharply illusionistic tomb. It is virtually impossible to see the relief in detail - in fact, it requires a very careful eye to notice its existence at all - which is very probably the reason that it was not used for any of the other seven. It is impossible to deal with the question of attribution and with the matter of quality for the same reason.

Conclusion

The latest terminus post quem for this series of statuettes is 1427, the year in which Ciuffagni's Isaiah was completed, since the Evangelist carved by Piero is a

virtual copy of it. There is no firm terminus ante quem

for them before 1435, the year in which Piero died. There

are, however, reasons to believe that they were carved

before 1429, when work on the Fulgosio Monument began. The

poses of several of the Virtue statuettes on the tomb, par-

Pl. 138-
139
Pl. 110,
111 ticularly the Hope and the Faith, seem to reflect Niccolò's

two statuettes. They are more gracefully posed than any

of the figures on the Mocenigo Tomb and the Faith has

the taller proportions of Niccolò's Abraham and Isaac. It

may well be that this part of the program was begun in

about 1426/7 by both Lamberti, but that Niccolò's partici-

pation in it ended in 1428/9 when he was in Bologna. At

that point Giovanni Martino may have been called in to col-

laborate with Piero in the completion of the project.

Finally, he would have carved the majority of the remain-

ing statuettes on account of Piero's departure for Padua

in 1429 to work on the Fulgosio Monument. Then, following

his return to Venice in the early part of the next decade,

he and Giovanni Martino executed the sculptural decoration

of the outer face of the arch.

Part 5: The Later Work of Piero Lamberti

The Mocenigo Tomb

Pl. 119

Pl. 120-
121

Pl. 122-
126

Pl. 127-
128

Doge Tommaso Mocenigo died on April 4, 1423; his tomb is on the north wall of Santi Giovanni e Paolo. There are no known documents relating to the monument, but it fortunately bears an inscription which reads, "PETRVS MAGISTRI NICHOLAI DA FLORENTIA ET JOANNES MARTINI FESVLIS INCISERVNT HOC OPVS 1423."[1]

The design of the tomb is appropriately elaborate. The Doge is shown reclining under a tent-like baldachin which is drawn back by a pair of angels. On the face of the sarcophagus there are five round-arched shell niches which contain statuettes of Virtues;[2] they are divided one from another by strips of rosette ornament. At either end of the sarcophagus stand martial figures that are placed on projecting circular platforms which appear again above their heads. The sarcophagus is borne by two heavily decorated brackets, which in turn rest on lion heads. Between them is found a plaque with a laudatory inscription and two representations of the coat-of-arms and hat of the Doge. Behind the baldachin an independent superstructure appears which is made up of two rows. The lower one has six gabled round arches with domical structures behind the gables. The arches are divided into two tripartite round arches and have decorative ornaments in their gables. From each

of the gables foliated decoration rises to support a niche
Pl. 129-130
containing a statuette. The niches have round arches and
shell motifs, like those of the sarcophagus, and gables
with domical structures behind them, as in the lower row.
In place of the ornaments in the gables of the lower row,
these contain cherubim. The two rows are divided into six
vertical pairs by long, thin Corinthian pilasters which
support a relatively heavy cornice. The pilasters at the
two ends are decorated by foliage ornament and have at
their bases half-length putti who carry shields with the
1. 131
coat-of-arms of the Doge. Lastly, a statue of Justice
stands above the baldachin on a circular pedestal which
is borne by a heavily ornamented support. On either side
of this support there is a small figure of a lion.

Many of the specific aspects of the architectural
design are derivative, or at least have precedents. The
. 129-130
upper row of statuettes - showing the Annunciation and four
saints - and the Virtue figures on the front of the sar-
cophagus derive respectively from the tombs of Marco Cor-
naro and Antonio Venier, both also in Santi Giovanni e
Paolo.[3] The draped baldachin held back by angels has a
number of trecento precedents, although in none of them
does it take the form of a tent or is it as elaborate as
here.[4] There are also many details which relate the
Mocenigo Tomb to the architectural vocabulary of Niccolò
Lamberti. The domical structures behind the gables in

the two upper rows appear regularly in Niccolò's work and

P1.20 are closest to the one in the Datini Tomb. The rosette

decoration between the Virtue statuettes can also be found

P1.21 on the base of the seated _Saint Mark_, while the two lions

on the sides of the support bearing the pedestal of the

Justice were derived from those in a corresponding position

P1.61 below the _Saint Mark_ on the central arch of the basilica.[5]

Finally, the cherubim in the gables of the upper row of

niches also are present in those of the niche of the _Ma-_

P1.16 _donna della Rosa_.

The architecture of the Mocenigo Tomb aroused a

great deal of controversy at one time on account of a sup-

posed relationship between it and the Coscia Tomb.[6] In

particular, attention was focused on the use of round

shell niches for Virtue statuettes on the sarcophagi of

both tombs and on the draped baldachin which covers both

effigies. This relationship was denied by Kauffmann and

Janson,[7] who are followed in this respect by all recent

scholars. It is certainly possible that the idea of using

round shell niches could have been evolved independently

by Donatello and Piero Lamberti; moreover, Piero could

simply have adapted the motif from a slightly different

context, such as from the niches of the tower-like struc-

tures on the sides of the Tomb of Michele Morosini in

Santi Giovanni e Paolo.[8] Equally it is true that Piero

did not use Corinthian pilasters to separate the niches

from each other, as did Donatello, and that the draping above the effigies is very different as well. On the other hand, Corinthian pilasters are used by Piero to divide the niches of the upper row. Of decisive importance, though, is the fact that, contrary to the view of Janson and most other scholars, the Virtue statuettes on the front of the sarcophagus do reflect a knowledge of those on the Coscia Tomb. This seems virtually certain, as I will attempt to demonstrate below, and so it appears that Piero saw a model or drawings of the Coscia Monument shortly before starting work on the Mocenigo Tomb.[9] It is therefore possible that the use of both the draped baldachin and the round shell niches on the front of the sarcophagus was derived from that source. Furthermore, there is every likelihood that the design of the Coscia Tomb underwent extensive change between the time that Piero saw this early design and the date that it was constructed, since Michelozzo joined Donatello during the intervening years.[10] It is therefore entirely possible that the use of Corinthian pilasters to separate the niches was not part of the first design.

Of the various architectural elements and motifs employed in the Mocenigo Tomb, there is only one which is enigmatic; this is the series of domical structures in the lower row behind the baldachin. There is no precedent for these structures within this context and it is possible

that they serve no more than a decorative purpose. Yet,
they do not have the appearance of pure decoration and
may have some further significance. Each unit consists
of a round arch which is divided into two tripartite arches
by a mullion; this part of the ensemble is set back slightly
into an outer structure which is, in turn, surmounted by
a gable with a dome behind it. Largely on account of
the dome, but also because of the graduated moldings, the
viewer is encouraged to believe that there is a continuation
of space behind the planes of the gable and arch. However,
when one looks through the twin openings, he sees nothing
but the actual wall of the church without any form of deco-
ration. In other words, what one sees is a coherently de-
fined and illusionistically depicted empty space. There
is no direct precedent for this usage, but there is one
very famous example of a nearly empty interior space ap-
plied within a semi-funerary context. This occurs in
the Arena Chapel in the twin frescoes of "rooms," which
contain only lamps. Schlegel, in her analysis of the
program of the Arena Chapel,[11] has interpreted these two
rooms as tomb chambers and has successfully integrated
this explanation of them with the iconography of the rest
of the chapel. There are, of course, numerous differences
between Giotto's frescoes and the structures on the Mocenigo
Tomb. However, of these the only one which has any bear-
ing on iconographical matters is the presence of the lamps

in the frescoes and their absence on the tomb. Yet, when we look at the spandrels above the smaller twin arches of the structures on the Mocenigo Tomb we find flame-like motifs rising and spreading to the sides. I would therefore suggest that the lower row of structures on the Mocenigo Tomb may represent tomb chambers and that the idea may well have been derived from Giotto's frescoes in Padua.

The Sculpture

The fundamental study of the division of the work on the sculpture of the tomb was made by Planiscig.[12] He attributed the effigy of the Doge, the two angels, and the seven statuettes on the front of the sarcophagus to Piero, while giving the six niche figures of the upper level and the statue of Justice to Giovanni Martino. The only scholar to advance a different hypothesis was Fogolari, who attributed the two angels to Giovanni Martino and also claimed to see the hand of assistants in the heads of the Fortitude and Prudence, as well as in the figure of Saint Peter.[13] The two angels are very clearly the work of Piero Lamberti, not Giovanni Martino, as can be seen by comparing the drapery of the one at left with that of the Prudence and its head with the warrior at the left, and similarly, by comparing the other with the Charity and the Temperance. Neither in drapery style or in the treatment of the heads do they in any way resemble the work of Giovanni Martino. The problem of the degree of participation - and of the

Pl. 120-128, 132

Pl. 129-131

1. 122-123
1. 130

. 120, 123
. 127

. 121, 126

form that it took - of assistants is much more difficult
to resolve. There can be little doubt that on a work of
this magnitude which was completed within one year at the
most, that assistants were employed. Equally, there are
minor differences between all of the statuettes which are
attributed to Piero. There are, however, two fundamental
difficulties involved in trying to discover the precise
extent of Piero's participation in each figure. The first
is that in each case the similarities far outweigh the dif-
ferences, so that we cannot extract even one statuette
which is entirely distinct from all of the others. The
second and still greater problem is that there are no other
sculptures by Piero with which these can be compared in
order to ascertain the extent to which they were carved
by him. The only other documented works are the Strozzi
Tomb and the Fulgosio Monument; the former is obviously
of no use in this context and in the latter there is even
more reason to suggest the participation of assistants.
In any case, the visual evidence does not indicate that
categorical decisions as to whether a given figure - or
part of one - was carved by him or not are applicable. It
seems instead that the procedure followed consisted of
Piero designing all of the figures and executing parts of
each of them; perhaps he was responsible for finishing off
all of them after they had been brought to a state of par-
tial completion by assistants.

The statuettes on the front of the sarcophagus

Pl. 127 are largely derivative. As Paoletti noted, the warrior figure at the left was modeled after Donatello's Saint George, to which it owes its overall pose and the positions of the arms and feet.[14] The drapery style is also Dona-

Pl. 29 tellian, but is closest to that of the so-called Saint John the Baptist, which is probably the work of Nanni di Bartolo. From this source Piero also borrowed the gesture of the left hand and perhaps the position of the head. Finally, the treatment of the head is much closer to Nanni di Banco than to Donatello; more specifically, it can be compared to that of the figure at the right of the socle relief of the Eligius niche at Or San Michele.[15] This statuette illustrates very well many of the characteristic weaknesses of Piero's style. It goes beyond the Saint George in the extent of its contrapuntal pose, but is nevertheless stiff and immobile. It also reveals an inability to integrate the various parts of the body through smooth transitions of form. This is most easily noticed in the head, neck, and upper torso which seem artifically joined together.

. 128 The warrior at the other end of the sarcophagus has an entirely different heritage. The same figural type was used by Ghiberti for the soldiers at the extreme right of his Arrest of Christ and at the left of his Christ before Pilate;[16] more importantly, it was employed by the Lamberti for the second figure from the left in the relief of the

Beheading of Saint James. The position of the right hand is virtually identical to that of the David of 1408/9 by Donatello and the second figure from the left in the Quattro Coronati of Nanni di Banco.[17] This statuette is far more successful than its counterpart on the opposite side, in part because he simplifies rather than exaggerates the pose of its model. He also displays what for him was a rare interest in naturalistic detail. In the other warrior statuette he had simply indicated some form of expression in the eyes and in the furrowed brow and left the remainder of the face smoothly unmodeled; here he extends the naturalistic treatment of details to the other details of the face, thereby producing a far more effective result.

Of the five statuettes of Virtues on the front Pl. 122 of the sarcophagus, the first, representing Fortitude, is the most beautiful. The pose seems to be related to that of the soldier at the left of Ghiberti's Christ before Pilate, while the head was derived directly from one of the prophet heads of the second baptistry doors.[18] Lastly, the primary drapery motif repeats that of the spear-bearing Pl. 24 soldier in the Saint James relief. The Fortitude as a whole has a crispness of form and a decisiveness of movement which appear very infrequently in Piero's work. The derivation of the head from Ghiberti's prophet head indicates again that Piero was in Florence during the first years of the third decade of the century, since it is authoritatively

dated in the period of the great <u>Saint Matthew</u>.

Pl. 123 This Florentine visit is confirmed by the second
Virtue figure, representing Prudence. The pose of the statu-
ette is conventional, but its drapery style reflects that
of one of the great works of the early Renaissance, Dona-
tello's <u>Zuccone</u>. There are very few figures of this period
which have this form of Romanizing drapery, with the great
diagonal fold of the toga, and the <u>Zuccone</u> is the only one
which can even in part be dated as early as 1423. This
would serve to confirm the view of Janson and many other
scholars that the <u>Zuccone</u> was the penultimate statue which
Donatello carved for the campanile.[19] There would seem to
be a chronological problem involved in accepting this rela-
tionship, since the <u>Zuccone</u> - or at least the statue which
most scholars believe to be the <u>Zuccone</u> - appears in the
documents for the first time on March 9, 1423 and is first
mentioned as completed in 1425.[20] However, the document
of March 9, 1423 is not the document of commission and can-
not be taken as a firm <u>terminus post quem</u> for the statue.
It indicates that Donatello was already working on the fig-
ure and it appears that he was dedicating much of his time
to it, since the next payment document, that of August 27th
of the same year, describes the statue as being almost fin-
ished.[21] Lastly, there are six florins which are not ac-
counted for in the documents; they could conceivably have
been paid to Donatello before March of 1423. Therefore,

it is entirely possible that Donatello received the commission as early as the end of 1422 and that he began working on it by the very beginning of 1423. Returning now to the Mocenigo Tomb, we know that the Doge died on April 4th of 1423; therefore, if the tomb was not commissioned before his death, there would have been ample time for Piero to have been in Florence in the early months of the year and for him to have seen a design, a model or even the partially finished statue.

It is revealing to note the changes that were made by Piero from Donatello's figure. He lessens the rhythmic force and the decisive character of the drapery by introducing a series of folds on the right leg which break the sweeping downward movement of the primary diagonal motif. He also modifies the sharp verticality of the long diagonal folds and carves them with softer accents. A further significant change occurs around the right arm and shoulder. In the Zuccone the entire right side of the upper torso and the right arm project sharply from the outer drapery and contrast sharply with the left side of the statue. In the Prudence the drapery is brought back around the right shoulder and along the arm, where it then picks up the direction of the hand and forms an ovoid circuit with the fold hanging from the left shoulder. In the process, the marked sense of contrast between the two sides of the figure is lost.

The head of the _Prudence_ is unrelated to Dona-
tello. It seems instead to have much in common with the
lowermost figure of an angel which Nanni di Banco carved
for the arch reveal of the Porta della Mandorla. They both
have broad, unmodeled facial planes, large, expressive
eyes, and a series of ornamentalized curls enframing the
face.

Pl. 124 The same stylistic characteristics appear in the
third Virtue statuette. The drapery forms are again lacking
in decisive movement and again conceal the form of the fig-
ure. The most prominent motif, covering the lower abdomen,
seems artifically constructed and does not flow easily into
the nearby forms. The head is again more closely related
to the work of Nanni di Banco than any other Florentine
sculptor, but is more classically conceived than that of
the _Prudence_. It therefore not only refers back to the
angel reliefs of the arch reveals, but also indicates a
knowledge of more recent works, such as the flying angel
at the lower right of Nanni's _Assumption_.[23]

Pl. 125 The figure of Charity, which is the fourth in
this group, is the weakest from the point of view of exe-
cution. It is cruder and harsher than any of its companions
and is therefore the most likely to have been carved mainly
by an assistant. Nevertheless, it is important from a
historical standpoint, since it seems to reflect the version

Pl. 133 of the same subject on the front of the Coscia Tomb. The

poses of the two statuettes are quite similar; the only

differences in this respect are that the head of the Coscia

Charity is tilted slightly forward, while the one on the

Mocenigo Tomb is not, and that the hands of the former are

situated a bit differently. However, there are several

details in which they are strikingly alike. The most impor-

tant of these is the treatment of the left hand, which is

similar to that of the Coscia Charity and virtually identi-

cal to that of the Faith. In addition, the thin vertical

strip of drapery which falls from the right shoulder of

the Charity on the Coscia Tomb appears on the opposite side

of the version on the Mocenigo Tomb. It therefore seems

very likely that by the time Piero returned to Venice to

work on the Mocenigo Tomb, Donatello had already made de-

signs for the Coscia Monument. One need not suggest that

the Coscia Virtues were already carved by this time, but

only that some form of preliminary design - either in the

form of a drawing or of a wax model - had been made by

1423. This hypothesis gains some support from the Temper-

ance of the Mocenigo Tomb, which recalls the figure of Hope

on the Coscia Tomb in facial type and expression, as well

as in several drapery motifs.

Pl. 120, The two angels who stand at the ends of the effigy
121
were not carved entirely by one hand. The drapery forms

Pl. 121, and the face are much coarser in the one at the right and
125

recall the statuette of <u>Charity</u> below. The angel at left

Pl. 120,
122, 123
Pl. 127
is similar to the <u>Fortitude</u>, the <u>Prudence</u>, and the warrior

figure at the left and is much more likely to have been

carved in great part by Piero. The angel at right and the

<u>Charity</u> appear instead to be largely the work of a single

assistant.

The **effigy** of the Doge is one of the finest

achievements of Piero's career. It has an uncharacteris-

tically accomplished sense of transition between the various

parts of the figure, which is in large part the result of

. 132
a more fluid drapery style. The face, which was carved

with the aid of a death mask, is unimpressive when seen

from nearby, but has a sharp and distinctive profile when

viewed from the intended vantage point.

. 129-
130
The **six** statuettes of the upper row of niches

are all the work of Giovanni Martino da Fiesole. The

drapery style employed for all of them is more linear and

more Gothic than that of the Virtues on the front of the

. 129
sarcophagus. Only one of the six, the <u>Saint Paul</u>, betrays

a knowledge of contemporary developments in Florentine

sculpture in that it is shown in sharp <u>contrapposto</u>; in

addition, the position of the right hand recalls Donatello's

91
<u>Saint John</u> and Ciuffagni's <u>Saint Matthew</u>. At the same time,

these characteristics, as well as the physiognomic type of

54
the <u>Saint Paul</u>, are found on the lower right prophet bust

of the Justice arch at San Marco and may have reached Giovanni second-hand. To judge from these six statuettes, Giovanni was not an artist with a very subtle or varied sensibility. The facial expressions of his figures are either entirely bland or aggressively direct. His drapery forms tend to be repeated throughout the six statuettes, as do gestures and poses.

Pl. 131 Only in the statue of Justice does Giovanni rise somewhat above this dismal level of achievement. The facial expression is still bland and is morphologically akin to
Pl. 130 that of the Virgin in the right-most niche, but the drapery is much livelier and more varied than in the niche figures. In certain respects of both conception and specific motifs, it is reminiscent of the drapery style used by Jacopo della Quercia for the standing figures of the Trenta Altar, particularly the Saint Lawrence and the Saint Richard.[23] The point cannot be pursued, though, since we know nothing of Giovanni's life before his appearance in Venice.

Conclusion

 As a complete entity, the Mocenigo Tomb is an impressive achievement. The architecture design is ingenious in several respects, and is overall a harmonious blending of Tuscan and Venetian concepts. The figural sculpture is generally on a much lower plane, but in the effigy of the Doge, the warrior at the right, the Fortitude,

and the Justice, Piero and Giovanni attained a level of
accomplishment which they would never again attain.

The Fulgosio Monument

Pl.134 The tomb of Raffaelle Fulgosio, who was a famous

Professor of Jurisprudence at the University of Padua, is

the third and last documented work of Piero Lamberti's

career.[24] It was commissioned by Giovanna Beccaria, Ful-

gosio's widow, on March 9, 1429, approximately a year and

a half after his death.[25] The tomb was intended for and

originally located in the presbytery of the Santo, but

was moved to its present location, near the end of the

left side aisle, in 1651.[26] As was the case with the Mo-

cenigo Tomb, Piero was assisted here by another sculptor,

who was identified by Rigoni as Giovanni Bartolomeo da

Firenze.[27] The monument was completed within a very short

period of time, for on October 11, 1430 Piero wrote from

Verona to Giovanni, telling him to request the money which

was due from Fulgosio's widow.[28] The rapid execution of

the project is definitively confirmed by the agreement made

between Fulgosio's widow and Giovanni d'Allemagna on Janu-

ary 15, 1431, in which the painter contracted to gild and

paint the tomb for fifty gold ducats.[29] The tomb as it

exists today is generally in accord with the contract of

March 9, 1429;[30] in it virtually all of the parts of the

tomb are stipulated and a drawing of the tomb is mentioned.

The major changes are that the tomb does not rest on

columns, but instead rises from a solid base and that the

students have been moved. The gilding and painting by Giovanni

d'Allemagna can no longer be seen.

The Fulgosio Tomb is a double-sided monument with
two co-equal faces. The first side shows the effigy of
Fulgosio lying beneath a draped baldachin, which in turn
is surmounted by a gable containing his coat-of-arms. Four
of his students are shown standing at the head and foot of
the bed, which is borne by a pair of lions. Below them, a
Pl.136 relief field appears, containing a pair of scroll-bearing
putti.[31] Finally, the next level consists of three shell
niches that are enframed by four dark Corinthian pilasters.
Pl.137- They contain statuettes of Fortitude, Hope, and Faith. On
139
the second side the scroll-bearing putti are replaced by
three quatrefoil relief supon which are represented Christ
1.140 the Man of Sorrows, the Virgin, and Saint John. The
1.141- three Virtue statuettes on this face of the monument repre-
143
sent Justice, Prudence, and Charity.

As has been noted by many scholars since Gonzati,
the design of the Fulgosio Monument depends on that of the
Coscia Tomb.[32] In both, the effigy is shown reclining on
a bed carried by a pair of lions which surmounts a relief
showing two putti unfolding a scroll. The clearest rela-
tionship, however, exists in the treatment of the section
showing the Virtue figurines. In both tombs they appear
within round shell niches that are separated from one another

by Corinthian pilasters. Piero seems surely to have
visited Florence in about 1427, since the _Evangelist_
which he carved on the right side of the intrados of the
window arch of San Marco was copied from Ciuffagni's _Isaiah_
of 1425-7. During this visit he saw the nearly completed
Coscia Tomb which he used as a model in his design for
the Fulgosio Monument.

The overall conception of the Fulgosio Monument
is much more classical than that of the Mocenigo Tomb, but
is also much drier and less inventive. The change in feel-
ing may be seen in a detail such as the drapery of the
baldachin; in the Doge's tomb it falls softly and is used
to form graceful curvilinear rhythms, whereas in the later
monument it descends in sharp angular movements and is geo-
metrically regularized. Furthermore, the major zones of
the tomb are united in an additive manner, so that each
is coherent within itself, but not organically tied to the
next. There are two primary reasons for this fundamental
change in the spirit and tone of his work. The first is
simply the influence of Donatello's example. Of perhaps
equal importance was the fact that he was working in a
different cultural atmosphere which was more closely re-
lated to the classical past than was Venice and also far
more literal in the evocation of that past.[33]

The Sculpture

 The sculptural decoration of the Fulgosio Monu-
ment is on a very low qualitative level. In terms of
design, Piero borrowed freely from the Mocenigo Tomb, both
from his own work and that of Giovanni Martino da Fiesole.

l. 137 This can be easily seen in the statuettes of Fortitude and
l. 139 Faith on the front of the monument. The former is a crude
repetition of the representation of the same subject on
l. 122 the earlier tomb, whereas the latter derives its drapery
l. 130 forms from the statuette of a saint in the niche next to
the Virgin by Giovanni Martino. At the same time, it ap-
pears as if different hands were responsible for the drapery
of the three Virtues on each side. The drapery forms of

. 137- the three figures on the front of the tomb are composed of
139
sharp, thin folds and grooves, whereas those of the second
. 141- face are treated in a broader and smoother manner; the
143
latter group are closer to Piero's work elsewhere in this
respect. However, it is difficult to extract more from
this disparity of drapery styles than the fact that he
employed assistants on this project. This is so because
the differences which appear in the treatment of the drapery
do not recur in the heads; although there are variations
among them, there are no significant deviations from a
basic type. Therefore, it is best to avoid categorical
decisions as to which of the statuettes were carved by
Piero himself. Perhaps he made models from which the

statuettes were carved by assistants.[34] There is even one

detail which may have been worked over by Giovanni Bartolomeo,

Pl.141 his collaborator on the project; this is the head held by

Justice, which was probably carved by the same hand which

Pl.140 executed the image of Christ on the back of the tomb.

Equally, it is clear that Giovanni Bartolomeo did not exe-

cute any other part of this figure, which is in all other

respects entirely within the orbit of Piero, nor did he

participate in the carving of any of the remaining Virtue

statuettes. Whatever the precise nature of the procedure

may have been, the Virtues represent an apparent decline

in Piero's creative ability from the time of the Mocenigo

Tomb. The poses and forms are repetitive and unexpressive,

and their range in both respects is markedly narrower than

in the earlier monument.

The relatively low quality of the work on the

Fulgosio Monument is nowhere more apparent than in the

Pl.136 relief of the two scroll-bearing putti. Like those on

the saroophagus of the Strozzi Tomb, their poses are re-

duced to a few angular directions of movement. The physiog-

nomic type which is employed for both is the same as that

of the Virtues below and also recalls the four putti

Pl.31- of the Strozzi Tomb. However, the execution is much cruder
32
here and the various parts of the figures are even less

ably integrated. There is very little chance that Piero

carved them himself, since they are far below even his

normal level of accomplishment. They are, however, very
close to his autograph work in terms of design and must
therefore have resulted from a highly detailed plastic
model or drawing.

ı. 140 The Pietà on the other side bears no relation-
ship to the style of Piero Lamberti and was instead carved
by Giovanni Bartolomeo.[35] It is far more naturalistic
than any of Piero's works and betrays a very pronounced
North Italian influence. Giovanni Bartolomeo evidently
originated from Florence, but if one may judge from this
work, appears to have spent the formative years of his
career in the north, since his style contains not a single
Florentine characteristic.

 The remaining section of the monument shows the
135 reclining figure of Fulgosio surrounded by four students,
two at either end of the bed. This format derives from a
trecento type in which the professor was shown teaching
his students.[36] The execution of the head is entirely
different from that of the Mocenigo Tomb; there is very
little naturalistic modeling and the facial planes are
treated in a broad and generalized manner. It is clear
that a death mask was not employed here and it is very
possible that Piero had no more than a very general con-
ception of what Fulgosio looked like. Furthermore, there
are a number of specific similarities between the forms

Pl.141 of the face and those of several of the Virtues on the

monument, such as the figure of Justice. The drapery is

handled in a different manner from that of Piero's works.

The fold patterns are much more rigid and have an uncha-

racteristically brittle texture. It was very possibly not

carved by him, but may be instead also the work of Gio-

vanni Bartolomeo. This is suggested by a comparison of

the forms below Fulgosio's right forearm with those in the

corresponding part of the figure of the Virgin in the

Pietà. The attribution is further supported by the simi-

larity in the treatment of Fulgosio's hands and those of

Christ. The four statuettes of Fulgosio's students are not

easily studied on account of their placement, but may also

be by Giovanni. The sharply chiselled features and drapery

forms are characteristic of his style. Similarly, the lions

who carry the bed are by him. The larger role which attri-

bute to Giovanni Bartolomeo in the execution of this monu-

ment is fully consistent with the documentary evidence.

Piero was no longer in Padua nineteen months after the com-

mission was given to him and it is even possible that the

tomb was unfinished at the time of his departure. On the

other hand, Giovanni was still there and may have been en-

trusted with the completion of the monument after Piero left.

Conclusion

The Fulgosio Monument is, as a whole, a work of

very little distinction. Its design is derivative and un-
imaginative from almost every standpoint. The figurative
sculpture that is due to Piero is repetitive and poorly
carved, whereas those parts which were executed by Giovanni
Bartolomeo are more expressive, but betray severe technical
limitations. Perhaps the low overall quality is the result
of Piero's hasty departure from Padua and the extensive
participation of assistants, but this alone cannot fully
account for what is surely the least impressive achievement
of his career.

The Four Doccioni on the North Side of San Marco

Pl. 87-
90 The four waterspout carriers on the north side of San Marco are among the most controversial sculptures carved in Venice in the first third of the quattrocento. Fiocco attributed all four to Piero Lamberti and has been followed in this respect by many other scholars.[37] Brunetti ascribed all but the one nearest to the main facade to Nanni di Bartolo,[38] while Del Bravo also assigns this one to Rosso.[39] Fiocco has modified his opinion somewhat and most recently attributes the figure furthest from the west facade to Michelangelo.[40] Lastly, Gnudi has proposed that all four are the work of Jacopo della Quercia.[41]

Pl. 87 As Brunetti indicated, the first figure was carved by a different sculptor from the remaining three.[42] It alone has the waterspout protruding from an animal head; other features which are unique to it are the Antique swirl of drapery which appears behind the figure and the boots which it wears. The manner of execution is clearly different as well; this can be seen very readily in the strip of drapery which comes around the hips and in the hair. Finally, this figure has a much more sensitive facial expression and its movements are more coherently integrated than any of the other doccioni. The monumental character of this figure, as well as its contrapposto stance and idealized head, relate it to classical art. However, I do not feel that it reveals a direct study of the Antique,

but rather of a somewhat diluted version of it, such as
is found in many Early Christian and Byzantine ivory re-
liefs. The schematized conception of anatomy and the
tendency to flatten out the volumetric nature of the forms
of the torso point away from the Antique and towards Byzan-
tine examples such as the figure of Bellerophon in an
ivory relief in the Victoria and Albert Museum.[43] The
treatment of the head in broad, flattened planes, with
prominent features and small knot-like curls also recalls
a type found in many Early Christian and Byzantine ivor-
ies.[44] On the other hand, the linear rhythm of the sil-
houette of the figure, with its gently swaying hips, re-
veal northern Gothic influence. These various elements
are brought together to form a synthesis of style that
results in a form which is both graceful and energetic,
sensitive and robust. It does not conform to its setting,
but instead seems "imprisoned" within it; this is particu-
larly noticeable in the positioning of the arms. Both the
style and expression of this figure and the diverse and
unusual sources which are synthesized in it strongly favor
Gnudi's attribution to Jacopo della Quercia. The influence
of northern Gothic art on Quercia has been accepted by many
scholars and appears most strongly in his early work, while
specific examples of derivations from Early Christian ivor-
ies have been discovered by Janson and Hanson;[45] the latter
has acutely noted that Jacopo's interest in Early Christian

art does not appear until the period following the Fonte
Gaia.[46] To choose one particularly revealing example,
the figure of Saint Lawrence in the relief of his martyrdom
on the predella of the Trenta Altar has been convincingly
related to Early Christian models by Hanson[47] and to a
miniature from the workshop of the Boucicaut Master by
Meiss.[48] The figures of this relief, particularly those
of Saint Lawrence and his tormentor at the left, are re-
latable to the San Marco doccione in many respects. The
treatment of the head and hair of Saint Lawrence is analo-
gous to that of the waterspout carrier, while the heavy
biceps appear in all three figures. The strip of drapery
which is situated around the hips of the doccione can be
found in slightly variant form in the corresponding posi-
tion on the figure to the right of Saint Lawrence in the
predella relief of the Trenta Altar and between the hands
of the Apostle statue which formerly stood on one of the
buttresses of the Church of San Martino in Lucca.[49] The
date of this figure cannot be far from that of the predella
of the Trenta Altar and must surely be at some point between
the completion of the Fonte Gaia and the commencement of
work on the portal of San Petronio.[50]

Pl. 88 The second waterspout carrier is in many respects
modeled after the first. The large features of the face,
particularly the bulging eyes, and the exaggerated movement
of the torso and head seem to represent a conscious attempt

to equal the expressive vigor and the forceful movement
of the first doccione. The result is, however, very much
weaker than in the first figure. The expression is more
grotesque than forceful and the forms of the body are
handled with an unusually poor sense of transition; this
latter characteristic occurs most strongly in the neck and
in the joints between limbs and torso. The execution of
this figure could not possibly have been due to Jacopo
della Quercia; aside from the technical disparity between
it and his secure work, there is also the very simple fact
that it is far below his normally high level of accomplish-
ment. It is, instead, the work of Piero Lamberti. The
treatment of the torso reflects one of the characteristic
weaknesses of Piero's work, his inability to create smooth
transitions between the various parts of a figure. The
drapery style is closely analogous to that employed for
the statuette of Fortitude in the left-most niche on the
front of the Mocenigo Tomb and to that of the warrior figure
standing next to it. The prominent chin is a more emphatic
version of the type which was employed for many of Piero's
figures on the Mocenigo Tomb, such as the angel standing
at the foot of the bed and the statuettes of Fortitude and
Prudence.

l. 122,
127

l. 122

l. 123

The pose of this waterspout carrier was derived
from that of the statue performing the same function to the
immediate left of the main window of the west facade of

. 86

San Marco. It is interesting to note that Piero's pseudo-
Quercesque version was employed, with a few minor variations,
as the model for one of the figures of grape-gatherers in
the background of Uccello's Battle of San Romano in the
Uffizi.[51]

Pl. 89 The third doccione was also carved by Piero Lam-
berti. It closely agrees with its predecessor in the hand-
ling of many details; this is particularly evident in the
carving of the eyes, nose, drapery, and upper torso. The
treatment of the hair and the composition of the face are
different, though, but are very similar to those of the
Pl. 127 martial figure at the left of the Mocenigo Tomb. The pose
is much less activated than that of the previous waterspout
carrier and unlike it, betrays not a trace of quercismo.
For this reason it is very likely that it is the later of
the two by Piero.

 Piero's two doccioni were very likely carved
near the middle of the third decade of the century. Quercia's
figure was undoubtedly completed by 1425 and may well date
from several years earlier.[52] Since Piero's first doccione
presupposes a knowledge of Quercia's figure, it could not
have been carved much before the middle of the decade, es-
pecially since he seems to have been in Florence late in
1422 or at the beginning of 1423 and then appears to have
spent the better part of the latter year working on the

Mocenigo Tomb.[53] Furthermore, he seems to have visited
Florence towards the end of the decade and was occupied on
the Fulgosio Monument in 1429/30.[54] Both slightly before
and after the Paduan tomb he probably worked on the deco-
ration of the central window of San Marco.[55] The circum-
stantial evidence therefore strongly favors a dating of
his two doccioni in the period of 1424 to 1427. This is
supported somewhat by the fact that the execution of these
statues is closer to that of the figures of the Mocenigo
Tomb than to any of his remaining works.

Pl.90 The fourth and last of the doccioni on the north
side of the cathedral is in many ways different from the
preceding three. The torso and the head are much heavier
and more rounded, while the eyes are uniquely small. More-
over, there is a technical difference between this one and
the other three; the back of the figure is, at least in
part, uncarved and retains the shape of the original block.
Lastly., there is a clear distinction that exists with re-
gard to the sources employed for this statue. In the pre-
vious three, whatever relationship that can be drawn to
Antique art is generalized and indirect, whereas here the
connection is much more conclusive. The upper half of the
statue was derived from an Antique source such as the
fountain figure from the Cesi garden in Rome which inspired
a drawing by Michelangelo[56] or the putto at the right of

one of a pair of Augustan reliefs in the Museo Archeologico in Venice, which were in Venice already in 1335.[57] The position of the legs is not at all unusual and it is therefore impossible to sensibly propose a source. From the study of the Antique, the sculptor of this statue derived not only a pose, but also a more monumental conception of the human form. He was, however, rather primitive in his understanding of the Antique and so his figure lacks the anatomical definition and the natural feeling of movement which more sophisticated students of it were then acquiring. There is little chance that the sculptor of this statue was either Piero Lamberti or Jacopo della Quercia. Very simply, it cannot be related to the creative processes of either of these sculptors, in terms of both overall conception and the technique of carving. Professor Fiocco has indicated a belief in the possibility that Michelangelo may have carved it.[58] However, I feel that the only connection between it and Michelangelo is that he and its author coincidentally employed a roughly common source; indeed, the direct result of Michelangelo's use of this source, a drawing of his early maturity in the Louvre, demonstrates how very far this doccione is from his orbit.

There is, I believe, only one realistic choice, which is the same sculptor who carved the executioner in
Pl. 144-146 the Judgment of Solomon at the corner of the Ducal Palace,[59]
Pl. 147-149 the soldiers on the Brenzoni Tomb in Verona,[60] and the

-216-

Pl. 150-
152 Madonna and Child over the doorway of the Church of San
Niccolò in Tolentino[61] - that is, Nanni di Bartolo. The
closest parallel exists between the treatment of the exe-
cutioner in the Judgment of Solomon and the doccione; in
both, the forms are monumental and heavy and the details
of the head, such as the hair, eyes, and nose, are very
similar. This massive conception of form appears with
equal assertiveness in the soldier at the right of the
Brenzoni Monument in San Fermo Maggiore, which, unlike the
Judgment of Solomon is a signed work by Rosso; the shape
of the face and some of its features, as well as the hand-
ling of the drapery which covers the right leg, recall very
strongly the corresponding aspects of the waterspout car-
rier. Finally, the head of the statue of the Virgin over
the entrance to San Niccolò at Tolentino is a refined and
slimmed down version of that belonging to the doccione.

The dating of this figure is made very hazardous
by the fact that it corresponds in certain respects to all
three of Nanni's works after his departure from Florence,
which took place before February of 1424. The Brenzoni
Monument dates from or about 1426 and may well have been
his first work after leaving Florence.[62] The sculpture
of the Tolentino doorway was carved between 1432 and 1435
and represents his last surviving work.[63] However, they
are both problematical, since he received considerable
assistance with each project. In the Brenzoni Monument

Pl. 147-
149 he contributed the design, the soldiers in the foreground, the two _putti_, and very likely the figure on top of the baldachin.[64] It is more difficult to judge the individual sculptures of the Tolentino doorway because of their high placement and the absence of adequate photographs, but it appears that he designed the whole ensemble and executed Pl. 150-
151 only the Madonna and Child and the head of the saint to her right.[65] The Judgment of Solomon was very probably carved after the Brenzoni Monument - perhaps this accounts for the fact that he left half of the sculpture, including the most important statue, to be carved by weak assistants - and before the Tolentino portal. The Brenzoni Monument, that is, those parts of it which are due to Rosso, reveal very strong influence from other Florentine sources. As Professor Krautheimer has noted, the composition of the Resurrection scene on the Tomb derives from Ghiberti's panel on the second baptistry doors.[66] Furthermore, the "architectural" design of the tomb from which the figure of Christ emerges presupposes an understanding - or at least an appreciation - of the new Brunelleschian architectural style which was being employed by Donatello and Michelozzo for the Coscia Monument and the niche of the Parte Guelfa. Since this classicizing architectural style does not appear in any respect in the Tolentino doorway, we may perhaps postulate that it reflects a momentary interest which was inspired by the two projects of Donatello and Michelozzo

and, more generally by Brunelleschi, which faded rapidly after Rosso had been away from Florence for several years. The Judgment of Solomon appears to fall roughly midway between the Brenzoni Tomb and the Tolentino portal. The handling of the executioner looks back to the soldiers of the Brenzoni Monument, whereas the "false mother" is a more classical interpretation of a physiognomic type which appears in the figure of the Virgin on the Tolentino doorway. The composition of the group reveals both Florentine and Venetian elements, so that the carefully structured arrangement of the figures and the architectural setting of the left side are Florentine in spirit, whereas the decorative tree-form is more closely analogous to the other two angle compositions of the Ducal Palace. The doccione was probably carved shortly before or after the Judgment of Solomon, since it is closest to the executioner of all of Rosso's figures. A likely date would be toward the end of the third decade of the century, that is, several years after the work on this side of the Ducal Palace had begun and also a few years after the Brenzoni Tomb and before the Tolentino doorway. The sculpture of the Tolentino portal represents a movement away from the calm and introverted expression which characterizes most of Rosso's previous work and towards the more animated style of Jacopo della Quercia. Jacopo's influence first makes its appearance in Rosso's work in the motif of the child held aloft by

. 146

the executioner in the Judgment of Solomon, which occurs
earlier on both the Fonte Gaia and the Trenta Altar.[67]
However, it is only with the Madonna and Child at Tolentino
that he displays a fully developed interest in Quercia's
style. There are, to be sure, certain Florentine aspects

Pl. 151 to the doorway - such as the saint at the left of the lun-
ette, which is based on Nanni di Banco's Saint Elegius[68] -
but the overall character of the sculpture here is the

Pl. 152 least Florentine of Rosso's career.[69]

The Justice Capital

The decoration of the octagonal capital at the northwest corner of the Ducal Palace is dedicated to the theme of justice. Its eight sides have depicted on them

Pl. 153-160

the following subjects: Justice Borne by Two Lions;[70] Trajan and the Widow;[71] Moses Receiving the Tablets of the Law;[72] Numa Pompilius as a Builder of Temples and Churches;[73] Scipio and the Carthaginian Virgin;[74] Solon Giving the Law;[75] Moses Teaching the Law;[76] and Aristotle Giving the Law.[77] The iconographical program of this capital places unusually great weight on the giving, receiving, and interpreting of the the law; four of the seven exempla of justice deal with this aspect of it.[78] It would appear that whoever determined the subjects of this program had in mind an idea much like that expressed by Brunetto Latini, who in his Book of the Treasure ". . . places Hercules side by side with Moses, Solon, Lycurgus, Numa Pompilius, and the Greek king Phoroneus as among the first legislators, who by instituting codes of law saved the nations of men from the ruin to which their own frailty and impurity would have condemned them."[79] This approach is interesting not only for the emphasis placed on the connection between justice and law, but also because of the identification of it with the ruler; all but the Aristotle scene fits into this category. This strong desire to identify justice with the ruler

. 153

receives major support from the conception of the personifi-

cation of justice. She is shown seated on a pair of lions -
which must surely be a reference to the Venetian Republic[80] -
and additionally, recalls directly the first visual con-
cretization of the theme of the ruler as dispenser and de-
terminant of justice - the fresco of the same subject in
the Scrovegni Chapel.[81]

It may very well be, therefore, that the impetus
behind this carefully chosen group of historical exempla
lay in the desire to aggrandize the role of the ruler by
visually defining his position as that of the individual
upon whom justice depends. This would not by any means
contradict what we know of Francesco Foscari, who was
elected Doge in 1423, one year before construction on this
side of the Ducal Palace began.[82] There is, however, one
seemingly discordant note in this interpretation; this is
Pl. 156 the Numa Pompilius scene in which the emperor is shown
standing beside his architect who directs his attention to
a tower which is a model of the Florentine campanile.[83]
There are several aspects of this scene which can be related
to Foscari. He had been the Procurator of San Marco during
at least part of the period in which it was decorated by
the Lamberti and others and continued to serve in that ca-
pacity while the restoration of those parts of the church
which were damaged by the fire of 1419 took place.[84] The
presence of the Florentine campanile would hardly have been
inappropriate in this context, since Foscari was the leading

advocate of a pro-Florentine policy which reached fruition in 1426 with the agreement between the two states.[85] His sympathies in this respect were perhaps best stated by his predecessor and enemy, Tommaso Mocenigo, who wrote: "Ser Francesco Foscari . . . ha detto . . . ch'egli e buono lo soccorrere a' Fiorentini, a cagione che il loro bene e il nostro, e per conseguente il loro male e il nostro."[86] It is even possible that this note was introduced into this relief to honor one of the Florentine dignitaries who journeyed to Venice during this period, someone like Lorenzo de' Ridolfi, who returned to Florence after a visit in 1425 with a message for the Florentines that the Venetians ". . . hanno et aranno quello pensiero all conservazione del vostro stato . . . , che al loro proprio."[87]

It is also within this spirit that the famous inscription which formerly was found on the abacus - which read, DUO SOTII FLORENTINI INCISE - must be interpreted.[88] It has been suggested by Muraro that the reason for the "anonymous signature" here - as opposed, for example, to the full signature of Bartolomeo Buon on the Porta della Carta - is that the sculptors were Florentine and that normally only Venetian artists were the recipients of state commissions.[89] They would therefore also sign collaborative works, such as the Porta della Carta or the Mascoli Chapel mosaics. Aside from the fact that the laws and protests of the Venetian Arti could not have been taken very seriously

and enforced - how else can one explain the fact that there are more sculptures by "foreigners" in Venice from this period than by Venetians? - there is also no interior logic to Muraro's position. If it was the custom for Venetian artists alone to sign state commissions, then it was obviously the simple fact of their citizenship which gave them this advantage. It therefore seems strange that it is precisely to this that the inscription of the Justice capital referred. On the contrary, it is necessary to interpret the intent of this unusual signature in light of its assertiveness in this respect.

Problems of Attribution

The eight scenes of the Justice capital were attributed to Piero Lamberti and Giovanni Martino da Fiesole by Zanotto and Paoletti.[90] Since then only Planiscig has offered a partially contrary proposal, suggesting that it was perhaps Giovanni Bartolomeo da Firenze who collaborated with Piero here.[91] He was also the only scholar to attempt to divide the individual scenes between the two sculptors who carved the capital reliefs. He attributed the figure

Pl. 153, 154, 156 157; 155, 158-160

of Justice, as well as the scenes showing Trajan, Numa Pompilius, and Scipio, to Piero and gave the remaining four to Giovanni Bartolomeo. The facial type of the seated figure

Pl. 153, 122

of Justice is related to that of the _Fortitude_ of the Mocenigo Tomb, as Planiscig noted,[92] while the drapery style of the

Pl. 156

two figures in the Numa Pompilius scene is comparable to

that of both the figure of Fortitude and the representa-

Pl. 93 tion of God in the Creation of Adam on the outer arch deco-

ration of the central window of San Marco. On the other

Pl. 154,
157 hand, the figures in the Trajan and Scipio reliefs do not

appear to have any significant similarities with the ones

in this pair and are much closer to the style of the scenes

Pl. 158,
159 of Moses and Solon teaching the law. Paoletti acutely re-

alized the similarity in the treatment of the hands between

the figures of the Solon relief and those of the upper row

Pl. 129-
130 of niches of the Mocenigo Tomb.[93] The latter were carved

by Giovanni Martino da Fiesole and therefore it is very

likely that he also carved these four scenes, that is, those

Pl. 154,
157-159 of Trajan, Scipio, Solon, and Moses Teaching the Law. This

is supported by the relationship between several of the

figures in this group and on the outer window decoration

of San Marco which were carved by Giovanni Martino; the

primary example of this connection may be seen in a compari-

Pl. 158,
98 son between the figures of Solon and Noah in the relief of

Pl. 160 the Drunkenness of Noah. The relief of Aristotle Giving

the Law was restored in 1858 and appears to have suffered

considerably in the process;[94] it is therefore hazardous

to attempt an attribution. It does, however, seem much

closer to the reliefs carved by Giovanni Martino than to

Pl. 155 those of Piero. The final relief, showing Moses Receiving

Pl. 100 the Law, is very similar to the relief of Abraham's Covenant

with God on the front of San Marco. It is, however, much

more coarsely executed and one is tempted to believe that it was restored by the same individual who worked on the Aristotle relief in 1858.[95] It cannot, in any case, ever have closely resembled Piero's Abraham relief and is much more likely to have been the work of Giovanni Martino.

In addition to the evidence which arises from comparisons of morphological detail, the greater role which I attribute to Giovanni Martino is supported by the design of the Trajan and Scipio scenes which Planiscig gave to Piero. As Planiscig himself demonstrated, Giovanni Martino was a much more Gothic artist than Piero.[96] Both of these reliefs have something of the character of Gothic miniatures and in this respect they seem much closer to Giovanni's orbit, if we may judge from the work he did on the Mocenigo Tomb. The possibility that individual motifs or figures may have been borrowed directly from Gothic manuscript illuminations cannot by any means be ruled out.

Pl. 154, 157

It is very difficult to date these reliefs precisely. Since in the case of both sculptors analogies can be drawn with the work on the Mocenigo Tomb and with the later window decoration at San Marco, a dating somewhere between the two projects would seem reasonable. Furthermore, if the Judgment of Solomon was carved towards the end of the 1420s, as appears likely, then a roughly comparable date would seem to be indicated for the capital below it.[97]

I would therefore suggest a dating of about 1425-8 for the
reliefs.[98]

Part 6: The Final Years of the Lamberti and Conclusion

In 1430 Piero Lamberti was in Verona for some
unknown purpose.[1] He apparently returned to Venice shortly
thereafter to work on the decoration of the window arch on
the facade of San Marco, but there are no documents con-
cerning him which remain for the period between 1430 and
1434. In the latter year he contracted to carve two chimney-
pieces for Marino Contarini's Ca d'Oro,[2] but they were never
completed. Piero died in 1435, very likely before the 4th
of June[3] and certainly by December 7th, when he is referred
to in a document as "quondam magistri petri nicolai de
florentia."[4]

Niccolò seems to have spent much of his later life
in Bologna. He was there in 1428 acting as an arbiter for
the officials of San Petronio in a dispute with a certain
Domenico di Sandro da Fiesole over the value of a capital
which the latter had carved.[5] In 1429 he was doing some
unspecified work at the Palazzo degli Anziani in Bologna,
which had been damaged by a fire four years earlier.[6] He
was in Bologna in 1434 and in 1439 when he rented Jacopo
della Quercia's house.[7] In the later year he was entrusted
with the belongings which were left behind by Jacopo at the
time of his death.[8] It would be tempting from a circum-
stantial standpoint to propose that Niccolò and Jacopo
were associated professionally during the years preceding
the latter's death, but there is no firm documentation to

support this position and the primary monument in question in this regard, the Bentivoglio Monument, betrays not a trace of Lamberti's style either in the architectural design or the sculpture.[9] It has also been proposed that during his Bolognese years Niccolò created the tomb of Pope Alexander V in the Church of San Francesco. The attribution to Niccolò was offered by Vasari, but has been sustained by very few modern scholars.[10] The primary reason for this is that in 1482 Sperandio of Mantua worked on the tomb and there is no reason to believe that the monument as it exists today bears any relationship to the one which Niccolò supposedly created.[11] The style of the architecture and of all of the figural sculpture precludes any possibility that either design or the execution of the extant tomb is in any respect the work of Lamberti. On the other hand, there is considerable evidence that an earlier tomb existed and that it was made at some point after 1424.[12] It is therefore possible that Niccolò could have worked on this earlier version, but in view of Vasari's uncommonly ill-informed biography of Lamberti, even this must be regarded as somewhat less than certain. The final mention of Niccolò in Bologna occurs in a document of December 15, 1439[13] in which he pays for stone which he acquired for some unknown purpose. There is not a single further mention of Niccolò for the next twelve years. He returned to Florence by 1451 where he died in June of that year.[14]

As a result of the lack of evidence, any hypo-
thesis concerning the last third of Niccolò's life is purely
speculative. Perhaps he ceased working as a sculptor and
spent these years as a consultant and as a non-participating
overseer of various unidentified projects. He had vast
experience in every aspect of sculptural activity and in
relating architecture and sculpture together. By the 1430s
his style was outmoded and he would doubtless have been
more successful in offering his expertise and knowledge
than in trying to acquire commissions to carve sculptures
on his own.

Conclusion

The career of Niccolò Lamberti followed a long
and gradually changing developmental pattern. His work from
the first campaign on the Porta della Mandorla through the
Saint Luke depends largely on the gentle linear style of
Nino Pisano, but also betrays a temporary and lesser in-
terest in the coarser and more robust idiom of Piero Tedesco.
During this span of the first fifteen years of Niccolò's
career, he reveals not the slightest interest in the classi-
cism of Giovanni d'Ambrogio or in the dramatic naturalism
of Brunelleschi and Ghiberti. His work during this early
period would give one no indication of the fundamental
changes which were taking place and which were to come in
Florentine art. It is fully trecentesque and, moreover,
responds not to any Florentine style of the late 14th cen-
tury, but instead to the insistent abstracting emphasis on
line which lies at the heart of Nino Pisano's aesthetic.
It is therefore clear that the decorative character of his
early works resulted not from some contemporary trend, but
from his own inner sensibility which led him to turn back
to an earlier point in the development of Italian sculpture.

Towards the end of the first decade of the quattro-
cento, Niccolò began to come under the influence of some
of the more progressive sculptors and his art takes on a
somewhat livelier tone and reflects a momentary interest
in classicism. The agents for this change - which occurs

in the gradually fuller and more life-like handling of the
angel reliefs and in the classicizing figurines of the
Porta della Mandorla arch reveals - were Nanni di Banco
and Giovanni d'Ambrogio.

The classicizing influence passed rapidly from
Lamberti's art and his work from 1410 to 1415 was decisively
oriented in the direction of Lorenzo Ghiberti and the Inter-
national Style. During this short span of years, trends
which are now considered more progressive began to make
themselves felt in the form of the early mature sculptures
of Nanni di Banco and Donatello. Although Niccolò was not
primarily concerned with naturalism, the two small campanile
figures and the seated Saint Mark display a new expressive
potency which is at least in part due to the influence of
Nanni and Donatello. However, his greatest debt was owed
to Ghiberti, from whose example he learned to synthesize
naturalistic expression with a vibrant, movemented use of
line.

Lamberti left Florence just as Donatello and Nanni
were establishing themselves as the equals of Ghiberti and
when their twin aims of monumental classicism and expressive
naturalism were being presented. In no significant way
did Lamberti participate in the formation of the early Re-
naissance, although there is nothing to suggest that he
left Florence for Venice on account of its advent. Indeed,

his first major work in Venice, the standing Saint Mark,
derives its forceful emotiveness, as well as its propor-
tional subtleties, from Donatello. At the same time, the
statue contains a very strong decorative aspect which sets
it apart from its Donatellian counterparts.

Aside from the standing Saint Mark, Lamberti's
career in Venice was focused around his role as capomaestro
of the project to complete the sculptural decoration of
the upper exterior of San Marco. The work which was car-
ried out under his direction, though coherent in style,
does not bear the mark of an individual personality. The
organization of his workshop would therefore appear to have
been much closer to that of the Buon than to that of any
of the leading Tuscan sculptors of the period.

Niccolò's impact on the development of Venetian
sculpture was minimal. This was not due to matters of
quality, but instead to the fact that the style and working
methods which he brought with him from Florence were not
fundamentally at variance with those employed in Venice
before his arrival. He cannot be considered a Renaissance
artist himself and was therefore in no position to serve
as a conductor of Renaissance ideas to Venice.

The primary distinction between Niccolò and his
great Tuscan contemporaries was that he had no evident in-
terest in classical art, whereas they all derived some vital

aspect of their respective styles from this very source.
The impetus behind the radical change that Nanni's art
underwent in the short span of years between the arch re-
veal angels of the Porta della Mandorla and the Isaiah,
on one hand, and the Saint Philip and Saint Luke, on the
other, was the profound influence which the Antique had
upon him.[15] The lively expressiveness of the arch reveal
angels and the massive character of the Isaiah are given
a much-needed sense of structure and a new monumentality
in the Saint Philip and Saint Luke. Similarly, the pri-
mary element which alters Ghiberti's idiom during the
second decade of the quattrocento and which accounts for
the striking difference between the Saint John the Baptist
and the Saint Matthew was his ever-expanding comprehension
of classical precepts of style. The case of Jacopo della
Quercia is more difficult to assess.[16] From the first - if
we may judge from the Caretto Tomb in Lucca - he displayed
an interest in the Antique and tried to combine it with a
Gothic sense of line.[17] In this tomb the two elements are
separated and dealt with in different parts of the sculp-
tural decoration, but by the second decade of the century
he began to attempt a synthesis of the two within the same
form. This attempted synthesis - along with a parallel one
in which rounded, sculptural form is combined with a partial
negation of spatial recession - accounts for the radical
expressiveness and formal tension which pervades Jacopo's

work. The emphasis on rhythmic movement of form, which
dominates his drapery style, and on frontal surfaces -
particularly evident in his reliefs - is generically Gothic.
At the same time, the robust monumentality of many of his
figures, the idealized rendering of their parts, and above
all, the overwhelming primacy in his work of the human form
as the agent of both formal and spiritual expression, are
classical in origin. The expressiveness of Jacopo's work
cannot be accounted for simply in terms of its component
parts and sources - this is true of all great artists - but
without a knowledge of classical art he could not possibly
have attained the sense of formal structure which underlies
his vibrantly emotive idiom. A clear demonstration of this
is present in his work on the Trenta Altar. The five large
figures in Gothic niches reveal scant knowledge of classical
art and are, generally speaking, graceful decorative forms
that lack a monumentality of structure and an elevated
spiritual expressiveness.[18] It is, by contrast, precisely
these qualities which typify the narrative reliefs of the
altar; their entry into Jacopo's creative machinery can
without doubt be ascribed to a careful study of the Antique.[19]
Finally, the relationship between Donatello and classical
art is the most complex of any which involves an early Re-
naissance artist.[20] Equally, he attained a far more compre-
hensive understanding of it and integrated it more fully
into his own idiom than did any other artist of his age.

At the same time, Donatello was the most individualistic
and varied artist before Michelangelo and therefore inter-
preted the Antique broadly and with considerable freedom.
His attitude towards it may at least in part be gauged by
reflecting on the relationship between his Saint Mark and
classical art. It is, as Janson has claimed, a work with-
out any source and was a mutational development. However,
this should not obscure the fact that in the millennium
which separates the Saint Mark from the classical world,
not a single work of art displays the monumentality of
form and expression which is evoked by Donatello. Equally,
the ponderated contrapposto pose and the functional use of
drapery are tools employed by both Antique sculptors and
Donatello alike to achieve the broader aims stated above.
The distinction between them - which is precisely the in-
verse of the relationship between Nanni and the Antique -
is that Donatello gives to his figure a deeper, more person-
alized, and more directed (at the viewer) expressiveness
than the vast majority of classical sculptors. He accepts
the precepts of classical art, but rarely - and in no major
works - presents them without significant change. Classi-
cism is therefore not a component part of Donatello's work
which can be isolated, but an ingredient that is inextricably
blended into his creative machinery.

Lamberti's interest in classical art can be seen
only in the figurines which he carved for the Porta della

Mandorla. The impetus for this momentary interest was in part due to the subject matter and in part to the proximity of the classicizing works of Giovanni d'Ambrogio. Niccolò's figurines lack both the structural fluidity and the monumentality of classical art and there is every reason to doubt that they resulted from a direct study of the Antique.

The crucial effect which the avoidance of classicism had on his work can be seen in his standing Saint Mark, one of the most accomplished statues of his career. The head is highly naturalistic and deeply expressive; in these respects it seems to represent Niccolò's response to the Saint John and the Saint Mark of Donatello. However, the drapery is treated in an entirely decorative manner, with softly looped folds flowing across the torso and down over the legs. The form beneath, instead of determining the pattern of drapery and the directions it takes, appears to move in accordance with it. The overall result is therefore less than fully satisfactory, as the expressive content and naturalistic modeling of the noble head are contradicted by the abstractly rhythmic treatment of drapery. It is as if the creative machinery of the artist was unable to keep pace with the expressive ideas which he wished to present. The sense and actuality of structure, which are lacking in Niccolò's statue, as well as a ponderated contrapposto stance, are precisely those elements of the Antique which help to form and to reinforce the dramatic monumentality

of Donatello's Saint Mark. To choose one example, the lower
drapery in Donatello's work consists of parallel vertical
folds along the right leg which emphasize its weight-bearing
function and also the tall and grand proportions of the
figure in general, and of irregular motifs which encase
the projecting left knee which is sharply distinguished
from the forms around it by the smoothness of the cloth
that covers it. Lamberti's overwhelming decorative sensi-
bility prevented him from adopted usages of this kind and
from profitably appreciating and learning from classical
art. This, more than any other factor in his development,
was decisive in determining the nature of his art and of
his historical position.

The distinction between Lamberti and his leading
contemporaries is also telling with respect to the relatively
narrow range of formal and expressive ideas which are found
in his oeuvre. He was most closely attuned to Ghiberti's
work and, if one may judge from his art, would seem to have
been closest to him in temperament as well. Like Ghiberti,
his development was gradual and without any mutational
changes. Similarly, the expressive content present in the
works of both artists is much more impersonal than in those
of Quercia and Donatello. On a purely qualitative scale,
Lamberti is perhaps grouped with Nanni di Bartolo and Ber-
nardo Ciuffagni. Beyond this, however, the similarity ends,
because both of these artists were formed after the advent

of Donatello and the effect of his startling genius may
be seen both in their works and in the stark individualism
to which each of them aspired. Niccolò was the product
of the workshops of the late Middle Ages and was pre-Dona-
tellian, both in fact and in spirit. He was in no sense
a progressive artist, but deserves a certain measure of
critical appreciation for the independence and the crafts-
manship of his work.

Piero Lamberti was different from his father in
almost every respect and his work reveals no decisive com-
mitment to any style. From his Florentine years, only the
relief below the Saint James (designed by his father) and
the sarcophagus of the Strozzi Tomb (probably after Ghi-
berti's design) survive. The reliefs on the latter consist
of poorly transcribed Antique motifs; they are carved with
almost a complete lack of understanding for figural struc-
ture and movement.

His first major work in Venice, the Mocenigo Tomb,
is the high point in Piero's career. The architecture is
a generally harmonious blend of Florentine and Venetian
elements, while that part of the figurative sculpture that
is due to him is in certain cases well designed and compe-
tently carved. There are, however, an inordinately large
number of borrowings in both the architecture and the sculp-
ture. These reveal no consistent approach and in several

instances the model has been poorly understood.

Toward the middle of the decade he carved two
doccioni for San Marco and part of the Justice capital of
the Ducal Palace. The first of the former is particularly
weak and reveals a momentary and totally uncomprehending
attempt to adopt the creative means of Jacopo della Quercia.

Piero visited Florence in about 1427, but the trip
seems to have achieved little more than to provide him with
a newer series of models for his next works. The primary
example in this context is the Fulgosio Monument in the
Santo, which is a poor variant of the Coscia Tomb. In the
early 1430s he worked on the decoration of the window arch
of San Marco, but his figures and compositions are again
almost entirely derivative.

In general, Piero was a much more ambitious and
much less able artist than his father. His work depends
throughout on that of his leading Florentine contemporaries
and therefore has about it a superficial air of modernity.
Yet there is not a single sculpture he produced that would
indicate that he had a fundamental understanding of contem-
porary events in sculpture. Furthermore, his allegiance
to the style of one or another of the great sculptors of
his day changed from monument to monument and even from
figure to figure within one project. Finally, the qualita-
tive level of the carving in his works is generally poor -

the sole major exception is the figure of the Doge in the
Mocenigo Tomb - and serves as an unfortunate complement to
his lack of creative imagination. There is no reason what-
soever to consider him a major figure, even by the rela-
tively low standard of Venetian sculpture of the first
third of the quattrocento. Had he been an artist of higher
caliber, he might well have contributed to the early forma-
tion of a Venetian Renaissance style, but his Venetian con-
temporaries apparently found little in his work that they
desired to emulate. A large and heterogeneous group of
sculptures has been attributed to him by Fiocco,[21] but
the limits of his oeuvre, just like those of his talents,
are pitifully narrow. It is therefore to the Buon studio
and to Antonio Bregno that one must turn to understand the
subsequent development of Venetian sculpture in the first
half of the quattrocento.[22]

Footnotes for Part 1

[1]The majority of scholars who have written on
Lamberti have given his birthdate as about 1370. This is
the view of C. von Fabriczy, "Neues zum Leben und Werke
des Niccolò d'Arezzo - 2," Repertorium für Kunstwissen-
schaft, XXV, 1902, p. 161; A. Venturi, Storia dell'Arte
Italiana, VI, Milan, 1908, p. 222; G. Fiocco, "I Lamberti
a Venezia - I, Niccolò di Pietro," Dedalo, VIII, 1927-8,
p. 298; J. Pope-Hennessy, Italian Gothic Sculpture, London,
1955, p. 221; R. Krautheimer and T. Krautheimer-Hess, Lor-
enzo Ghiberti, Princeton, 1956, p. 40. Lamberti's birth-
date is not documented; my reasons for agreeing with this
dating are given below. Lamberti's place of birth is
similarly undocumented. Giorgio Vasari, Le Vite Del Più
Eccelenti Pittori, Scultori, ed Architettori scritte da
Giorgio Vasari, edited and annotated by G. Milanesi, II,
Florence, 1878, p. 135 ff., stated that Niccolò was Aretine.
However, his account of Lamberti's career is erroneously
combined with that of Niccolò di Luca Spinelli. This con-
fusion was not rectified until the fundamental article of
U. Procacci, "Niccolò di Pietro Lamberti, detto il Pela e
Niccolò di Luca Spinelli d'Arezzo," Il Vasari, I, 1927-8,
pp. 300 ff. All previous literature on Lamberti is tainted
by this confusion and there is no reason whatsoever to be-
lieve that he was born in Arezzo or ever worked in its
close environs. It seems reasonable to presume that he
was Florentine, since he is always referred to as that in
the documents; this was also the opinion of L. Planiscig,
"Die Bildhauer Venedigs in der ersten Hälfte des Quattro-
cento," Jahrbuch der Kunsthistorischen Sammlungen in Wien,
N.F. IV, 1930, pp. 50-1, and Pope-Hennessy, 1955, p. 221.
In addition to the works cited above, the most important
studies of Niccolò are the following: C. von Fabriczy,
"Neues zum Leben und Werke des Niccolò d'Arezzo - 1," Re-
pertorium für Kunstwissenschaft, XXIII, 1900, pp. 85 ff.;
M. Wundram, "Niccolò di Pietro Lamberti und die Florentiner
Plastik um 1400," Jahrbuch der Berliner Museen, IV, 1962,
pp. 79 ff.; M. Wundram, "Der heilige Jacobus an Or San
Michele in Florenz," Festschrift Karl Oettinger, Erlangen,
1967, pp. 193 ff.

[2]This material has been sifted carefully and ana-
lyzed by M. Wundram, 1962, pp. 79 ff. From these early
documents Wundram is not able to derive a definitive identi-
fication of the young Lamberti and, unfortunately, it does
not appear that one is possible.

[3]Published in full in C. von Fabriczy, 1902, pp.
157-8. During the same year Niccolò was fined for having
thrown rocks at someone's house. For this incident see R.
Piattoli, "Il Pela, Agnolo Gaddi e Giovanni d'Ambrogio alle

prese con la guistizia (1392-3)," Rivista d'Arte, XIV, 1932, pp. 377, 380-1.

[4]The nearly complete documentation for the decoration of the Porta della Mandorla is available in G. Poggi, Il Duomo di Firenze, documenti sulla decorazione della chiesa e del campanile tratti dell'archivio dell'Opera, Italienische Forschungen, Kunsthistorisches Institut in Florenz, II, Berlin-Leipzig, 1909. Lamberti first appears in relation to the Porta della Mandorla in # 348.

[5]C. Seymour, Sculpture in Italy 1400 to 1500, Baltimore, 1966, p. 265. Seymour suggests a possible birth-date of c. 1375. There is no evidence to support this view and it is more reasonable to assume that Niccolò was mar-mied at the age of twenty-two than at seventeen.

[6]Poggi, # 348-9, 95-7, 99-101, 103, and 106.

[7]Ibid., # 105, 107, 119, and 120.

[8]Ibid., # 123.

[9]The commission document of October 15, 1395 (Poggi # 111) does not give the subjects of the four statues; they are first specified in August (Poggi # 122) and November (Poggi # 127) of 1396.

[10]He received final payment on July 19, 1401 (Poggi # 146).

[11]Poggi # 404.

[12]Ibid., # 149. For Urbano see below p. 143.

[13]Poggi # 150.

[14]For the competition see Krautheimer, 1956, pp. 12 and 33 ff. Vasari speaks poorly of Lamberti's panel, saying that it had ". . . le figure tozze," (Vasari-Milanesi, II, 1878, p. 227) and that his and the one by Simone da Colle were ". . . le peggio di tutte . . ." (Vasari-Milan-esi, II, 1878, p. 335). It is questionable whether Vasari knew which of the panels was Lamberti's (see above note 1). C. Seymour, "The Younger Masters of the First Campaign of the Porta della Mandorla," Art Bulletin, XLI, 1959, p. 13, note 37, states that it was probably melted down after the competition.

[15]For the Madonna and Child see Poggi # 152-3; for the Angel see Poggi # 154, 158, and perhaps 155, 156, 158, 160, 163, and 164.

[16]C. von Fabriczy, 1900, pp. 86-7.

[17]The reply of the Florentine Signoria was first published by G. Gaye, Carteggio inedito d'artisti, I, Florence, 1839, p. 82.

[18]C. von Fabriczy, 1902, p. 164.

[19]Ibid., p. 164.

[20]Poggi # 162, 163.

[21]This is the view of: H. W. Janson, The Sculpture of Donatello, II, Princeton, 1957, p. 13; Seymour, 1959, pp. 14, 15, note 43; G. Brunetti in L. Becherucci and G. Brunetti, Il Museo dell'Opera a Firenze, I, Florence, n.d., p. 261. Seymour additionally indicates his belief that the commission for the four seated Evangelists was first given to Lamberti and Lorenzo di Giovanni; there is no hard evidence to support this view.

[22]See C. von Fabriczy, 1900, p. 87.

[23]Poggi # 363-5, 367-70. # 370 records the final payment.

[24]Ibid., # 172.

[25]A full discussion of the documents and progress on the Saint Mark is given below on pp. 42-3.

[26]C. von Fabriczy, 1902, p. 165, and Janson, II, 1957, p. 17.

[27]Janson, II, 1957, p. 17. There is no reason to believe, as do Seymour, 1959, p. 14, note 40 and 1966, p. 59, and Wundram, 1962, p. 114, that Lamberti ever received the commission for the Saint Mark. See below p. 58.

[28]C. von Fabriczy, 1902, p. 166; Procacci, 1927-8, p. 307; M. Wundram, "Albizzo di Piero: Studien zur Bauplastik von Or San Michele in Florenz," Das Werk des Kunstlers: Studien zur Ikonographie und Formgeschichte - Hubert Schrade zum 60. Geburtstag, Stuttgart, 1960, pp. 161 ff. Niccolò is referred to as "chapomaestro della porta del oratorio."

[29]Procacci, 1927-8, p. 307.

[30]C. von Fabriczy, 1902, p. 160.

[31]Ibid., p. 161. Final payment was made on August 16, 1412.

[32]C. Guasti, Il Pergamo di Donatello pel Duomo di Prato, Florence, 1887, p. 12.

[33]Poggi #199.

[34]See above note 31 for reference.

[35]Poggi # 200.

[36]See below pp. 42-3.

[37]Poggi # 422.

[38]P. Paoletti, L'Architettura e la Scultura del Rinascimento a Venezia, I, Venice, 1893, p. 117.

[39]C. von Fabriczy, 1900, pp. 87 ff.

[40]C. von Fabriczy, 1902, p. 167.

[41]Ibid., p. 167.

[42]This is the view, however, of Wundram, 1967, pp. 193 ff., especially p. 205. My reasons for rejecting this opinion are given below on pp. 75-6.

[43]Paoletti, I, 1893, p. 14, note 2.

[44]I. B. Supino, La scultura in Bologna nel secolo XV, Bologna, 1910, pp. 86-7.

[45]Ibid., p. 87, and I. B. Supino, L'arte nelle chiese di Bologna, II, Bologna, 1938, p. 277.

[46]Supino, 1910, p. 87 and Document # 88; and Supino, II, 1938, pp. 276-7. Also in J. Beck, Jacopo della Quercia e il portale di San Petronio a Bologna, Bologna, 1970, p. 56, note 1 and p. 59, note 3.

[47]Supino, 1910, p. 87 and Document # 88; Supino, II, 1938, p. 277; Beck, 1970, p. 56, note 1.

[48]Supino, 1910, p. 87.

[49]Procacci, 1927-8, p. 309.

[50]Poggi # 95-7, 99-104, 106, 348-52.

[51]Ibid., # 356-9.

[52]Ibid., # 363-5, 367-70.

[53]Until recently the figure of Christ in the keystone was generally attributed to Nanni di Banco. M. Lisner, "Zum Frühwerk Donatellos," Münchner Jahrbuch der bildenden Kunst, XIII, 1962, p. 63 ff. and "Intorno al Crocifisso di Donatello in Santa Croce," Donatello e il suo Tempo, Atti dell'VIII Convegno Internazionale di Studi sul Rinascimento, Florence, 1966, pp. 127-8, has attributed it to Donatello. This possibility was previously rejected by Janson, II, 1957, p. 10, note 1, who sees the similarity between it and the Crucifix in Santa Croce as one of type and states that the body of the Santa Croce figure is ". . . both more Gothic and more naturalistic . . ." than the figure of Christ from the Porta della Mandorla. G. Brunetti, "I Profeti sulla porta del Campanile di Santa Maria del Fiore," Festschrift Ulrich Middeldorf, I, Berlin, 1968, pp. 106 ff., and in Becherucci-Brunetti, Il Museo dell'Opera, I, n.d., p. 260, ascribes the figure to Nanni di Bartolo. In my opinion the relationship between it and the Santa Croce Crucifix is telling and there is every likelihood that it is the first surviving work by Donatello. A complete survey of the scholarly literature on the subject is available in Becherucci-Brunetti, Il Museo dell'Opera, I, n.d., pp. 258-60.

[54]Poggi # 362, 366. A critical survey of the scholarly literature is found in Janson, II, 1957, pp. 219-22. He rejects both of the figures presently above the Porta della Mandorla as possible works by Donatello. There is general agreement now that the one on the left was carved by Bernardo Ciuffagni, but, M. Wundram, Donatello und Nanni di Banco, Berlin, 1969, pp. 56-9, has revived the ascription of the statue on the right to Donatello. A recent attempt by M. Trachtenberg, "Donatello's First Work," Donatello e il suo Tempo, Atti dell'VIII Convegno Internazionale di Studi sul Rinascimento, Florence, 1966, pp. 361 ff., to identify Donatello's "Prophet of 1406-8" as one of the statuettes over the windows of the cathedral tribunes is very unconvincing. The work in question appears to be no more than a composite of Donatello's Saint Mark and Nanni di Banco's Saint Elegius.

[55]The bibliography until 1942 is summarized by W. Paatz and E. Paatz, Die Kirchen von Florenz, III, Frankfurt-au-Main, 1940-52, pp. 486-8. The scholarly literature since then is given in Becherucci-Brunetti, Il Museo dell'Opera, I, n.d., pp. 255-8.

[56]H. Kauffmann, "Florentiner Domplastik," Jahrbuch der preussischen Kunstsammlungen, XLVII, 1926, pp. 216-35; M. Wundram, "Der Meister der Verkündigung in der Domopera zu Florenz," Beiträge zur Kunstgeschichte - eine Festgabe für H. R. Rosemann zum 9. Oktober 1960, Munich, 1960, pp. 109 ff., and Wundram, 1962, pp. 92 ff.

[57]G. Brunetti, "Jacopo della Quercia a Firenze," Belli Arti, I, 1951, pp. 3-17, and G. Brunetti, "Jacopo della Quercia and the Porta della Mandorla," Art Quarterly, XV, 1952, pp. 119-30, and in Becherucci-Brunetti, Il Museo dell'Opera, I, n.d., pp. 258-60.

[58]Seymour, 1959, pp. 1 ff., and Seymour, 1966, pp. 33-4.

[59]Wundram, 1962, pp. 92 ff.

[60]Photographs of the sections of the arch reveals not illustrated here are to be found in P. Toesca, Il Trecento, Turin, 1951, figure 320 (for Lamberti's third angel relief), and in Wundram, 1969, # 109 (for Lamberti's third figurine) and # 38-43 (for all the sections by Nanni).

[61]Wundram, "Der Meister," 1960, pp. 109 ff. Photographs are to be found in Wundram, 1969, # 115-18, 121.

[62]Seymour, 1959, p. 13, note 37, and Seymour, 1966, p. 32.

[63]J. Lanyi, "Le statue quattrocentesche dei Profeti nel Campanile e nell'antica facciata di Santa Maria del Fiore," Rivista d'Arte, XVII, 1935, p. 152, note 2, pp. 152-3, 248, 252, 268-72, 274, 280. He was followed by J. Pope-Hennessy, Italian Renaissance Sculpture, London, 1958, p. 277, and Seymour, 1966, p. 68. The documentary problems concerning the mysterious series of Giuliano di Giovannis is analyzed thoroughly by Krautheimer, 1956, p. 118, note 10. G. Brunetti, "Ricerche su Nanni di Bartolo il Rosso," Bolletino d'Arte, 28, 1934, pp. 258 ff., G. Brunetti, "Riadattamenti e Spostamenti di Statue Florentine del Primo Quattrocento," Donatello e il suo Tempo, Atti dell'VIII Convegno Internazionale di Studi sul Rinascimento, Florence, 1966, pp. 277 ff.; Brunetti, 1968, pp. 106 ff., and Becherucci-Brunetti, Il Museo dell'Opera, I, n.d., pp. 265-6, has ascribed the statue to Nanni di Bartolo. I can see no reason to believe that it was carved by him.

[64]M. Wundram, "Donatello e Nanni di Banco negli Anni 1408-9," Donatello e il suo Tempo, Atti dell'VIII Convegno Internazionale di Studi sul Rinascimento, Florence, 1966, pp. 69 ff., and Wundram, 1969, especially pp. 3-10, 62-9, and 150-2.

[65]Toesca, 1951, figure 287.

[66]Poggi # 106 and Poggi # 363-5, 367-70.

[67]Ibid., # 367.

[68]Wundram, 1962, p. 84, note 62.

[69]See above note 62 for references.

[70]Poggi # 107.

[71]Ibid., # 120.

[72]A. Venturi, Storia dell'Arte Italiana, IV, 1906, pp. 706 and 724, was the first scholar to attribute the group to Lamberti, while Kauffmann, 1926, p. 227, note 4, was the first to associate it with the documents of 1395-6. His view was followed by Planiscig, 1930, p. 51. Pope-Hennessy, 1955, p. 209, ascribes it to Lamberti (1399), while Krautheimer, 1956, p. 71, seems to favor this attribution as well. Planiscig's opinion is incorrectly reported by Paatz, IV, 1940-52, p. 298, who, however, provides a clear account of the history of the sculpture, its condition, and previous attributions (in Paatz, IV, 1940-52, pp. 527-8, note 95).

[73]The attribution to Giovanni d'Ambrogio was made by G. Fiocco, Review of L. Planiscig, "Die Bildhauer Venedigs in der ersten Hälfte des Quattrocento," Rivista d'Arte, XIII, 1931, p. 280. The ascription to Piero Tedesco was offered by G. Brunetti, "Osservazioni sulla Porta dei Canonici," Mitteilung des Kunsthistorisches Instituts in Florenz, VIII, 1957, p. 9, and in Becherucci-Brunetti, Il Museo dell'-Opera, I, n.d., p. 23. The attribution to Lorenzo di Giovanni was made by Seymour, 1966, p. 60 (with a question mark).

[74]Paatz, III, 1940-52, p. 528, and Wundram, 1962, p. 110, note 139 and note 140.

[75]Becherucci-Brunetti, Il Museo dell'Opera, I, n.d., p. 23.

[76]Ibid., # 131 for illustration.

[77]Ibid., # 123-4 for illustrations.

[78]Ibid., # 131-2 for illustrations.

[79]Ibid., # 134 for illustration.

[80]Toesca, 1951, figures 290 and 235.

[81]Ibid., figure 291.

[82]Wundram, 1969, # 111 and 112 for illustrations.

[83]Toesca, 1951, figures 14 and 15.

[84]Poggi # 111.

[85]A document of August 29, 1396 mentions that one of Niccolò's statues is to be a Saint Augustine (Poggi # 122), and in November of that year the second statue is also named (Poggi # 127).

[86]Poggi # 112.

[87]Ibid., # 136 and 138.

[88]See note 87 above for references.

[89]Poggi # 146.

[90]Ibid., # 140.

[91]Paatz, III, 1940-52, p. 395, and Becherucci-Brunetti, Il Museo dell'Opera, I, n.d., p. 254.

[92]The drawing is reproduced in Becherucci-Brunetti, Il Museo dell'Opera, I, n.d., facing p. 8.

[93]Ibid., I, p. 254, for references.

[94]Ibid., I, pp. 254-5.

[95]Kauffmann, 1926, pp. 162-7, was the first to correctly separate the four statues.

[96]Poggi # 152 and 153.

[97]Ibid., # 154.

[98]Ibid., # 158. It is also possible that # 155-6, 158, 160, 163-4, refer to this figure, but it is not determinable.

[99]This is the view of: Planiscig, 1930, p. 51; Paatz, III, 1940-52, p. 365; Brunetti, 1957, pp. 1 ff.; and Wundram, 1962, p. 108. The bibliography and previous opinions are summarized by Paatz, III, 1940-52, p. 485.

[100]Wundram, 1962, p. 109.

[101]Toesca, 1951, figures 291 and 295.

[102]The earlier literature on this problem is summarized in Paatz, III, 1940-52, pp. 485-6, note 216. Brunetti, 1957, pp. 10 ff., gave them both to Lamberti, but indicated that the one on the right was restored at a later date; there is no evidence to support this suggestion.

Seymour, 1959, p. 12, ascribes the one on the right to Lamberti; whereas Wundram, 1962, p. 109, reverses this attribution.

[103]C. von Fabriczy, 1900, pp. 86-7. The statue is now in the Bargello; for a discussion of its replacement at Or San Michele see Paatz, IV, 1940-52, p. 535, note 106.

[104]C. von Fabriczy, 1900, p. 87. Although the payments could hypothetically have followed the actual work by a year or more, it seems very likely that this was not the case. In 1404/5 Niccolò was involved in other activities - see above p. 5 - while for the year 1406 there is no record of him occupied in any other undertaking. Seymour, 1966, p. 60, dates the statue in c. 1405-10; there is no reason to believe that this is the case.

[105]See Wundram, 1967, p. 194, and Wundram, 1969, pp. 32-3, 116-7.

[106]Wundram, 1969, #57-8, 85, 30-1, for illustrations.

[107]The inscription, which was first transcribed by C. von Favriczy, "Opere dimenticate di Niccolò d'Arezzo," Archivio Storico dell'Arte, Anno III, Fasc. III-IV, 1890, p. 161, reads as follows: "HIC JIACET CORPVS PRVDENTIS ET HONORABILIS VIRI FRANCESCI MARCI DATINI DE PRATO CIVIS ET MERCATORIS PROVIDI FLORENTINI QVI OBIIT DIE XVI MENSIS AVGVSTI A.D. MCCCCX CVJVS ANIMA REQVIESCAT IN PACE." The translation used here was taken from I. Origo, The Merchant of Prato, Oxford, 1957, p. 339; the book as a whole provides a complete account of the life and dealings of Francesco Datini.

[108]C. von Fabriczy, 1902, p. 161.

[109]Ibid., p. 160

[110]Marble for the Datini tomb slab was purchased on January 1, 1411. For this see C. von Fabriczy, 1902, p. 158.

[111]E. Panofsky, Tomb Sculpture, New York, 1964, p. 72.

[112]Ibid., p. 72.

[113]They are discussed by Janson, II, 1957, pp. 75-7, and 101-2, respectively.

[114]Krautheimer, 1956, Plate 75.

[115]Ibid., figures 56-7.

[116]Poggi # 172.

[117]Ibid., # 183.

[118]Ibid., # 162-3.

[119]Ibid., # 177, 179, and 181.

[120]Ibid., # 199.

[121]Ibid., # 200.

[122]Ibid., # 202.

[123]Ibid., # 204.

[124]Ibid., # 207 (on June 30th).

[125]Guasti, 1887, p. 12, and G. Marchini, Il Duomo di Prato, 1957, n.p., pp. 47-9.

[126]Poggi # 208.

[127]He received ten florins on December 19, 1414 (Poggi # 209) and five more on February 27, 1415 (Poggi # 212). The document of evaluation is Poggi # 213.

[128]Poggi # 214.

[129]Wundram, 1962, p. 89. The original reads as follows: "Als Summe ergibt sich eine geradezu 'manieristische' Anhäufung den Faltenmotiven, die die Gesamterscheinung unter einer Vielzahl kleinteiliger, ein Eigenleben führender Einzelformen ersticken."

[130]Seymour, 1959, p. 14.

[131]Krautheimer, 1956, Plates 30-1.

[132]Ibid., Plates 19-22 and 24.

[133]Ibid., p. 124.

[134]Ibid., p. 125.

[135]Ibid., p. 74.

[136]For their history see Becherucci-Brunetti, Il

Museo dell'Opera, I, n.d., pp. 261-4.

[137]Vasari (Vasari-Milanesi, II, 1878, p. 137) states
that the statue by Niccolò was placed on the left side of
the main entrance portal. Brunetti (Becherucci-Brunetti,
Il Museo dell'Opera, I, n.d., p. 261) claims that Vasari
locates Niccolò's figure in the first niche to the left
of the main entrance portal; this is not the case. The
correct reconstruction of the respective positions of the
four statues on the facade is given by Seymour, 1966, pp.
56 ff.

[138]Janson, II, 1957, p. 14.

[139]The best stylistic analysis of these four statues
is given by Seymour, 1966, pp. 54-8. See also Wundram, 1969,
pp. 23-5 and pp. 86-93 for the Saint John and the Saint Luke.

[140]In this point and in what follows, I am follow-
ing the exemplary discussion of this problem which is offered
by Krautheimer, 1956, pp. 83-5.

[141]The statue was attributed to the "school of Ghi-
berti" by Venturi, VI, 1908, pp. 141-2. Pope-Hennessey,
1955, p. 209, ascribes it to Ciuffagni; this opinion was
offered tentatively by L. Planiscig, Lorenzo Ghiberti, Flor-
ence, 1949, p. 96. Krautheimer, 1956, p. 71, indicates his
belief that the statue was in all probability by Niccolò.
The firm attribution of the work to Lamberti was made by
Wundram, 1967, pp. 193 ff.; this is the definitive study
of the statue. Seymour, 1966, p. 60, ascribes the work to
Piero Lamberti (with a question mark). G. Fiocco, "I Lam-
berti a Venezia - II, Pietro di Niccolò Lamberti," Dedalo,
VIII, 1927-8, pp. 347-8, advanced the possibility that it
was a work of collaboration between the two Lamberti. Sey-
mour, 1959, p. 13, feels that Piero assisted his father with
the statue. Paatz, IV, 1940-52, p. 493, is undecided between
Niccolò and Piero. Procacci, 1927-8, p. 308, considers it
possible that the statue may be related to a document of
1410; for a discussion of this point see below, pp. 93-4.

[142]Krautheimer, 1956, p. 71, note 8; Seymour, 1966,
p. 60 (Seymour, 1959, p. 13, note 39, dated it in about 1410);
Paatz, IV, 1940-52, p. 493; Wundram, 1967, pp. 193 ff.

[143]Wundram, 1967, pp. 200-1.

[144]Krautheimer, 1956, p. 91.

[145]Ibid., Plate 37.

[146]Ibid., p. 125.

[147]Ibid., p. 74.

[148]Wundram, 1967, pp. 194-7.

[149]Ibid., p. 196. Wundram's views on the development of the niche architecture at Or San Michele are also found in Wundram, "Albizzo di Piero," 1960, pp. 167 ff., and Wundram, 1969, pp. 31-4, 116-8, 128-32, and 140-2.

[150]Wundram, 1969, p. 141.

[151]Krautheimer, 1956, p. 73.

[152]Wundram, 1969, pp. 140-1.

[153]For Wundram's discussion of the statuary see Wundram, 1969, pp. 120-6. The final payment for the Saint Luke is Poggi #205.

[154]Krautheimer, 1956, Digest of Documents, # 32-5, 37-8, 42, and 47. See also Wundram, "Albizzo di Piero," 1960, pp. 167-9, for the niche containing Ghiberti's Saint John the Baptist.

[155]Wundram, 1969, pp. 32-6.

[156]Wundram, 1967, p. 197.

[157]Wundram, 1969, # 61, for illustration.

[158]Ibid., p. 32, note 44.

[159]Ibid., pp. 109 ff.

[160]Janson, II, 1957, p. 17.

[161]Krautheimer, 1956, p. 71 and note 8, indicates that the statue is probably by Niccolò and does not mention another master in connection with the relief. Seymour, 1959, p. 13, ascribes the relief to Niccolò with assistance from Piero. Wundram, 1967, pp. 193 ff., ascribes it to Niccolò. Seymour, 1966, p. 60, attributes the statue to Piero (with a question mark) and does not name another sculptor for the relief. Pope-Hennessy, 1955, p. 209, gives the statue to Ciuffagni and does not mention another master in connection with the relief. Venturi, VI, 1908, pp. 141-2, ascribes the relief to Ghiberti's workshop.

[162]Lorenzo Ghibertis Denkwuerdigkeiten (I Commentarii), edited by J. von Schlosser, II, Berlin, 1912, p. 183, note 17. Planiscig, 1949, p. 96, feels that it may have been carved after a drawing by Ghiberti; he does not offer a

proposal for the sculptor of the relief.

[163]Wundram, 1967, pp. 197-8.

[164]For illustration see B. Berenson, Italian Pictures of the Renaissance: The Florentine School, I, London, 1963, Plate 340.

[165]Wundram, 1967, pp. 197-8.

[166]Krautheimer, 1956, Plate 40.

[167]Becherucci-Brunetti, Il Museo dell'Opera, I, n.d., # 48 for illustration.

[168]An analogous figure is also found in Spinello Aretino's fresco of the Condemnation and Martyrdom of Saint Ephysius, in the Camposanto at Pisa. For an illustration see Berenson, I, 1963, Plate 418.

[169]Wundram, 1967, p. 197. For an illustration of Ghiberti's panel see Krautheimer, 1956, Plate 27.

[170]Wundram, 1967, p. 197. For illustrations of Ghiberti's two reliefs see Krautheimer, 1956, Plates 44 and 36.

[171]For illustrations of Ghiberti's panels see Krautheimer, 1956, Plates 33 and 28.

[172]Wundram, 1967, p. 197. For illustrations of Ghiberti's panels see Krautheimer, 1956, Plates 48 and 50.

[173]For the documentary evidence concerning Niccolò in Venice at that time see below p. 113. For the dating of Ghiberti's reliefs see Krautheimer, 1956, pp. 127-8, 130.

[174]The chronology of Ghiberti's panels as presented by Krautheimer is viewed by him as somewhat flexible. See R. Krautheimer and T. Krautheimer-Hess, Lorenzo Ghiberti, I, 2nd Printing, Princeton, 1970, p. XVII of "Preface to the Second Printing."

[175]For a discussion of Ghiberti's model books, with specific examples of their influence, see Krautheimer, 1956, pp. 209 ff.

[176]For an illustration of this panel see Berenson, I, 1963, Plate 212.

[177]Krautheimer, 1956, p. 126.

[178]For the documentation concerning Piero Lamberti in Venice see below pp. 92-4.

[179]See below p. 113.

[180]This is, however, the view of Wundram, 1967, p. 205.

[181]C. von Fabriczy, 1900, pp. 88-91.

[182]G. Fiocco, L'arte di Andrea Mantegna, 2nd revised edition, Venice, 1959, pp. 17-8, and Fiocco, "I Lamberti - I," 1927-8, p. 311. Although there is no proof that this was the purpose for which he purchased the marble, it does seem to be a very reasonable proposal.

[183]C. von Fabriczy, 1902, p. 167.

[184]Poggi # 307.

[185]For the previous literature on this figure and an attribution to the "maniera di Francesco Talenti" see Becherucci in Becherucci-Brunetti, Il Museo dell'Opera, I, n.d., p. 244.

[186]The literature on this subject is summarized in Becherucci-Brunetti, Il Museo dell'Opera, I, n.d., p. 244 (by Becherucci) and p. 265 (by Brunetti).

[187]See above note 185 for reference.

[188]For the history and condition of these two figures see Brunetti in Becherucci-Brunetti, Il Museo dell' Opera, I, n.d., p. 265.

[189]A. Schmarsow, "Bemerkungen Uber Niccolò d'Arezzo," Jahrbuch der königlich preussischen Kunstsammlungen, VIII, 1887, p. 228. Schmarsow also felt that Vasari may have confused this pair with two of the statues on the campanile which he attributed to Niccolò (Vasari-Milanesi, II, 1878, p. 136).

[190]Brunetti, 1934, pp. 254 ff.; Brunetti, 1966, pp. 277 ff.; Brunetti, 1968, pp. 106 ff.; and Brunetti in Becherucci-Brunetti, Il Museo dell'Opera, I, n.d., p. 265.

[191]Brunetti, 1934, pp. 262 ff. (for the arch reveals only); Brunetti, 1968, p. 108 (for the figure of Christ); Brunetti in Becherucci-Brunetti, Il Museo dell'Opera, I, n.d., pp. 257-8.

[192]For these two statues see Janson, II, 1957, pp.

225-31. He is, I believe, correct, in all respects save
the attribution of the head of the "Poggio," which is very
plausibly ascribed to Ciuffagni by Wundram. For this last
point see M. Wundram, "Donatello und Ciuffagni," <u>Zeitschrift</u>
<u>für Kunstgeschichte</u>, XXII, 1959, pp. 94-9.

[193]Janson, II, 1957, pp. 33-8.

[194]Lanyi, 1935, pp. 152-3, 248, 252, 268-72, 274
and note 1, and 280.

[195]Krautheimer, 1956, p. 118, note 10.

[196]Wundram, 1966, pp. 69 ff., and Wundram, 1969,
pp. 3-10, 62-9, and 150-2.

[197]Brunetti, 1968, p. 108.

[198]Wundram, 1969, # 5 for illustration.

[199]Poggi # 405-11.

[200]Krautheimer, 1956, p. 124.

[201]For his <u>Saint Mark</u> in Venice see below pp. 144-7.

[202]For this and the following points see Wundram,
1962, pp. 114-5.

[203]In 1405, 1419, and 1420.

[204]Janson, II, 1957, pp. 16-7.

[205]See above pp. 17-8.

[206]For the vital distinction between the Interna-
tional Style and earlier Gothic styles, and for the entry
of the former into the center of Florentine artistic activ-
ity see Krautheimer, 1956, pp. 75-85.

[207]The drapery style of Lamberti's <u>Saint Mark</u> is
close to that of the image of God the Father in a drawing
by Stefano in the Albertina, whereas the overall style and
character of his two small Campanile figures are relatable
to a sheet of studies of prophets by Stefano, also in the
Albertina. Illustrations of these drawings may be found
in L. Magagnato, <u>Da Altichiero a Pisanello</u>, Venice, 1958,
Tavole XXXIII and XXXVI.

Footnotes for Part 2

[1]The document was published by Procacci, 1927-8, p. 307. Virtually all scholars give his birthdate as c. 1393, beginning with C. von Fabriczy, 1902, p. 168. The most important studies of Piero are the following: Fiocco, "I Lamberti - II," 1927-8, pp. 343 ff.; C. Gamba, "L'opera di Pietro Lamberti," Rivista mensile della Città di Venezia, IX, 1930, pp. 257 ff.; Planiscig, 1930, pp. 47 ff.; V. Lazzarini, "Il Mausoleo di Raffaello Fulgosio nella Basilica del Santo," Archivio Veneto-Tridentino, III, 1923, pp. 147 ff.; E. Rigoni, "Notizie di scultori toscani a Padova nella prima metà del quattrocento," Archivio Veneto, VI, 1929, pp. 118 ff.; G. Fogolari, "Gli scultori toscani a Venezia e Bartolomeo Bon, Veneziano," L'Arte, XXXIII, 1930, pp. 427 ff.; G. Fogolari, "Ancora di Bartolomeo Bon Scultore Veneziano," L'Arte, XXXV, 1932, pp. 27 ff.

[2]See below pp. 93-4.

[3]C. von Fabriczy, 1902, p. 168.

[4]Paoletti, I, 1893, p. 117.

[5]The document appears in C. von Fabriczy, 1902, pp. 168-9 and in many other places. See below p. 93.

[6]Lazzarini, 1923, pp. 154-5.

[7]Rigoni, 1929, pp. 121 and 130.

[8]Paoletti, I, 1893, p. 26. The complete documentation for this commission was published by Fogolari, 1932, p. 45.

[9]Rigoni, 1929, pp. 121 and 130.

[10]Procacci, 1927-8, pp. 307-8. He considered it possible that the document might refer to work on the completion of the statue of Saint James, but also noted that it is a problematical suggestion, since the payments were not made by the Furriers' Guild.

[11]C. von Fabriczy, 1902, pp. 168-9.

[12]Ibid., p. 168; G. Poggi, La cappella e la tomba di Onofrio Strozzi nella Chiesa di Santa Trinità 1419-23, Florence, 1903; Venturi, VI, 1908, p. 222; Lazzarini, 1923, p. 148; Fiocco, "I Lamberti - II," 1927-8, p. 356; Gamba, 1930, p. 257; W. Paatz, "Eine frühes Donatellianisches Lunettengrabmal vom Jahre 1417," Mitteilung des Kunsthistorisches Instituts in Florenz, III, 1932, p. 540.

[13]W. von Bode, Denkmäler der Renaissance - Sculptur Toscanas, Munich, 1892-1905, p. 44 (text volume); M. Reymond, "La Tomba di Onofrio Strozzi," L'Arte, VI, 1903, pp. 7 ff.; Planiscig, 1930, p. 61; Fogolari, 1930, p. 445; F. Burger, Geschichte der Florentinischen Grabmals, Stassburg, 1904, pp. 183-4; in the caption below Figure 1, Tafel X, he gives it to Piero (with a question mark). M. Gosebruch, "Florentinische Kapitelle von Brunelleschi bis zum Tempio Malatestiano," Römisches Jahrbuch für Kunstgeschichte, 8, 1959, pp. 132 ff., has suggested that Piero carved the sarcophagus, but that Michelozzo was responsible for its design and for that of the arch and base of the tomb. There is no reason to connect Michelozzo with this project and he would have been about eighteen years old at the time that Piero carved the sarcophagus.

[14]Reymond, 1903, p. 10.

[15]Poggi, 1903, especially p. 11.

[16]M. Lisner, "Zur frühen Bildhauerarchitektur Donatellos," Münchner Jahrbuch der bildenden Kunst, IX-X, 1958-9, pp. 94-101 and 113-7.

[17]Janson, I, 1957, Plate 161b.

[18]Ibid., I, Plates 159a and 167b.

[19]Krautheimer, 1956, Plate 76, pp. 138-9 and 143, and Digest of Documents # 138. The Ghibertian character of the Strozzi Tomb was brought to my attention by Dr. Ulrich Middeldorf in a personal communication.

[20]Krautheimer, 1956, p. 256, and Digest of Documents # 73a.

[21]G. Marchini, "Aggiunta a Michelozzo," Rinascità, VII, 1944, pp. 24 ff.

[22]Krautheimer, 1956, p. 261 and note 16.

[23]A classical example which seems especially close to the paired putti of the Strozzi Tomb is found on a sarcophagus in the Camposanto; it is illustrated in E. Panofsky, Renaissance and Renascences in Western Art, Stockholm, 1957, figure 110.

[24]Vasari-Milanesi, II, 1878, p. 138; Schmarsow, 1887, p. 228.

[25]See below note 33 for references.

[26]Vasari-Milanesi, II, 1878, pp. 135 ff.

[27]Ibid., II, p. 138.

[28]Krautheimer, 1956, p. 86.

[29]Krautheimer, 1956, pp. 87-8, note 5, dates the work in about 1437; despite the fact that he has obvious authority in this matter, I find it much more likely than not that the Annunciation was part of the original project.

[30]Seymour, 1966, p. 72.

[31]Ibid., p. 71

[32]Vasari-Milanesi, II, 1878, p. 138, note 2; also Planiscig, 1930, p. 87, and Paatz, IV, 1940-52, p. 492.

[33]The attribution to Piero Lamberti was first made by C. Gamba, cited with agreement by C. von Fabriczy, 1902, p. 166, note 7; this was also the view of Fiocco, "I Lamberti - II," 1927-8, p. 356. The ascription to Nanni di Bartolo was first offered by Venturi, VI, 1908, p. 228; his opinion was followed by Planiscig, 1930, p. 87. Paatz, IV, 1940-52, p. 522, note 87, states that both Ludwig Heydenreich and Ulrich Middeldorf attributed the figures to Michelozzo. W. R. Valentiner, Studies in Italian Renaissance Sculpture, London, 1950, p. 63, and Krautheimer, 1956, pp. 87-8, note 5, also ascribe them to Michelozzo. Paatz, IV, 1940-52, p. 492, is undecided between Michelozzo and Piero Lamberti.

[34]Krautheimer, 1956, Digest of Documents # 71.

[35]Poggi # 233 and also # 234-7.

[36]Ibid., # 239.

[37]Ibid., # 240-1 and 247.

[38]Ibid., # 245.

[39]Ibid., # 251.

[40]Ibid., # 253-4, 256-7.

[41]Ibid., # 258.

[42]Ibid., # 261.

[43]Ibid., # 268.

[44]Krautheimer, 1956, pp. 87, 109-11, and Digest of Documents # 100 and 84.

[45]Ibid., p. 87.

[46]For the Coscia and Brancacci Tombs see Janson, II, 1957, pp. 59-65 and 88-92.

[47]Pope-Hennessy, 1958, Plate 40.

[48]Ibid., Plate 39.

Footnotes for Part 3

[1]La Basilica di San Marco, edited by F. Ongania, Documents Volume, Venice, 1881, # 835.

[2]The opinion that it refers to a tabernacle on the south side was offered by P. Paoletti, "Nuovi Ritocchi all Storia della Chiesa di San Marco," Atti del Reale Istituto di Belle Arti in Venezia, July, 1904, p. 80. He proposed that this tabernacle is the one which contains the statue of the Virgin Annunciate. The hypothesis that it refers to a tabernacle on the south side was accepted by Planiscig, 1930, p. 52, but without comment on the remainder of Paoletti's hypothesis.

[3]Fiocco, "I Lamberti - I," 1927-8, p. 290.

[4]Ongania, 1881, Documents Volume, # 845.

[5]Planiscig, 1930, p. 52.

[6]Fiocco, "I Lamberti - I," 1927-8, pp. 296-7, and Fiocco, 1959, p. 16.

[7]Paoletti, I, 1893, p. 117.

[8]Ibid., I, p. 117.

[9]C. von Fabriczy, 1902, pp. 168-9.

[10]Fiocco, "I Lamberti - I," 1927-8, pp. 304-5.

[11]Fiocco, "I Lamberti - II," 1927-8, p. 348.

[12]Fiocco, "I Lamberti - I," 1927-8, pp. 304-9, and Fiocco, 1959, p. 16.

[13]Fiocco, "I Lamberti - II," 1927-8, pp. 347-8, for the tabernacle statues. His opinion on the prophet

busts seems somewhat variable. In Fiocco, 1959, pp. 16-7, he attributes them to Niccolò, whereas in Fiocco, "I Lamberti - II," 1927-8, p. 348, and in captions to the photographs on pp. 344-6 he ascribes them to Piero Lamberti with help from the Campionesi in carving the foliage.

[14]Fiocco, "I Lamberti - I," 1927-8, pp. 304 and 310. G. Gombosi, "Eine Kleinbronze Niccolò Lambertis aus dem Jahre 1407," Adolph Goldschmidt zum seinen 70. Geburtstag, Berlin, 1935, p. 119, related the bronze statuette of Saint Christopher, now in the Boston Museum of Fine Arts, to one of the waterspout carriers of the main facade; he, in turn, claimed that the latter was carved by one of Niccolò's Lombard assistants. There is no reason to believe that Niccolò had anything to do with the doccioni of the main facade or with the Saint Christopher; the latter, as Dr. Middeldorf has suggested (in an oral communication), is the work of a North Italian sculptor. It has also been attributed to Matteo Raverti by G. Mariacher, "Matteo Raverti nell'arte veneziana del primo quattrocento," Rivista d'Arte, XXI, 1939, pp. 32-4, to Nanni di Banco (with some hesitancy) by G. Swarzenski, "A Bronze Statuette of St. Christopher," Bulletin of the Museum of Fine Arts, XLIX, 1951, pp. 84-95, and to Niccolò again by Seymour, 1959, p. 13.

[15]Planiscig, 1930, pp. 52-4.

[16]Ibid., p. 54. See below, notes 53-4 for further bibliography.

[17]Ibid., pp. 53-4.

[18]Ibid., p. 54; he states that there are only two secure works by Piero Lamberti, neither of which is on San Marco. Pope-Hennessy, 1955, pp. 55-6 and 221, seems to generally follow Fiocco's view of the authorship of these various works; this is also true of Gamba, 1930, p. 258.

[19]For the sculpture of the Cathedral of Milan see U. Nebbia, La scultura nel Duomo di Milano, Milan, 1907, and C. Baroni, Scultura Gotica Lombarda, Milan, 1944, pp. 123-64. A shorter account is given by Toesca, 1951, pp. 393-8.

[20]Baroni, 1944, figures 297 and 299.

[21]Ibid., figures 311 and 308.

[22]For the Dalle Masegne see: L. Planiscig, "Geschichte der Venezianischen Skulptur im XIV Jahrhundert," Jahrbuch der Kunsthistorischen Sammlungen des Allerhoechsten

Kaiserhauses, XXXIII, 1916, pp. 176-98; R. Krautheimer,
"Zur Venezianischen Trecento-Plastik," Marburger Jahrbuch
für Kunstwissenschaft, V, 1929, pp. 193-212; C. Gnudi,
"Jacobello e Pierpaolo Dalle Masegne," Critica d'Arte, II,
1937, pp. 26-38; C. Gnudi, "Nuovi appunti sui fratelli
Dalle Masegne," Proporzioni, III, 1950, pp. 48-55; G. Mari-
acher, "Orme Veneziane nella scultura Lombarda; i fratelli
dalle Masegne a Milano," Ateneo Veneto, CXXXVI, 1945, pp.
25-7; Toesca, 1951, pp. 420-7; Pope-Hennessy, 1955, pp.
37-8, 204-5. For the altar in San Francesco in Bologna
see I. B. Supino, La Pala d'altare di Jacobello e Pier Paolo
dalle Masegne nella chiesa di San Francesco di Bologna,
Bologna, 1915, and R. Roli, La Pala Marmorea di San Fran-
cesco in Bologna, Bologna, 1964.

[23]Baroni, 1944, figure 291, and pp. 134-5. See
also for Giovannino de' Grassi, P. Toesca, La pittura e
la miniatura nella Lombardia, Milan, 1912, pp. 294-323,
and Toesca, 1951, pp. 98, 395-7, 772-4. A brief account
is given by Pope-Hennessy, 1955, pp. 33-5 and 202-3.

[24]Krautheimer, 1956, Plate 28.

[25]Ibid., Plate 53.

[26]Ibid., Figure 10.

[27]Wundram, 1969, # 5 for illustration.

[28]The complete documentation for this relief was
published by G. Fogolari, "La Chiesa di Santa Maria della
Carità di Venezia (ora sede delle Regie Gallerie dell'Acca-
demia), Archivio Veneto-Tridentino, V, 1924, pp. 36-9.

[29]For Buon see: Paoletti, I, 1893; P. Paoletti,
La Scuola Grande di San Marco, Venice, 1929; L. Planiscig,
Venezianische Bildhauer der Renaissance, Vienna, 1921, pp.
3-30; Planiscig, 1930, pp. 89-111 (the most thorough account);
G. Fiocco, "I Lamberti a Venezia - III, Imitatori e Seguaci,"
Dedalo, VIII, 1927-8, pp. 432-43; G. Fiocco, "La Lunetta
nel Portale della Scuola Grande di San Marco," Rivista men-
sile della Città di Venezia, VII, 1928, pp. 177-86; G. Fiocco,
"Agostino di Duccio a Venezia," Rivista d'Arte, XII, 1930,
pp. 261 ff.; G. Fiocco, Review of E. Rigoni, "Notizie di
scultori toscani a Padova nella prima meta del quattrocento,"
Rivista d'Arte, XII, 1930, pp. 151-60; Fiocco, 1931, pp.
265-82; Fogolari, 1930, pp. 427-65; G. Fogolari, I Frari
e I Santi Giovanni e Paolo, Milan, 1931; Fogolari, 1932,
pp. 27-45; R. Gallo, "L'Arma di Marco Dandolo sulla Porta
di Borgo Poscollo a Udine," Rivista mensile della Città di
Venezia, VII, 1928, pp. 15-28; Pope-Hennessy, 1955, pp.
60-2 and 223-4; J. Pope-Hennessy, Catalogue of Italian Sculp-
ture in the Victoria and Albert Museum, I, London, 1964, pp.
342-6.

[30] Wundram, 1969, pp. 342-6.

[31] Ibid., # 48 for illustrations.

[32] Ibid., # 66 for illustrations.

[33] Krautheimer, 1956, Plate 21b.

[34] Wundram, 1969, # 87 for illustration.

[35] Poggi # 381. For the best analysis of the relief, its style and dating, see Wundram, 1969, pp. 94-108.

[36] See above note 10 for reference.

[37] Fiocco, "I Lamberti - I," 1927-8, p. 306, and Fiocco, 1959, p. 16. He is followed in this respect by G. Lorenzetti, Venice and its Lagoon, translated by J. Guthrie, Rome, 1961, pp. 172 and 174, and seemingly also by Pope-Hennessy, 1955, pp. 55-6 and 221. The contrary view was offered by Planiscig, 1930, pp. 52-4.

[38] Toesca, 1951, figures 284, 292, 295, and 296.

[39] Baroni, 1944, figure 283.

[40] A. C. Hanson, Jacopo della Quercia's Fonte Gaia, Oxford, 1965, # 68 for illustration.

[41] Ibid., p. 81.

[42] Ibid., # 4 for illustration and pp. 11-2 for discussion. See also R. Krautheimer, "A Drawing for the Fonte Gaia in Siena," Metropolitan Museum Bulletin, X, 1952, pp. 265-74.

[43] Fiocco, "I Lamberti - I," 1927-8, p. 304.

[44] Ibid., pp. 305-6, and Fiocco, 1959, p. 16. He was followed by Lorenzetti, 1961, pp. 172 and 174, and by Pope-Hennessy, 1955, p. 55.

[45] Planiscig, 1930, pp. 52-4.

[46] Baroni, 1944, figure 362.

[47] Ibid., figure 322.

[48] Poggi # 147, 149-51.

[49] Ibid., # 150-1.

[50] The documentation relating to Urbano's figure of

a prophet is found in Annali della Fabbrica del Duomo di Milano, Appendix, I, 1883, p. 264; see also Nebbia, 1907, p. 87. Venturi, VI, 1908, pp. 49-50, attempted to identify "Prophet 2838" as Urbano's figure; a contrary view was offered by Baroni, 1944, p. 141. Until a secure work by Urbano appears, I do not think it will be possible to make a sensible decision on this matter. Urbano's return to Milan and further work at the cathedral is recorded in documents found in Annali della Fabbrica del Duomo di Milano, Appendix, II, 1885, pp. 7, 10-1, and 14. For his presence in Pavia see Nebbia, 1907, p. 87, note 2, and Venturi, VI, 1908, p. 49.

[51]See above note 50.

[52]Despite Baroni's objections (Baroni, 1944, pp. 157-8), the Arca Carelli seems very likely to date from between 1406 and 1408; see Annali della Fabbrica del Duomo di Milano, I, 1877, pp. 278, 286-7. Krautheimer, 1956, p. 79, dated it in 1406.

[53]Fiocco, "I Lamberti - I," 1927-8, p. 309, and Fiocco, 1959, p. 16. Paoletti, I, 1893, p. 13, already noted that there was a resemblance between the Saint Mark in Venice and the one which Niccolò carved for the facade of the Cathedral of Florence; however, he was hesitant and did not attribute the former work to Lamberti. C. von Fabriczy, 1900, p. 88, considered the Saint Mark as one of the works by "Niccolò d'Arezzo und seine Schuler," but did not go into the matter in greater detail than that.

[54]Planiscig, 1930, p. 54; Pope-Hennessy, 1955, p. 56; Lorenzetti, 1961, p. 170. They all agree with Fiocco.

[55]Fiocco, "I Lamberti - II," 1927-8, pp. 347-8; he was followed by Gamba, 1930, p. 258, and by Lorenzetti, 1961, p. 170. Planiscig, 1930, excluded them from his discussion of Piero's career and therefore presumably did not accept them as his work.

[56]Janson, II, 1957, p. 135, states that this form was first employed by Donatello (for the San Lorenzo roundels); however, it appears earlier here at San Marco.

[57]Baroni, 1944, figure 337.

[58]Fiocco, "I Lamberti - II," 1927-8, p. 347; the attribution was accepted by Gamba, 1930, p. 258, and Lorenzetti, 1961, p. 170. It was rejected by omission by Planiscig, 1930. Gnudi's attribution to Jacopo della Quercia was made in a lecture given at the Accademia Gallery in Venice and is mentioned in A. M. Matteucci, La Porta

Magna di San Petronio, Bologna, 1966, p. 68, note 32. According to Matteucci, Gnudi dates this pair of figures at about the time of Jacopo's Madonna and Child in Ferrara. Professor Gnudi was kind enough to confirm his ascription in a personal communication.

[59]The attribution of "Gigante 51" was made by Nebbia, 1907, p. 60. The ascription is opposed - I think wrongly - by Baroni, 1944, p. 144. For the best illustration of this work - although of a cast - see Seymour, 1966, Plate 3. For the San Babila see Nebbia, 1907, p. 103, and Baroni, 1944, p. 144 and figure 336.

[60]For Raverti (aside from the sources mentioned in note 59 above) see: Paoletti, I, 1893, pp. 20-3, 27, and 75-6; G. Mariacher, "Premesse Storiche alla Venuta dei Lombardi a Venezia nel '400," Atti del Reale Istituto Veneto di Scienze, Lettere, ed Arti, XCVII, 1937-8, pp. 577-86; Mariacher, 1939, pp. 23 ff.; G. Mariacher, "Di Alcune Sculture della Madonna dell'Orto," Ateneo Veneto, Anno CXXXI, V. 127, 1940, pp. 155-9; M. C. Visani, "Proposto per Matteo Raverti," Arte Veneta, XVI, 1962, pp. 31-41.

[61]See above p. 112 and note 4.

[62]Fiocco, "I Lamberti - I," 1927-8, p. 297, and Fiocco, 1959, p. 16.

Footnotes for Part 4

[1]Paoletti, I, 1893, pp. 13-4. The reliefs of the Genesis cycle and the eight seated figures are in a generally poor state of preservation; they are badly weathered and in many cases are missing important sections. The eight standing statuettes are in much better condition and lack only a few minor details.

[2]Ibid., I, p. 14. C. von Fabriczy, 1900, p. 88, ascribed the decoration of the main window to Niccolò and his school.

[3]Fiocco, "I Lamberti - II," 1927-8, pp. 348-50, and Fiocco, 1959, p. 16; his opinion was followed by Gamba, 1930, p. 258. Pope-Hennessy, 1955, p. 56, states that Piero possibly carved the Old Testament freize. Seymour, 1966, p. 44, speaks of the main arch reliefs as by the Lamberti.

[4]Planiscig, 1930, p. 54. Brunetti, 1934, p. 270, note 6, suggested that Rosso may have worked on the freize and that he possibly followed Niccolò to Venice in about

-265-

1416. There is no evidence of any kind to sustain this suggestion and it has not been taken up by Brunetti or any other scholar in recent years.

[5]Wundram, 1959, p. 100, note 31.

[6]Krautheimer, 1956, p. 210, note 9.

[7]O. Morisani, Tutta la Scultura di Jacopo della Quercia, Milan, 1962, Tavole 36 and 114.

[8]See Krautheimer, 1956, p. 5 and notes 3 and 5, and Fiocco, "I Lamberti - II," 1927-8, p. 346, for Ghiberti. For Uccello see J. Pope-Hennessy, Paolo Uccello, London, 1950, p. 2.

[9]Beck, 1970, Documents 26, 74, 119, 147, 151, 156-8, 160, 181, and 183.

[10]Krautheimer, 1956, Plates 82-3 and figures 70-1.

[11]Ibid., pp. 207-11.

[12]Planiscig, 1930, p. 54.

[13]Hanson, 1965, # 36, 68-9, for illustrations. Hanson is, I believe, correct in claiming the Rea Silva for Jacopo's hand (pp. 71-5).

[14]Beck, 1970, figure 34.

[15]Ibid., pp. 46, 51, and also 49.

[16]Ibid., figures 49-50.

[17]Paoletti, I, 1893, p. 13.

[18]Toesca, 1951, figure 275.

[19]Krautheimer, 1956, Plate 37.

[20]M. Muraro, "The Statutes of the Venetian Arti and the Mosaics of the Mascoli Chapel," Art Bulletin, XLIII, 1961, p. 264.

[21]Wundram, 1969, # 73-8 for illustrations.

[22]S. Bettini, Mosaici Antichi di San Marco a Venezia, Bergamo, n.d., Tavola LVII.

[23]Toesca, 1951, figure 274.

[24]Krautheimer, 1956, Plates 89-90.

[25] Ibid., Plates 27 and 48.

[26] See above note 11 for reference.

[27] Krautheimer, 1956, p. 162.

[28] Ibid., Plates 19-22.

[29] Ibid., Plate 40.

[30] Paoletti, I, 1893, p. 13; see also figure 16 and Tavola 3 for illustrations of the relief before it was heavily damaged.

[31] Krautheimer, 1956, Plate 93.

[32] Paoletti, I, 1893, p. 14, note 2, suggested that the decoration of the window arch took place during the period of restoration after the fire of 1419; C. von Fabriczy, 1900, p. 88, agrees with him.

[33] Poggi # 225 and 428.

[34] Wundram, 1969, # 48 for illustration.

[35] Krautheimer, 1956, Plates 30-1.

[36] Ibid., Plate 19a.

[37] Ibid., Plate 28.

[38] The documents for Ciuffagni's Isaiah are Poggi # 271, 273-8, 282-3, 285-91, and also 310 and 318.

[39] Paoletti, I, 1893, p. 14.

[40] See above p. 8 and notes 44-6 (for Part 1).

[41] Paoletti, I, 1893, p. 13.

[42] Lisner, 1958-9, p. 115, note 171, first noted this relationship.

[43] Fiocco, "I Lamberti - II," 1927-8, p. 350. He identifies the eight figures as the four Evangelists and the four Church Fathers; this is incorrect. The first three are Abraham, Isaac, and Jacob, as identified by inscriptions on their pedestals, while the fourth appears to be Noah, shown holding a model of his ark. The seventh statuette is identified by an inscription on its pedestal as Saint Matthew and it seems certain that its companions represent the remaining three Evangelists.

[44]See below p. 193.

[45]See above note 5 for Wundram's suggestion to that effect.

Footnotes for Part 5

[1]The full inscription reads as follows: "HEC BREVIS ILLVSTRI MOCENIGA AB ORIGINE THOMAM MAGNANIMUM TENET VRNA DVCEM GRAVEM ISTE MODESTVS IVSTICIE PRINCEPQ. FVIT DECVS IPSE SENATVS ETERNOS VENETVM TITOLOS SVPER ASTRA LOCAVIT HIC TEVCRVM TVMIDAM DELEVIT IN EQVORE CLASSEM OPPIDA TARVISI CENETE FELTRIQ. REDEMIT VNGARIAM DOMVIT RABIE PATRIMQ. SVBEGIT INDI FORI IVLII CATARVM SPALATVMQ. TAGVRAM EQVADRA PIRATIS PATEFECIT CLAVSA PEREMTIS DIGNA POLVM SVBIIT PATRIIS MENS FESSA TRIVMPHIS." This is followed by the sentence concerning the authorship of the tomb. For the death date of Tommaso Mocenigo see F. Zanotto, Il Palazzo Ducale di Venezia, IV, Venice, 1861, p. 203.

[2]On the short sides of the sarcophagus the figures of Hope and Justice are shown in niches; they are not easily seen and have never been photographed to my knowledge.

[3]These derivations were first pointed out by Planiscig, 1930, p. 63, and Paoletti, I, 1893, p. 76, respectively. Illustrations of the two earlier tombs are available in F. Z. Bocazzi, La Basilica dei Santi Giovanni e Paolo in Venezia, Venice, 1965, # 34 and 26.

[4]For examples see Toesca, 1951, figure 238, and Panofsky, 1964, # 397-8 and 401.

[5]Paoletti, I, 1893, p. 14.

[6]E. Müntz, Histoire de l'art pendant la Renaissance, I, Paris, 1889, p. 426, note 1; L. Courajod, Leçons professées a l'École du Louvre (1887-1896), II, Paris, 1901, p. 592; Fiocco, "I Lamberti - II," 1927-8, p. 362; Planiscig, 1930, p. 63.

[7]H. Kauffmann, Donatello, Berlin, 1935, p. 228, note 313; Janson, II, 1957, p. 62. Paoletti, I, 1893, p. 76, already doubted this relationship.

[8]Bocazzi, 1965, # 31, for illustration.

[9]Planiscig, 1930, p. 63; however, he does not relate the statuettes of the Mocenigo Tomb to those of the Coscia Tomb. They were related, though, by C. von Fabriczy and W. von Bode, in Jacob Burckhardt - Der Cicerone, 8th

edition, II, Leipzig, 1901, p. 496. Janson, II, 1957, p. 62, note 4, specifically rejects this possibility, claiming that the <u>Virtues</u> of the Fulgosio Monument, and not those of the Mocenigo Tomb, depend upon those of the Coscia Tomb. He also states that he follows Lord Balcarres, <u>Donatello</u>, London, 1903, p. 75, in this respect. Balcarres does not make this point and it is entirely incorrect in any case, since the figures of the Fulgosio Monument do not derive from those of the Coscia Tomb.

[10]For their collaboration see Janson, II, 1957, pp. 54-6, 61-2.

[11]U. Schlegel, "Zum Bildprogram der Arena Kapelle," <u>Zeitschrift für Kunstgeschichte</u>, XX, 1957, pp. 125-46, especially p. 130.

[12]Planiscig, 1930, pp. 63-8.

[13]Fogolari, 1930, p. 455 and figure 45. Fiocco, "I Lamberti - II," 1927-8, p. 363, states that the tomb was carved by assistants, while Lisner, 1958-9, p. 114, note 163, suggests that he was helped considerably.

[14]Paoletti, I, 1893, p. 76.

[15]Wundram, 1969, # 77 for illustration.

[16]Krautheimer, 1956, Plates 44 and 48.

[17]Wundram, 1969, # 5-6 and 66 for illustrations.

[18]Krautheimer, 1956, Plate 62b.

[19]For a review of the scholarly literature see Janson, II, 1957, pp. 39-40. Since then a contrary view has been offered by Pope-Hennessy, 1958, p. 277.

[20]Poggi, # 260 and 272.

[21]<u>Ibid</u>., # 263.

[22]Wundram, 1969, # 89 for illustration.

[23]Morisani, 1962, Tavole 57 and 63.

[24]B. Gonzati, <u>La Basilica di S. Antonio di Padova descritta ed illustrata</u>, II, Padua, 1854, p. 121, for a brief account of Fulgosio's career.

[25]Lazzarini, 1923, p. 154. The tomb was first related to Piero by W. von Bode, in <u>Jacob Burckhardt - Der</u>

Cicerone, 5th edition, II, Leipzig, 1884, p. 863.

[26]Lazzarini, 1923, p. 152.

[27]Rigoni, 1929, p. 121. Venturi, VI, 1908, pp. 226 and 228, had identified Giovanni Martino da Fiesole as Piero's collaborator, while Lazzarini, 1923, p. 150, had suggested Nanni di Bartolo.

[28]Rigoni, 1929, pp. 121 and 130.

[29]Lazzarini, 1923, p. 151.

[30]Ibid., p. 154.

[31]The inscription on the scroll reads as follows: "FVLGOSVS RAPHAEL VIRTVTVR IASRPIS VTROQE IVRE STVPOR TATVS Q FAMA QVATVS ET ORBIS SCRIPTIS MORTE VACAT TAR PARVO CLAV-DITVR ANTRO OBIIT ANN DOMINI M CCCC XXVII."

[32]Gonzati, II, 1854, pp. 119-20.

[33]See F. Saxl, "Jacopo Bellini and Mantegna as Antiquarians," Lectures, I, London, 1957, pp. 150-60.

[34]This was the opinion of Fogolari, 1930, p. 436.

[35]Planiscig, 1930, p. 69.

[36]The identity of these figures was first mentioned by Lazzarini, 1923, p. 149. For several trecento examples see Panofsky, 1964, # 289-90 and 400.

[37]Fiocco, "I Lamberti - II," 1927-8, pp. 350-2, and Fiocco, 1959, p. 16; followed by Gamba, 1930, p. 258, and Lorenzetti, 1961, p. 174. Pope-Hennessy, 1955, p. 56, as probably by Piero.

[38]Brunetti, 1934, pp. 265-6.

[39]C. Del Bravo, "Proposta e Appunti per Nanni di Bartolo," Paragone, XII, 1961, pp. 29-30.

[40]Fiocco, 1959, p. 23. He says that the fourth doccione, ". . . potrebbe essere stato aggiunto forse da Michelangelo, di cui ricorda gli Schiavi, nel tempo del suo esilio (1508)."

[41]See above Part 3, note 58 for reference. Professor Gnudi has also confirmed this attribution in a letter. Lorenzetti, 1961, p. 174, reports that G. Bariola had already attributed two of them to Quercia, G. Fiocco, "Antonio

da Firenze," Rivista d'Arte, XXII, 1940, p. 54, note 2, indicates that Bariola and Gombosi attributed the doccioni to Quercia, but gives no details or references.

[42] This is also the view of Dr. Wolfgang Wolters (personal communication).

[43] For illustration see K. Weitzmann, Greek Mythology in Byzantine Art, Princeton, 1951, figure 227.

[44] See, for example, the figure of Jonah on the back of the "Brescia lipsanotheca"; for an illustration of it see A. Grabar, Christian Iconography: A Study of its Origins, Bollingen Series XXXV, Princeton, 1968, # 337. For other examples see Weitzmann, 1951, figure 206 and many others.

[45] For examples of the scholarly opinion of the relationship between Jacopo and northern Gothic art see Pope-Hennessy, 1955, pp. 48 and 211, and Seymour, 1966, p. 38. Pope-Hennessy states, ". . . the course of his development can hardly be explained unless we assume him to have been familiar with Transalpine sculpture from the circle of Claus Sluter at Dijon." For his connection with Early Christian art see H. W. Janson, History of Art, New York, 1962, p. 311, and Hanson, 1965, pp. 62-3.

[46] Hanson, 1965, pp. 46-7, and note 1 on each page.

[47] Ibid., # 22 for illustration and pp. 62-3.

[48] M. Meiss, French Painting in the Time of Jean de Berry: The Boucicaut Master, London, 1968, pp. 68, 100, and figure 364.

[49] Hanson, 1965, # 17, for illustration.

[50] Matteucci, 1966, p. 68, note 32, dates them after 1410-2, but before the Trenta Altar. It is not clear from her note whether she is following Gnudi in this respect.

[51] Illustration in U. Baldini, L. Berti, and E. Michetti, Mostra di Quattro Maestri del Primo Rinascimento, Florence, 1954, Tavola XV.

[52] He received the commission for the San Petronio doorway on March 28, 1425; see Beck, 1970, Document 1.

[53] See above pp. 195-6.

[54] See above pp. 202-3.

[55] See above pp. 161-2 and 184-5.

[56]C. De Tolnay, The Youth of Michelangelo, Princeton, 1943, Plate 90.

[57]Saxl, II, 1957, Plate 90b.

[58]See above note 40.

[59]Those who have favored an attribution to Rosso are: Paoletti, I, 1893, p. 18 (hesitantly); Venturi, VI, 1908, p. 216; Lazzarini, 1923, p. 150; Brunetti, 1934, pp. 264-5; G. Mariacher, The Ducal Palace of Venice, translated by G. Heberdeen, Rome, 1956, p. 21; C. Gomez-Moreno, "Wandering Angels," Metropolitan Museum Bulletin, XX, 1961, p. 130, seems to favor the ascription to Rosso; Seymour, 1966, p. 103, gives it to.him with some hesitancy; G. Robertson, Giovanni Bellini, Oxford, 1968, p. 3, considers it mainly by Rosso; C. Gilbert, in an article entitled, "La Presenza a Venezia di Nanni di Bartolo Il Rosso," which will appear in a volume of dedicatory essays in honor of Antonio Morassi, supports the attribution to Rosso. The work was first related to Piero Lamberti by W. von Bode, II, 1884, p. 863. This attribution has since been agreed to by: W. von Bode and C. von Fabriczy, II, 1901, p. 406, with hesitancy; C. von Fabriczy, "Niccolò di Pietro Lamberti d'Arezzo. Nuovi appunti sulla vita e sulle opere del Maestro," Archivio Storico Italiano, 29, 1902, p. 325; Fiocco, "I Lamberti - II," 1927-8, pp. 364 and 368, and Fiocco, 1959, p. 19; Lorenzetti, 1961, p. 241. Pope-Hennessy, 1955, pp. 221-2, lists it as a work by Piero, but suggests that it ". . . probably results from some form of collaboration between Giovanni and Bartolommeo Buon and a Florentine artist." He also indicates that the quality of the work is above Piero's level, but recognizes the similarity between the figure of the executioner and the doccioni, which he considers the work of Piero. Finally, he allows that the attribution to Rosso is not untenable. Gamba, 1930, p. 258, agreed with the attribution to Piero. Gnudi (for reference see above Part 3, note 58), ascribed the group to Jacopo della Quercia, but in a personal communication has indicated some hesitancy on this point. Planiscig, 1930, pp. 110-1, attributed the group to the Buon studio. Fogolari, 1932, pp. 42-3, insisted upon its Venetian character, but offered no specific attribution.

[60]For the Brenzoni Tomb see: Planiscig, 1930, pp. 79-86; R. Brenzoni, "Niccolò de Rangonis de Brenzono e il suo mausoleo in S. Fermo di Verona," Archivio Veneto, XII, 1932, pp. 242-70; Brunetti, 1934, pp. 263-4 and p. 270, note 7; Del Bravo, 1961, pp. 28-9; Pope-Hennessy, 1955, p. 217; Seymour, 1966, p. 100; Gilbert, "La Presenza," (not yet published).

[61]For the Tolentino portal see: C. von Fabriczy, "Giovanni di Bartolo il Rosso and das Portal von S. Nicolò zu Tolentino in der Marken," Repertorium für Kunstwissenschaft, XXVIII, 1905, pp. 96-7; Planiscig, 1930, pp. 77-9, 82, and 84-6; Brunetti, 1934, p. 266 and p. 271, note 10; Pope-Hennessy, 1955, pp. 56 and 217; Del Bravo, 1961, p. 29; Gilbert, "La Presenza," (not yet published).

[62]Brenzoni, 1932, especially pp. 266-7. Gilbert, "La Presenza," (not yet published), feels that the tomb was only begun in 1426, while Brenzoni interpreted the inscription as indicating that it was completed by that year. Either view seems acceptable from a documentary standpoint; for reasons which support Brenzoni's opinion see below.

[63]For a correct reading and interpretation of the two inscriptions on the doorway see C. von Fabriczy, 1905, pp. 96-7, and Gilbert, "La Presenza" (not yet published). The first inscription states that the work was ordered by Niccolò da Tolentino in 1432. The second reveals that the sculpture was brought from Venice by Battista da Tolentino in 1435 and composed ("composuit") by Rosso. Despite this seeming ambiguity as to Rosso's role, I see no reason to doubt that he was in charge of the decoration from the outset.

[64]See above note 60 for bibliography on this matter.

[65]See above note 61 for bibliography on this subject.

[66]Krautheimer, 1956, p. 116, note 7.

[67]Hanson, 1965, # 23 and 69 for illustrations.

[68]Wundram, 1969, # 80 for illustration.

[69]Gilbert, "La Presenza" (not yet published), feels that the architectural design is in part dependent upon the form of the arches over the upper exterior windows of the three tribunes of the Cathedral of Florence (for illustration see Toesca, 1951, figure 20). He uses this point to argue against the idea that the design is North Italian in character (Planiscig, 1930, p. 79). He could also have noted that the illusionistic niches with domes along the side pilasters were derived from the work of Niccolò Lamberti. Despite Gilbert's argument to the contrary, I feel that the overall effect of the portal is quite decorative and not classicizing, and that it would be difficult to imagine it coming into existence in its present form without Rosso's northern experience. It should also be noted

that the specific forms which Gilbert believes reflect those
found on the Cathedral of Florence can be seen with equal
or greater frequency in Venice.

[70]The inscription behind it reads, "IVSTITIA."

[71]Inscription: "TRAIANO IPERADORE CHE DIE IVSTITIA
A LA VEDOVA."

[72]Inscription: "QVADO MOISE RICEVE LALEGE I SVL
MONTE."

[73]Inscription: "NVMA PONPILIO IPERADOR EDIFICHADOR
DITEPI ECHIESE." Planiscig, 1930, p. 74, transcribed
"IPERADOR" as "IMPERADOR."

[74]The inscription was transcribed by Planiscig,
1930, p. 74, as follows: "ISIPIONE ACHASTITA CHE . . .
ELAFIA ARE." The section from the E of CHE through the F
is no longer legible.

[75]Inscription: "SALO VNO DEISETE SAVI DIGRECIA
CHE DIE LEGGE."

[76]Inscription: ". . . (a)L PVOLO DLE SVO ISELERITA."

[77]Inscription: "ARISTOT(I or E)LE CHE DIE LEGE."
The inscription may have been altered since the time when
Planiscig transcribed it (1930), since the E at the end
of ARISTOTILE is easily legible, but was not transcribed
by him (Planiscig, 1930, p. 74).

[78]F. Zanotto, Il Palazzo Ducale di Venezia, I,
Venice, 1853, p. 224, refers to it as the, ". . . capitello
detto della Giustizia o de' Legislatori."

[79]J. Seznec, The Survival of the Pagan Gods, trans-
lated by B. Sessions, Bollingen Series, XXXVIII, New York,
1953, p. 18.

[80]Venturi, VI, 1908, p. 224, describes the repre-
sentation as "Venezia nell'aspetto della stessa Giustizia."

[81]I. B. Supino, Giotto, Florence, 1920, # CLII for
illustration. For iconographic points see N. Rubenstein,
"Political Ideas in Sienese Art; The Frescoes by Ambrogio
Lorenzetti and Taddeo di Bartolo in the Palazzo Pubblico,"
Journal of the Warburg and Courtauld Institutes, XXI, 1958,
pp. 179 ff.

[82]For Foscari see: Zanotto, IV, 1861, pp. 205-22;
A. da Mosto, I Dogi di Venezia, Milan, 1960, pp. 162 ff.;

H. R. Trevor-Roper, "Doge Francesco Foscari," The Horizon
Book of the Renaissance, New York, 1961, pp. 273-80;
Muraro, 1961, p. 264.

[83]Paoletti, I, 1893, p. 12, was the first to notice
this.

[84]Foscari was made Procurator of San Marco on January 26, 1415; see Zanotto, IV, 1861, p. 219.

[85]H. Baron, The Crisis of the Early Renaissance,
revised edition, Princeton, 1966, pp. 391-4.

[86]Ibid., p. 547, note 66.

[87]Ibid., p. 548, note 68.

[88]For the various ways in which the inscription
has been read see G. Fiocco, "La Segnatura del Capitello
della Giustizia," Atti del Reale Istituto Veneto di Scienze,
Lettere, ed Arti, XC, 1930-1, pp. 1041-8. It was first
published by Zanotto, I, 1853, p. 219. Fogolari, 1930, p.
438, note 1, has doubted the fact that the inscription once
existed; this seems unreasonable to me.

[89]Muraro, 1961, p. 270, note 31.

[90]Zanotto, I, 1853, pp. 219-24; Paoletti, I, 1893,
p. 13. This view has been followed by: Fiocco, "I Lamberti -
II," 1927-8, pp. 363-4; C. von Fabriczy, "Neues zum Leben -
2," 1902, p. 169; Venturi, VI, 1908, pp. 224-6; Lorenzetti,
1961, p. 243.

[91]Planiscig, 1930, pp. 74-5.

[92]Ibid., p. 74.

[93]Paoletti, I, 1893, p. 12.

[94]Ibid., I, pp. 11-2.

[95]Ibid., I, p. 11. It was restored by a sculptor
named Pietro Lorandini.

[96]Planiscig, 1930, p. 65.

[97]See above pp. 217-9. Paoletti, I, 1893, p. 18,
distinguished between the styles of the Judgment of Solomon
and the capital reliefs. Seymour, 1966, p. 103, states,
". . . the chances are overwhelmingly strong that the capital,
its inscription, and the group were conceived as a unit, and
should be considered so today." It may well be that the

capital and the group above were, generally speaking, conceived together, but I can see no reason to apply the inscription to the Judgment of Solomon because of this. As Paoletti noted, the stylistic character of the two works is entirely different.

[98]Work on the western side of the Ducal Palace began in 1424; this is therefore a firm terminus post quem for all of the sculpture which adorns it. See Paoletti, I, 1893, p. 6.

Footnotes for Part 6

[1]See above Part 2, note 7 for reference.

[2]See above Part 2, note 8 for reference.

[3]See above Part 2, note 9 for reference.

[4]Rigoni, 1929, p. 130, for document.

[5]See above Part 1, note 44, for reference.

[6]See above Part 1, note 45, for reference.

[7]See above Part 1, note 46, for reference.

[8]See above Part 1, note 47, for reference.

[9]The suggestion was first made by F. Filippini, "Nicolò Lamberti e il monumento di Alessandro V in Bologna," Il Comune di Bologna, November, 1929, pp. 5-6. It has been taken up again, with hesitancy, by Beck, 1970, p. 59, note 33. F. Filippini, "La Tomba di Alessandro V in Bologna," L'archiginnasio, 9, 1914, p. 401, note 2, states, in reference to the work at San Petronio, "Fu forse il Lamberti impiegato come direttore di lavoro ed architetto?" Beck, 1970, p. 139, note 2, makes a similar tentative suggestion.

[10]Vasari-Milanesi, II, 1878, p. 139; illustrations of the tomb are found in Supino, II, 1938, pp. 277-9. The attribution to Niccolò was maintained at first by A. Rubbiani, La Chiesa e il Convento di San Francesco in Bologna, Bologna, 1886, p. 74. A. Venturi, "Sperandio da Mantova," Archivio Storico dell'Arte, Anno II, Fasc. V-VI, 1889, pp. 229-34, ascribed it to Sperandio. Rubbiani then changed his original opinion and gave it to Sperandio; for this see A. Rubbiani, "La Tomba di Alessandro V in Bologna, opera di M. Sperandio da Mantova," Atti e Memorie della Regia Deputazione di Storia Patria per le provincie di Romagna, Serie 3, II, 1894, pp. 57-68. C. von Fabriczy, "Niccolò

di Pietro Lamberti," 1902, p. 323, considered the present
monument a substitute for one made by Lamberti. Supino, II,
1938, pp. 276-7 and caption to the illustration on p. 279,
gave the upper three figures and the effigy to Lamberti,
while to Sperandio, he attributed the lower section of the
monument. Filippini, 1914, pp. 392-406, and Filippini,
1929, pp. 3-6, ascribed it to Lamberti. M. Salmi, Letture
Vasariane: La Vita di Niccolò di Piero, Scultore e Archi-
tetto Aretino, Arezzo, 1910, p. 30, rejected the attribution
to Lamberti. This was also true of L. Planiscig, "Nicolò
di Piero Lamberti," Allgemeines Lexikon der Bildenden Kunst-
ler von der Antike bis zur Gegenwart, U. Thieme and F. Becker,
XXV, Leipzig, 1931, p. 437; he ascribed it to Sperandio.
Pope-Hennessy, 1958, p. 90, gives the Madonna and Child to
Sperandio, but does not mention the tomb otherwise. Sey-
mour, 1966, p. 274, states that, ". . . he (Sperandio) did
the monument of Alexander V in S. Francesco." Beck, 1970,
p. 59, note 33, says that Lamberti worked on the tomb, but
does not indicate whether or to what extent the tomb pres-
ently in San Francesco is the same as Lamberti's.

[11]For the documents relating Sperandio to the tomb
see Filippini, 1914, p. 394. It is true, as he suggests,
that they do not prove that Sperandio was responsible for
the entire work.

[12]Ibid., pp. 395-7.

[13]See above Part 1, note 48 for reference.

[14]For the document see above p. 8; for the refer-
ence see above Part 1, note 49.

[15]Wundram, 1969, p. 146, suggests that Nanni may
have visited Rome just before his work on the Saint Phillip
began. This seems like a very reasonable, if not a provable,
hypothesis.

[16]For the relationship between Ghiberti and the
Antique see Krautheimer, 1956, pp. 277-93, and pp. 86-93
(for the Saint Matthew and its connection with classical
art).

[17]Morisani, 1962, Tavole 12-27, for illustrations.

[18]Ibid., Tavole 56-65.

[19]Ibid., Tavole 68-73.

[20]By far the best study of the relationship between
Donatello and the Antique is offered by H. W. Janson, "Dona-
tello and the Antique," Donatello e il suo Tempo, Atti dell'

-277-

VIII Convegno Internazionale di Studi sul Rinascimento, Florence, 1966, pp. 77-96.

[21]Fiocco, "I Lamberti - II," 1927-8, pp. 343-76, and Fiocco, 1959, pp. 16, 19-20.

[22]For bibliography on the Buon see above Part 3, note 29. For Bregno see: Paoletti, I, 1893, pp. 44-5, 143, 145-7, and 149; Planiscig, 1921, pp. 30-7; G. Mariacher, "Antonio da Righeggio e Antonio Rizzo," Le Arti, II, 1941, pp. 193-8; G. Mariacher, "New Light on Antonio Bregno," Burlington Magazine, XCII, 1950, pp. 123-8; Pope-Hennessy, 1958, pp. 107 and 348-9; Seymour, 1966, pp. 97-8, 103, and 260.

Bibliography

Baroni, C. Sculture Gotice Lombarda. Milan, 1944.

Becherucci, .., and Brunetti, G. Il Museo dell'Opera del Duomo a Firenze. 2 volumes. Florence, n.d.

Beck, J. H. Jacopo della Quercia e il portale di San Petronio a Bologna. Bologna, 1970.

Bocazzi, F. Z. La Basilica dei Santi Giovanni e Paolo in Venezia. Venice, 1965.

Bode, W. von. Denkmäler der Renaissance - Sculptur Toscanas. Munich, 1892-1905.

Brenzoni, R. "Niccolò de Rangonis de Brenzono e il suo mausooleo in San Fermo di Verona." Archivio Veneto, XII, 1932, pp. 242 ff.

Brunetti, G. "Ricerche su Nanni di Bartolo il Rosso." Bolletino d'Arte, 28, 1934, pp. 258 ff.

_____. "Jacopo della Quercia a Firenze." Belli Arti, I, 1951, pp. 3 ff.

_____. "Jacopo della Quercia and the Porta della Mandorla." Art Quarterly, XV, 1952, pp. 119 ff.

_____. "Osservazioni sulla Porta dei Canonici." Mitteilung des Kunsthistorisches Instituts in Florenz, VIII, 1957, pp. 1 ff.

_____. "Riadattamenti e Spostamenti di Statue Fiorentine del Primo Quattrocento." Donatello e il suo Tempo, Atti dell'VIII Convegno Internazionale di Studi sul Rinascimento. Florence, 1966, pp. 277 ff.

_____. "I Profeti sulla porta del Campanile di Santa Maria del Fiore." Festschrift Ulrich Middeldorf. I, Berlin, 1968, pp. 106 ff.

Jacob Burckhardt - Der Cicerone. Bode, W. von. 5th edition. II, Leipzig, 1884.

Jacob Burckhardt - Der Cicerone. Bode, W. von., and Fabriczy, C. von. 8th edition. II, Leipzig, 1901.

Burger, F. Geschichte der Florentinischen Grabmals. Stassburg, 1901.

-279-

Courajod, L. Leçons Professées a l'École du Louvre (1887-
1896). II, Paris, 1901.

Del Bravo, C. "Proposta e Appunti per Nanni di Bartolo."
Paragone, XII, 1961, pp. 26 ff.

Fabriczy, C. von. "Opere dimenticate di Niccolò d'Arezzo."
Archivio Storico dell'Arte, Anno III, Fasc. III-IV,
1890, p. 161.

_____. "Neues zum Leben und Werke des Niccolò d'Arezzo -
1.", Repertorium für Kunstwissenschaft, XXIII, 1900,
pp. 88 ff.

_____. "Neues zum Leben und Werke des Niccolò d'Arezzo -
2." Repertorium für Kunstwissenschaft, XXV, 1902,
pp. 157 ff.

_____. "Niccolò di Piero Lamberti d'Arezzo.Nuovi appunti
sulla vita e sulle opere del Maestro." Archivio
Storico Italiano, 29, 1902, pp. 308.

_____. "Giovanni di Bartolo il Rosso und das Portal von
S. Nicolò zu Tolentino in der Marken." Repertorium
für Kunstwissenschaft, XXVIII, 1905, pp. 96-7.

Filippini, F. "La Tomba di Alessandro V in Bologna." L'ar-
chiginnasio, 9, 1914, pp. 392 ff.

_____. "Nicolò Lamberti e il monumento di Alessandro
V in Bologna." Il Comune di Bologna, November,
1929, pp. 3-6.

Fiocco, G. L'arte di Andrea Mantegna. 1st edition. Bologna,
1927.

_____. "I Lamberti a Venezia - I, Niccolò di Pietro."
Dedalo, VIII, 1927-8, pp. 287 ff.

_____. "I Lamberti a Venezia - II, Pietro di Niccolò
Lamberti." Dedalo, VIII, 1927-8, pp. 343 ff.

_____. "I Lamberti a Venezia - III, Imitatori e Seguaci."
Dedalo, VIII, 1927-8, pp. 432 ff.

_____. "La Lunetta nel Portale della Scuola Grande di
San Marco." Rivista mensile della Città di Venezia,
VII, 1928, pp. 177 ff.

_____. "Agostino di Duccio a Venezia." Rivista d'Arte,
XII, 1930, pp. 261 ff.

_____. Review of E. Rigoni, "Notizie di scultori toscani

a Padova nella prima meta del quattrocento." Ri-
vista d'Arte, XII, 1930, pp. 151 ff.

_____. "La Segnatura del Capitello della Giustizia."
Atti del Reale Istituto Veneto di Scienze, Lettere
ed Arti, XC, 1930-1, pp. 1041 ff.

_____. Review of G. Fogolari, "L'Urna del Beato Pacifico
ai Frari." Rivista d'Arte, XIII, 1931, pp. 281 ff.

_____. Review of L. Planiscig, "Die Bildhauer Venedigs
in der ersten Hälfte des Quattrocento." Rivista
d'Arte, XIII, 1931, pp. 265 ff.

_____. "Antonio da Firenze." Rivista d'Arte, XXII, 1940,
pp. 51 ff.

_____. L'arte di Andrea Mantegna, 2nd endition. Venice,
1959.

Fogolari, G. "La Chiesa di Santa Maria della Carità di
Venezia (ora sede delle Regie Gallerie dell'Accade-
mia)." Archivio Veneto-Tridentino, V, 1924, pp.
57 ff.

_____. "L'Urna del Beato Pacifico ai Frari." Atti del
Reale Istituto Veneto di Scienze, Lettere ed Arti,
LXXXIX, 1929-30, pp. 937 ff.

_____. "Gli scultori toscani a Venezia e Bartolomeo Bon,
Veneziano." L'Arte, XXXIII, 1930, pp. 427 ff.

_____. I Frari e I Santi Giovanni e Paolo. Milan, 1931.

_____. "Ancora di Bartolomeo Bon Scultore Veneziano."
L'Arte, XXXV, 1932, pp. 27 ff.

Gallo, R. "L'Arma di Marco Dandolo sulla Porta di Borgo
Poscollo a Udine." Rivista mensile della Città
di Venezia, VII, 1928, pp. 15 ff.

Gamba, C. "L'opera di Pietro Lamberti." Rivista mensile
della Città di Venezia, IX, 1930, pp. 257 ff.

Gaye, G. Carteggio inedito d'artisti. I, Florence, 1839.

Guasti, C. Il Pergamo di Donatello pel Duomo di Prato.
Florence, 1887.

Gilbert, C. "La Presenza a Venezia di Nanni di Bartolo Il
Rosso." Unpublished article which will appear in
a book of essays in honor of Antonio Morassi.

Gombosi, G. "Eine Kleinbronze Niccolò Lambertis aus dem
Jahre 1407." Adolph Goldschmidt zum seinen 70.
Geburtstag. Berlin, 1935, pp. 119 ff.

Gomez-Moreno, C. "Wandering Angels." Metropolitan Museum
Bulletin, 20, 1961, pp. 127 ff.

Gonzati, B. La Basilica di S. Antonio di Padova descritta
ed illustrata. II, Padua, 1854.

Gosebruch, M. "Florentinische Kapitelle von Brunelleschi
bis zum Tempio Malatestiano." Römisches Jahrbuch
für Kunstwissenschaft, 8, 1959, pp. 132 ff.

Hanson, A. C. Jacopo della Quercia's Fonte Gaia. Oxford,
1965.

Janson, H. W. The Sculpture of Donatello. 2 volumes.
Princeton, 1957.

Kauffmann, H. "Florentiner Domplastik." Jahrbuch der preus-
sischen Kunstsammlungen, XLVII, 1926, pp. 141 ff.
and 216 ff.

Krautheimer, R. "Terracotta Madonnas." Parnassus, VIII,
1936, pp. 4 ff. (reprinted in: Krautheimer, R.
Studies in Early Christian, Medieval, and Renais-
sance Art. New York, 1969 - with a postscript).

_____. "A Drawing for the Fonte Gaia in Siena." Metro-
politan Museum Bulletin, 10, 1952, pp. 265 ff.

_____., and Krautheimer-Hess, T. Lorenzo Ghiberti.
Princeton, 1956.

Lanyi, J. "Le statue quattrocentesche dei Profeti nel
Campanile e nell'antica facciata di Santa Maria
del Fiore." Rivista d'Arte, XVII, 1935, pp. 121 ff.

Lazzarini, V. "Il Mausoleo di Raffaello Fulgosio nella
Basilica del Santo." Archivio Veneto-Tridentino,
III, 1923, pp. 147 ff.

Lisner, M. "Zur frühen Bildhauerarchitektur Donatellos."
Münchner Jahrbuch der bildenden Kunst, IX-X, 1958-9,
pp. 94 ff. and 113 ff.

_____. "Zum Frühwerk Donatellos." Münchner Jahrbuch der
bildenden Kunst, XIII, 1962, pp. 63 ff.

_____. "Intorno al Crocifisso di Donatello in Santa
Croce." Donatello e il suo Tempo, Atti dell'VIII

Convegno Internazionale di Studi sul Rinascimento, Florence, 1966, pp. 115 ff.

Lorenzetti, G. Venice and its Lagoon. Translated by J. Guthrie. Rome, 1961.

Marchini, G. Il Duomo di Prato. 1957, n.p.

Mariacher, G. "Premesse Storiche alla Venuta dei Lombardi a Venezia nel '400." Atti del Reale Istituto Veneto di Scienze, Lettere ed Arti, XCVII, 1937-8, pp. 577 ff.

_____. "Matteo Raverti nell'arte veneziana del primo quattrocento." Rivista d'Arte, XXI, 1939, pp. 23 ff.

_____. "New Light on Antonio Bregno." Burlington Magazine, XCII, 1950, pp. 123 ff.

_____. The Ducal Palace of Venice. Translated by G. Heberdeen. Rome, 1956.

Müntz, E. Histoire de l'art pendant la Renaissance. I, Paris, 1889.

Muraro, M. "The Statutes of the Venetian Arti and the Mosaics of the Mascoli Chapel." Art Bulletin, XLIII, 1961, pp. 263 ff.

Nebbia, U. La Scultura nel Duomo di Milano. Milan, 1907.

Ongania, F., ed. La Basilica di San Marco. Documents volume, Venice, 1881.

Origo, I. The Merchant of Prato. Oxford, 1957.

Paatz, E., and Paatz, W. Die Kirchen von Florenz. 6 volumes, Frankfort-au-Main, 1940-52.

Paatz, W. "Ein frühes Donatellianisches Lunettengrabmal vom Jahre 1417." Mitteilung des Kunsthistorisches Instituts in Florenz, III, 1932, pp. 539 ff.

Panofsky, E. Tomb Sculpture. New York, 1964.

Paoletti, P. L'Architettura e la Scultura del Rinascimento a Venezia. 2 volumes, Venice, 1893.

_____. "Nuovi Ritocchi alla Storia della Chiesa di San Marco." Atti del Reale Istituto di Belle Arti in Venezia, July, 1904, p. 80-9.

_____. La Scuola Grande di San Marco. Venice, 1929.

Piattoli, R. "Il Pela, Agnolo Gaddi e Giovanni d'Ambrogio alle prese con la giustizia." Rivista d'Arte, XIV, pp. 377 ff.

Planiscig, L. Venezianische Bildhauer der Renaissance. Vienna, 1921.

_____. "Die Bildhauer Venedigs in der ersten Hälfte des Quattrocento." Jahrbuch der Kunsthistorischen Sammlungen in Wien, N.F., IV, 1930, pp. 47 ff.

_____. "Nicolò di Piero Lamberti." Allgemeines Lexicon der Bildenden Kunstler von der Antike bis zur Gegenwart. U. Thieme and F. Becker. Vol. XXV.

_____. "Piero di Nicolò Lamberti." Allgemeines Lexicon der Bildenden Kunstler von der Antike bis zur Gegenwart. U. Thieme and F. Becker. Vol. XXVII.

Poggi, G. La cappella e la tomba di Onofrio Strozzi nella Chiesa di Santa Trinità 1419-1423. Florence, 1903.

_____. Il Duomo di Firenze, documenti sulla decorazione della chiesa e del campanile tratti dell'archivio dell'Opera. Italienische Forschungen, Kunsthistorisches Institut in Florenze, II, Berlin - Leipzig, 1909.

Pope-Hennessy, J. Italian Gothic Sculpture. London, 1955.

_____. Italian Renaissance Sculpture. London, 1958.

_____. Catalogue of Italian Sculpture in the Victoria and Albert Museum. 3 volumes. London, 1964.

Procacci, U. "Niccolò di Pietro Lamberti, detto il Pela e Niccolò di Luca Spinelli d'Arezzo." Il Vasari, I, 1927-8, pp. 300 ff.

Reymond, M. La sculpture florentine, I: Prédécesseurs de l'école florentine et la sculpture florentine au XIV siecle. Florence, 1897.

_____. "La Tomba di Onofrio Strozzi." L'Arte, VI, 1903, pp. 7 ff.

Rigoni, E. "Notizie di scultori toscani a Padova nella prima metà del quattrocento." Archivio Veneto, VI, 1929, pp. 118 ff.

Rubbiani, A. "La Tomba di Alessandro V. in Bologna, opera
di M. Sperandio da Mantova." Atti e Memorie della
Regia Deputazione di Storia Patria per le provincie
di Romagna, serie 3, II, 1892-3, pp. 57 ff.

Salmi, M. Letture Vasariane: La Vita di Niccolò di Piero
Scultore e Architetto Aretino. Arezzo, 1910.

Schmarsow, A. "Bemerkungen Uber Niccolò d'Arezzo." Jahr-
buch der königlich preussischen Kunstsammlungen,
VIII, 1887, pp. 227 ff.

Semper, H. Donatello. seine Zeit und Scule. Vienna, 1875.

Seymour, C. "The Younger Masters of the First Campaign of
the Porta della Mandorla." Art Bulletin, XLI, 1959,
pp. 1 ff.

_____. Sculpture in Italy 1400 to 1500. Baltimore, 1966.

Supino, I. B. La scultura in Bologna nel secolo XV. Bologna,
1910.

_____. L'arte nelle chiese di Bologna. II, Bologna, 1938.

Swarzenski, G. "A Bronze Statuette of St. Christopher."
Bulletin of the Museum of Fine Arts, XLIX, 1951,
pp. 84 ff.

Toesca, P. Il Trecento. Turin, 1951.

Vasari, G. Le Vite De' Più Eccelenti Pittori, Scultori, ed
Architettori, scritte da Giorgio Vasari. edited
and annotated by G. Milanesi. II, Florence, 1878.

Venturi, A. "Sperandio da Mantova." Archivio Storico dell'
Arte, Anno II, Fasc. V-VI, 1889, pp. 229 ff.

_____. Storia dell'Arte Italiana. IV, Milan, 1906.

_____. Storia dell'Arte Italiana. VI, Milan, 1908.

Wundram, M. "Donatello und Ciuffagni." Zeitschrift für
Kunstgeschichte, XXII, 1959, pp. 85 ff.

_____. "Der Meister der Verkündigung in der Domopera zu
Florenz." Beiträge zur Kunstgeschichte - eine Fest-
gabe für H. R. Rosemann zum 9. Oktober 1960. Munich,
pp. 109 ff.

_____. "Albizzo di Piero: Studien zur Bauplastik von
Or San Michele in Florenz." Das Werk des Kunstlers:

Studien zur Ikonographie und Formgeschichte -
Hubert Schrade zum 60. Geburtstag. Stuttgart,
1960, pp. 161 ff.

_____. "Niccolò di Pietro Lamberti und die Florentiner
Plastik um 1400." Jahrbuch der Berliner Museen,
IV, 1962, pp. 79 ff.

_____. "Donatello e Nanni di Banco negli Anni 1408-9."
Donatello e il suo Tempo, Atti dell'VIII Convegno
Internazionale di Studi sul Rinascimento. Florence,
1966, pp. 69 ff.

_____. "Der heilige Jacobus an Or San Michele in Florenz."
Festschrift Karl Oettinger. Erlangen, 1967, pp.
193 ff.

_____. Donatello und Nanni di Banco. Berlin, 1969.

Zanotto, F. Il Palazzo Ducale di Venezia. I, Venice, 1853.

_____. Il Palazzo Ducale di Venezia. IV, Venice, 1861.

ILLUSTRATIONS

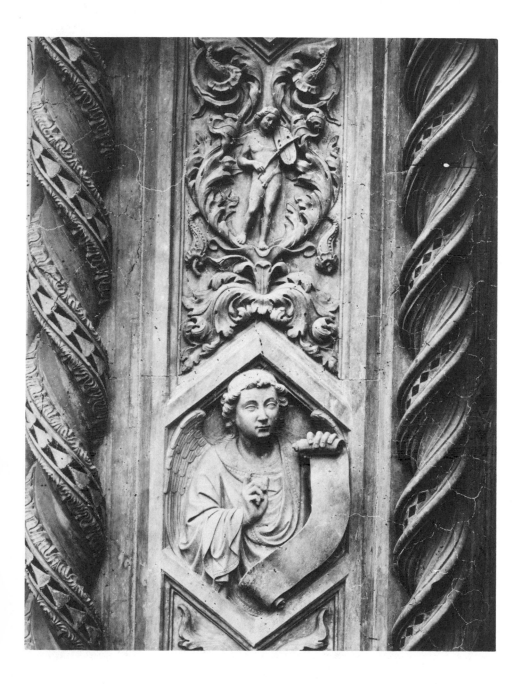

1

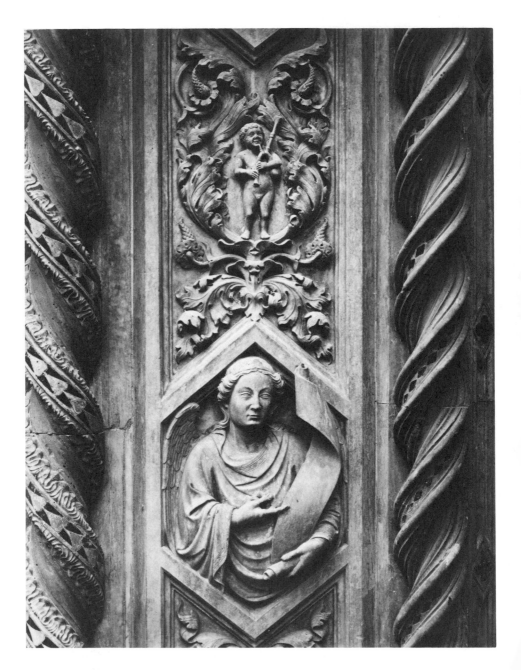

2

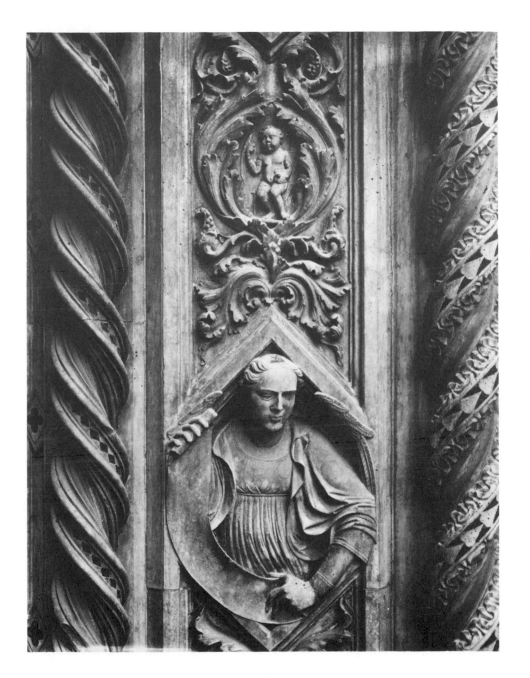

3

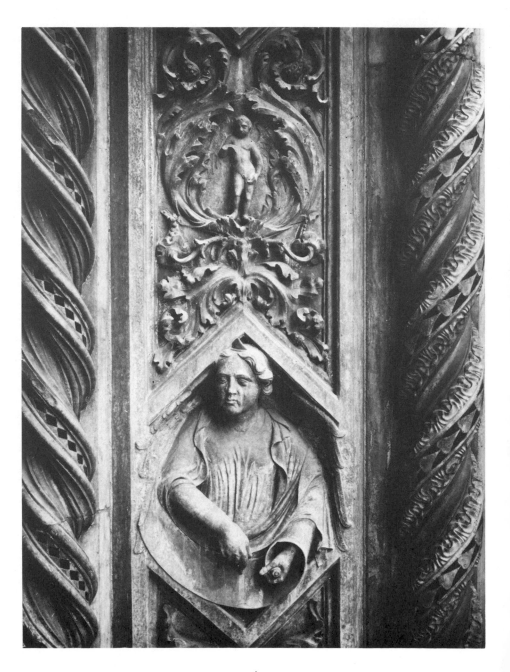

4

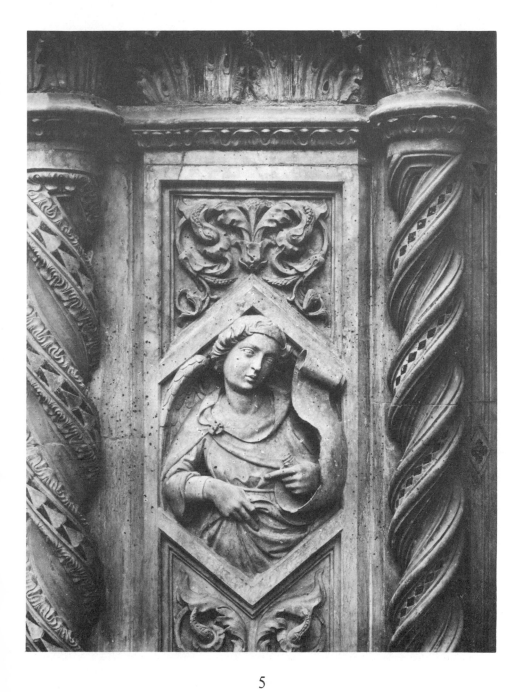

5

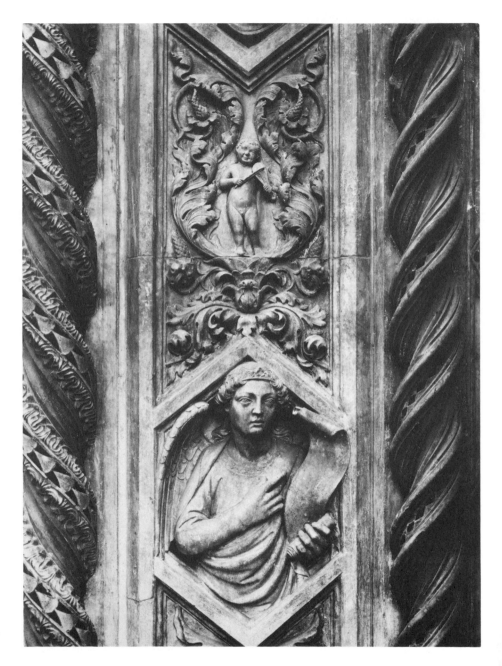

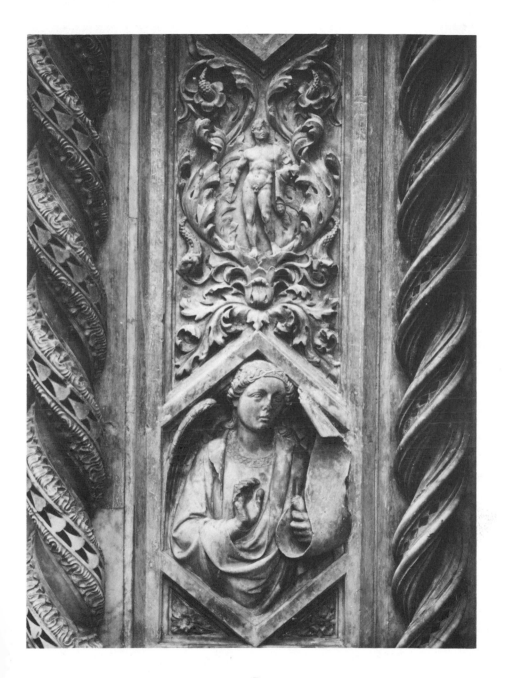

7

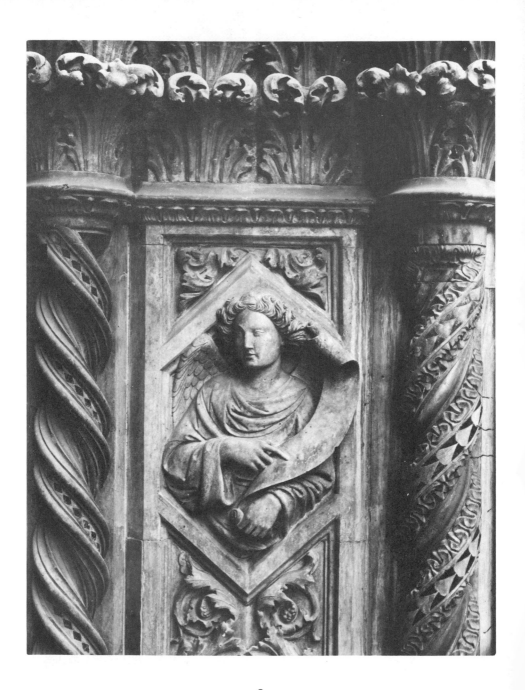

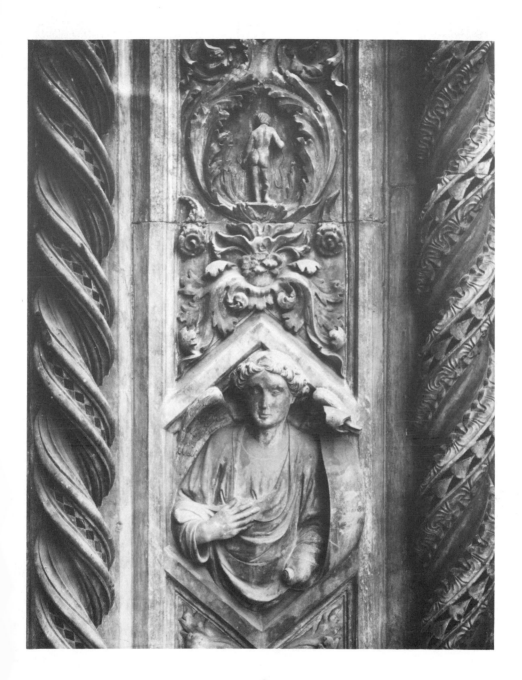

9

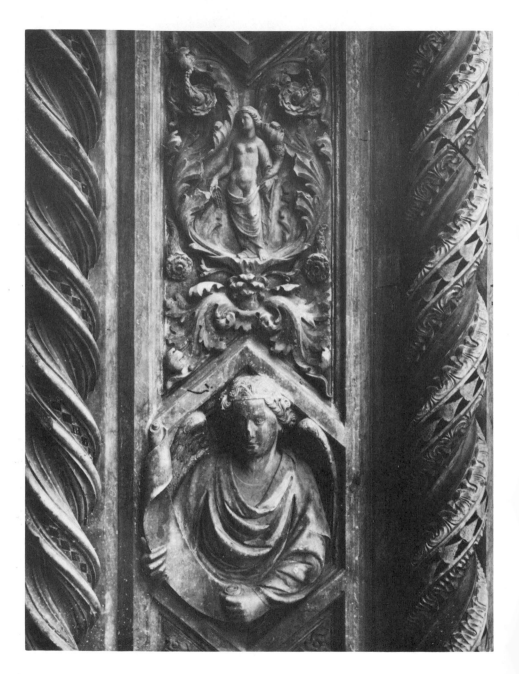

10

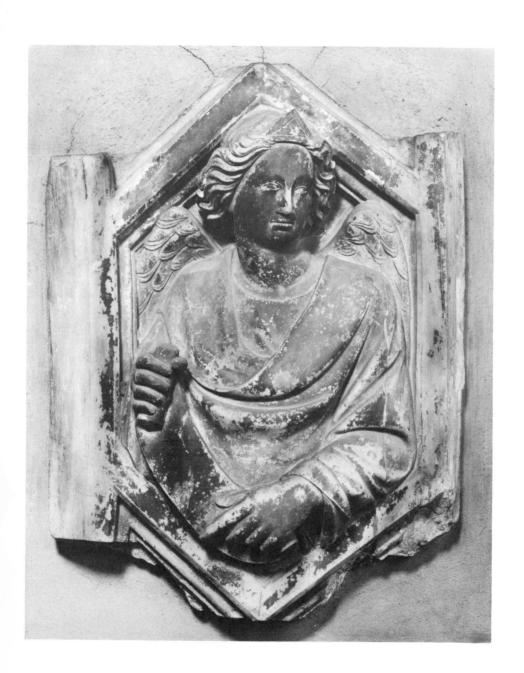

11

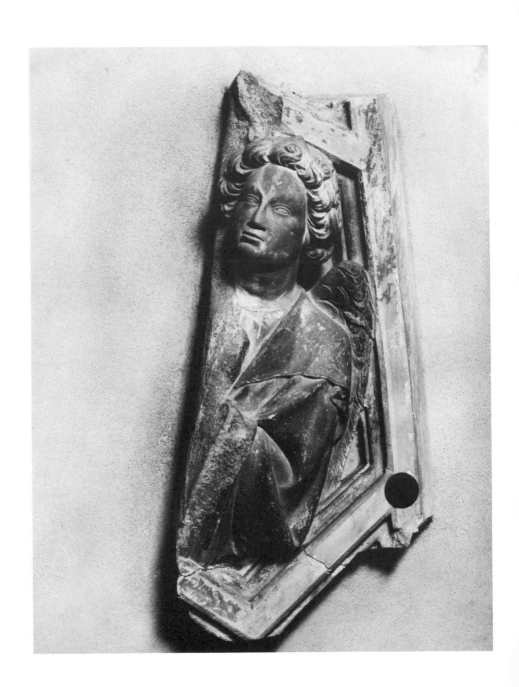

12

13

14

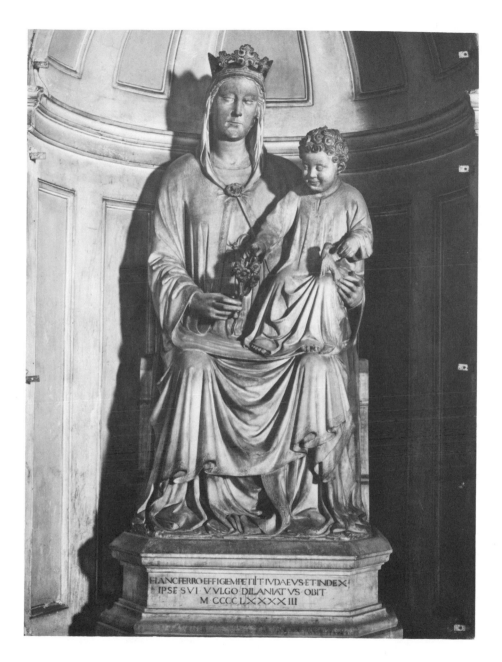

15

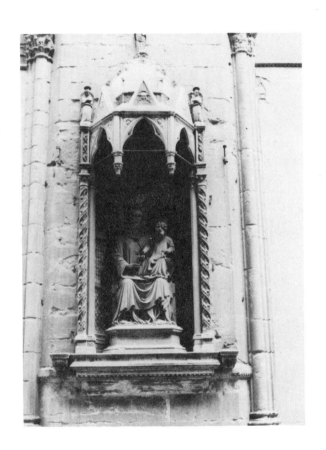

16

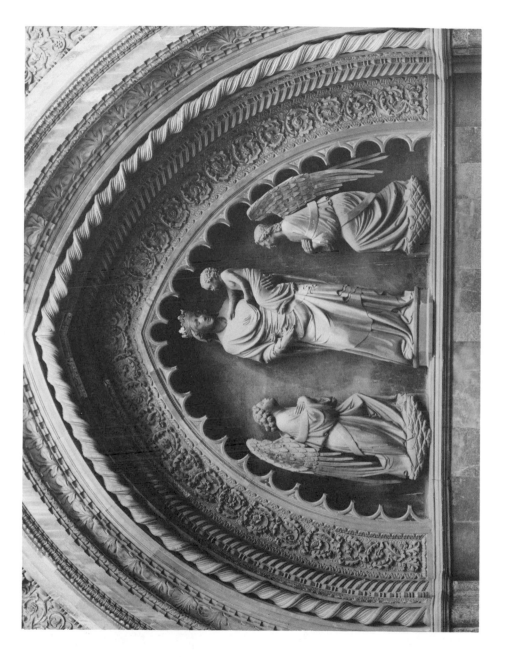

17

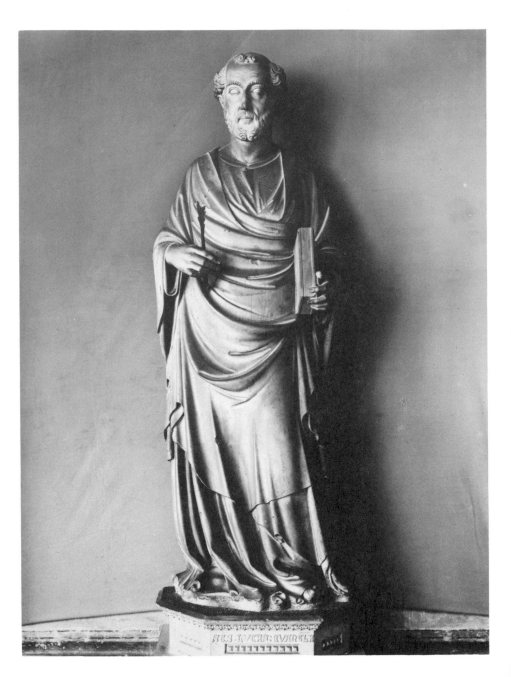

18

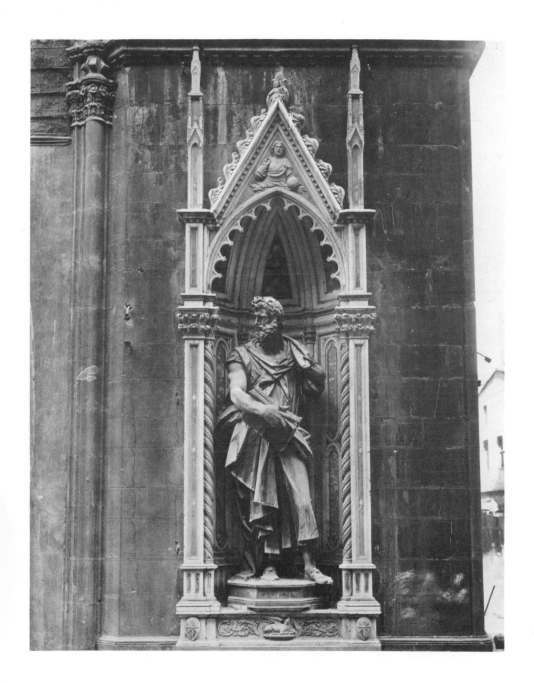

19

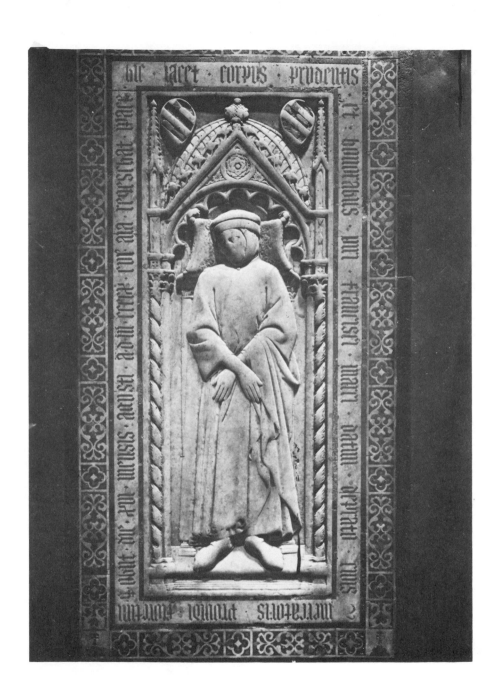

20

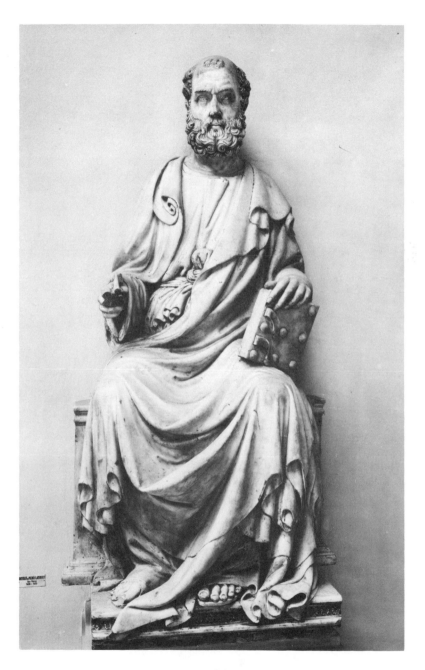

21

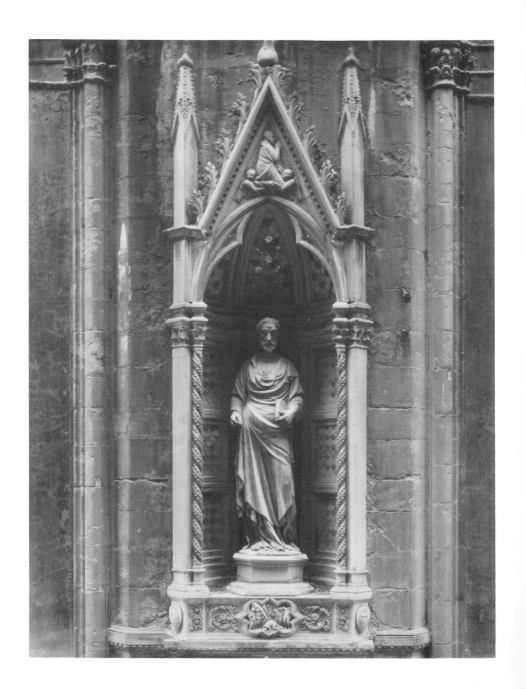

23

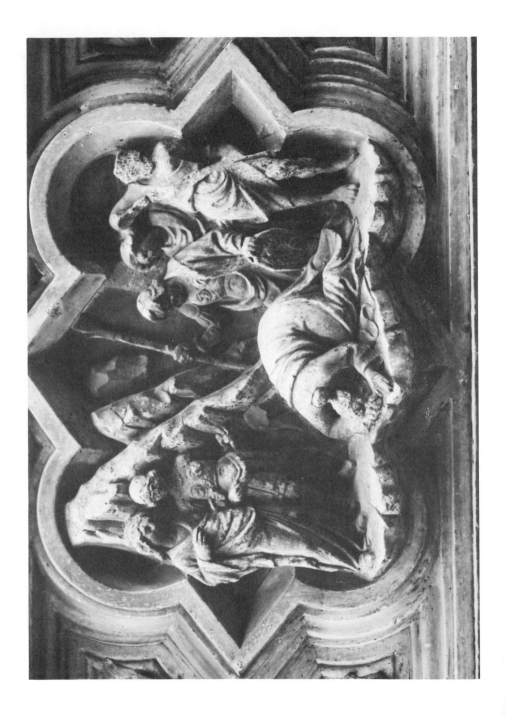

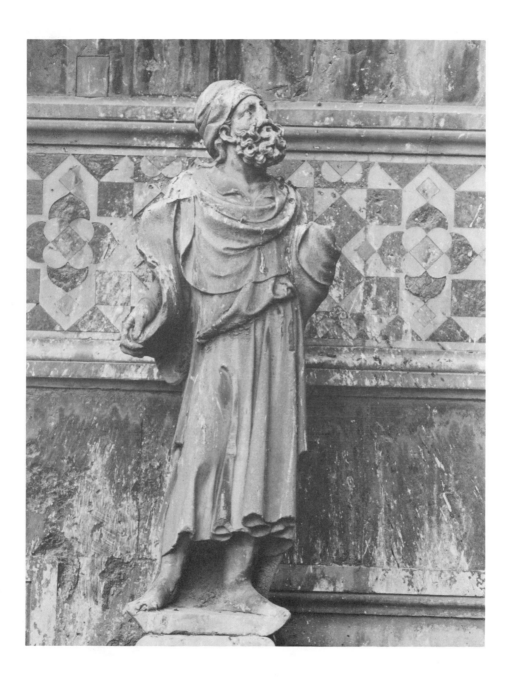

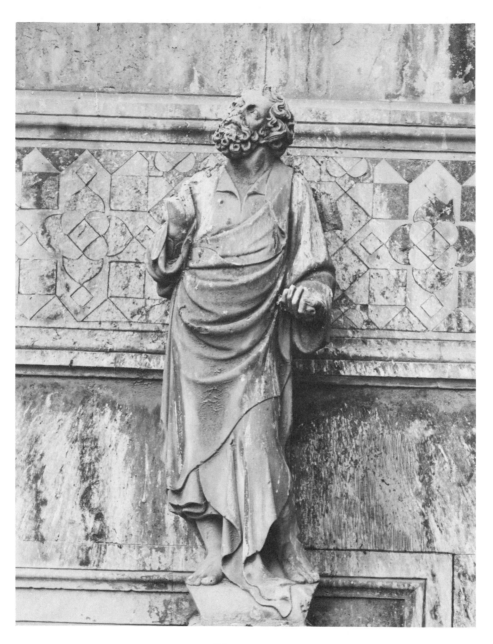

26

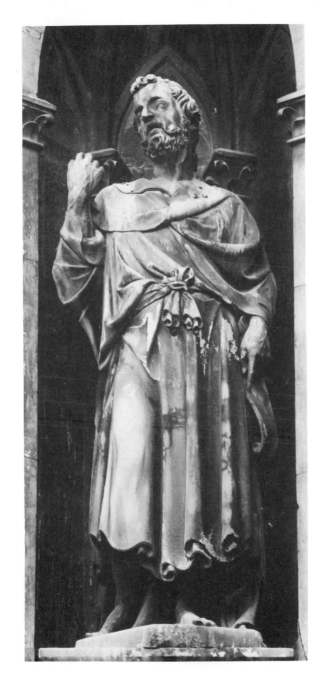

27

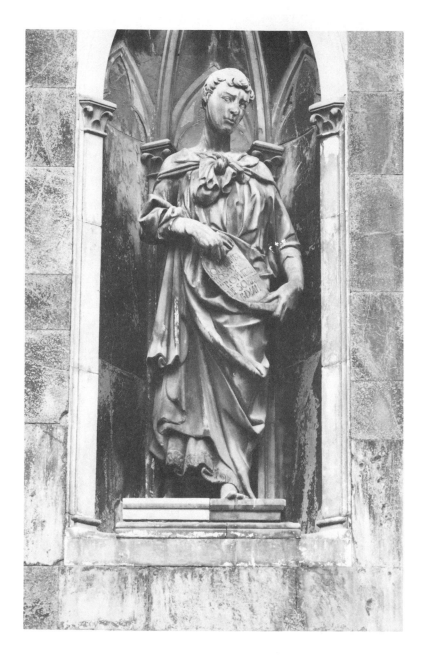

28

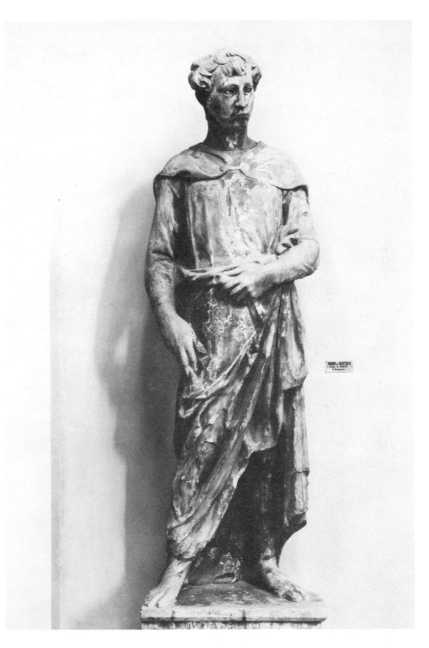

29

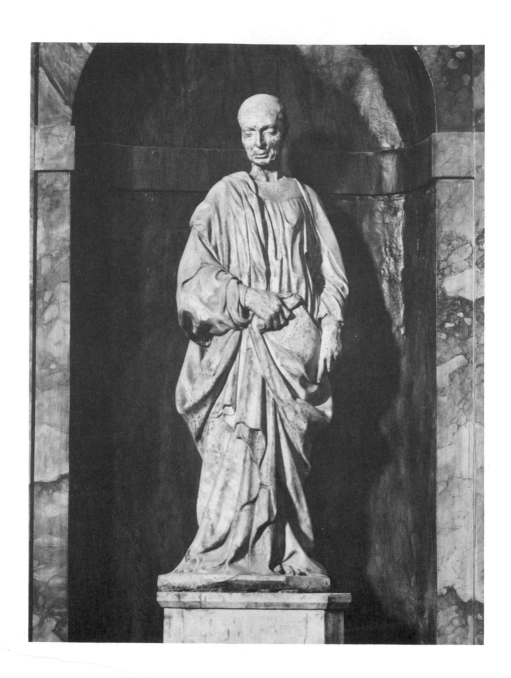

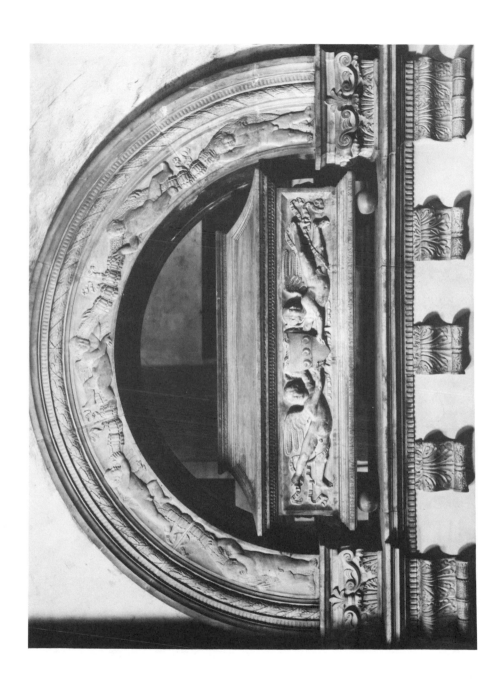

31

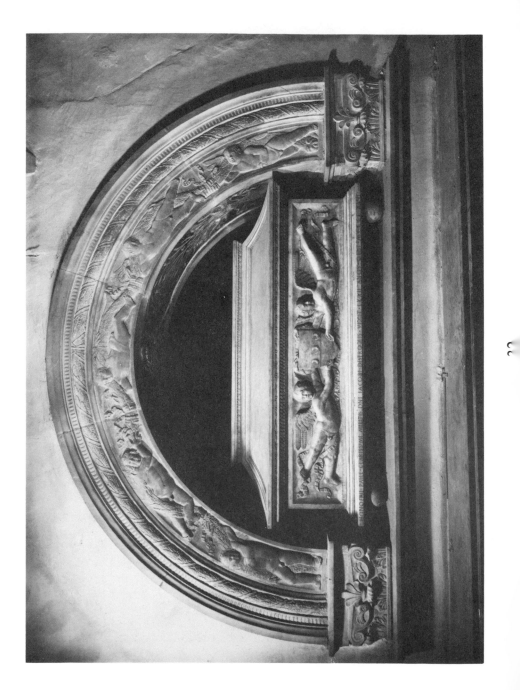

33

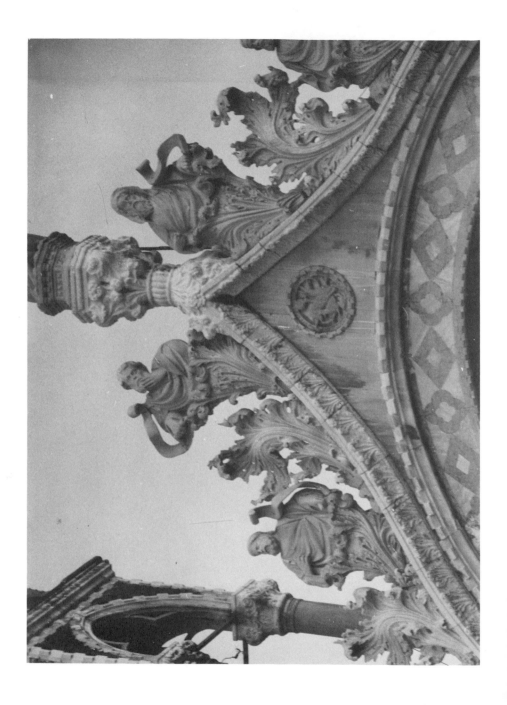

35

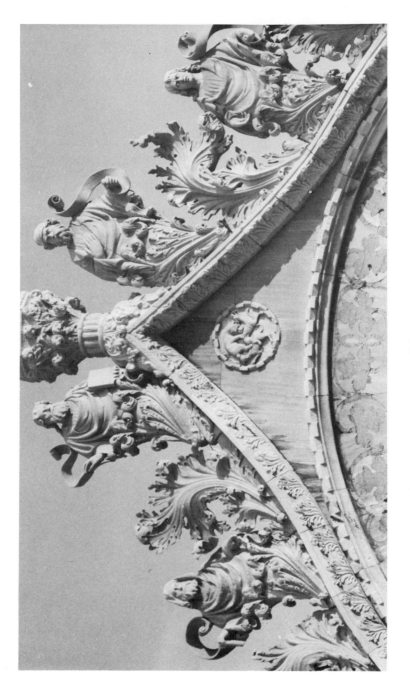

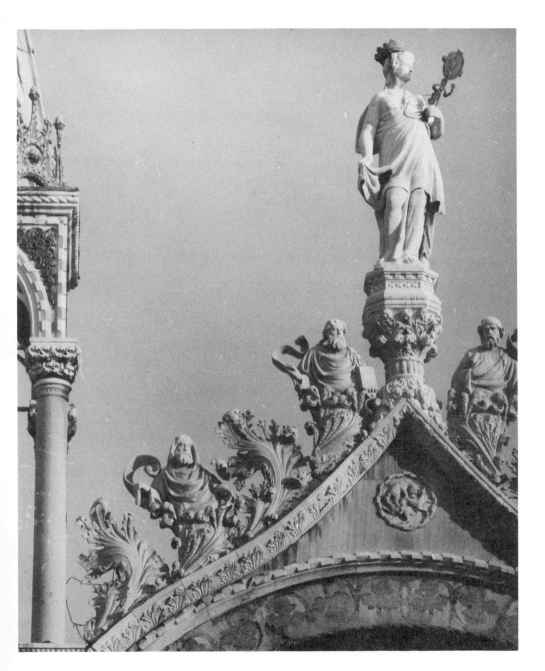

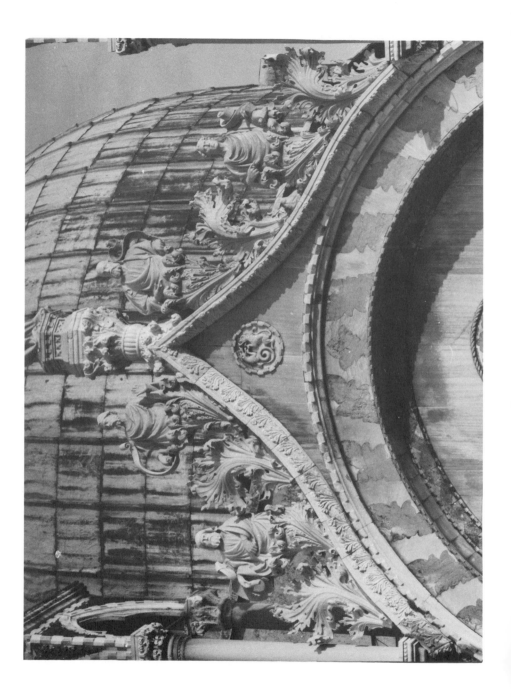

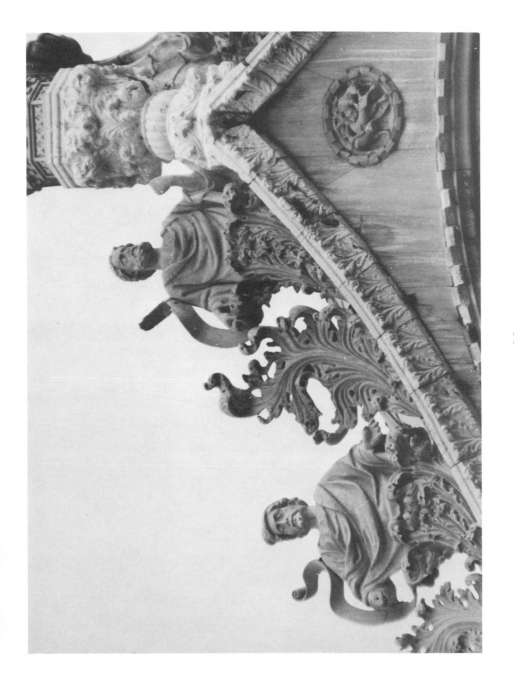

39

41

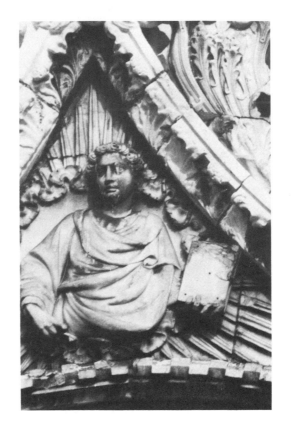

44

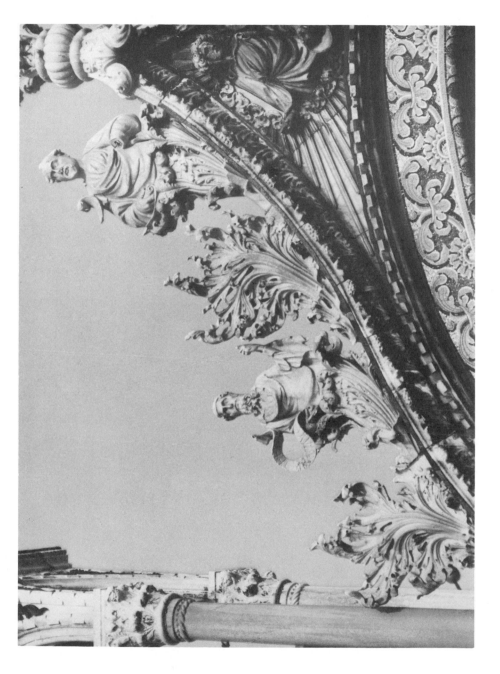

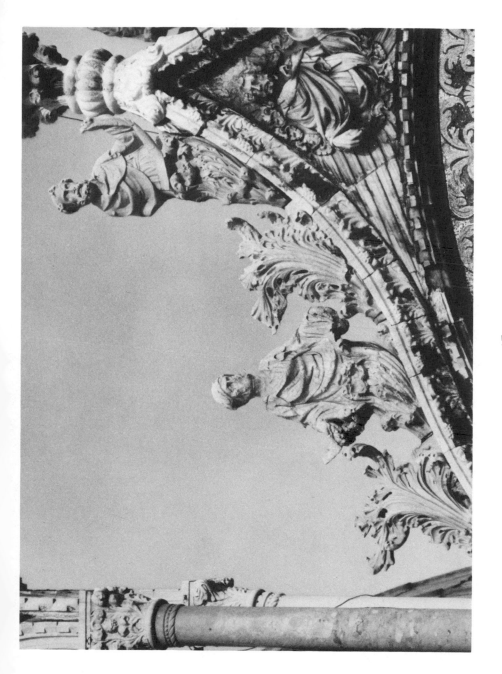

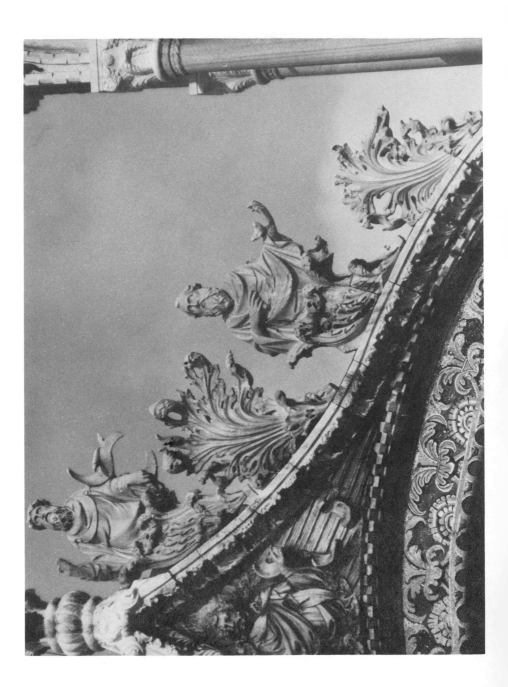

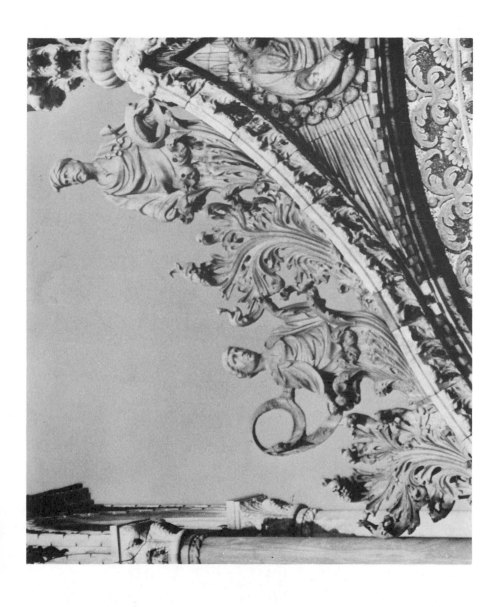

49

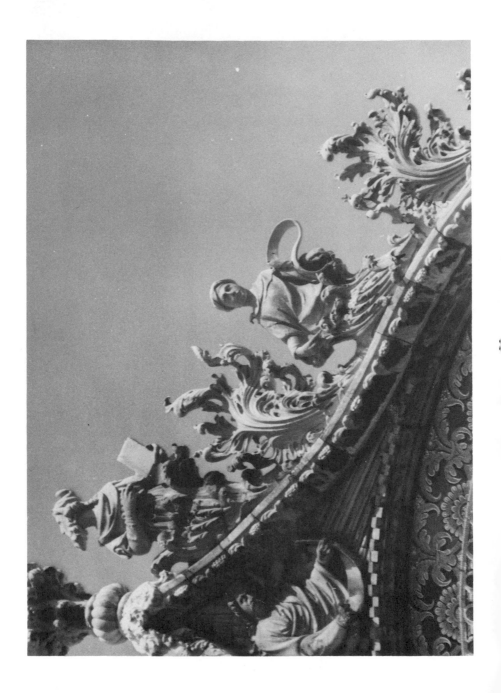

51

53

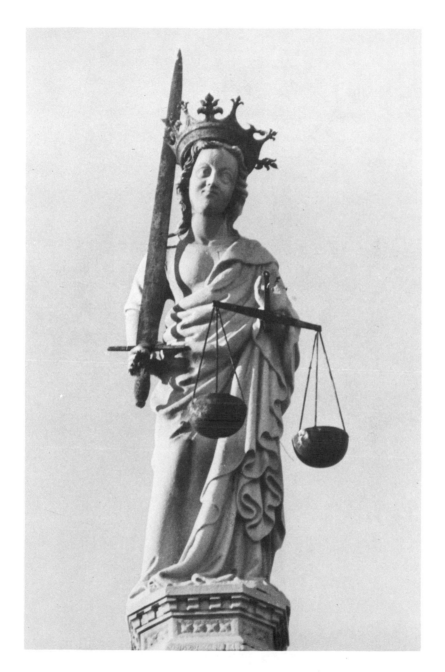

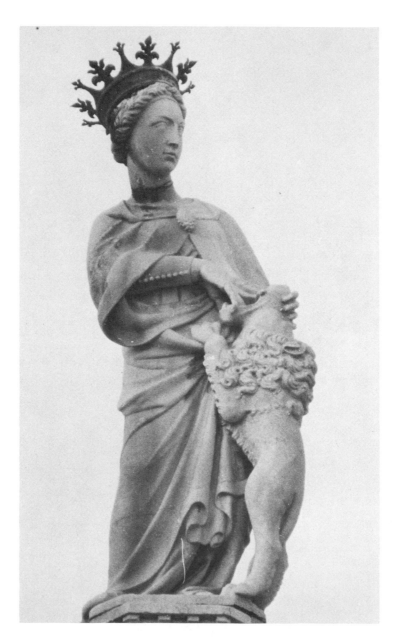

56

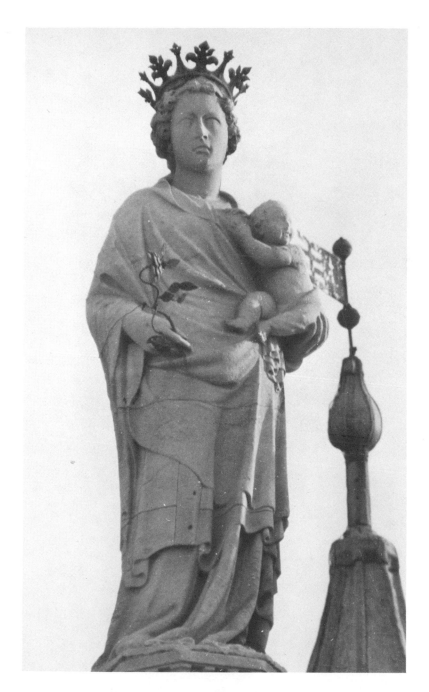

57

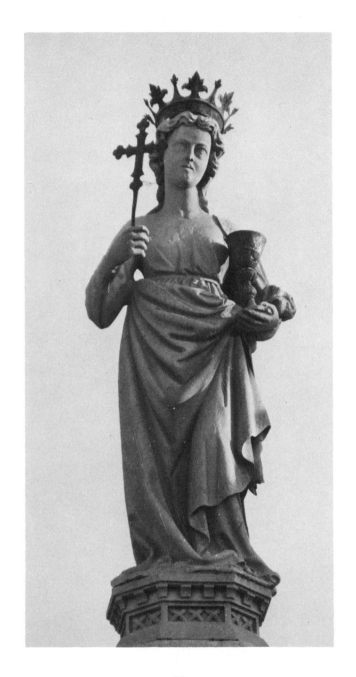

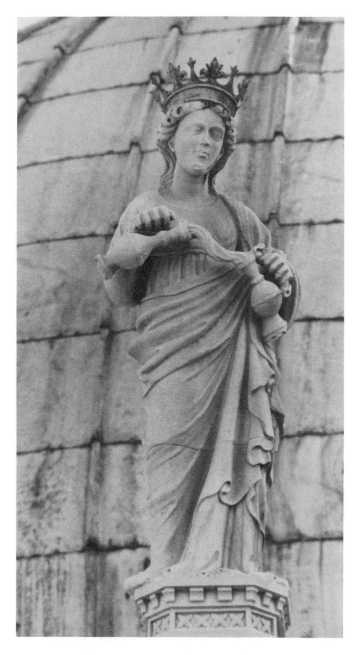

59

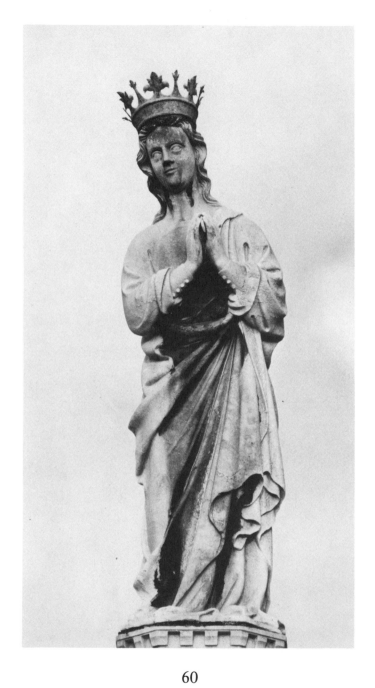

60

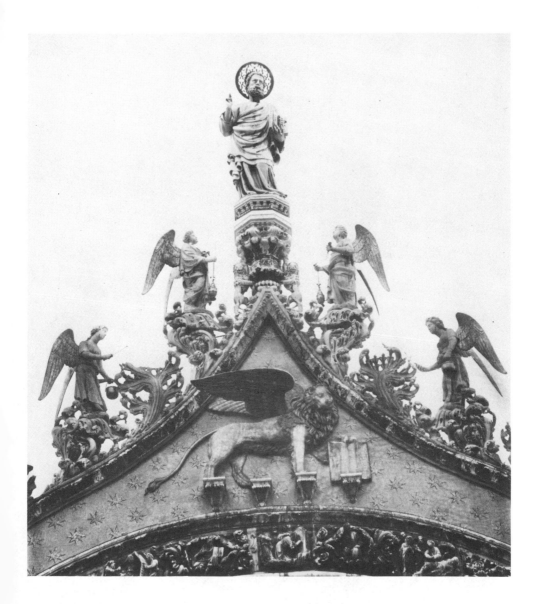

61

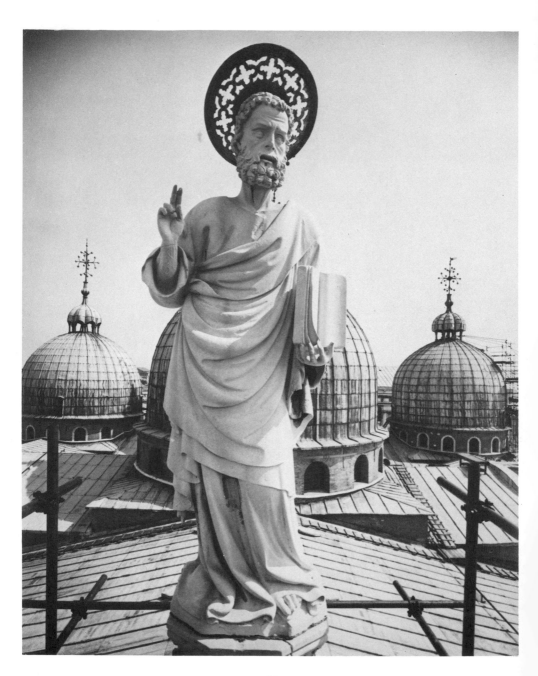

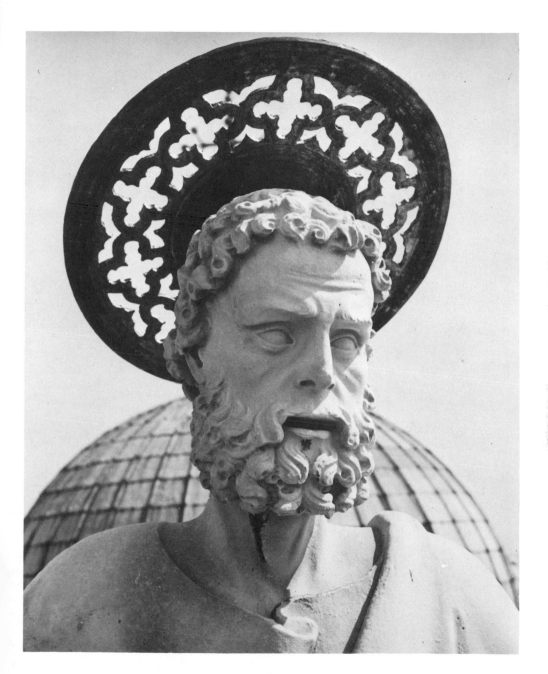

63

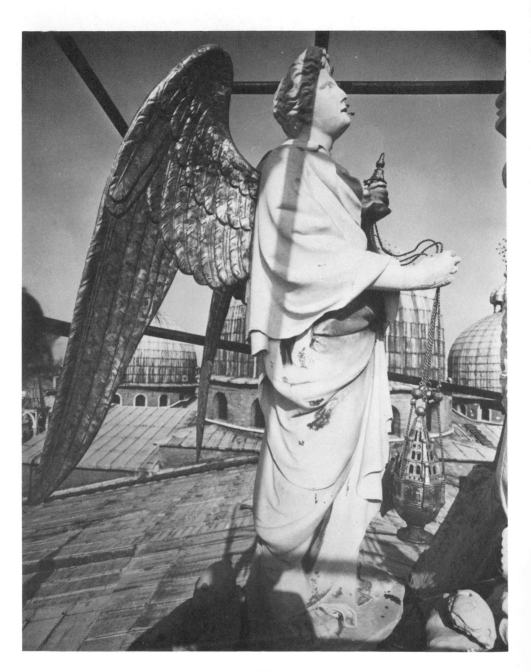

64

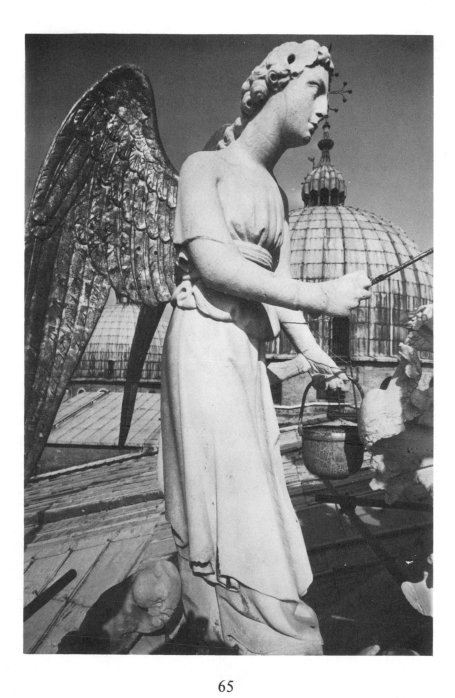

65

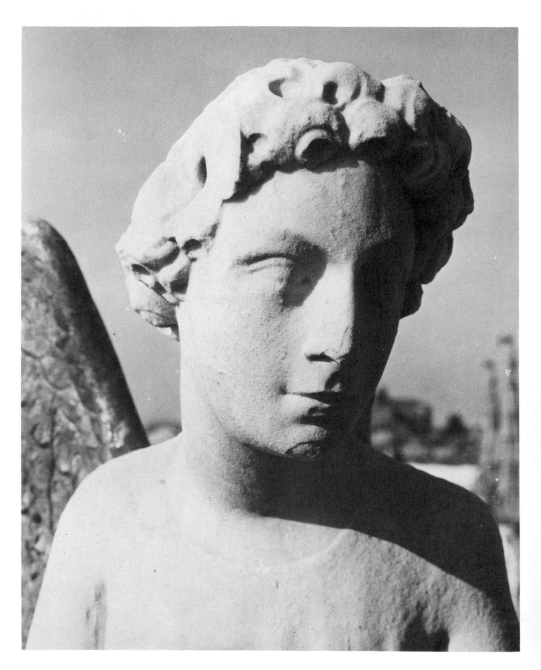

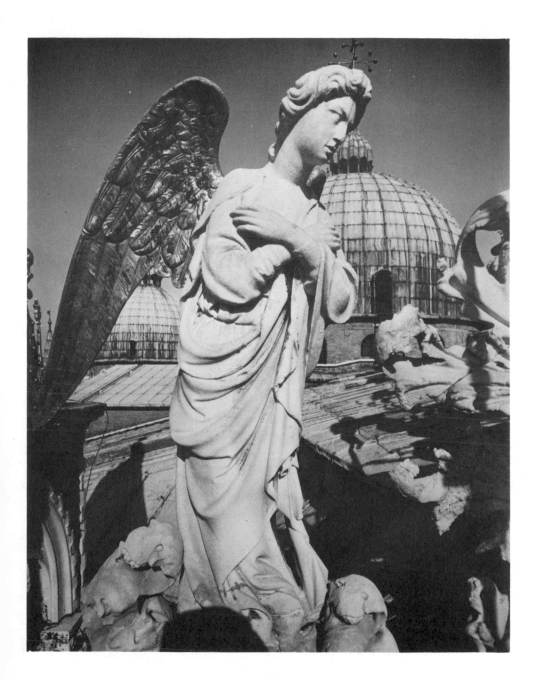

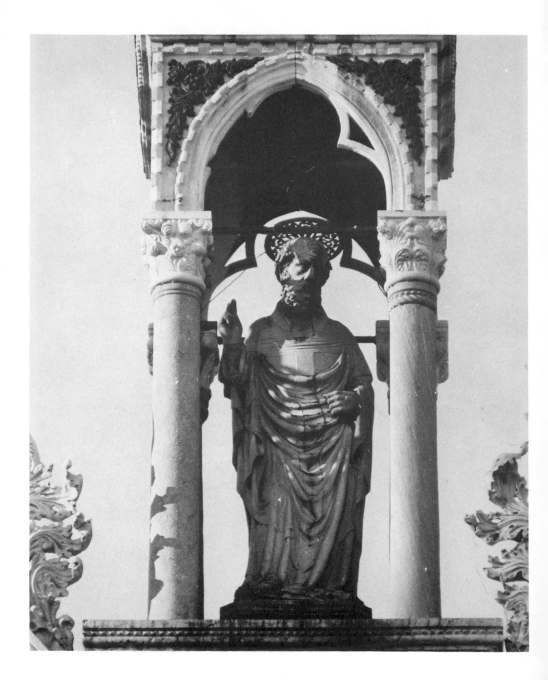

68

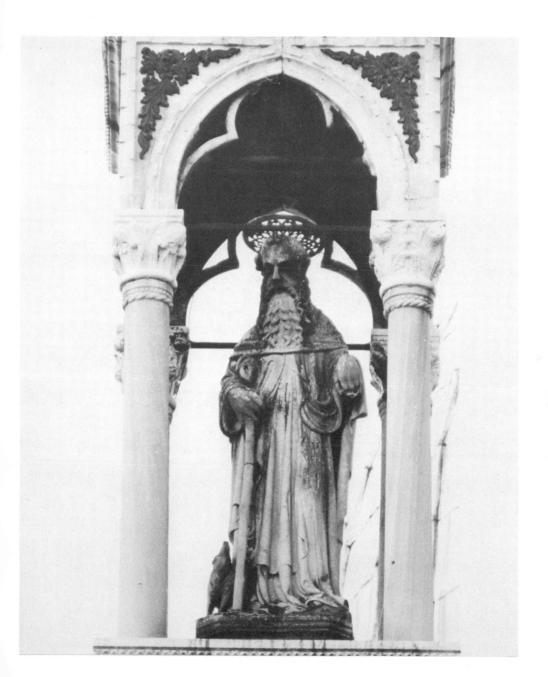

69

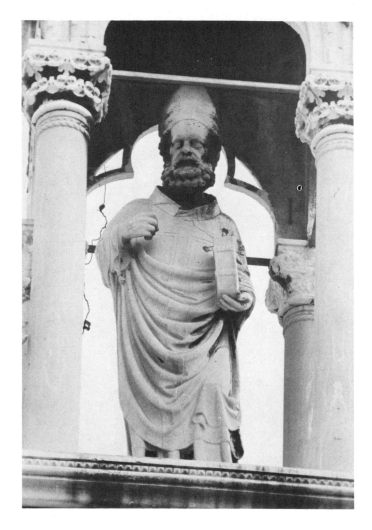

70

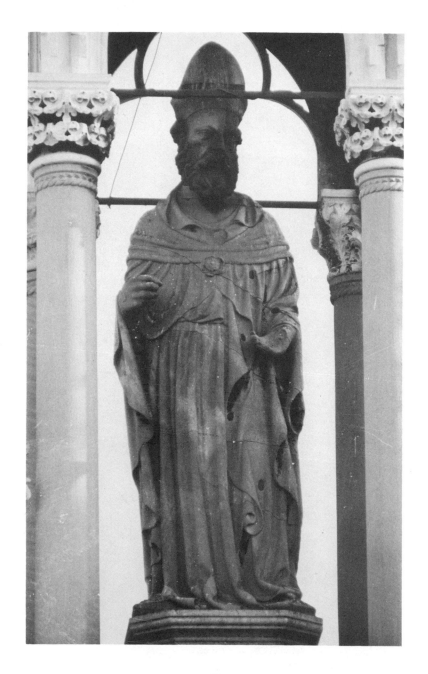

71

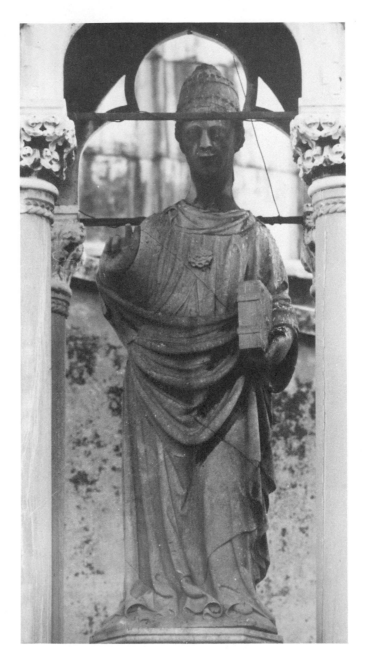

72

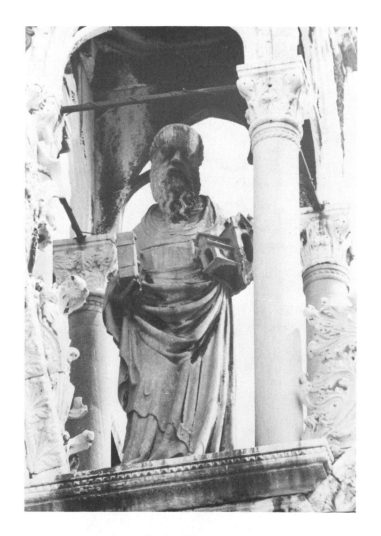

73

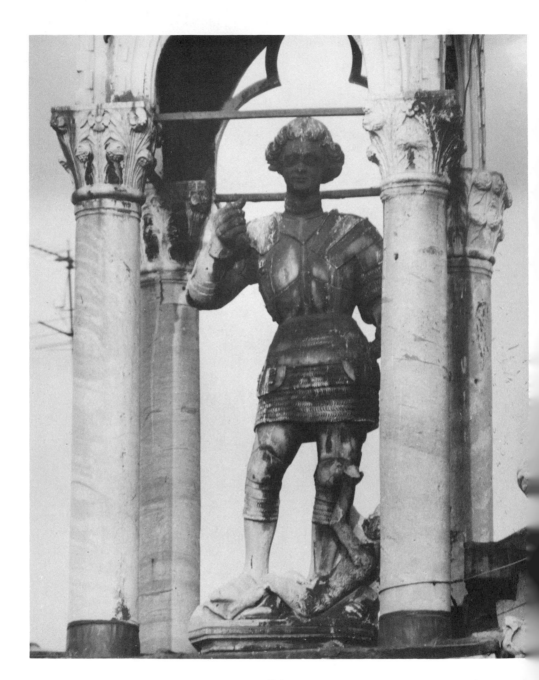

74

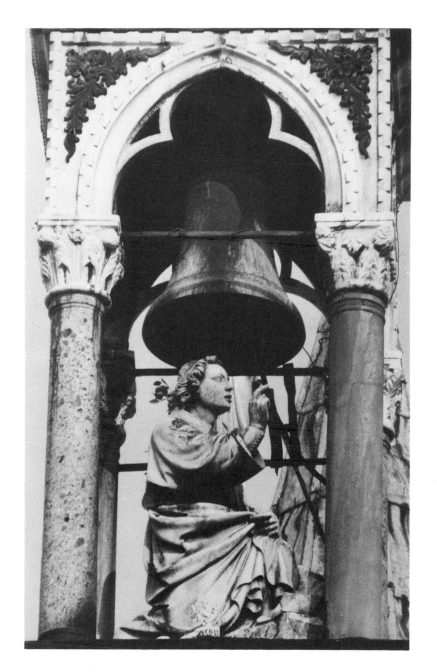

75

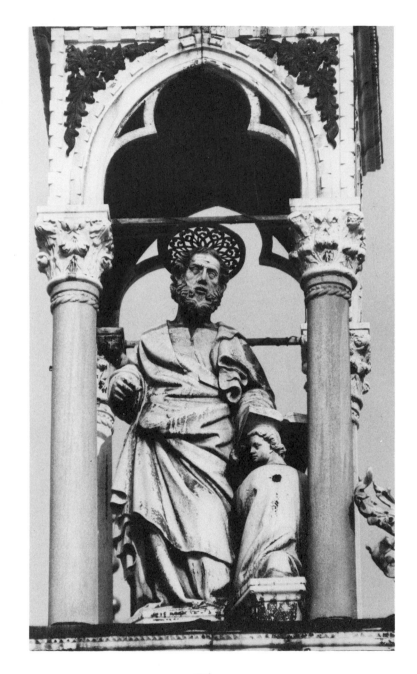

77

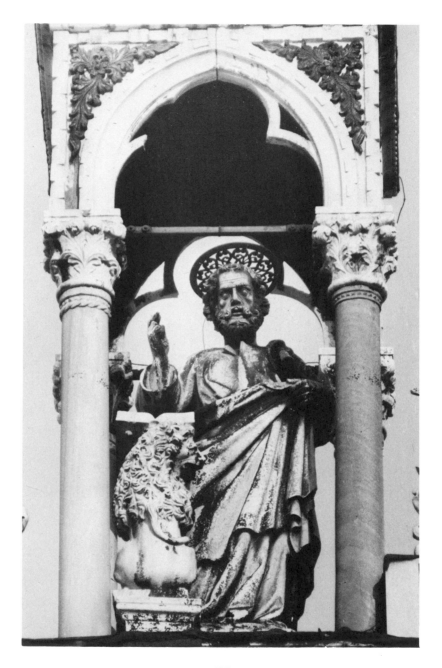

78

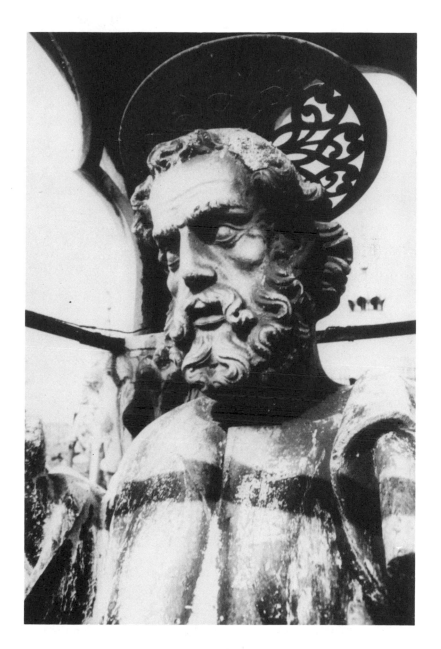

79

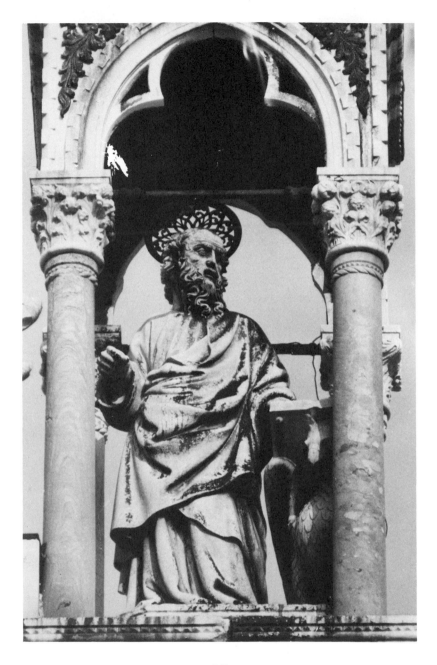

80

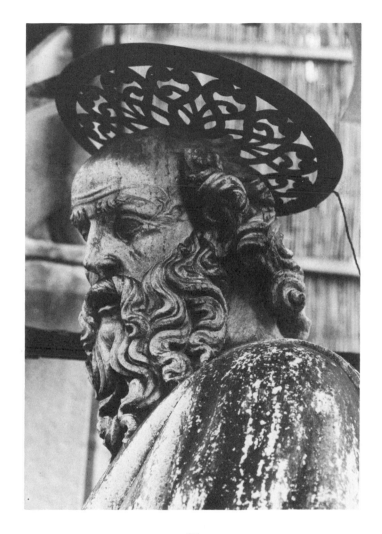

81

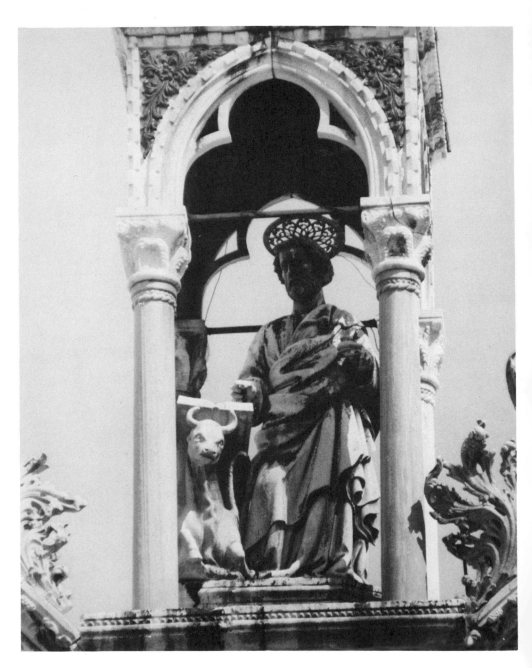

82

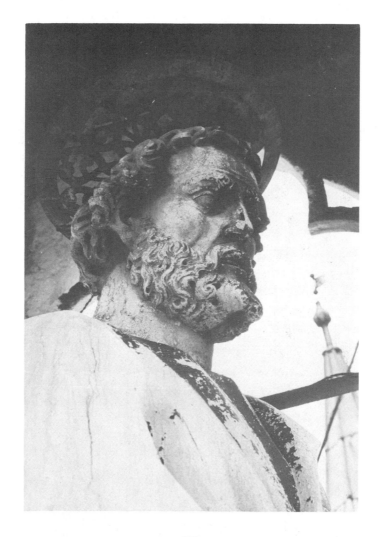

83

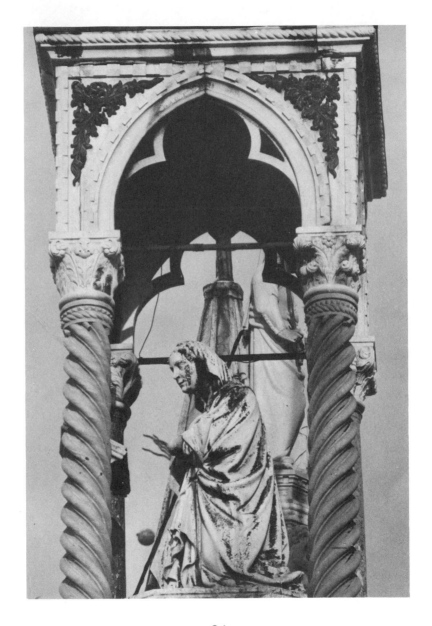

84

85

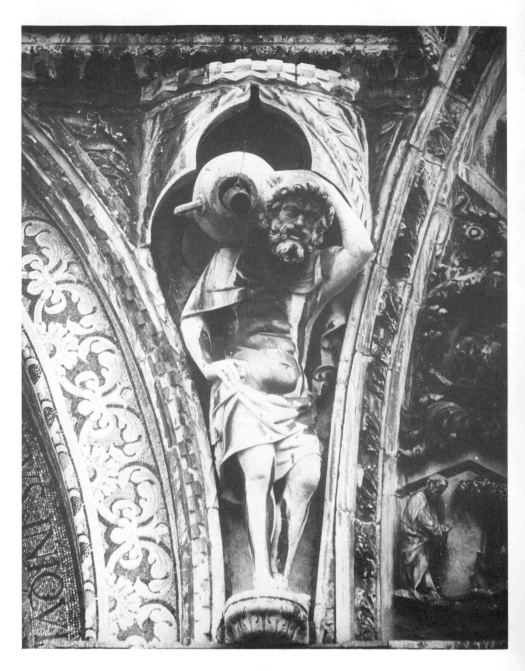

86

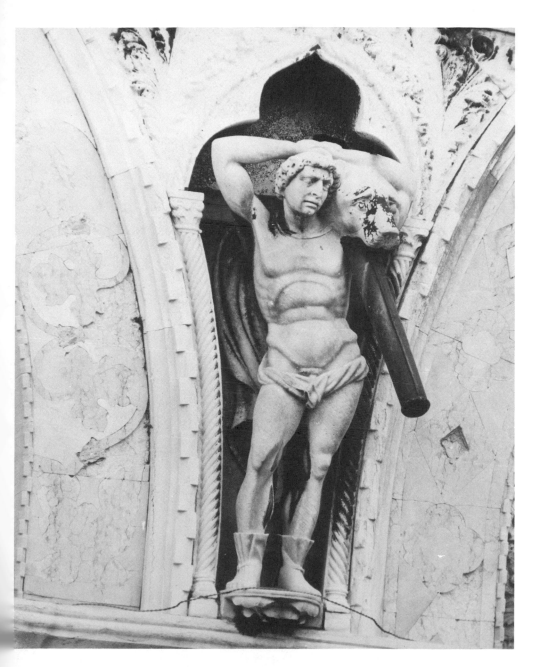

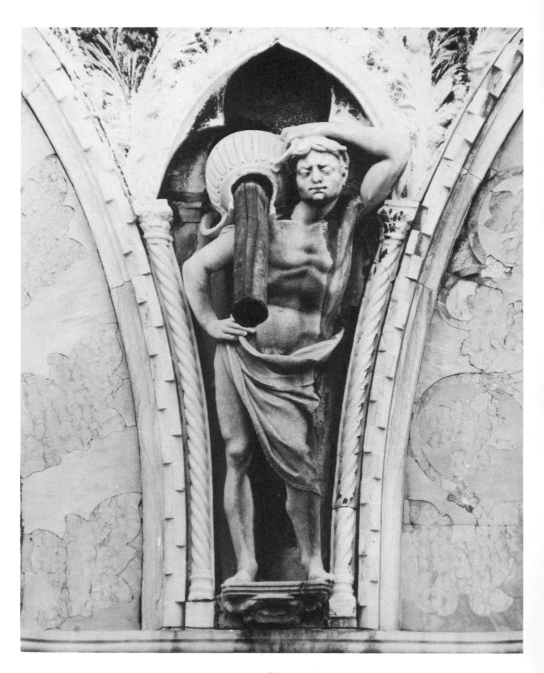

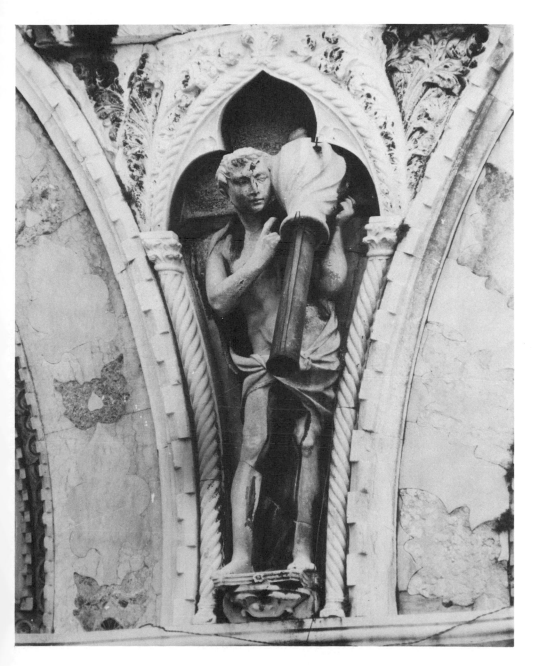

89

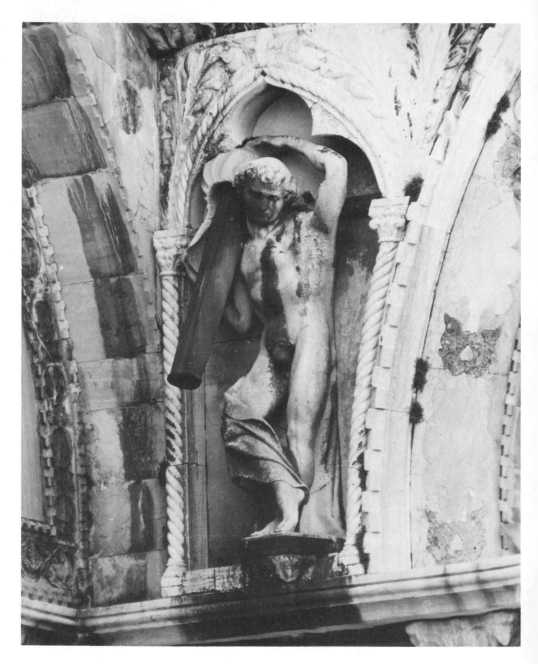

90

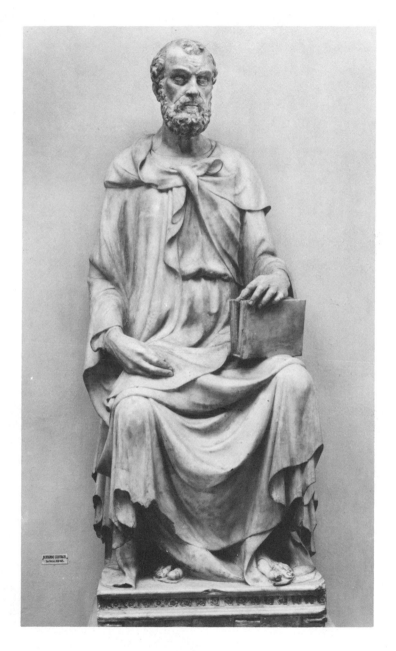

91

93

94

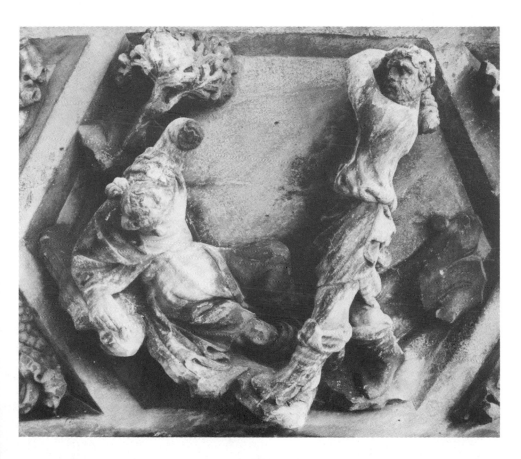

95

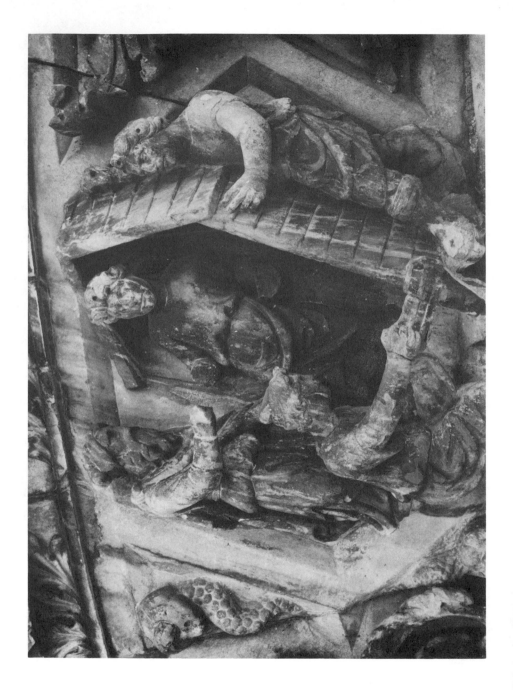

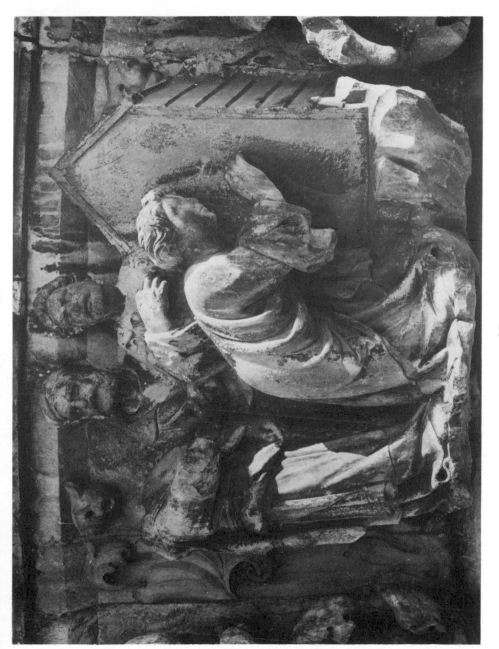

97

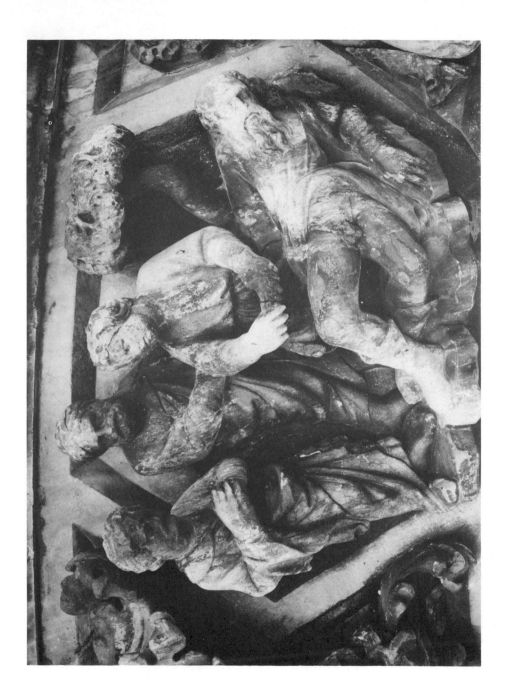

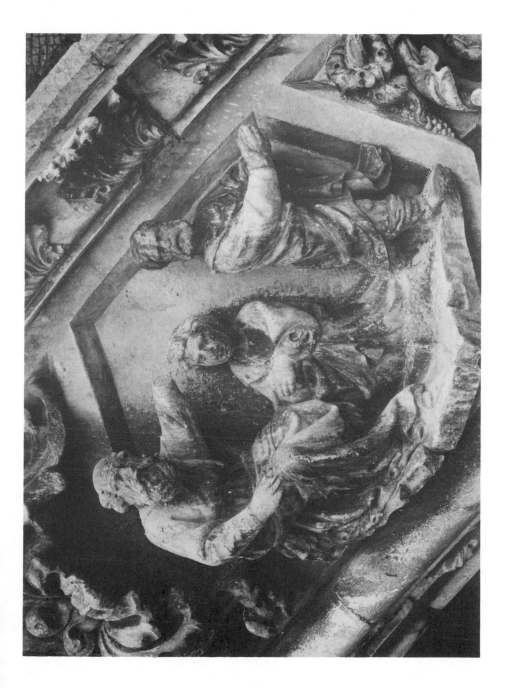

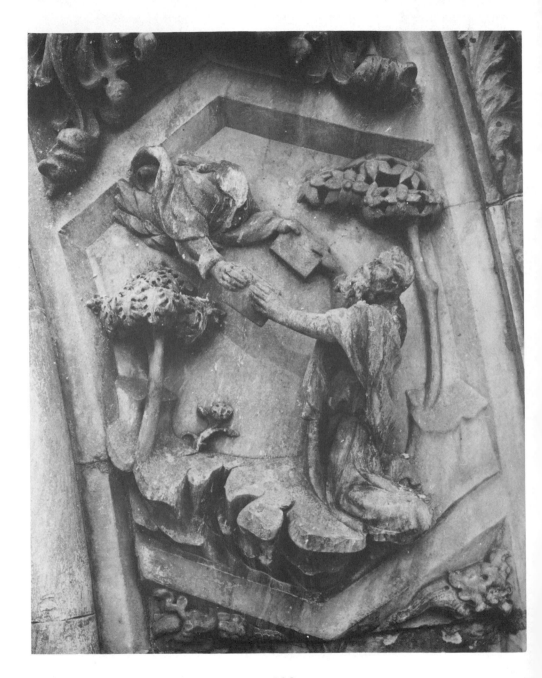

100

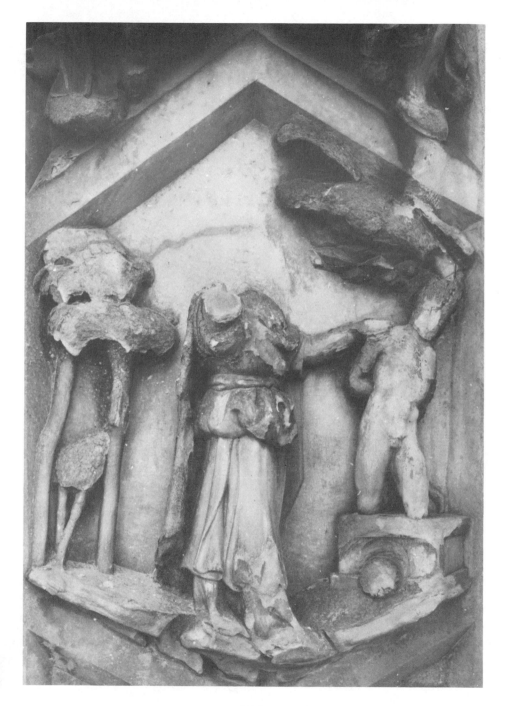

101

102

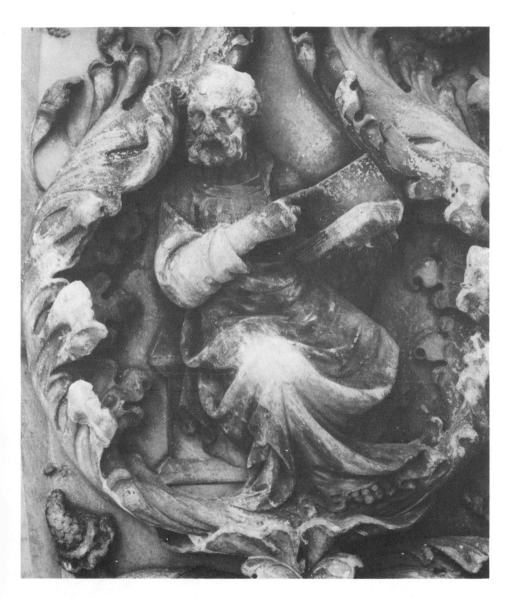

103

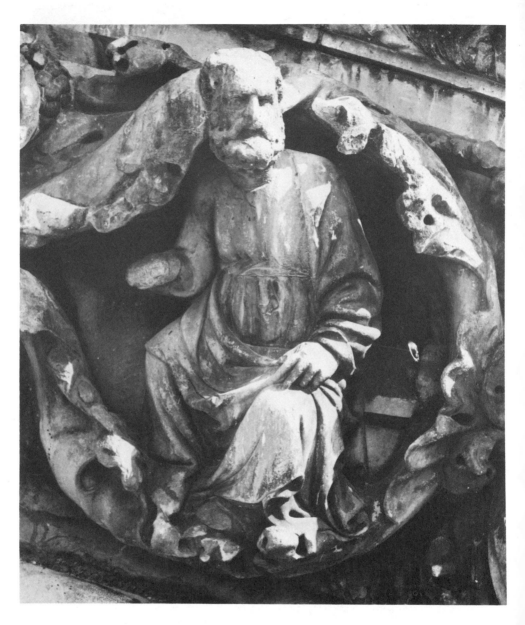

106

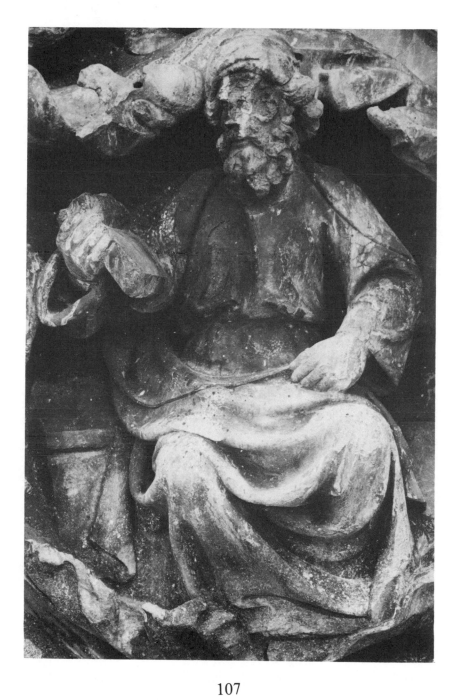

107

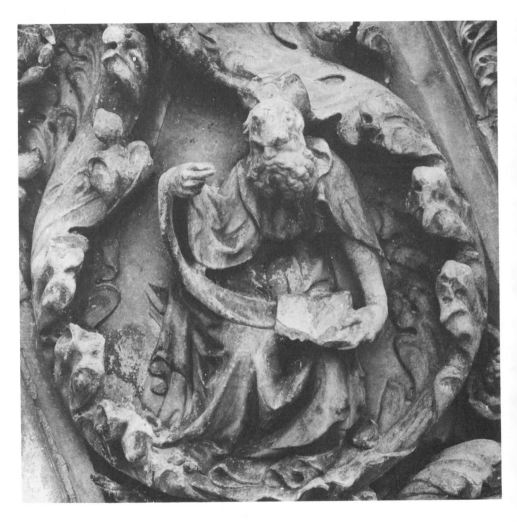

108

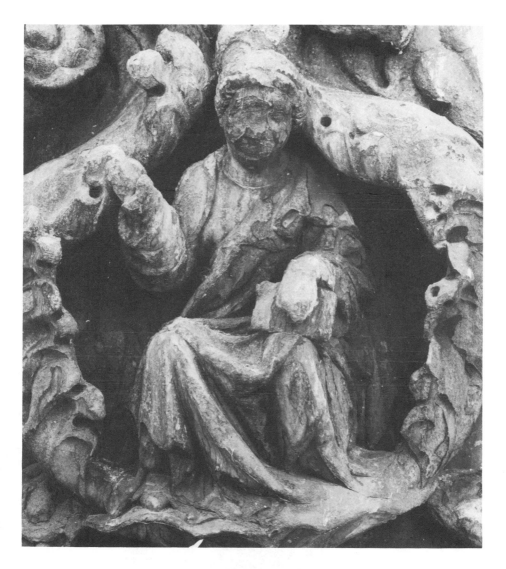

109

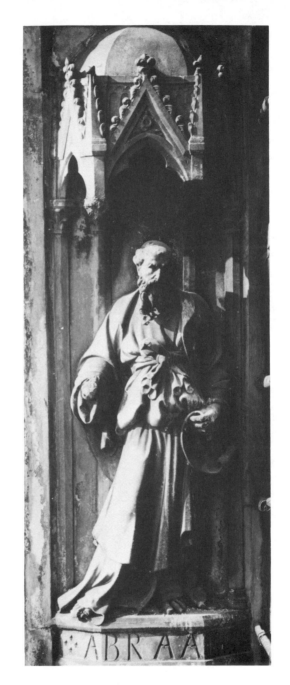

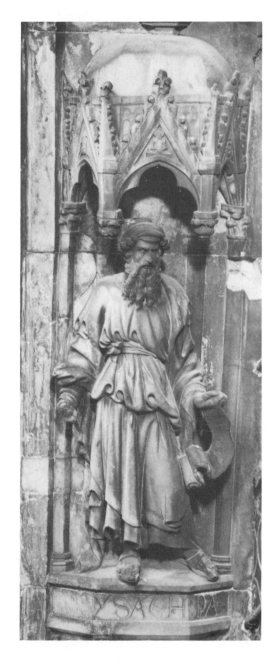

111

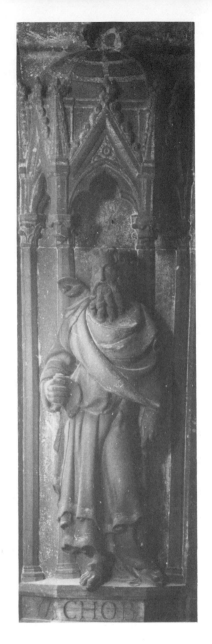

112

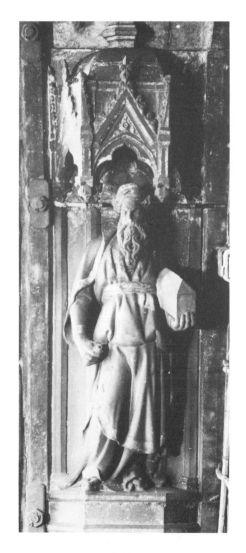

113

114

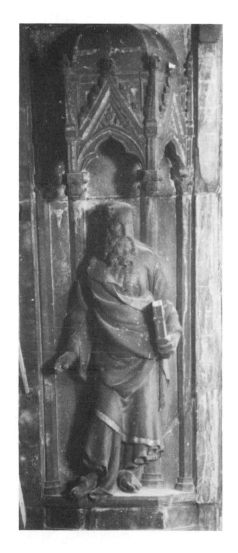

115

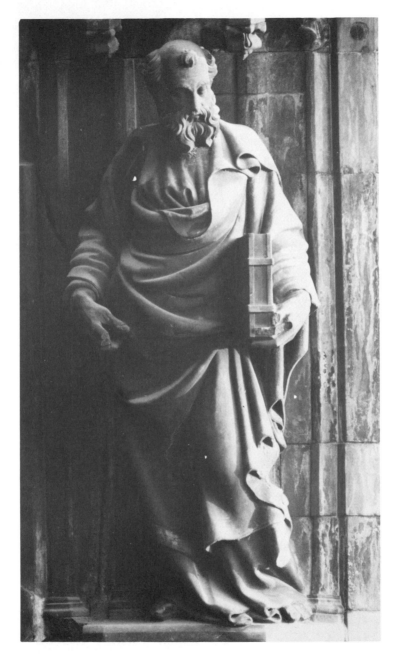

116

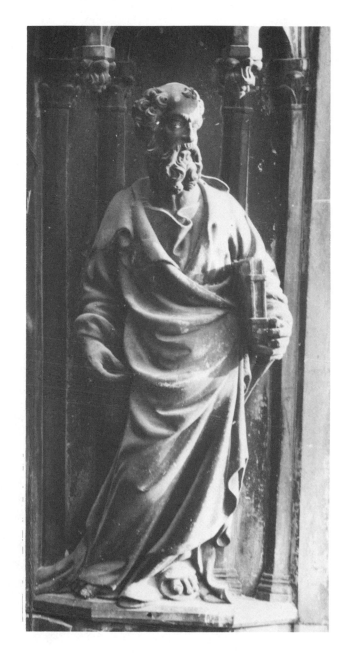

117

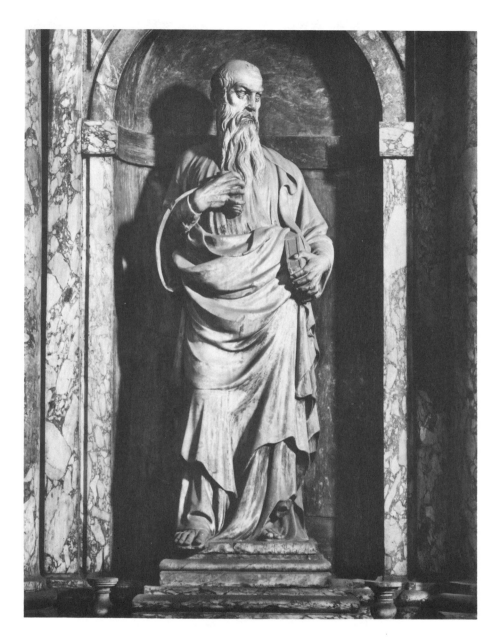

118

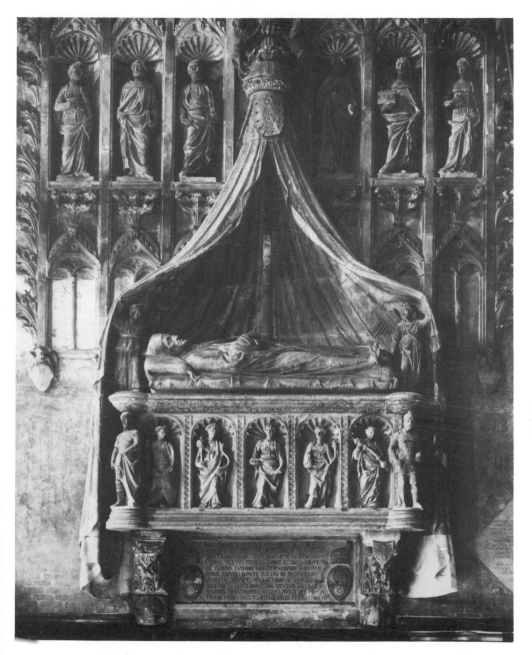

119

122

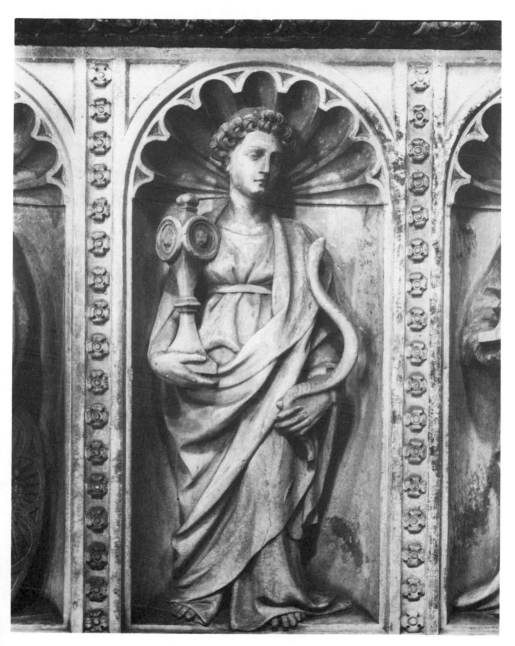

123

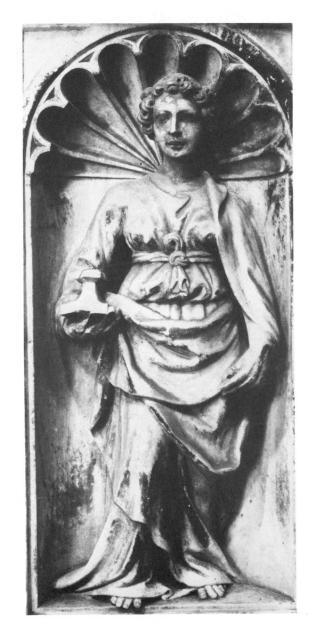

124

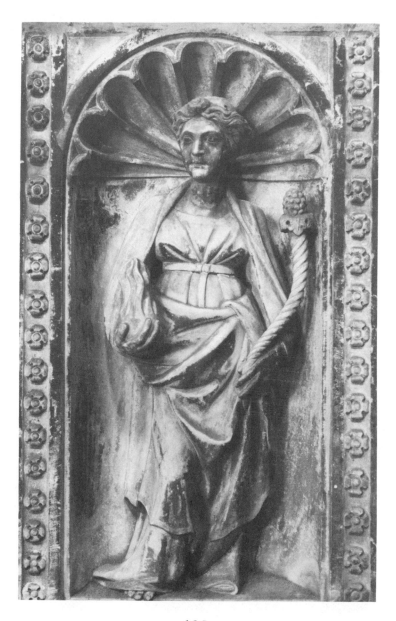

125

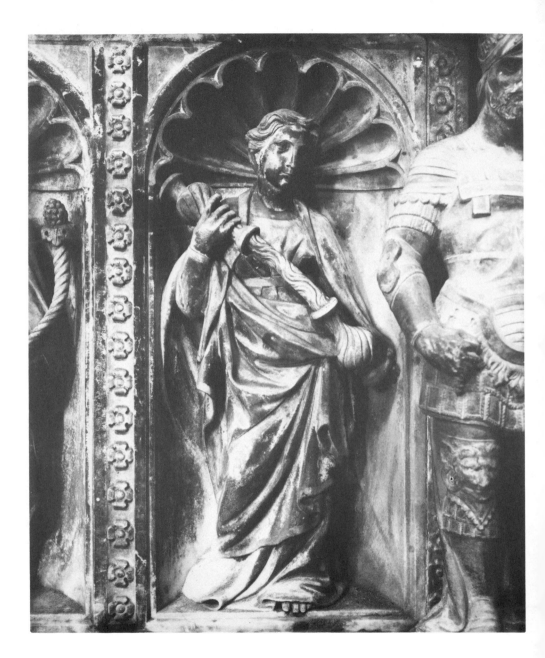

126

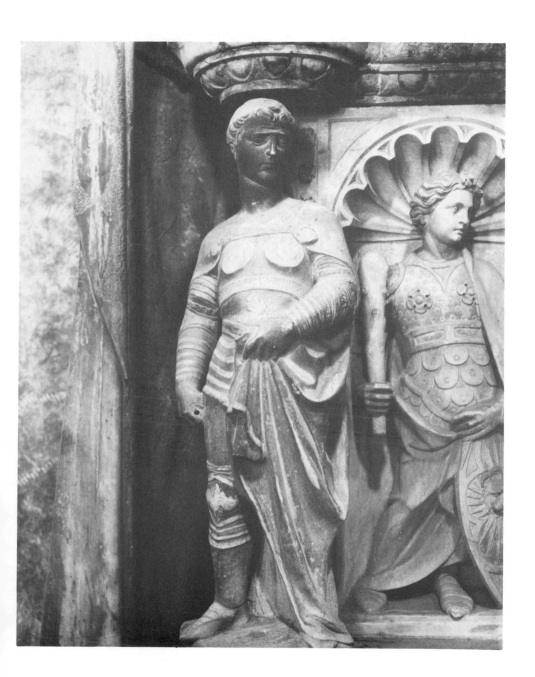

127

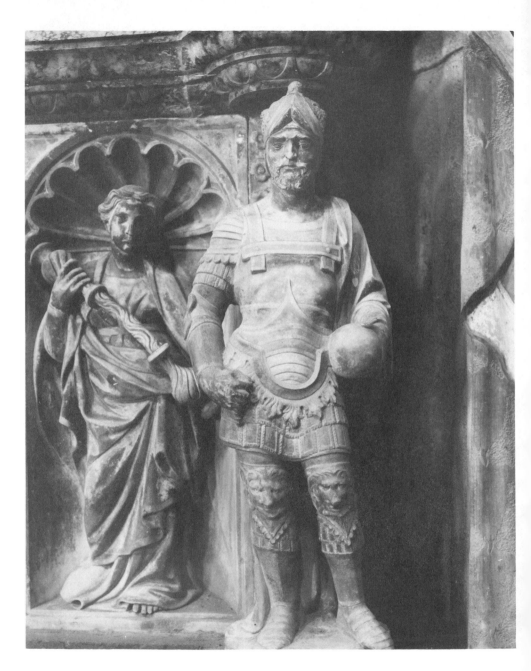

128

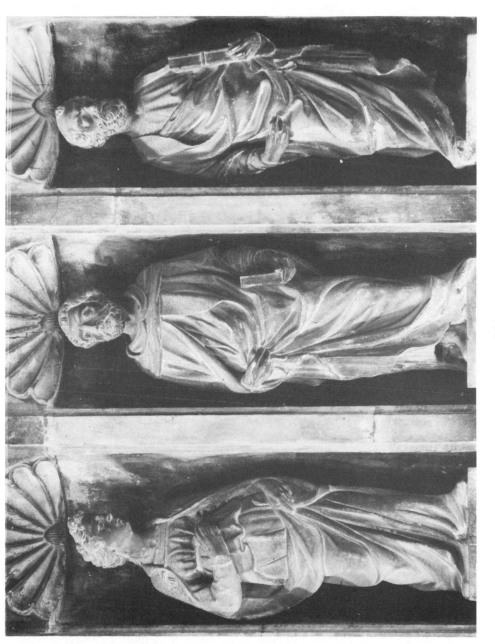

129

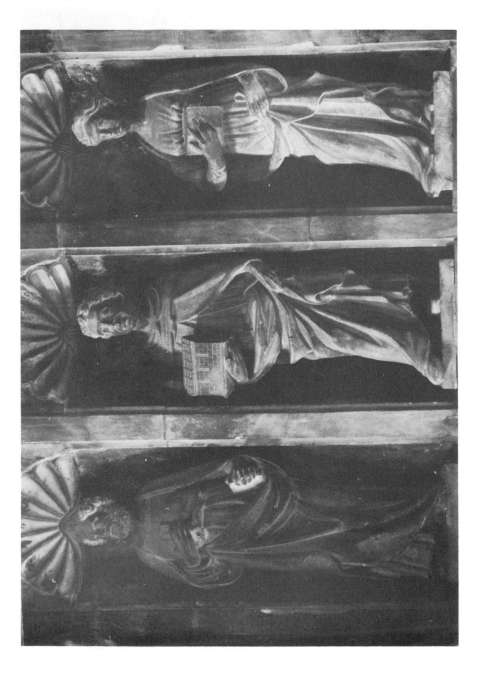

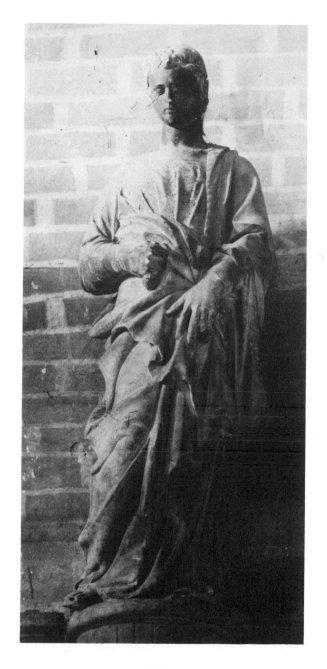

131

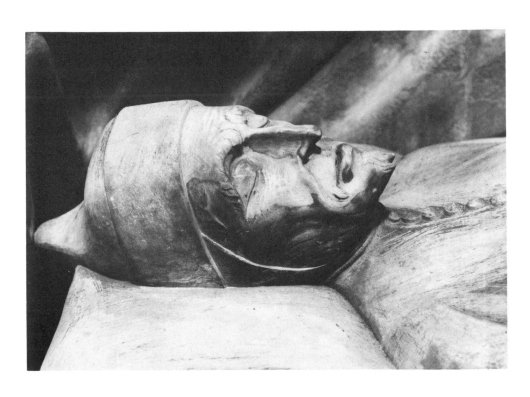

132

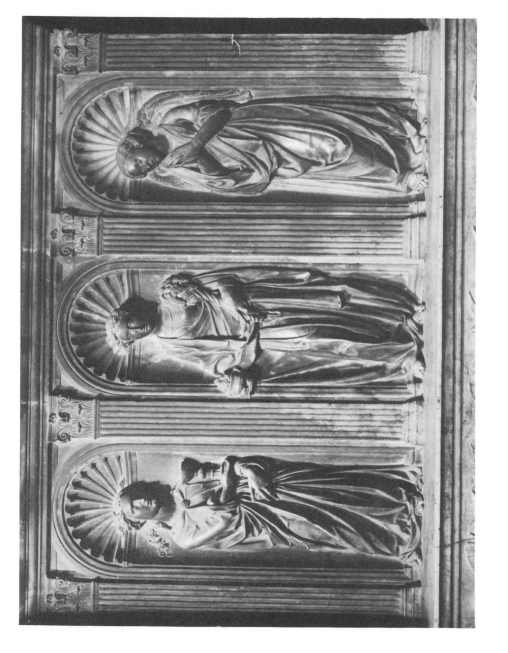

133

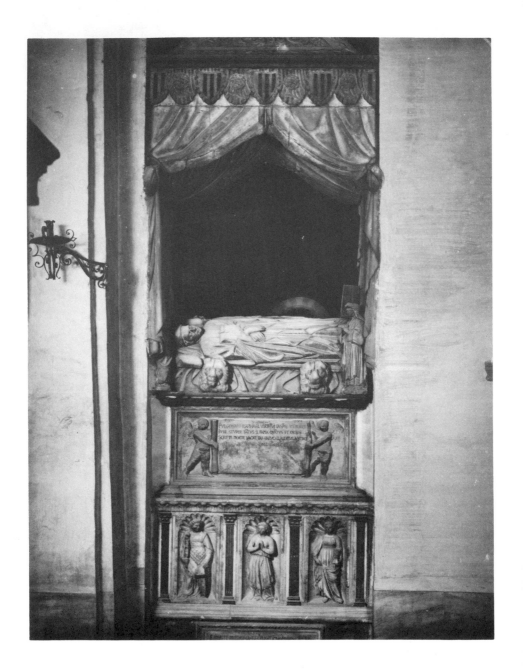

134

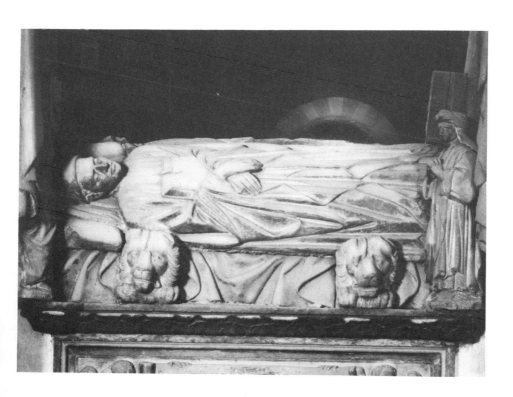

135

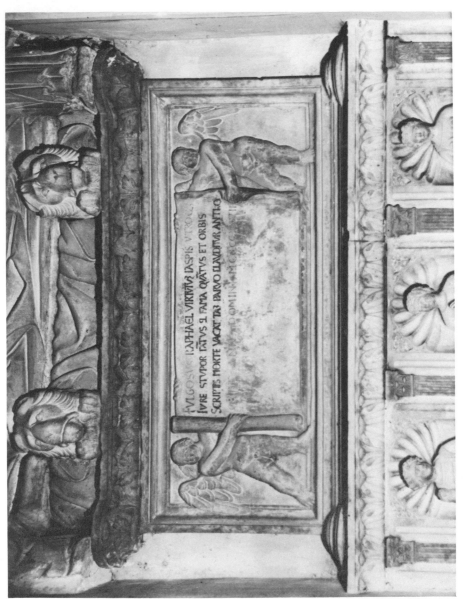

137

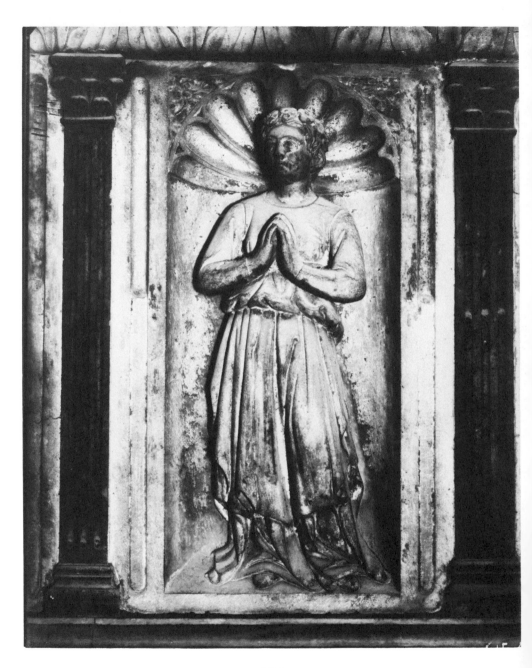

138

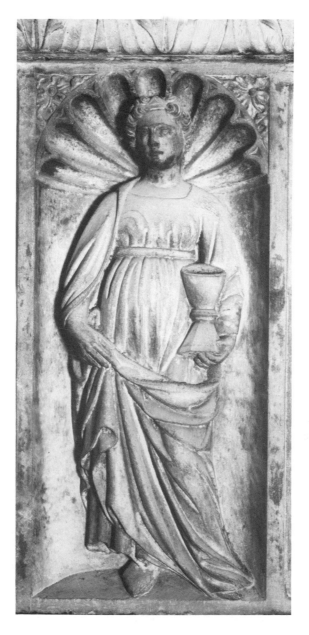

139

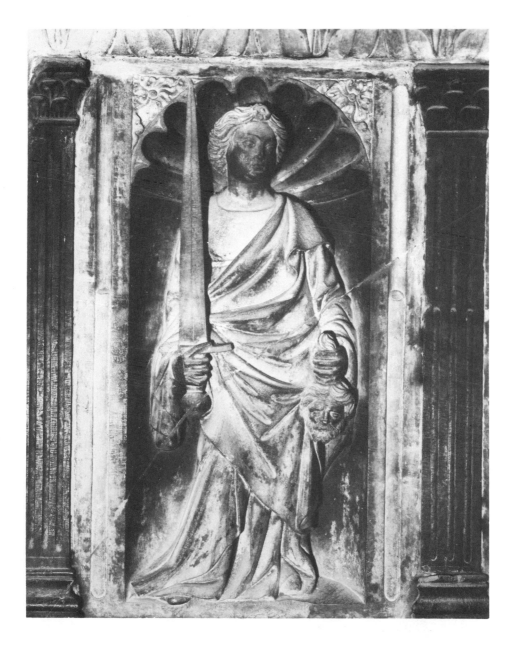

141

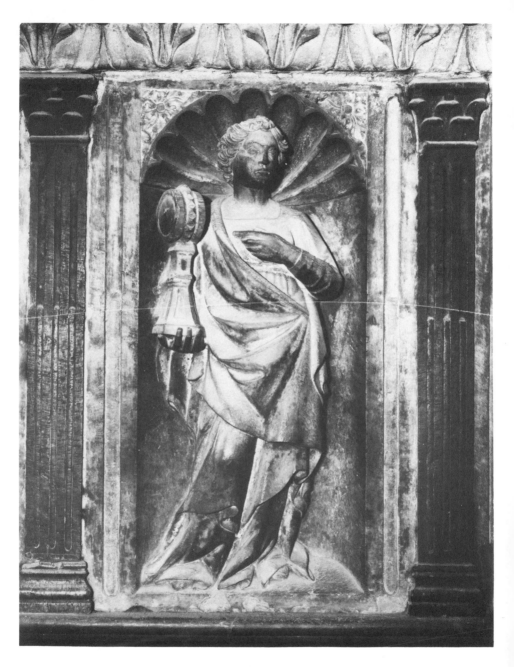

142

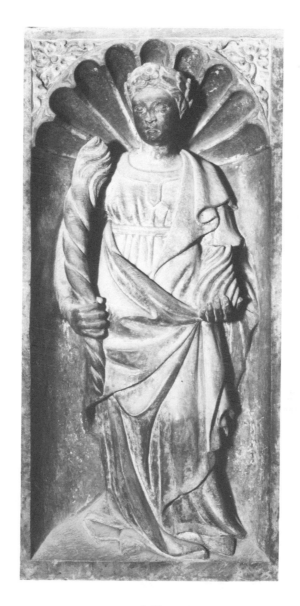

143

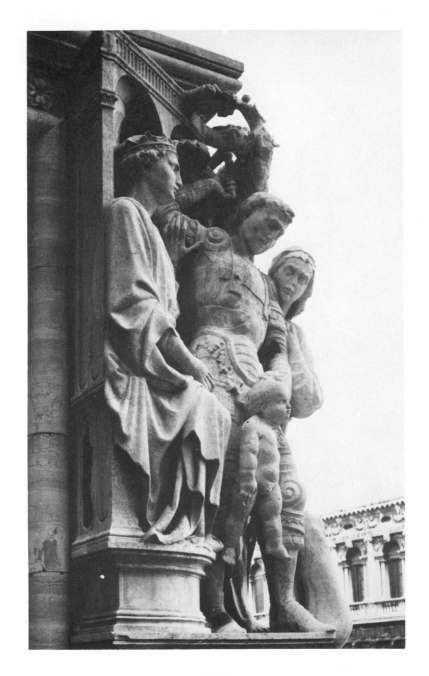

144

146

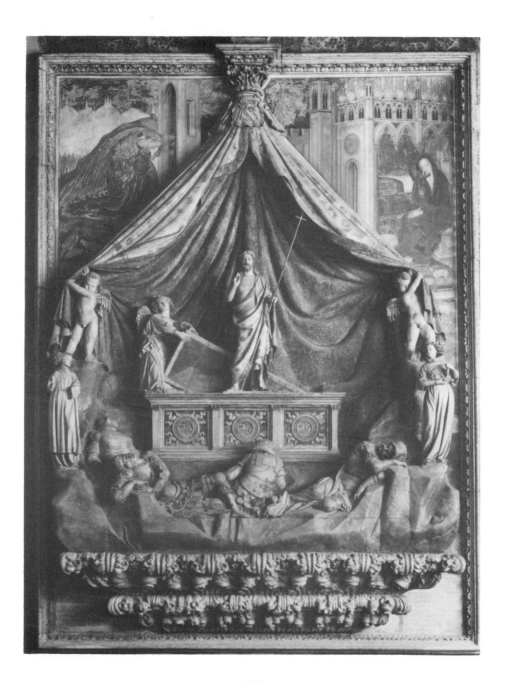

147

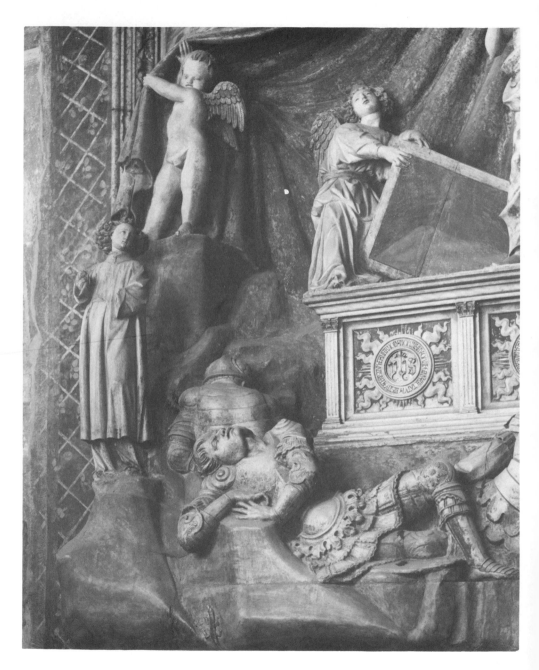

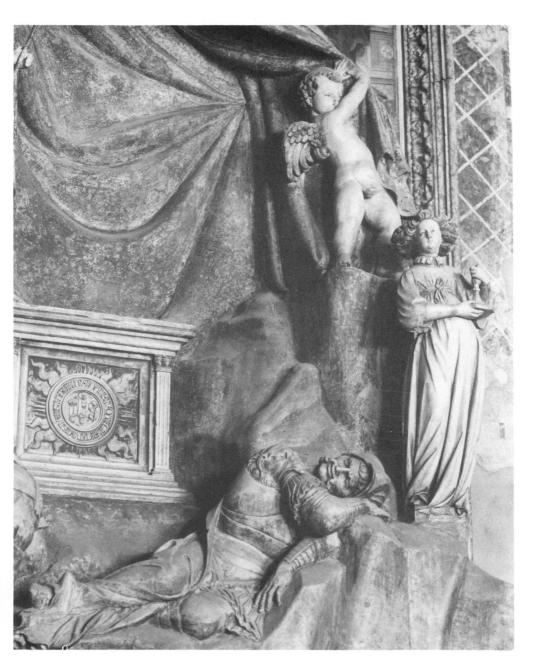

149

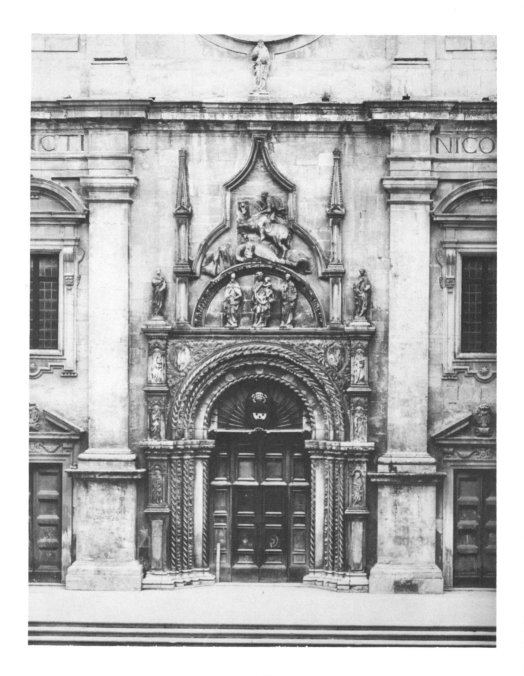

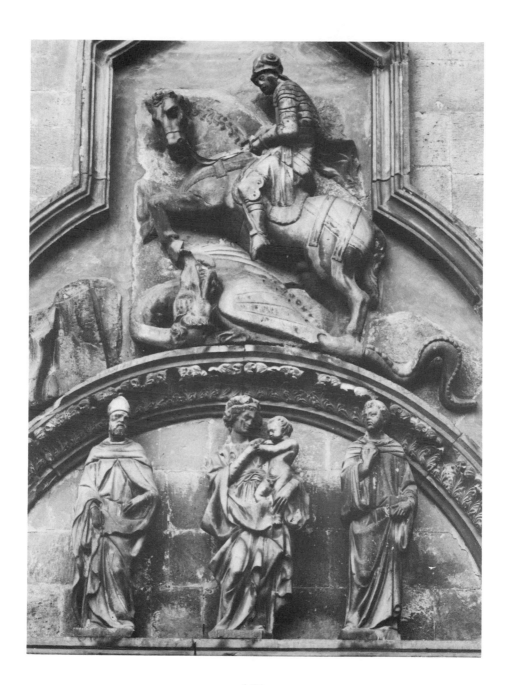

152

153

155

157

158

159